Visual Poetry

A Creative Guide for Making

Engaging Digital Photographs

CHRIS ORWIG

New Riders

VOICES THAT MATTER™

VISUAL POETRY:

A CREATIVE GUIDE FOR MAKING ENGAGING DIGITAL PHOTOGRAPHS

Chris Orwig

NEW RIDERS

1249 Eighth Street
Berkeley, CA 94710
510/524-2178
510/524-2221 (fax)

Find us on the Web at: www.newriders.com
To report errors, please send a note to errata@peachpit.com
New Riders is an imprint of Peachpit, a division of Pearson Education

Editor: Susan Rimerman
Copy Editor: Peggy Nauts
Production Editors: Tracey Croom, Becky Winter
Cover and Interior Design: Mimi Heft
Composition: Kim Scott, Bumpy Design; Danielle Foster
Indexer: Karin Arrigoni

ISBN-13: 978-0-321-63682-9
ISBN-10: 0-321-63682-1

9 8 7 6 5 4 3
Printed and bound in the United States of America

For my three girls—Annika my sweet pea, Sophia my sunshine, and Kelly my first love.

Acknowledgements

First and foremost Susan Rimerman—my editor, coach, and keel. You have added clarity and deepened my voice, enlivened my vision, and unearthed my strength to go faster and further; kept me on course and quickened my resolve to press on. Your contributions have been immense.

The production and design team of Tracey Croom, Mimi Heft, Kim Scott, Danielle Foster, Peggy Nauts, Becky Winter, and Karin Arrigoni. Thank you for your tireless resolve in making this project come alive.

Nancy Ruenzel, the publisher who planted the seed for this book years ago.

I am grateful beyond words to the guest speakers who have graciously contributed to the cause. Their wisdom and photographs have broadened and deepened this project in remarkable ways—thank you!

David Litschell and Scott Miles from the Brooks Institute where I teach—thank you for your vision and effort that make our school one of the world's best. I am incredibly proud to be a part of such an amazing team.

Lynda Weinman—thank you for taking a risk on me. Your belief in me has opened so many doors. You are is a constant source of brightness in my life.

Bruce Heavin, as a mentor, colleague, and good friend, your words of wisdom and encouragement have helped me soar to new heights. Martyn Hoffmann, you are a brother in the truest sense of the word. More than anyone I know, you have taught me how to live intensely and without regret.

Mom—your creativity, curiosity, energy, and enthusiasm have been a wellspring of nourishment and life. Thank you for passing on a passionate and artistic way of living.

Dad—this all started by seeing your black and white prints in the attic which made me want to make some myself. Thank you for giving me my first SLR camera and letting me borrow yours before I had my own!

Carol Burke, your love of books, travel, and family, and your indefatigable spirit have taught me so much.

Kelly, you are my soul mate, lover, and best friend. Through thick and thin you have helped me become who I was intended to be.

The Creator of Light, who strengthens my resolve, imbues my life with purpose, renews my vision, and continually teaches me how to see.

Contents

INTRODUCTION xi

PART I GETTING STARTED

CHAPTER 1 Poetry and Photography 3

Inspiration 4

Guest Speaker: Marc Riboud 12

CHAPTER 2 Creativity and Photography 15

Inspiration 17

Guest Speaker: Pete Turner 30

CHAPTER 3 Learning to See 33

Inspiration 34

Guest Speaker: John Sexton 48

CHAPTER 4 Camera Creativity and Technique 51

Inspiration 52

Which Lenses? 57

What Exposure? 63

Guest Speaker: Douglas Kirkland 67

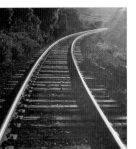

PART II LET THE ADVENTURE BEGIN

CHAPTER 5 Portraits **71**

Inspiration 72

Practical Tips 82

Gear at a Glance 97

Workshop Assignments 98

Guest Speakers: Joyce Tenneson, Rodney Smith 101

CHAPTER 6 Kids and Families **105**

Inspiration 106

Practical Tips 117

Gear at a Glance 125

Workshop Assignments 126

Guest Speakers: Jose Villa, Greg Lawler 129

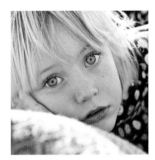

CHAPTER 7 Wedding Bells **133**

Inspiration 134

Practical Tips 138

Gear at a Glance 143

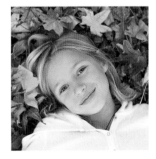

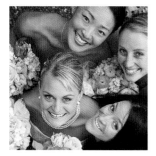

Workshop Assignments 143

Guest Speakers: Elizabeth Messina, Michael Costa 147

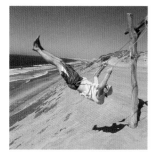

CHAPTER 8 Travel **151**

Inspiration 152

Practical Tips 164

Gear at a Glance 170

Workshop Assignments 170

Guest Speakers: Steve McCurry, Chris Rainier 174

CHAPTER 9 Action and the Great Outdoors **179**

Inspiration 180

Practical Tips 194

Gear at a Glance 199

Workshop Assignments 200

Guest Speakers: Ralph Clevenger, Todd Glaser 203

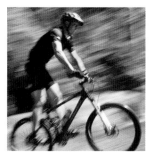

CHAPTER 10 Found Objects and Subjects **207**

Inspiration 208

Practical Tips 217

Gear at a Glance 225

Workshop Assignments 226

Guest Speakers: Paul Liebhardt, Joe Curren 229

PART III WHAT'S NEXT

CHAPTER 11 Camera Gear **235**

Inspiration 236

Camera Handling 241

Camera Lenses 242

Camera Body 244

Insurance 247

Additional Resources 248

Guest Speakers: Dan and Janine Patitucci, Jeff Lipsky,
John Paul Caponigro 249

CHAPTER 12 The Path to Becoming a Professional **255**

Inspiration 256

Additional Resources 270

Guest Speakers: Chase Jarvis, Erik Almas, Keith Carter 273

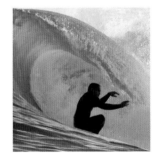

INDEX **279**

"Photography is savoring life at 1/100th of a second."

 –Marc Riboud

INTRODUCTION

I am a teacher and photographer who thrives on learning, listening, and taking pictures. And I think William Yeats said it best: "Education is not about filling a pail, it is about lighting a fire." Over the years I've watched hundreds of students pass through the photography school where I teach. It's thrilling to witness and to be a small part of many students' life trajectory.

Fire

Some of them reach graduation and walk across the stage, excitedly shake the president's hand, and place their diplomas in a pail. They blankly look around for direction and aren't sure what to do next. Others graduate, celebrate, and everywhere they go is set ablaze. Their stamina, drive, vision, and passion are contagious, and they reach previously unattainable heights.

Teaching

There's nothing more gratifying than getting those e-mails that say, "Chris, I got the job assisting for Annie Leibovitz!" "Chris, remember how I told you my dream was to get a cover of *Surfing Magazine*? Well, just be sure to read this month's issue!" "Chris, I just opened my own studio in New York!" And there's so much to learn and glean from students. They are so free and unfettered by convention and the restraints of rules. They are wide-eyed and grateful. A day doesn't go by that I don't learn something from them. That's the truth all teachers know: "By teaching, you learn."

One of the things I've paid close attention to, is why some students soar while others fade away? There are many facets to the answer, yet I've noticed a few commonalities. For starters, the best and brightest students don't say "if only." You won't catch them saying, "If only I was in New York..." or "If only I had this lens..." or "If only I had more experience..." The best students make the most of what they have. They realize that education is as much (if not more) about them than it is about their teacher, their school, their age, or their camera. They approach their education with a contagious passion.

This book is written for this type of student. It is written for those who are interested in going against the grain and who believe that putting in effort pays off. It is written for those who are willing to grow and change. And most of all, it is written for those who are enamored with photography, and who want to learn how to create the most compelling and engaging photographs of their lives.

How

How can we set out to accomplish this task? While the answer is multifaceted, there are a few practical parts. One part: how to create better photographs. Another part: how to become more creative people. The "what" and the "who" are intertwined. And thus, this book isn't an ordinary photo book. It is a book about becoming. Becoming authentic, alive, vibrant, unfettered, and renewed. It is written for those interested in discovering what it means to grow and change. Whether you are an amateur or a pro, photographer or physician, architect or acupuncturist, filmmaker or financial consultant, this book is written for you.

Workshop

I approached this book as if it were a photography workshop in a book. A workshop is different than photo school on a number of levels. Photo school is designed for the passionate beginner who can afford to take three to four years to learn, study, and grow. Photo school is a one-time, long-term process.

On the other hand, a workshop is something that you can take over and over again when you are in need of a boost. Even more, a workshop is designed to be a short course that inspires and causes quick and noticeable growth. And this workshop is designed for the beginner, the enthusiast, and the pro. It's designed for my past students and the ones to come. Believe it or not, it's designed for photographers and non-photographers. For there isn't a soul who doesn't need a regular dose of inspiration, a new perspective, and a breath of fresh air.

If you're looking to grow, expand, and improve, this workshop is for you.

Structure

In order to accomplish this task, this book is divided into three sections:

Getting Started—understanding photography and poetry, learning to see, and camera creativity. These initial chapters will be more conceptual and full of inspiring ideas.

Let the Adventure Begin—specific types of photography, including portraits, families and kids, weddings, travel, action and outdoors, and found objects and subjects. Each chapter includes inspiration, practical tips for shooting, gear suggestions, and workshop assignments to jump-start the progress of your own work.

What's Next—a practical conversation about photography gear, and how to make the transition from amateur to pro and get paid to do what you love.

Guest Speakers

Through teaching I have found that photography is broad and deep. And learning photography requires that we listen to more than one voice. I'm honored to have some of the world's leading photographers as featured guest speakers in this book. They will stop by our "workshop class" to share their photographs and wisdom to broaden and quicken your growth.

Sharing

The resources and workshop assignments—survey, shoot, and review and respond—in this book are just the beginning. They will give you a chance to test your wings. You can also join our Flickr group to share your photographs and receive feedback.

Find the group at www.flickr.com/groups/visual-poet. When you add your images make sure you have permissions from the subjects (especially for weddings and kids), and tag the images with the appropriate assignment information. For instance, "Chapter 10, Found Objects, assignment #5." On Flickr we can view and comment on each other's photos. I'm excited to see what you come up and I will stop by and leave some comments. Also visit the Web site created for this book for additional information and links: www.visual-poet.com.

Journey

Let go of the obligations. Slow down. Join up with some other friends. The time to make captivating and compelling photographs is now.

Being a teacher is one of my life's deepest honors and privileges. I'm grateful to you for partnering with me in this learning adventure. My hope is that this book will light a fire that will extend beyond the pages you are about to read.

—Chris Orwig

GETTING STARTED

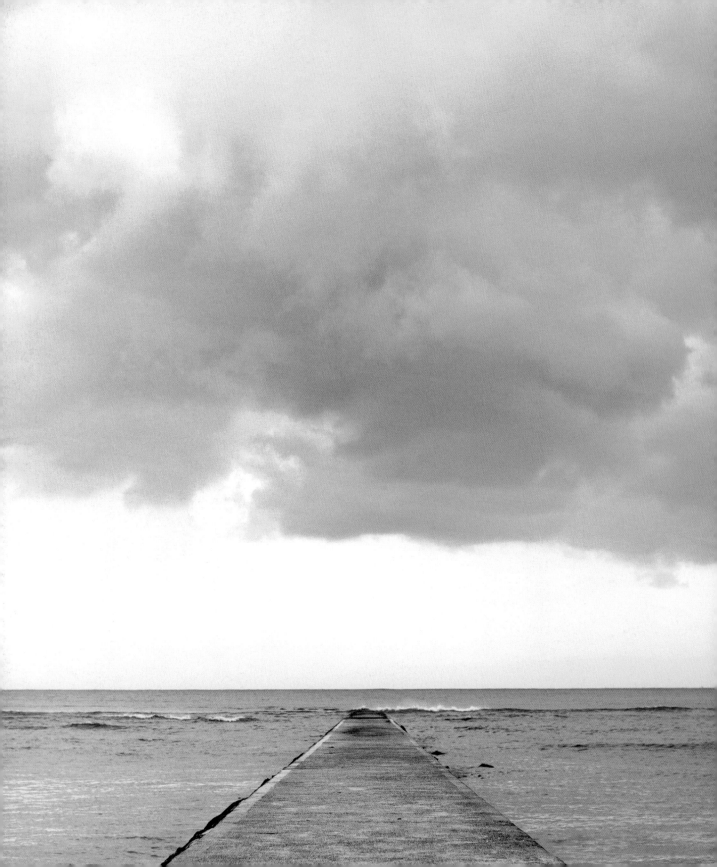

POETRY AND PHOTOGRAPHY

1

POETRY IS AS diverse as culture. Certain poems are esoteric and abstract while others are concrete and easy to understand. And poems show up all over the place: in song lyrics, carved into the trunk of a tree, tattooed on the back of an arm, or spoken out loud at a café. Why then poetry and photography?

What the novelist says in 20,000 words, the poet says in 20. And after reading a poem we don't just have more information, we have more experience. A good poem isn't about reductionism. It is about reducing, simplifying, and deepening. A poem always gives more.

And poems are spare. With so little space, they require a distillation, which concentrates and intensifies their meaning and effect. Like evaporating seawater, where only the salt remains, those few lines communicate more. And the best photographs that I know follow this same trajectory.

Mystery and Truth

Some of the best things in life are impossible to define. Our attempts to demystify them fall short or sometimes cause harm. Like cutting down a tree to count its rings. And the meaning of the best photographs is almost always the most elusive. Sure, we can theorize about composition, the rule of thirds, color theory, subject matter, but it all falls short. For the best photographs make us feel and think. They captivate and take our breath away. It is those unforgettable and unexplainable photographs that are the most gratifying to make.

Consider Ansel Adams, the master photographer. His photographs have captured our hearts and are forever ingrained into our visual memory. And Adams wanted to create photographs that went beneath the surface of things. As a result, he took poetic license on camera and in the darkroom.

Adams was not interested in a one-to-one replication, but his photographs are true. He wanted photographs to connect, compel, and have presence. Later in his life he began to add a "subtle warm tone to bring a greater force to the image." Adams was interested in force, in feeling, and in life.

He said, "A good photograph is one that fully expresses what one feels." And Adams's approach to the places he photographed was full of emotion. Consider this 1923 entry in his journal: "It was one of those mornings when the sunlight is burnished with a keen wind and long feathers of cloud move in a lofty sky. The silver light turned every blade of grass and every particle of sand into a luminous metallic splendor."

Why is it, then, that Ansel Adams's photographs have connected with such a large audience? Why is it that his photographs of static places are true? It's the idea that good pictures are both a confounding mystery and a beautiful truth.

That is exactly what good art entails—mystery and truth. John Szarkowski said it best: "Ansel found some way to pull together those little fragments of the world and put them together in a picture. In the same way a poet uses the same dictionary the rest of us do.... It's just a matter of taking a few of the words and putting them in the right order." The order is like an undercurrent or a rhythm that resonates.

It's like what Edgar Allen Poe said: "Poetry is the rhythmical creation of beauty." And while the places Adams photographed have now all been seen, the beauty he captured remains unparalleled.

Wise Poverty

Good poems and good photographs create change. They can inspire, enthrall, challenge, anger, and heal. And it was healing I needed on one bitter cold morning.

Gray and aimless rain drifted down from the white sky. My stomach ached and I bleakly stared out the window. I tried to scribble some notes. Shuffling through some books, I picked up one with a blue monochromatic cover. I found a poem about a beech tree by Eugene Peterson.

The words spoke of the tree losing its leaves and being "Empty again in wise poverty." That simple line said exactly what I needed to hear—it was time to let go. It was time to move on. And I had hope. For even in emptiness there is "Ripeness: sap ready to rise; On Signal, buds alert to burst; To leaf." I could breathe easy again.

And at that juncture in my life, only something indirect, concise, and accurate like this poem could have gotten through. That's what good art does; it sneaks up on you and changes how you think, how you feel, and ultimately who you are.

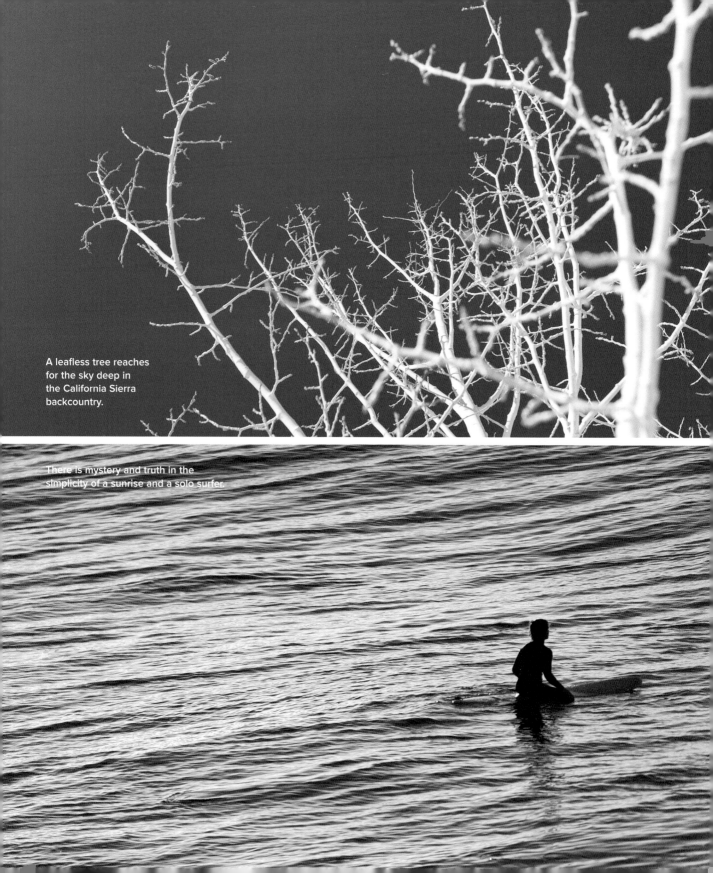

A leafless tree reaches
for the sky deep in
the California Sierra
backcountry.

There is mystery and truth in the
simplicity of a sunrise and a solo surfer.

The world is full of trite clichés and messages. Imagine if I had read something that said, "In life when you face difficulty, don't worry about it. It'll get better—get over it. Let it go." Would that have made a difference? Not at all! While the messages are similar, the details are in the delivery. The straight-forward message has a directness that hits you over the head. The poem has a magnetic power that draws you in like a campfire on a cold night. The poem respects, engages, and renews.

More with Less

Photography literally means "writing with light." And the best photographers, like the best writers, are economical with their craft. Ernest Hemingway said it best: "Write all the story, take out all the good lines, and see if it still works." And Hemingway's fiction isn't simplistic minimalism. It is vital, visceral, and alive.

Hemingway changed fiction with his short sentences, reportorial style, and ability to leave a portion of the story untold. He allowed his readers to participate. That's what great artists do; they use different forms to tell just enough of the story. The result is art that relies on the viewer. It's participatory. It invites you in. It asks questions. It begs for a response.

Beginning artists, lacking the creativity that comes from experience, employ the obvious. The result is something that tastes like overcooked food. How then can we begin to say more with less?

Discovery

Discovery is exciting. That's why we wrap presents even when they are small. There's something about tearing through paper without knowing what lies beneath.

Good artists do more than conceal, they create a sense of adventure like the scavenger hunt my wife prepared for me on Father's Day. The hunt started with a note, which led me to the orange tree. The kids were running at my heels. We laughed and raced to find the next clue. Scrambling from note to note was actually more fun than the final gift.

The trick of great poems and photographs is to tell just enough. Let the viewer decide. To illustrate this idea in my classes, I'll play a song over the sound system like the poetic lyrics of "Until the End of the World," written by the band U2. The song begins:

> "Haven't seen you in quite a while. I was down the hold just passing time. Last time we met was a low-lit room. We were as close together as a bride and groom. We ate the food, we drank the wine. Everybody having a good time..."

After listening to the entire song, I asked the students, what is it about? A few suggested betrayal or loss, but they were not sure. And then I gave them the key. When the lead singer performs this song, you have to listen closely but he starts off by singing, "Jesus, this is Judas..." It's about the Last Supper.

The lyrics told enough, but not too much. The song stays connected to the past while transcending the subject matter. It becomes a metaphor that reminds us of something else—it resonates. And you have to wonder, had the band called the song "The Last Supper" or used the names Jesus and Judas in the lyrics, would it have been a hit? No way!

If you want to make amazing photographs, take your cues from the art, the poetry, and the lyrics you enjoy. Some people prefer messages that are buried. Others like the simple unwrapping of twine and brown paper. Or maybe you're a bit more adventurous and enjoy detailed treasure maps or scavenger hunts. Ask yourself what ignites your imagination and work to create photographs that say more with less.

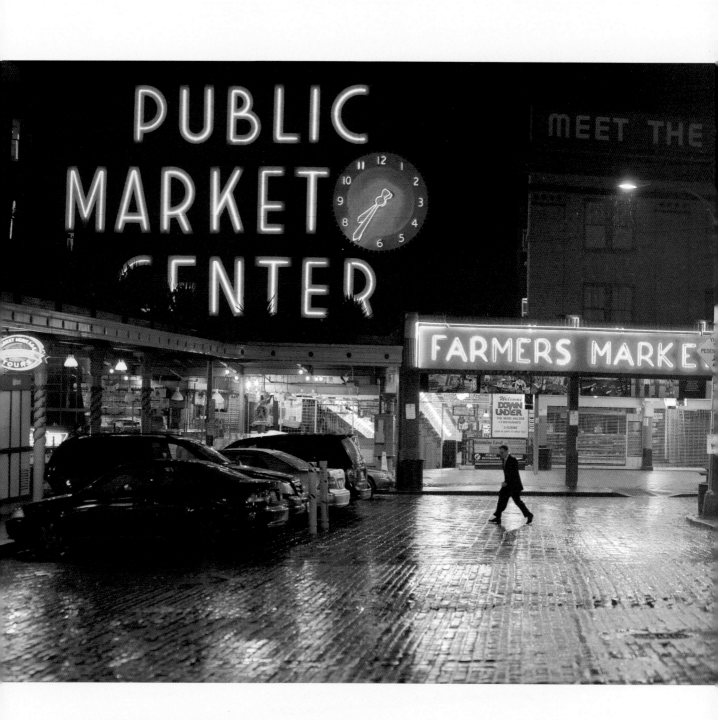

The soft Seattle rain made these reflections that caused me
to pause in front of this overly familiar scene. It wasn't until
the man began to cross the street that I pressed the shutter.

The muted tones and the rough water of this off-season beach scene ignite the imagination.

Fill in the Gaps

Poetry rekindles your imagination. It sets it ablaze and gets things going. With poetry, frozen gloves are thawed and hot water is boiled. And a few sips of hot tea warm from the inside out.

The reason poetry kindles is because it forces you to use your imagination to fill in the gaps. The same is true in photography. You can kindle the imagination in so many ways. Consider this idea with the composition or content of a photograph.

If you compose a photograph with a pattern that extends to the edge of the frame, the viewer assumes it goes on forever. But if you intentionally crop something out of the frame and the viewer imagines it is there, he will see it as missing. In other situations, you can use shapes, positioning, or light to create a unique context or to direct the eye to a particular place in a photograph. Whatever technique you employ, you should aim to involve viewers to make connections themselves, whether consciously or subconsciously.

For a more direct approach, try to create photographic content in a way that asks an unresolved question. When you're shooting ask yourself, "who, what, why, where, and how." Who is that? What exactly is it that I'm looking at? Why does this person look so sad? Where is this road leading? How is that possible?

Lean Forward

Good poems, like stories, films, or photographs, have a systemic logic that is consistent and cohesive. And it is this logic that keeps you involved and committed. As a poem progresses, the pattern, rhythm, and theme loop back to where it began. And poets work hard to make this happen.

Perhaps you've experienced this while waiting in the dentist's office or after a long day of work. You pick up a book or magazine and impatiently flip page after page. You're not even really looking—it's just something to do like twiddling your thumbs. And then, startled, you frantically flip back two pages while holding your breath. Eyes widen and you lean forward. A startling image catches you by the collar. The more you look, the stronger its grasp. It keeps you tied to the page.

When this happens, typically it is just a single image, which says everything you need to know. There's no need to flip forward or backward; you know there won't be anything that comes close. And with images like these, your eye travels around the frame and then repeats the same path again. Each element of the frame keeps you there and reminds you what you've already seen.

Effortless

Some of my favorite artists, athletes, and authors execute their work with a clean and elegant style. They are the ones who maintain grace under pressure. They accomplish their task as if it were effortless.

The idea of effortless isn't new. The Renaissance author Baldassare Castiglione called it "Sprezzatura." It was his word to describe the need in art to make whatever is done or said to appear to be without effort.

This approach enlivens, inspires, and builds a sense of authenticity that draws us in. If it looks like someone has tried too hard, it depletes. And this happens all the time with beginning photographers. The images look contrived, forced, or faked. Thus, regardless of the great light, the good composition and strong subject matter, the value is gone.

In your photographic journey, you have to work incredibly hard. But always hide your tracks and the final results will be that much more amazing.

Discard

Poets are intimate with words. While the rest of us rush by, the poet carefully selects words like delicate shells on a beach. He savors language and revels in its sound and meaning.

And the best poets aren't attached to what they've found. They drop what's unneeded back on the sand. Only the right word will do.

Photographers can learn something from this particular stroll on the sand. We are good at collecting, too, but sometimes we don't know how to let go. The best photographers in the world drop images with a fury. As my colleague Ralph Clevenger constantly reminds me, "Edit ruthlessly."

It is not enough to take award-winning photographs. We have to know how to find them. I'm fond of what the composer Igor Stravinsky says: "To proceed by elimination—to know how to discard, as the gambler says, that is the great technique of selection."

Inside Out

To feel the wind on your face as you pedal fast down a steep trail or the sun on your back as you crunch through fresh snow. To feel is to be alive.

The complexity of life easily overwhelms, and it numbs all five of our senses. Thinking that perhaps buying something new will be the fix, we pile on more and more. The result is both dry and hollow. Then along comes a poem or a poetic picture, and it reawakens our senses. The best photographs do the same. It may not be sunshine but rather pain. And pain, too, is a gift.

Pain—how can that be a gift? Many great poets and photographers embrace both joy and pain. And they know that to communicate and connect with their subjects they cannot remain distant observers hidden behind their words or lenses. There is no better way to capture an unarticulated feeling than in verse or image. W.S. Merwin wrote, "Your absence has gone through me like thread through a needle. Everything I do is stitched with its color."

Last year a different type of loss reached my town. Tragic fires swept through the hills in Santa Barbara and burned hundreds of homes. A good family friend lost everything. She asked if I would come along to document her return as she and a few close friends dug through the ashes. The photos were sad, but in her words, "The photographs gave voice to what was happening inside me."

And the best poems and photographs do just that. The numbness recedes and they make us come alive. They bring what's inside out.

Live Well

Imagine the poet's life. In my mind, I see huge trees, a winding gravel road, and a sturdy wooden house. There is an old renovated barn in back converted to a studio. Big windows overlook a pond and a nearby mountain range. The days are spent intentionally. Life is lived thoroughly and full-heartedly.

This picture was not a stretch for me to create. I simply had to think about a few of the artists I know who integrate art and life. Who they are and how they live is awe-inspiring. Your current boss might not like it if you met some of these friends. You'd likely give up your day job and start down an enviable path.

Poetry is a way of living that requires you to look, listen, and live well. And so it goes with photography. For me personally, this means there isn't a day that goes by that I don't think about the craft of photography. I can't believe I get paid to do what I do. It is a great path. In the next chapter, we'll discuss how we can begin to live with this point of view.

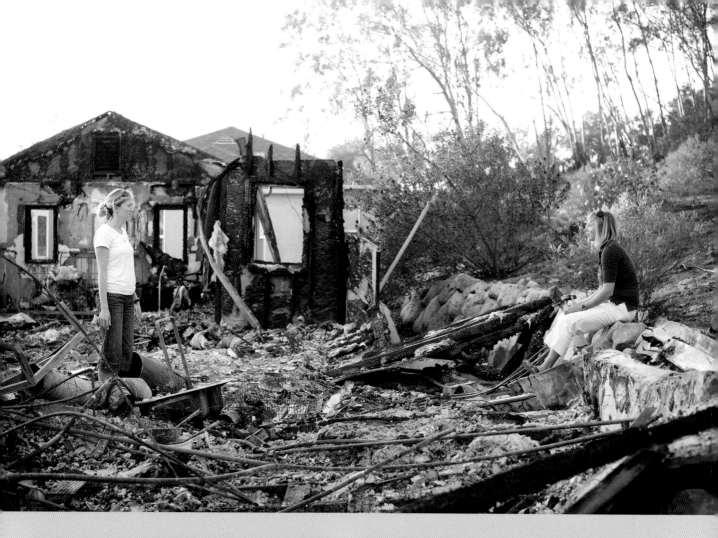

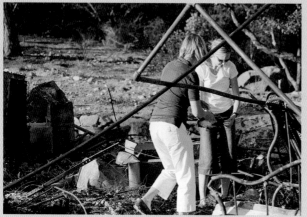

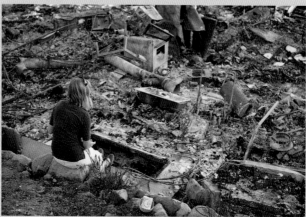

Rare times when photos say what words cannot.

Guest Speaker

Marc Riboud

I spoke by phone with Marc Riboud from his home in Paris. His voice was vibrant and his words infectious. Marc has been making pictures for over seventy years, and he has a unique ability to capture fleeting moments with strong composure. He is truly someone who says more with less. See his work at: www.marcriboud.com.

What inspires you?

Silence.

What makes a photograph good?

If it moves one person deeply, it's already a success.

What character qualities should the photographer nurture?

Geometry should be the solfège of the photographer.

What is your advice for the aspiring photographer?

The subject of the photography is less important than the picture composition.

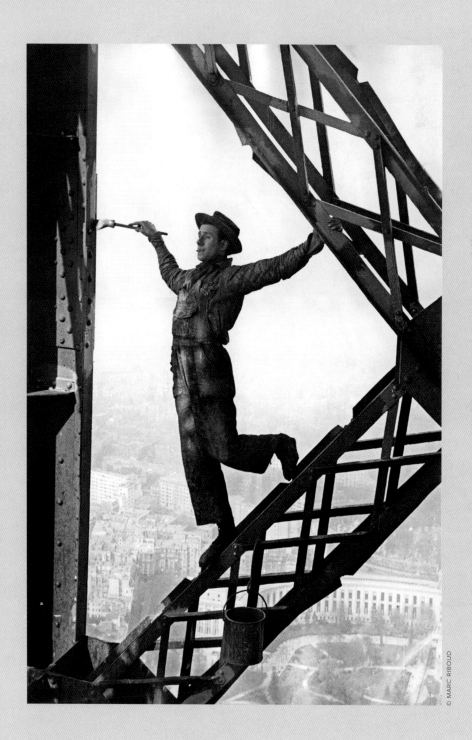

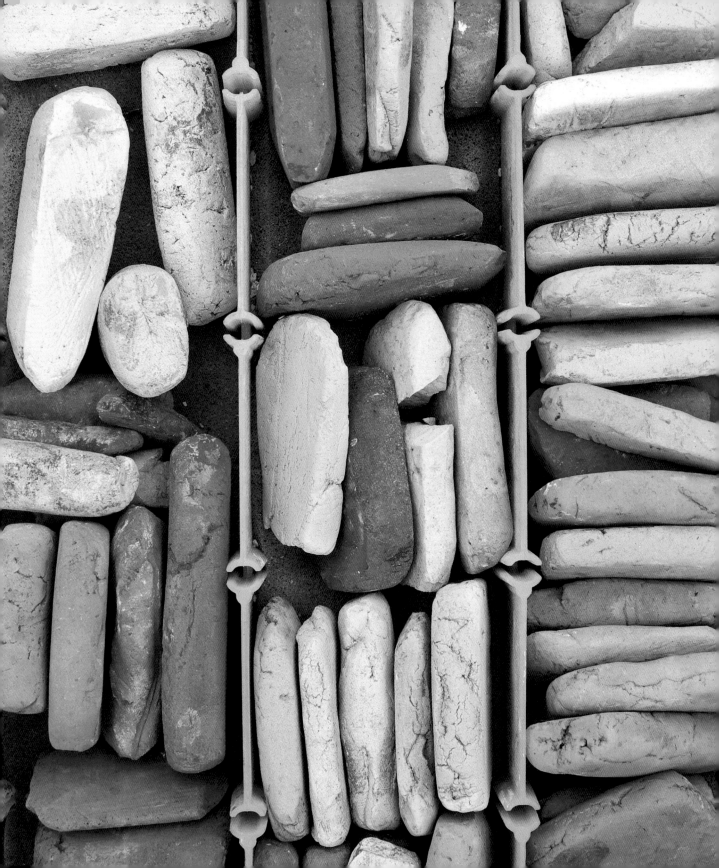

CREATIVITY AND PHOTOGRAPHY

2

TAKING GREAT PHOTOGRAPHS requires more than following seven magic steps. It requires becoming someone new. Great photographs flow from who we are. And great photographs are fueled by new ways of thinking, seeing, and living. To be creative we need to tap into new sources and simultaneously let go of convention. Picasso said it best: "The chief enemy of creativity is common sense."

In much of our culture and in our day-to-day lives, common sense works well. It's an easy path to take, and we're drawn by the initial simplicity and safety. Yet, it only takes a brief time to realize that common sense quickly dries up anything within its reach.

Creativity is vibrant, vital, and ever changing. It's contagious and unquantifiable. You can't even really define it. Wikipedia says, "Unlike many phenomena in science, there is no single, authoritative perspective or definition of creativity." Like water, creativity is something that fuels our growth. It's something that we always need. The more dried out we are, the more wonderful it is.

Finally, regardless of your current circumstances, my hope is that this chapter will revitalize you. And ultimately help you become like the proverbial tree, "...planted by streams of water, which yields its fruit in season and whose leaf does not wither."

Breathe

"To photograph is to hold one's breath, when all faculties converge to capture fleeting reality. It's at that precise moment that mastering an image becomes a great physical and intellectual joy."
—*Henri Cartier-Bresson*

There is something incredibly invigorating and inspiring about photography. And to inspire literally means to "breathe in." That breath of air brings new life. It deepens your senses and awakens you to discover new beauty, irony, metaphor, pattern, color, and more. And it is an incredibly exciting time to be interested in photography as more pictures are taken, shared, and printed than ever before. What was once limited to the elite is now accessible. Images are everywhere and photography is easy. All you have to do is push the button!

But then you download the photos or look at the prints. And what started as genuine enthusiasm has become a disappointment as you sift through the hundreds and hundreds of mediocre photos. How then can you create better, more compelling, and lasting photographs? What's the secret?

Effort

Ask anyone who has recently bought a digital camera and they'll tell you the answer to everything is digital. You can see the results instantly; you can take many photos and delete the ones you don't want. As a friend recently bragged, "When I was in Australia, I took 700 photos!" Are more photos always better? Does it lead to creating more engaging photographs? Isn't the point to keep photos rather than to delete them?

The technological advances and the affordability of digital cameras have generated an exciting swell of creativity and previously unachievable results. But the goal isn't quantity, it's quality. If you're interested in digging deeper and going further, the path you'll need to take isn't the effortless one but the more difficult one that will change who you are, how you think, and what you see. That path will remind you that some of the most valuable things in life require the most effort.

Great photographs flow from who we are. And great photographs are fueled by new ways of thinking, seeing, and living.

Curse or Cry

The secret is effort. It's brute force, grit your teeth, put your shoulder to the grindstone, push, shove, GO! Or maybe not. Maybe there's something more. As the author Anne Lamott once said, "You can do brickwork as a laborer or as an artisan." The task is the same, yet the process and the result vary. The laborer works long days looking forward to it all being over. He sweats and toils and the final results are often average.

The artisan works even harder, because it's a labor of love. He sweats, toils, and is engaged in the process. He loses track of the hours and can't believe it's already time to pack up and go. Finally, when the job is done, there is a quality about the essence of the artisan's brickwork that is intangible, inspiring, warming, and full of pride. And then, imagine if the brickwork was tragically damaged. The laborer would curse, while the artisan would cry. Which one are you?

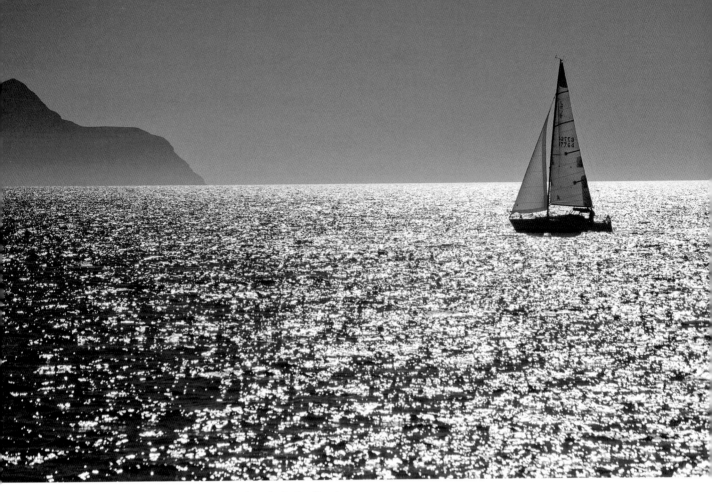

The farther you stray from the harbor, the better the view.

Become

How then do we become creative? Some argue that creativity can't be taught—it's a gift for the privileged few. Based on my own experience, I couldn't disagree more. Throughout every step of my journey, there have been people, books, movies, classes, and workshops that have helped me to become more creative. Creativity is not something only a few are born with. It is an aspect of life that some nourish and others ignore. I stand with Paul Arden who says, "Creativity is imagination and imagination is for everyone."

Imagination is the lifeblood that fuels our vitality. This is especially true in our information-rich age. Imagination isn't something that can be held captive, retrieved at will, or Googled. That's the value of imagination. It is limitless.

When we were younger, our imaginations were limitless and unfettered by practicality and qualifications. Once when I visited my wife at the local elementary

school where she teaches, I asked her class, "How many of you can draw?" The entire class raised their hands. Then I asked, "How many of you can sing?" Jubilantly the entire class raised their hands and they all began to sing different songs. It was a chaotic and wonderful sound.

When I am teaching, I ask my college-age students the same questions. In each class, sadly only a couple of brave people raise their hands. You see, the students have added a self-imposing qualifier to the question. While I asked, "How many of you can sing?" they heard, "How many of you can sing well?" Picasso said it: "All children are artists. The problem is to remain one when you grow up."

Who

There is something inspiring about living near past or present artists. The proximity of their presence challenges, invites insights, and awakens your creativity. That struck me a few years ago as I stared out the window of a Carmel beach bungalow. My thoughts drifted to Ansel Adams's home just down the way, and the poet Robinson Jeffers's stone house around the corner. John Steinbeck lived in Monterey, the town next door. The cold, damp fog drifted through the moss-covered oak tree, and at the moment I realized I had a choice.

Who would I be? Would I be an observer or a participant? Would I disengage or engage? Would I let life's complexity overwhelm me, or would I choose the path of craft, creation, and art?

Now, the story once again turns to you. You may not live in a town with famous artists, but the old limitations of geography are diminished in today's small world. In many ways, the artist's voice can be heard even more clearly—challenging, inviting, inciting, and awakening our creativity. Who will you be?

Ease

Back in our Carmel bungalow, I sat down next to the fire and read John Steinbeck's *Cannery Row*. I was lost in the details, the characters, and the story. And then it happened—I read something that transformed this novel from a bestseller to something that was hand typed just for me.

Steinbeck was describing one of the main characters, a scientist named Doc. Steinbeck wrote, "Doc was at ease with himself and that put him at ease with the world."

On most occasions, I would have simply skimmed over such a detail. That night the words traveled beyond my mind and all the way to my heart. Steinbeck's words, because they were embedded in a story, got through. They reminded me that what I do matters less than who I am. And that's the case with creativity.

Factories

My mom is an artist, and she lives like an artist. Artists find, discover, look, listen, and engage. When I was child, my mom would take us on summer field trips. While other kids were slumped over their gaming systems, my mom took us out into the world. Some of our adventures included tours of different types of factories. We saw how grape licorice was made, how fortune cookies were folded, how pasta was cut and stretched, how jellybeans got their flavor, and how animal cookies were coated with colorful sprinkles.

The highlight of all the factory tours was visiting the Hostess factory. There we learned about one of the great mysteries of childhood: how Twinkies were made. As a reasonable adult you may think Twinkies are disgusting. Remember to a child, Twinkies equaled power and respect. A Twinkie in

your lunch box meant that you could trade another child for practically anything—first game on the tetherball court, two cartons of chocolate milk... you name it!

I'll never forget being in the factory and watching how it all began—the mixing of the ingredients, flour and sugar. Next came the process of shaping and baking the dough. Finally, that glorious moment when the tour guide led us around the corner to see hundreds of freshly baked Twinkies. The skinny cakes marched down the conveyor belts and were being filled with whipped cream. The tour guide casually said, "Feel free to take a Twinkie or two off the conveyor belt. There's nothing that beats eating a freshly baked Twinkie." Our jaws dropped and my brother, sister, and I looked at each other in complete disbelief—there truly was a God!

During those trips, I vividly remember being struck by the process. The Twinkies started with the same flour and sugar that we had in our kitchen. Those field trips were one of my mom's ways to teach us about the creative process. She showed us that many of the greatest and most creative inventions of all time started with ordinary ingredients.

To this day, thanks to my mom, I believe that creativity is taking the ordinary and making it extraordinary. No matter what the situation there is always more than what is in plain view. This has led me to look for what others have overlooked. It has helped me realize that I want nothing other than to live a full and creative life. The camera, among other things, helps me do this.

Apple Pie

One day in class, after I told the Twinkie story, a few of my enthusiastic students said, "So it's all about positive thinking!" My response disappointed them. "No, not at all. In fact, I couldn't disagree more." And I proceeded to share another story.

In college, one of my brother's best friends was an incredibly talented athlete and all-around inspiring person. He grew up in Colorado, yet he and his brother had always wished they had lived in California. In fact, when they were on family vacations, they would lie and tell people they were from California and that they were surfers. They wanted nothing more than to be the surfers they saw in the movies.

Winter would come around and their dreams for surfing grew stronger. One day they had an idea. What if we surfed the mountains? Without skipping a beat, they took apart an old picnic table and turned it into a mountain surfboard. And the rest is history. These two brothers, along with a handful of others, invented a new sport—snowboarding.

When you really stop to think about it, isn't it inspiring that a global, competitive, and even Olympic sport has been invented in our lifetimes? And this new sport wasn't just the result of positive thinking. They didn't say, this situation is bad, but let's call it good. They honestly squared off with their frustrations and dreams. They were unwilling to settle for the commonplace. They applied a bit of ingenuity and voilà!

The story is reminiscent of the old parable that divides people into two categories. One category says, "Life is like an apple pie with a limited number of slices—get yours while you can." The other category says, "Life is like an apple pie with a limited number of slices. If you run out of slices, find another apple tree and bake another pie."

Contagious

Fishermen notoriously tell stories about the one that got away, or about the fish they caught that was as long as a telephone pole. Well, I've got a fish story that tops them all.

After a romantic dinner at a small Italian restaurant, I asked my then-girlfriend Kelly if she would like to go fishing. It was a surprisingly warm evening and she agreed. We made our way to the coast and walked across the old wooden pier. I spread a blanket, baited the hook, and threw our line in. The ocean waves crashed and I suggested we lie down to gaze at the stars. After a few minutes

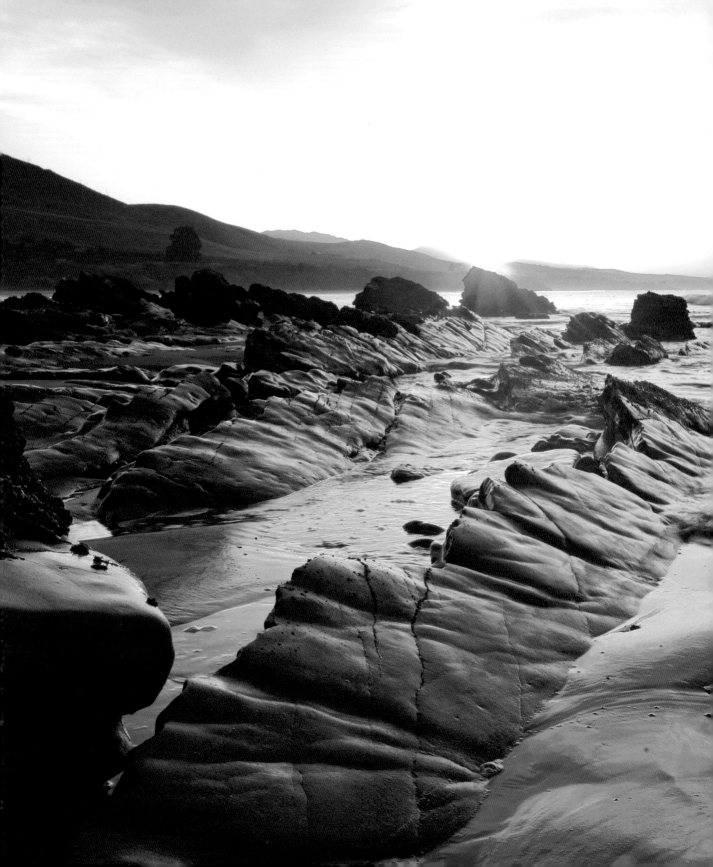

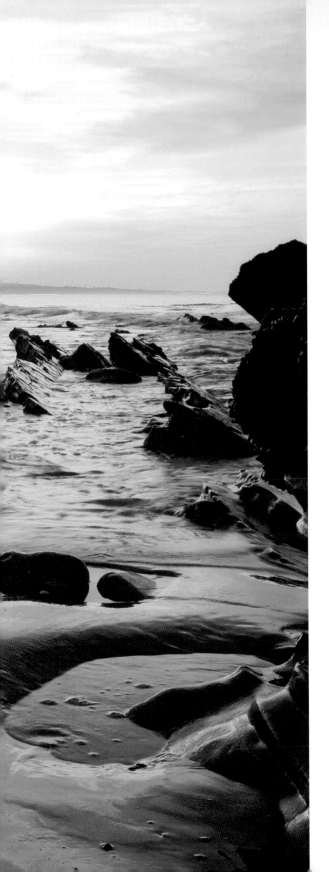

there was a tug on our line, the pole bent, and I jumped to my feet and reeled it in. We both cheered in excitement. Amidst the celebration I said, "We have to kill the fish." Kelly responded in anguish, "Oh no!" I swung the fishing line around. The fish slapped on the wood and was still. Being an environmentalist, I suggested that we had to gut the fish in order to throw the remains back into the ocean. As I gutted the fish, Kelly spotted something shiny. "It's a key! I've heard of this happening. Sharks swallowing tires. Wow!" We saved the key.

Unbeknownst to Kelly, my friend Martyn and I had purchased a freshwater rainbow trout from the local grocery store. We placed the key in its stomach. That night Martyn paddled on a surfboard under the pier and hooked the fish on our line. He was right beneath us and he gave a tug and then paddled away. When I reeled in the fish I made it flop by moving my hand. Rather than watch my hand, Kelly watched the fish on the end of the line. It was the magician's classic sleight of hand. My plan was working perfectly.

Our date had to end early as my hands were covered in fish guts. I dropped Kelly off and said I'd be back in a few minutes. I returned and we sat in the living room of her apartment. From my bag I pulled a 3-by-2-foot book with a wooden hand-carved cover. It was a book I had written and illustrated just for her. Because the book was wood, I engineered a system so that it was locked with a small padlock. I asked Kelly to open the book. It didn't budge. I said, "No, try the key." She replied, "What key?" I said, "The fish key." She tried it and asked in disbelief, "How'd you get the fish to swallow the key?" I was all smiles.

And that began a week of activities that led up to one of Kelly's favorite things—a porch swing. Again, Martyn and I had collaborated. We built a porch swing and hiked with it up to a cliff overlooking the ocean in the middle of nowhere. I blindfolded Kelly as we walked out to the ocean's edge. I set

A view of the California coast from the porch swing.

her down in the swing and got on my knees and asked her to marry me. She said yes. It was one of the best days of my life.

As you can tell, our engagement was quite a story. And many people have asked me, "How did you come up with such a creative way to do that?" The answer is actually quite simple: "I listened to other stories and then created an experience that Kelly would cherish." You see, before asking Kelly to marry me, I asked people how they got engaged. I began to collect outlandish and inspiring stories. And my friends began to create their own stories. It was amazing.

Creativity doesn't just happen. You have to go searching for it. You have to develop the skills of seeking, looking, and listening. Had I only heard the classic engagement story of dinner and dessert, that's all I would have known. The creative stories I heard were so contagious that I wanted to make my own.

If you want to become a more creative person, take time to stop, look, and listen for stories. Become a "story sponge" and start to spend time with people who are creative. Ask a local photographer if you can tag along on a shoot. Ask a local painter if you can come by her studio. Most important, start searching for stories in your day-to-day life and you'll be surprised at what you'll find.

Stories are about perspectives and decisions. As Yogi Berra said, "When you come to a fork in the road, take it." Stories are found everywhere, even on the evening subway commute. Within just a few moments you can collect a whole range of photos.

Bold Mistakes

I completely agree with photographer and digital guru Julieanne Kost who once said, "If you want to be creative, you need to continually become a beginner." This means stepping out of your comfort zone. And anytime you get uncomfortable you are bound to learn.

When I left the United States to live in Spain for one year, I remember being without many of my comforts: language, shared sense of humor, family, and friends. Everything was invigorating. And the travel I did overseas was intoxicating—from hiking the Swiss Alps to watching snake charmers in Morocco. I was enthralled.

While travel is a wonderful way to go, it's equally valuable to seek out experiences in your regular life. That's why last year I decided to take cello lessons. I had never played the instrument but was always enamored with its deep and resonant voice.

My goal was simple; I wanted to learn how to *play*. When was the last time you dedicated time, money, and effort to learning how to play? The experience

was both excruciating and enlivening. I was so excited I couldn't contain myself, celebrating small steps of progress by playing songs for my friends and neighbors. I would call my sister and make her listen to a new tune.

Then I would go to my lesson. My teacher would introduce a new technique or a new song. At first, I would timidly try something out and the sound would be horrible. My teacher would rally, "Chris, make bold mistakes. Commit to it. Make bold mistakes!"

She was teaching me about music, but I was learning about life. In the days that followed those lessons, her words have taken permanent root in who I am and how I live. If I am to live, to grow, to learn how to play, I can't hide or play half-heartedly. The only way to find the note is to play boldly. And yes, it will sound bad, sometimes really bad. But in a strange way, you have to go through that pain in order to find and experience harmony.

Penguins

Many beginning artists start off by imitating the masters. And it is a great place to start. But it's just that, a starting point. In music, it's called being a cover band. And cover bands end up playing at weddings and parks. If you want to play in a sold-out stadium, you have to write your own original songs. As Paul Arden perfectly states, "To be original seek inspiration from unlikely sources."

In other words, you have to look outside your own realm. This is true with almost any line of work. In photography, start off by looking outside of your genre. If you're a fashion photographer, study still life or nature photography. Then go even further.

My greatest source of inspiration is literature. A good author is able to create a picture using words. Recently, I was reading about penguins. One author described penguins as the best-dressed birds.

Another author described penguins as the flight-less bird. Now if I were ever to go and photograph penguins I have two pictures in mind. The best dressed is easy; I'd use a zoom lens and capture the penguin on top of an iceberg waddling or dancing like Charlie Chaplin in a tuxedo. For the flight-less penguin, I'd use a wide-angle lens. Then I'd get close and lie on the ground catching a penguin looking up at a flock of geese flying overhead as if the penguin was thinking, "If only I could fly."

The written word gave me those two pictures. I enjoy reading books on all sorts of topics. It requires that I use my imagination to create visual pictures I cannot see. Ultimately, what I read filters into how I see.

What I am saying is that you need to begin to define what inspires you. Then you need to dedicate time to that endeavor. I have a friend who loves music. There was a song with a haunting melody he couldn't get out of his mind. His solution? He put his iPod on shuffle and drove to some abandoned warehouses. He listened to the song as he took pictures and he used the song as a soundtrack for the shoot. The set of photos was evocative.

This oak tree is part of my childhood backyard where I learned about crossing creeks, catching frogs, and climbing trees. Take photographs like this to remind you who you once were and who you want to become.

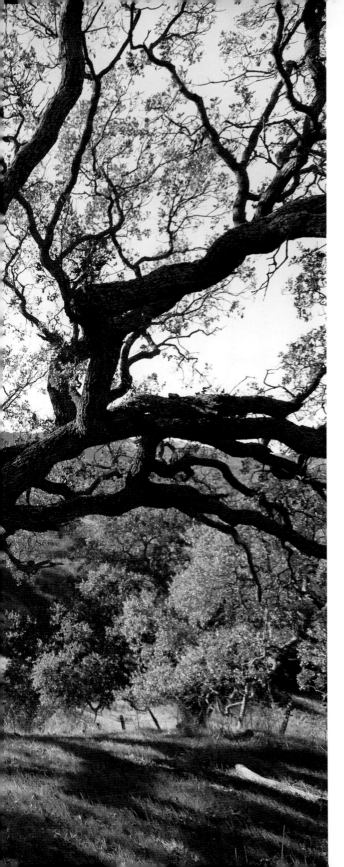

Bad Art

I'm often asked, "How did you become a photographer?" My response always begins with childhood. I grew up in a creative family and we lived in Northern California in a home that was designed and built by my father and filled with art by my mother. Our backyard opened up to rolling hills with oak trees, rope swings, creeks, cows, llamas, and lizards.

It was there that I developed an insatiable desire to explore and a knack for creativity. And in many ways, being a photographer is simply a continuation of my childhood. Even now, I consider myself someone creative who happens to have a camera, or crayons, or wood, or words in my hands. It's creativity first, and second, the means I use to create.

My mom informally tutored us in her artistic ways. She was always bringing home art supplies and creativity was part of the mix. As we painted, made ceramics, and built tree forts, my mom used to consistently tell my brother, sister, and me that there was no such thing as bad art. Being an impressionable kid, I believed her.

I have no doubt that her lie was intentional. It was an artist's way to encourage us to experiment, to play, to grow. And it worked incredibly well. We had no fear and creativity flowed.

Now as an adult, her lie is one of my deepest and most valued truths. It is the "lie-truth" which, in the right context, becomes a "true-truth." It reminds me that in art, regardless of the outcomes, the process matters. It reminds me to not hold on to the results too tightly and let go. It reminds me that if my photographs turn out badly, it doesn't mean I'm bad or that all is lost. Instead, I accept the mistakes and move on. This empowers me to take risks, to experiment, to express, and to explore.

Draw a House

In my classes, I often start off by asking the students to draw a house. Inevitably, they draw a square with a triangle on top. I then ask them to tell those sitting around them about the house. The conversation is dull and flat. There's not much to tell.

Then I ask, "Why draw that house? Would you want to live in that house? Is that house appealing to you?" They all shake their heads. "Forget the first house and let's try it again. This time, draw a house you'd want to live in! And I want to see some sense of geography. Is it in the mountains, the desert, by the ocean? Are there any people at the house? Do you have a barn you converted into a photo studio out back? Is there a hot tub, a redwood deck, and an organic garden? What kinds of cars, motorcycles, and bikes are parked in the driveway? OK, go!"

This time the students passionately draw a scene that includes a house filled with more character than you can imagine. The results are stunning. I ask the students to tell those sitting around them about the house. The dialog is loud, full of smiles, laughter, and oh-yeahs.

Then we have a discussion about the house. The second house was obviously more enjoyable to draw. Yet it required more energy and effort. But because you were more interested in the project, the drawing came effortlessly. And the second one was so much more fun to talk about.

I tell them in this class and in your career, if someone asks you to draw a house, take the challenge. Draw a HOUSE! Throw yourself into the project. The more "you" you put into it the better it will be. Sure, you can give your clients what you think they want, but don't stop there and always deliver more. Not because the client will be happy, but because anything less falls short of who you are and how you want to live.

Favorite Color

Having kids opens you up to new worlds. And that happened recently when my bright 4-year-old daughter asked my mom a question I had never thought to ask: "Grandma, what's your favorite color?" I was curious to hear how my mom would respond.

"Oh, that depends," she said. "In the spring I just love green, pink, and yellow and all those Easter egg colors. Remember the color of those faint yellow marshmallow candies? I love that color. But then, in the summer how can you not love the bright yellow of the sun? And of course there is the fall... Oh, in the fall my favorite colors are those strong earth tones; the reds, pumpkin oranges, and faded yellows. And I just love all those colors of the leaves..."

Their conversation continued as they talked back and forth about all of their different favorite colors. Thanks to my mom, my daughter now has more than one favorite color. Who wrote the rule that says you can only have one favorite color? And why limit our response? Life is much too short to live with such a small palette.

The Dead Sea

My brother was studying business at a world-renowned university in southern California. In one of his classes they learned about the Dead Sea in the Middle East. Why is it dead? There's no outlet. Water flows in and gets stuck there. The lesson—if you want to be something other than dead, you need an outlet. You need to let go. In more particular terms, you need to figure out how to give away at least 10 percent. And the justification wasn't religious, it wasn't moral; it was good business.

As I've gone through life, I've found this Dead Sea principle to be true in all areas of life, including creativity. There is something invigorating and enlivening about letting go, and I've experienced this firsthand.

For a few years of my life, I could only walk a short distance and spent much of my time in a wheelchair. My condition was worsening and I didn't anticipate a change. It was an extremely difficult season of my life.

During that time, a good friend was having a back-country bachelor party up in the Sierra mountains. That's my kind of bachelor party—getting out in wilderness, fishing, hiking, and camping. The first night was car camping so I decided to go—at least I could do that.

That night around the campfire I mentioned I was going to return home the next day. One friend said, "Nope, you're coming with us." Others joined in and agreed with the idea. I replied, "Yeah, right. Like I'm going to get my wheelchair up a mountain trail!"

The next morning the guys built what became affectionately known as the "chariot of pain." They took a low-profile lawn chair, two poles, sticks, rope, and duct tape and built a chariot. It took four people to manhandle this contraption. Hiking up thousands of vertical feet was grueling, but they pulled it off. Some guys wore two backpacks, ran up the trail, and then ran back to take their turn on the chariot. Occasionally, we would pass other hikers on the trail. I was riding high like an Egyptian pharaoh. I didn't really know what to do, so I'd wave and smile. You should have seen their faces and the looks of surprise.

What started out as an ordinary backpacking trip turned into something extraordinary. Deep friendships were forged. The accomplishment of getting to base camp and back was truly astonishing. It changed our lives. Those guys gave more than 10 percent, and it forever convinced me that the quickest path to creativity is to look beyond yourself. For at the end of the day, it isn't all about you.

What can you do today to integrate this business school principle into your own life? It may be something as simple as buying someone lunch, writing a letter by hand, or maybe even carrying a friend up a mountainside.

Guest Speaker

© PETE TURNER

Pete Turner

Pete Turner is often referred to as one of the founding fathers of color photography. His photographs are graphic, dynamic, and alive. He uses color in vivid and striking ways. The last time I spoke with Pete I marveled at the joy in his voice as he reflected on his career. He truly is a living legend. To view more of his work visit: www.peteturner.com.

What inspires you?

Painting inspires me. And black-and-white photography was a huge inspiration. Another inspiration was the wonderful black-and-white photographers of the early to mid-1900s. I loved their work when I was a student, but it was color that captivated my mind. Color was still very new and there wasn't much history. In a way, we were writing it ourselves. I'd see other photographers' color work that looked like they put in a roll of black-and-white and expected the color film to do the work for them. I see in color and I wanted to capture that. Color is in my DNA.

There were always times when I felt *shot out* and needed to recharge the old batteries. This happens to everybody. At the height of my commercial career I remember feeling this. Then I would go off and shoot for myself. I realized that my assignments took me to great locations, so I'd save a few days to shoot and to please myself. Or on an assignment, I would see something else. It is amazing how one thing leads to another.

What makes a photograph good?

That seems like a simple question, but it is really a big question. Anybody who presents a student with a list of instructions saying that this will make your photograph better is crazy! I agree that you have to start somewhere. Though all those rules whet your appetite to break them. Why can't you turn your camera upside down? You have to take all those rules and instructions and find ways to be creative and to have fun. Many times you'll be working on a photograph and you're not looking around you. You have to pull back and look at what's happening on the sidelines.

And back to the question: When editing your work looking for the good photograph, it is difficult. I'm considered a good editor, but there have been so many times that I've submitted work and the client would pick the one I didn't like. A good photograph has to be something that pleases you, that you like. That's the most important thing. Does it pass your litmus test? If so, you're well on your way. Having projects and continually reviewing legacy work keeps me inspired, as it can lead to other projects. Frankly, 50 years of shooting is a lot of work, and you're liable to overlook things that have been important. It gets harder because there are too many things to do. Somehow it keeps pushing me on. Now, with digital shooting it is very fast and the ease to press the button is amazing. Overshooting is a real problem. It is too easy and it is hard to trash it and you end up with terabtyes of images. The trick is to not let it bog you down but to edit your work as you go along.

What character qualities should the photographer nurture?

Thinking back to when I was in school and those who were successful, they were at R.I.T. in 1956, they were on the button back then. Guys like Jerry Uelsmann, who was very surrealistic with his floating monoliths and crawling vines. And Bruce Davidson was creating amazing work. Those students, the ones who survived and excelled, followed their instincts of what they wanted to photograph. Many were not constrained by formulas. And ultimately, that is key—what's fun to shoot. And that's a great thing about being a photographer. If you listen to your feelings, you get to shoot what's most interesting to you.

What advice would you give the aspiring photographer?

There really is no crystal ball answer to that question. It is a tough field. There are so many schools and workshops. To stand out in the field is very difficult. So it is important when you are starting to have some projects that you want to do that you stick to your guns on them. And this is not contingent upon being in a type of photography—commercial or fine art or whatever. You need to have a project that you want to work on that inspires you and keeps the creative juices flowing.

LEARNING TO SEE

SEEING IS A MIRACLE that begins when we wake up each day. Darkness changes to light and blurred lines become clear. Muted colors become saturated, then fill with life. In spite of daily miracles like this, many of us move through life with our eyes only half open. We see but we don't fully take it all in. Now and then something piques our interest. In between these moments our vision declines. And the loss is much more than simple sight.

What we see affects us in profound ways. I'm convinced that it isn't dependent on what sits before our eyes. Rather, seeing depends on who we are. Learning to see is an adventure like no other. As Marcel Proust said, "The real voyage of discovery consists not in seeking new landscapes but in having new eyes."

Imagine having a vision, which profoundly clarifies and deepens what you already know—seeing what escapes almost everyone else. Imagine that a world you once thought ordinary comes completely alive. Learning to see is about approaching life from a new perspective and rediscovering a wonderment with the world.

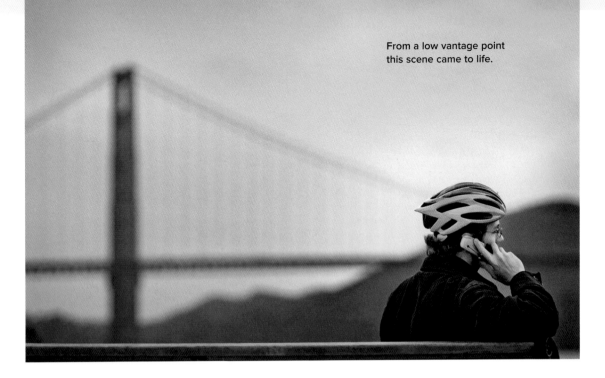

From a low vantage point
this scene came to life.

You've been given the gift of sight and the time to start exercising and expanding this privilege begins now. Whether young or old, we all have the potential to see things anew. Discovering this potential will not only make you a better photographer but might even fill you with new life. I've seen it happen to many of my students. They have that unique spring in their step and bright sparkle in their eyes. Equipped with this new vitality, I watch them head out and take on the world. Their trajectory reminds me that true photography isn't just a profession but a more abundant way of life.

Observe

The best poets are tied to the earth. They live regular lives and wear regular clothes. They walk around incognito, yet they look at the world with keen eyes. Whether stuck in a meeting or crossing a city street, they cultivate their observation skills. They look and then look again, knowing that there has to be more.

Their approach to daily life really works. Consider the poet whose hope-filled persistence pays off in subtle ways. Because of her observations she is able to pen extraordinary lines about the seemingly ordinary. These lines could be sparse or full; the power resides in the way they connect.

As readers of a poem, we follow the lines and relax our defenses. Like most good songs or stories, their ordinary disguise allows them to sneak past our closed minds and hardened hearts. The words push us to the edge and the result is change. That is the great gift of art. It changes what we know, how we think, and what we see.

Learning to see requires that we follow the poet's path. It is the poet who reminds me that it's not what we see but how we see it. As A.A. Milne once said, "Weeds are flowers, too, once you get to know them." It's about getting to know the world by looking at it from every vantage point possible; as a traveler, stranger, guest, resident, dog, bird, or turtle. And then, after looking and watching, rather than impose your own story on the scene it's time to be still and to listen.

Listen

John Sexton is a world-renowned photographer who creates images that are deep, quiet, and strong. For the last year, I have left one of his photo books open in my office. Each week I flip one page. In a way, I've started to live with these photographs and they have begun to take effect. Even in busy times, these images have slowed me down. When I walk by, it's as if they speak and ask me to pause.

Throughout the year, I've often wondered how it is that John creates images with such voice. One day, I decided to ask him myself. After a few minutes of conversation, everything made sense. John was talking about a photograph of snow-covered trees. He explained that he not only looks, he listens. He said, "I listen to the trees." It was that key phrase that unlocked the mystery and made everything clear to me.

Listening requires a posture of openness. It requires quiet and calm. I believe that you can listen with your eyes. You see lovers do this all the time. Or perhaps you've experienced the opposite. For example, when you're talking with someone on

At the ocean's edge, I closed my eyes to listen for the wind and the waves. What I heard was the colorful pebbles under my feet, something I had almost overlooked.

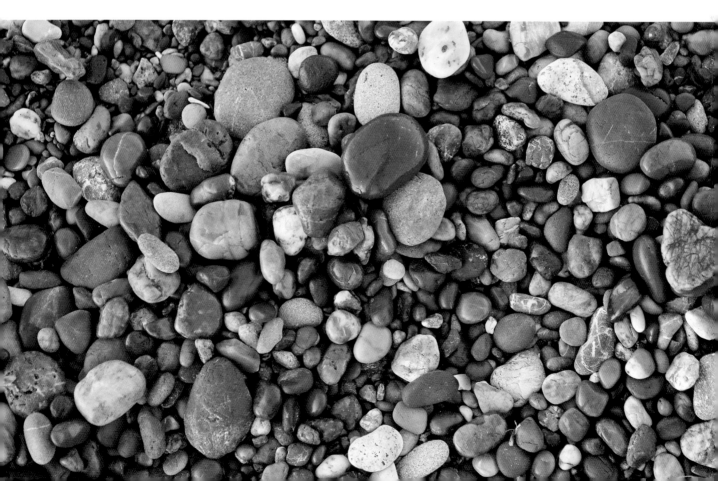

Mindful

the phone, you know they are looking at something else. They pretend to be attentive but it's obvious they are only half there.

By listening we can begin to notice, and then eventually tell more. Sometimes what we hear is subtle and other times the voice may be loud. Either way, seeing requires silence.

The world is restless and full of repetitive noise. If you want to make pictures that stop people in their tracks, become friends with silence and solitude and bring them with you everywhere you go.

By listening we can begin to notice, and then eventually tell more. Sometimes what we hear is subtle and other times the voice may be loud.

I've never been one to wear a watch, but I can still accurately tell the time. After decades of living watch free, I've learned how to be mindful of time. In a way, I've developed a "peripheral" sense of time. Sometimes this means looking at a cell phone, glancing at the waiter's watch, examining the time stamp on the parking lot ticket stub, or taking notice of the clock by the front desk at the dentist's office. Without a watch, I've come to realize that time exists around every bend.

Learning to see requires this same type of mindful attentiveness. And becoming mindful is an art. Before you can make good photographs with natural and available light, you have to know what's there. It means noticing the small details of color and qualities of light. Every location has beautiful light, colors, and context, but not everyone sees them.

Nuance

If you want to create more compelling photographs, you need to look deeper. The first view, and the first click of the shutter, is often too obvious. Accomplished photographers scour the context looking for the subtle nuance of light, line, shape, and form.

In learning to see, nuance is key. Think of it like Mona Lisa's smile; it's the subtlety that draws in hundreds of thousands of viewers each year. Noticing nuance gives you the ability to create photographs that express the delicate shadings of meaning, feeling, and value. In a way, nuance is a signpost for something more.

In the beach town where I live, the tourists think the ocean always looks the same. The locals, especially the surfers, sailors, and fishermen, know more. Their astute observations pick up the nuances, which provide the indications of season, approaching weather, wind, or waves. For those in the know, the subtle differences of the sea are a signpost for more.

One of the first steps in learning to see is widening your eyes and deepening your mindful gaze in search of nuance. In this way you will capture photographs that don't give it all away. Your photographs will suggest that there is something more and deepen the experience for the viewer.

To create a more subtle and nuanced frame, I focused on the foreground and the rest of the picture became a blur.

Carry

Even without taking pictures, carrying a camera enhances life. It provides you with an excuse to pause, to look, to inquire, to talk, and to take notice. We follow in the footsteps of great photographers like Henri Cartier-Bresson, who said, "For me, the camera is a sketchbook." It allows us to take notes, scribble observations, and deepen what we know and what we will later remember. While it seems like carrying a camera causes the whole world to transform right before our eyes, something deeper is taking place. The change isn't occurring in the world, it's happening inside of you.

If you want to learn to see, bring your camera with you everywhere for a specific amount of time. For example, start off by trying it for one week. When you go to sleep, set it on the bedside table. In the morning, pick it up and bring it to the breakfast table. Bring it to work. Take it for a walk. Its presence will open your eyes.

Compose, frame, press the shutter, and create photographs of daily life. Let your camera be part of the flow. Be generous with what you see and let some photographs go. The goal isn't to greedily snap up everything in sight. Instead, it's about provoking thought, heightening awareness, integrating your mind and sight. And ultimately, learning to see is about living a more full and wonderful life.

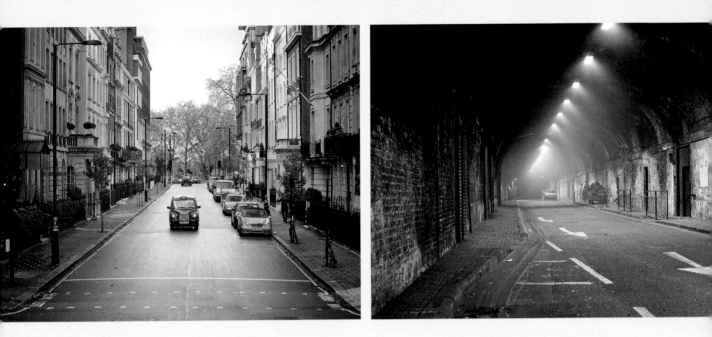

Visual intrigue can be found anywhere—even riding a bus (left) or walking through a dark tunnel at night (right).

Filter

The strongest photographers shoot a range of subjects, but their internal filter always affects the frame. In other words, how we define what we see and then ultimately display is completely up to us. We have the potential to choose our own filter and fate.

What we choose to see is the result of our own internal terms. With life you have a choice. Even Abraham Lincoln agreed: "Most people are about as happy as they make up their minds to be." On a larger scale, how we approach the world filters everything that crosses our path. If we are interested in beauty we will find it everywhere. Our filters are not singular but complex. Consider Albert Einstein's filter: "Out of clutter find simplicity. From discord find harmony; in the middle of difficulty lies opportunity." It's no wonder he was able to go so far.

The key is to begin to define what filters we carry in our bag. Do we have hope, happiness, beauty, power, irony, dignity, distress, compassion, humanity, or something else? Once you define your filters you will again discover that vision isn't the result of what's in front of our lens. It's what's inside us that counts.

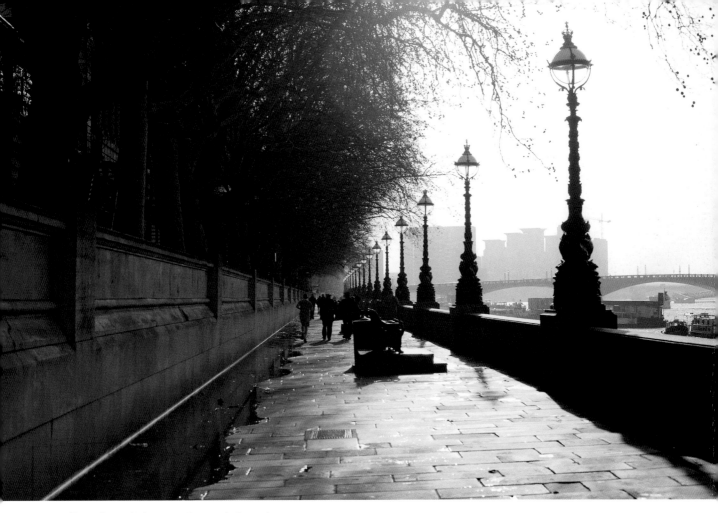

Regardless of where you live or what you do, carry a camera and compose pictures that tell a story about your life.

Rainbows

Carrying a camera is not enough to fully transform one's eyes, especially as we grow older and more accustomed to the world around us. As we age some become jaded and their vision is wearied and dulled. Yet think about how a child sees the world. Everything is brand-new.

My daughter Sophia has a big heart and eager eyes. One day I was feeding her in the high chair. I lifted the spoon and raised my eyebrows as I offered her some food. Unbeknownst to me, lifting my eyebrows caused a series of arched wrinkles on my forehead. As Sophia saw this, she kicked her feet and giggled with glee, "Da Da. Rainbows!"

To truly see we need to mentally go back in time. We need to forget labels and discover what the world looks like for the first time.

It took a few moments for me to figure out she was referring to my forehead. And to this day, Sophia and now my other daughter Annika love to kiss my "rainbows." It is their preferred "Daddy kissy spot." And those rainbows that were once wrinkles have become something new. They are something I will always cherish, especially as I age and they increase in size.

Learning to see requires that we, like my daughters, use new language to redefine the world. Fresh language ushers in fresh sight. Do whatever it takes to pick up some new words. Spend time with kids and listen to them talk. Read a book you've never tried. Even better, learn a language and you will gain a new lens to see the world.

Naive

Uncertainty is a pro photographer's secret weapon. It allows one to see with youth-filled eyes. When you take this approach, some will think that you are a bit off your rocker. In fact, now and again people heckle me, asking me why I am taking a picture of this or that. But I say who cares? I will never let visual apathy set in. I want to see things anew. I want to dream big dreams and let my imagination loose. As Miguel de Cervantes said, "Too much sanity may be madness and the maddest of all, to see life as it is and not as it should be."

In a sense, learning to see requires that we become a bit quixotic or naive. Someone who is naive is unlearned, unenlightened, and unconditioned. The Latin root for *naive* is nativus, which means native, rustic, innate, and natural. I can't think of a better way to approach the world. You could instead choose to follow some of the antonyms for the word *naive*: blasé, worldly, and refined. Yet that doesn't sound like much fun.

Don't get me wrong, I strongly believe in the value of the higher mind. It is a question of being open or closed, enthusiastic or lukewarm, eager or indifferent. If you want to really see, follow in the footsteps of the world's best. And the finest photographers I know use their naive, fresh, and eager eyes to create images that are awe-inspiring, memorable, and full of visual impact and surprise.

Mystery and Truth

In photographic circles, the rule of thirds is included in practically every instructional text. The rule states that equal compositional spacing is static and contains less visual interest. In other words, centering the subject in the middle of the frame, or composing a landscape with equal amounts of land and sky, is ordinary.

By moving the subject out of the middle of the frame, you can create more tension, energy, and visual impact. The rule suggests you first use imaginary lines to divide the frame into thirds horizontally and vertically. Next, compose the photograph so that the points of interest are placed where the lines that divide up the frame intersect. In this way, you have the opportunity to create more visual intrigue.

Without a doubt, the rule of thirds is a helpful tool. And much has been written about it. There is something that I think most photographers leave out. They forget that the rule is based on an ancient mathematical concept referred to as the golden mean, golden ratio, or divine proportion.

The golden mean is used by artists, architects, and musicians to observe and create symmetrical beauty. In design it has been used for pyramids, skyscrapers, and cars like the modern VW Bug. In nature the golden mean shows up everywhere: the human body, tree branches, flower petals, and seashells.

The golden mean is based on the ratio of phi which is 1.61803399. Mathematicians call this an irrational number because there is no equivalent fraction and its decimal keeps going and never stops.

Did you catch the irony? The rule is based on something that is rationally irrational. And isn't that the truth with all beauty? Sure, we can use logic to create, deconstruct, and analyze visual appeal. Yet, beautiful is always a mix of mystery and truth.

This is a bit of a stretch, but perhaps we shouldn't call it a rule. For composing a photograph isn't just a problem to be solved but a mystery to be enjoyed.

Learning about the rule can expand how you look at the frame. It has the potential to remind you that straightforward and safe composition rarely captivates the mind. Compositional risks can reap great rewards. If you want to learn to see with fresh eyes, begin to study and revel in the mystery of compositions that excite your mind.

A parking garage stairwell that shows the rule of thirds.

Order

When we look at photographs, our mind works hard to make sense of the scene. We like to discover order, line, shape, and form. I believe that visual order does soothe the soul and suggest that there is a higher law. When looking at photographs the eye asks, "Which way should I go?"

It is the photographer's task to direct the flow of the eye. When most people approach a scene

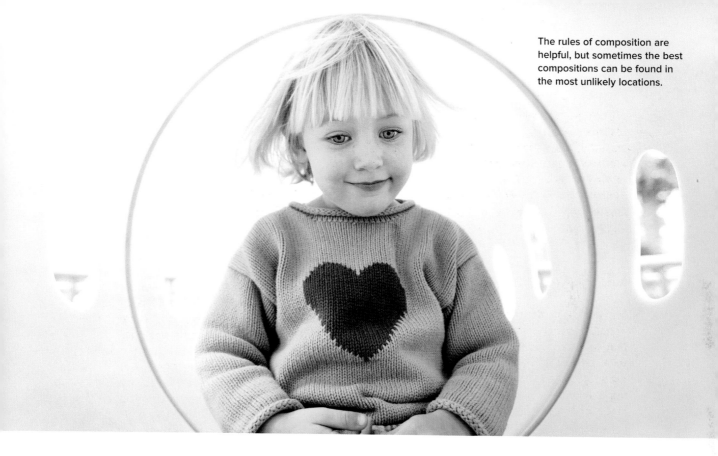

The rules of composition are helpful, but sometimes the best compositions can be found in the most unlikely locations.

they breathe deep and take it all in. The photographer goes a step further, wondering how she can make sense of it all. It becomes a question of how to organize the scene and what to include. Or put another way, as Susan Sontag suggests, "to photograph is to frame, and to frame is to exclude." Learning to see requires that we limit or view. In limitation we discover that less becomes more. With less in the frame the photographer then needs to direct the view.

I grew up in a small town in Northern California. Our main street had everything—pizza, candy, video games—and we knew exactly where to go. The junior high and high school were located there. The street was like an artery that carried the lifeblood of the town. As a photographer, when I compose a frame I often think of that street and its magnetic pull. It wasn't the only street in town, but it was the one where you wanted to be.

Learning to see means using the frame to align the lines, shapes, and forms so that the eye knows which path to take. Or at least it knows that there is a way. And if the path has a magnetic pull, the eye will travel on its course again and again.

Light Sings

Surfer and musician Jack Johnson says, "The morning light sings and brings new things." There is something magical about the dawn of a new day. Becoming a photographer requires that we learn to see light in many forms. By understanding light we can share what we see. Photography is a helping craft. It opens other's eyes to the mystery and wonder of life on planet Earth.

Learning to identify the qualities of light becomes key. By developing a trained eye, you can start to

discover spectacular lighting conditions in the most ordinary locations. What I'm talking about is more than simply taking photographs at dawn or dusk.

Rather it is looking for the way light works. Being in tune with light can help you know what photographs you can create. For example, with less light your shutter speed will need to slow down. Then it might make sense to create photographs that capture a bit of motion and blur. Other times, when the light is bright and strong, you can shoot at a fast shutter speed, freezing action in inspiring ways.

You'll also start to become aware that there is always more light than we first realize. For example, light from the sun bounces sideways off of big white building walls. Or it bounces up off of gray concrete sidewalks. Other times, the savvy photographer is aware that the direct light isn't any good at all. In these situations, it's best to look for a location that is indirectly illuminated, yet protected in the shade.

Color Dances

Color matters. It triggers emotions, boosts memory, informs, attracts, affects us physically and mentally. Colors have personalities; yellow is optimistic, red is romantic, and blue is cool. There is no such thing as correct color. Color exists in relationship with other colors. It rarely stands alone. If you want to learn to see, it's helpful to reignite your own relationship with the colors of our world.

The naturalist John Burroughs wrote, "How beautiful the leaves grow old. How full of light and color are their last days." John reminds us that the colors of fall are beautiful for more reasons than color alone. They bring memories and emotion and remind us of the passing of time. The leaves are exemplary in their grace.

Becoming tuned in to your own thoughts and emotions surrounding colors enables you to see them anew. This connection develops a new sensibility and nuance that will show up in your photographs. Other times, relating to color is as simple as noticing that it is there. One observation will lead to another.

Noticing that shadows are typically blue will make you aware that overcast clouds will cast a blue shadow over your subject. Or that green summer grass or dry yellow wheat both reflect their colors on anything close by. This will make you realize that color never sits still but has a life of its own—color is alive. And learning to become color aware will deepen your appreciation and expand what you see.

Best Spot

An important aspect of learning to see is noticing shapes, lines, and color, then finding the best spot to stand. As hard as you try, there will inevitably be times when you will feel stuck in a desaturated, uninteresting, and overcrowded scene. This often happens to me during peak tourist seasons when I get overwhelmed by the crowd. Other times it may be that I've arrived at one of those "over-photographed" spots and can't find a new view. In these situations I think of the old adage, "The greater the difficulty, the more glory in surmounting it."

If you want to learn to see, it's not about traveling to that pristine and perfectly photogenic spot. It's about honing your skills wherever you are. If you find that everything looks ordinary or if everything is going wrong, don't give up. The *National Geographic* photographer Sam Abell once told me, "Negative experiences can be a great source of inspiration." In other words, it's not just puppy dogs and sunsets that ignite our creative passion. There are times when the challenge can bring out your best.

Creating compelling photographs requires that we turn up the volume on our color sensory skills.

Two Shoes

If you want your life to be an adventure, you have to position yourself so that something eventually goes wrong. In other words, we need to challenge ourselves to stay alive. Otherwise, life will be lived inside an ordinary and dull white box.

How, then, can we create a stunning photograph in an uninteresting and overcrowded scene? How can we change what we see? Here's my advice: If you want to see outside the box, it begins with a challenge.

In my photography class, I explain that what we do affects how we see, just as rearranging the furniture in your house can heighten what you notice and your creative sense of space. I ask the students to do a physical act of creativity and reflect on how it affects their view. One student decided to wear two different shoes, one on each foot, for an entire day. In her reflection she wrote, "As I walked I couldn't help but smile. I started to notice more. At first I was self-conscious; then it became fun. For the first time in my life, I felt like I was marching to the beat of my own drum."

When you find yourself stuck in an overcrowded and uninteresting scene, try something new. Resist the flow of the crowd and make your own way. Spin in a circle, climb a tree, or lie on the grass. Do whatever you need to do in order to subtly act outside of the norm. With your camera in tow, you'll likely loosen up and uncover new and overlooked sights.

Lost and Found

Learning to see isn't just something we do on the front end of digital photography. Rather, it requires that we develop the skill of evaluating and identifying the results. Selecting and editing our photographs is a profound and critical skill. Anyone can take a lot of pictures, but it takes something special to determine which one is best.

Certain photographs will be easy to identify, as they have instant visual appeal. Others will be more difficult to find. To see the photographs with fresh eyes, it can be helpful to let some time pass. I know some photographers who wait a month before they begin their review. If I have the luxury of time, I typically wait a few days. Then, when you begin to review the photographs it is essential to tap into your sense of dignity, self-worth, confidence, and drive. Otherwise the sheer volume of inferior photographs can easily overwhelm.

Next, it's helpful to actively think what it is that you actually want. Otherwise editing hundreds of

The simple composition and subtle cues whisper like a secret—tell enough, but not too much. Without knowing what's going on, the viewer is invited to lean in, ask questions, and become involved.

photos dulls your senses like channel surfing satellite TV. Determine a few qualities that you want. Create some criteria for your search. For example, you could take inspiration from Diane Arbus, who once said, "A photograph is a secret about a secret. The more it tells you, the less you know." Decide to select the photographs that tell enough but not too much. Create a whole list of criteria and then begin the search.

As you dig through your files, follow your list but also be open to surprise. Many times you will find photographs that will exceed any of your preconceived ideas. When you find good photographs, remember that they will never be good enough. Even Ansel Adams said, "I strive for perfection but settle for excellence." When photographs are good, accept them for what they are. Moaning over falling short won't get you far. Instead, recommit that you can and will do better. That's the joy of photography—it is never dull and you never fully arrive. The journey is the destination and learning to see is a gift that will help you thrive.

End

Photographers are an animated bunch. They may or may not make a living at creating images, but they are all enlivened by it. Especially when they're together. For one particular conference, hundreds of photographers had traveled from all corners of the globe to celebrate their craft. The packed conference hall buzzed with vitality and excitement as they watched multimedia presentations from some of the best photographers in the world. The presentations were choreographed, loud, and exciting.

That is, except for one presentation. It started with a single image on the screen with no graphics or sound. The slide show slowly progressed one frame at a time. At first, it seemed like there was a projector malfunction, as each image appeared slightly dimmer than its predecessor. The photographs just kept appearing darker and darker. What was the deal?

Then it struck everyone. The hall became even quieter as the intent of the presentation sank in. It wasn't a projector malfunction. Rather, it was a set of photographs by a photographer who was going blind. Everyone knew him and knew about the disease that was causing him to lose his sight. In a poignant way, the dimming photographs chronicled his plight.

The slide show marched on, darker and darker. It was painful to watch. The show ended and the room was completely black. The lights remained off, and in the quiet darkness few eyes remained dry.

One day all of us will lose our sight. The surest way to learn to see is to savor what we have now. Savor every marigold, every mountaintop, every cloud, every color, every farm, and every face.

Guest Speaker

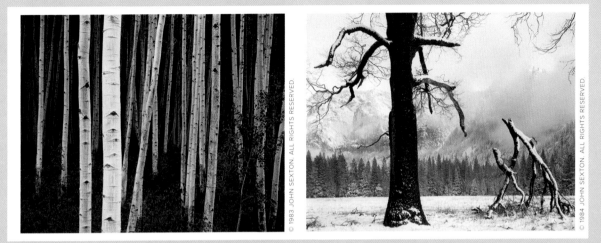

1) Aspen Forest, Dusk, near Aspen, Colorado, from the book *Listen to the Trees* by John Sexton. 2) Black Oak, Fallen Branches, Yosemite Valley, California, from the book *Listen to the Trees* by John Sexton.

John Sexton

John Sexton is a photographer, master print maker, author, and teacher. His images are poignant, profound, and luminous. He is accessible, down-to-earth, and authentic. Who he is and what he creates has inspired countless people from around the globe. To see his work visit: www.johnsexton.com.

What inspires you?

I find the entire process of photography to be inspiring. I was first inspired by the alchemy of the photographic process in 1969, when my high school friend showed me how a print was made. That event initiated my interest in photography. I was fortunate during my studies to have a number of teachers who inspired me. Their dedication and passion for photography was contagious.

In 1973 I first saw original prints by Ansel Adams, Edward Weston, and Wynn Bullock. That exhibition showed me a new dimension to the medium. I never had tears come to my eyes when looking at a photograph prior to that unforgettable experience. When you see the subject and the light come together in a favorable way, and then observe this through the camera's viewfinder or ground glass, it can be an event that transcends the physical world. On rare occasions that imagined image is fulfilled in the darkroom and the entire process is magic.

What makes a photograph good?

A good photograph should elicit a response that remains with the viewer either consciously or subconsciously. Photographs can soothe and reveal beauty. Photographs can disturb and question. Photographs can anger and incite. These are valid responses that can come from a meaningful photograph. I think a good photograph reveals not only what is in front of the camera—the subject; but also what is behind the camera—the photographer.

What character qualities should the photographer nurture?

A photographer should work honestly and diligently. Often that involves an element of play as well. I find that I do my best work when I am playing. Photographers should invest of themselves and reveal themselves honestly in their photographs.

What is your advice for the aspiring photographer?

Enjoy the magic of photography. Work hard and remember the apocryphal story of the old man standing on the street corner in New York City being asked, "How do you get to Carnegie Hall?" And his response, "Practice, practice, practice." As my friend and mentor Ansel Adams used to say, "The harder you work, the luckier you get." Photograph what is important to you, and hopefully your photographs will be important to you...and perhaps to others.

During setup I'm looking for the right angle to make the photographs of Shaun Tomson shown in Chapter 5. Photograph © Rob Mizell.

CAMERA CREATIVITY AND TECHNIQUE

4

THE FIRST PHOTOGRAPHS were an unexpected and startling surprise. The images were the result of successive experiments and inquisitive minds. Photography is a craft dependent on those willing to take risks. Now more sophisticated than ever, photography remains an experimental art form— a medium that you or I will never fully figure out. As new inventors, we build on what we already know and show the world what it has yet to see.

Many photographers lose their edge and fall behind. It happens to us all. We read about a new and shiny camera. Eventually, we buy one and hold it in our hands. The model is so impressive we don't really know what to do. So we give in and switch the camera or our mind-set to automatic mode. Society teaches us that it's typically best to defer—let the experts handle the case. The inventors in the crowd, though, think about things another way. They want to create.

To create is to consider, to envision, to imagine, and ultimately to make something new. Using your camera creatively is a mix of challenge, discovery, and revelation—to go beyond a point-and-shoot mentality with high and unrealistic hopes.

The reward for such an experimental approach is moments when everything becomes clear. These ah-ha's can be exciting or even bring us to tears, as if we feel we've invented or discovered something on our own. Nikola Tesla said, "I do not think there is any thrill...like that felt by the inventor as he sees some creation unfolding to success.... Such emotions make a man forget food, sleep, friends, love, everything." Make an investment in camera creativity, become an inventor, and you will reap many rewards.

Tea Stains

Technique is like the roots of a tree, reaching deep and encouraging branches to push for the sky. Empowered by something far below, the branches stretch and expand. The roots respond by digging deeper in the dirt. Unseen, they drink and carry sustenance, which produces blossoms and fruit.

The root and the fruit are intertwined. And so it is with the technical and creative aspects of photography. Not so long ago, it was easier to identify the connections. In the darkroom there was an interesting mix of chemistry, science, and experiment. Using the darkroom to make a toned black-and-white print required light, water, paper, specific time, and chemical solutions. After the print was made, it could be toned in a variety of ways.

Some photographers used tea to stain prints with wonderful warm tones. All tea is different and there was no exact science to how much tea or for how long to soak the print. It was a process of give and take. The fruit, or final result, was a beautifully toned black and white print.

Regardless of how you make your prints—in the darkroom or on your desk—there is still magic involved. It's just that the magic may now be more hidden behind closed doors. Becoming camera creative requires that you keep the wonder and magic of photography alive. We must never forget that our craft is a combination of the heart and the mind.

Blue

Picasso once said, "If I don't have red, I use blue." No wonder he was one of the most prolific artists of all time. His artistic appetite was strong. As you improve your technical and creative skill, art will help you move forward. Rather than being hung up on this or that, the best artists show up and get on with the game. Their insatiable curiosity furthers their growth. Two of photography's early masters and pioneers—

What color will you choose next?

Edward Steichen and Edward Weston—were technical virtuosos with unquench-able creative minds.

Steichen was practical, yet he was never willing to give up. He made hundreds of pictures of a tree near his house. In his own words he reflects, "Each time I look at those pictures, I find something new....Each time I get closer to what I want to say about that tree." It didn't matter that Steichen's subject rarely changed. For him, making photographs was a way to discover his voice.

Like Steichen, Weston pursued photography with complete passion. His photographs are precise, unusual, sensuous, and full of intrigue. He said, "Anything that excites me for any reason, I will photograph; not searching for unusual subject matter, but making the commonplace unusual."

Learning how to use your camera creatively will take the same stance. You will need to disregard common sense and pursue your vision again and again. In a sense, you will need to let yourself go and become a beginner with each frame that you make. The way an artist grows is from the ground up—just like a tree. Start small and follow Ralph Waldo Emerson's advice: "Do not call yourself an 'artist-photographer'...call yourself a photographer and wait for artists to call you brother."

Second Time

Becoming creative with your camera means that you will fail. You will miss important moments and make grave mistakes. Creativity is not an easy path. The more you care about your craft, the more mistakes will sting. One of my students once said, "Chris, I think photography hurts because we love it so much." Yet the hurt reinforces the worth.

When John Steinbeck worked as a farmhand, the experience gave him empathy for the hard life of migrant workers during the Great Depression. He set out to write a novel about their plight. In the fall of 1936 he was just about finished with what seemed like a great piece of work. One day, he came home to discover that his dog had torn the entire manuscript to shreds. Can you imagine the pain and agony Steinbeck experienced that day? Yet, like many of the most brilliant minds, he was not willing to cave in. Steinbeck rewrote the entire novel, *Of Mice and Men*, from scratch. And while we cannot know for certain, I'd be willing to bet the novel was better the second time around. Either way, I'm glad Steinbeck never gave up.

If you're reading this book I know that you haven't given up and I'm glad for that. As you progress with your camera technique, remember that you follow in the footsteps of those who have made many failed attempts. If you want to succeed, don't ever give up.

One way to make the commonplace unusual is to change your focus.
In this frame the complete lack of focus turns a typical surf photograph
into something more like a faint memory or a distant dream.

I never tire of taking pictures of the sea. For this shot I
was lying on the rocks and used a shallow depth of field.

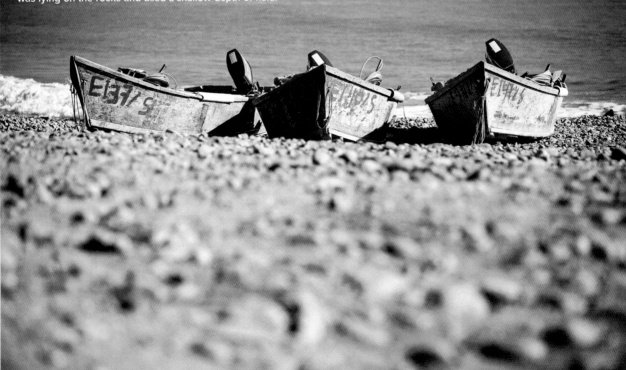

Let Go

Not giving up doesn't mean gritting your teeth. Creative photographic skill requires more than brute force. Photographers are problem solvers, looking for visual solutions that will enliven and surprise. Some problems require that we relax and let go.

A few years ago, a behavioral scientist put this notion to the test. She set up a study that involved two scenarios. In the first one, groups of people were asked to enter a room and solve a serious and important task. Very few groups were able to succeed.

For the next scenario, groups of people were asked to enter a room and solve a serious and important task. As they entered the room they noticed a table filled with delicacies. Next to the food was a note that said, "Enjoy these treats as a thank-you for your participation. Think of the task ahead of you as if it were a game—see if you can win. Good luck!" This time most of the groups accomplished the task and did so with great speed.

While the study isn't conclusive, it definitely made me think. It reminds me that creative solutions can often be found in curious ways.

Barbie

Paul Liebhardt is a well-loved photography faculty member at the school where I teach. In the classroom, his playful antics and unorthodox ideas quickly get the students excited. One afternoon, I sat in on one of his lectures while he was showing photographs that illustrated light patterns out in the natural world. Paul showed photographs that were powerful, humorous, intriguing, and heartbreaking. The photos were taken in dozens of countries around the world. Paul's point was to illustrate that good light exists everywhere—you just have to know how to find it.

Whether young or old, play is essential in our lives.

After this emotional and visual roller coaster ride, he put a Barbie doll picture up on the screen. The Barbie was standing in a graceful pose and was lit with fashion studio lights. A few people laughed. Paul said, "Now seriously, everyone. What would make this picture better?" A few people attempted to come up with some ideas, but they all fell short.

Paul picked up the slack and asked with a crescendo, "You know what would make this better?" He flipped the slide and the same picture appeared, except now the Barbie doll was wearing a shrimp on her shoulder. Paul said with a boisterous Australian accent, "Throw a shrimp on the barbie!" The whole class burst into laughter.

Once the laughter calmed down, Paul asked, "Why was that picture so good?" It was good because of the juxtaposition with the others and because of the visual surprise. In certain corners

I heard this woman ask her dog to smile. As if on cue, the dog joyously replied. I couldn't help but grin as I quickly captured this scene.

of the world, the diminutive word for barbecue is barbie, and Paul created a memorable image that played with this phrase. It was something his students will never forget.

If you want to use your camera creatively, adopt a playful attitude and capture visual surprise. Sometimes the surprise will be simple and subtle and other times a bit loud. Either way, when you are shooting, think beyond straightforward terms. Ask yourself, what's surprising or intriguing in this scene?

Limit

There is a creative myth that I would like to dispel. It is from the phrase "the more the merrier." In photography, more options, more gear, and more technical expertise does not equal something better.

There are times when limitation rules the roost. The composer Igor Stravinsky put it this way: "The more constraints one imposes, the more one frees oneself." What I've found is that it's a matter of learning all of the techniques and then knowing which

ones to leave behind. Like the painter who dabs his brush on his color-filled palette—it's helpful to have all the colors there, but it's more important to know which one to choose.

At this point many students say, "Yes, but where do I begin and how can I learn all the techniques really fast?" What I've discovered is that it's best to learn one technique at a time. It's like taking your vitamins once a day; having the whole bottle at once would defeat their usefulness and they might even become toxic. In addition, it is important to remember that you don't have to know everything in order to be good. Fine camera work can happen with simple means.

Consider the strategy of one of the greatest photographers of all time—Richard Avedon. Avedon often approached his projects armed with a list of limitations. He explains, "I've worked out of a series of nos. No to exquisite light, no to apparent compositions, no to the seduction of poses or narrative. And all these nos force me to the yes. I have a white background. I have the person I'm interested in and the thing that happens between us."

Flash

Limitations activate the creative mind. They require that you ask, How can I make the best of what I have? In your own photographic journey, you'll have to decide what tools and techniques work best. You can limit your own path and pursue the technical approach that fits who you are.

I once read a poem titled "The White Museum" that helped me decide my way. The poem, by George Bilgere, is sad, beautiful, and wonderful to read; a reflection on the death of the Bilgere's aunt. She was an organ donor and he refers to those who handled her case. Near the end of the poem he writes, "Do be respectful. Speak quietly. No flash photography. Tell your friends you saw something beautiful."

As I read those lines, they made me think. The more I thought the more I considered the word "respect" and the phrase "No flash photography." The poem made me wonder how well "flashless" photography could actually be done. And I've pursued this ever since. It doesn't mean I can't use a flash, but it makes me consider if there is another way. And maybe you like using lights and a flash—that's perfectly OK. The point of creative photography is that we all get to choose our own way.

Arnold Newman's words on this subject strike a chord. He said, "I don't think any student, any photographer, any person should take pictures the way I take pictures. I build them because it's the way I am." When we try to be something that we're not, we lose a bit of who we are. Of course it takes trying out different styles until we discover our own. So take that time and then chart an original course.

The point of creative photography is that we all get to choose our own way.

Which Lenses?

With so many options, which lens is best? If you read the brochures, you'll learn what lens work best for different types of photography. For example, the 85mm is a great portrait lens; the 16–35mm is indispensable for anyone photographing architecture. Because there are so many lenses, these bite-size morsels of information are helpful. They build up our familiarity and help us understand a lens's typical range. Remember, though, that there is a difference between information and wisdom.

Information informs us, providing us with new data. Wisdom is the result of experience lived out. Wisdom is where knowledge and experience shake hands. That's why the young may be smart, but only the old are truly wise. So what lens is best? That answer will come, but it will take time. Truth is contextual and it depends on who you are.

Take two legendary photographers, Eric Meola and Rodney Smith. They both visited and presented at the school where I teach within a short time. Both lectured and inspired the students in amazing ways. Both are revered. Both like to create photographs of people that are poignant and up close.

One of my favorite combinations is available light and a 50mm lens.

But in pursuit of these types of photographs, each photographer takes a different path.

When Rodney Smith presented he said, "I want to get close, physically close, so I use a normal focal length lens." Next, Eric Meoloa came to class. He talked about his craft and explained, "I don't want to intrude, so I use a long focal length lens." So which lens is best, normal or zoom? It's up to you to decide.

Fixed

While the lens choice is up to you, here are a few practical tips. For starters, it is worth thinking about using a fixed or variable focal length lens. Fixed length lenses are limiting, as the zoom cannot be changed. In other words, a 135mm lens is just that—nothing else. Before you write this type of lens off you have to consider a few things.

First, certain people built their careers on specific fixed length lenses. Like Henri Cartier-Bresson, who used a normal 50mm lens. Annie Leibovitz in the early days of her career consistently reached for her fixed 35mm lens to create portraits with a more environmental feel. While it is interesting to consider who used what, there is something even more important about these lenses.

The choice of a fixed length lens requires that you move. In other words, your composition is dependent on where you stand. Using these lenses will teach you how to see and prevent you from getting stagnant and standing still. Without the luxury of a zoom, composition must become physical. These lenses will get you involved. They will make you want to climb, sit, lie, and move all around. You will become aware of space, perspective, and form. And while these lenses are not easy, they will truly teach you how to use your camera more creatively.

Zoom

Zoom lenses provide immense flexibility. Some zoom lenses have a short range like 16–35mm while others cover the gamut from 28–300mm. Some photographers thrive on having lots of flexibility and not having to change lenses to capture a different view. And these types of lenses are widely used with every genre of photography, from fashion to fine art. If you want to differentiate yourself, keep this in mind: Use zoom lenses as if they were fixed. In other words, change the zoom, but don't stand in one spot. Rather, change the zoom and then move up, down, sideways, and around in the same way that you would with a fixed lens.

Macro

Many things in life are good from afar but are far from good. In other words, after getting close some things fall short of what we expected from a more distant view. Macro photography contradicts this to the core.

When we zoom in on a detail, it becomes something else. In the small details we notice textures and colors that were otherwise impossible to see. These details make viewers lean forward to see more.

The viewer experiences a revelation. What looked good from afar looks even better up close. At the same time, many argue that small details may have higher meaning. As the 18th-century architect Ludwig Mies van der Rohe said, "God is in the details." In other words, grandiose is grand because of the details. And each detail when put together suggests something more—the sum is greater than the parts.

Macro photographs make us say, wow! It's nice to know that something looks better close up. To get creative with your macro lens, move in as close as possible and keep in mind that by getting close you have the potential to capture something that transcends the frame.

Move in close with your macro lens to capture something unusual.

Switching from a normal lens to a fish-eye lens adds a surprising dimension to this family portrait.

Fish-eye

Have you ever wondered how a fish with big bubbly eyes sees its underwater world? And many fish have eyes positioned on each side of their head rather than in front—talk about peripheral vision. In photography, the fish-eye lens pays tribute to our underwater friends. This type of lens was originally developed to study the sky. Scientists were interested in learning more about clouds and so this lens was devised. It was originally called a "whole-sky lens," and I kind of like that name. The idea was to create a lens that could capture it all.

Fish-eye lenses typically provide a 180-degree view, an extremely wide depth of field, and the capability to focus on subjects close or far away from the lens. These factors combine to make fish-eye lenses interesting and unique. While the resulting images contain distortion that appears bubbly and surreal, for certain subjects this view makes the frame come alive.

With these lenses you need to get really close whether you're photographing waves, dogs, friends, or a family with ten kids. The closer to the subject with this lens, the better. Be sure to keep in mind that the distortion increases as you move further to the edge of the frame. In other words, for less distortion, compose so the main subject is in the middle of the frame.

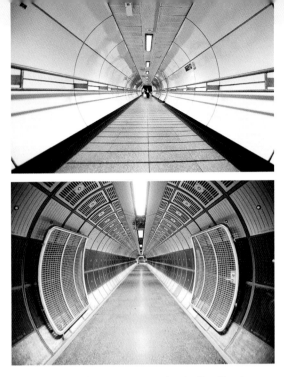

With wide-angle lenses pay attention to directional lines. If composed a certain way the lines resolve or converge like in these two subway tunnel shots (above).

Wide Angle

When someone watches something with wide-eyed wonder, what exactly does that mean? The phrase is bursting with information. There's the childlike connotation, a sense of wonder, astonishment, and surprise. It surely reveals that someone is awestruck. This is exactly how I imagine the personality of my wide-angle lens to be. When I look through, the lens begs me to see the world with wonder and awe.

Wide-angle lenses are exciting and true. Fish-eye distortion appears fake; the wide-angle lens distorts in a less dramatic way. These lenses help us take it all in in a believable way. They make images that are expansive, environmental, broad, all-encompassing, and spacious. Rather than zero in on one subject, wide-angle lenses help us tell more and remind us that some of the best views in the world are with wide eyes.

The problem most beginners have with wide-angle lenses is that they pull in too much. By showing everything they show nothing. To effectively and creatively use this lens, notice lines, capture scale, and think about the background and foreground.

The wide-angle lens allows you to quickly change perspective, bending lines or causing them to travel down the frame. On the other hand, when you're shooting a larger scene it's key to include a subject in the foreground. The foreground subject will anchor the frame. Or photograph something that shows a sense of scale and makes you realize how much grandeur there actually is.

Normal

While the other types of lenses tend to spice things up, the normal focal length lens is in a class of its own. I think of normal lenses like the 50mm as timeless, natural, honest, reliable, dependable, and fair. It is an unpretentious lens with an earnest and genuine soul. It's not overly dramatic, and it definitely doesn't play tricks. If I had to make a comparison, I'd say while other lenses are shiny, the normal focal length is like canvas, corduroy, or natural wood. If it were a note of the piano, it would be my middle C.

I could go on and on. And why wax poetic about such an ordinary lens? It is because I want you to give this often-overlooked lens a second chance. In my opinion, the 50mm lens is the perfect mix of form and function. It is compact and easy to carry around. The normal lens doesn't impose or get in the way. And this lens sees the world in a way that is close to the human eye. The normal focal length lens requires that you do the work. You can't rely on something else. The pictures this lens creates are honest and true.

To create a few compelling portraits of the world-champion surfer Kelly Slater, I chose a normal 50mm lens. The two images (above) show the results. The photo shoot (below) shows my approach. Photograph © Travis Lee.

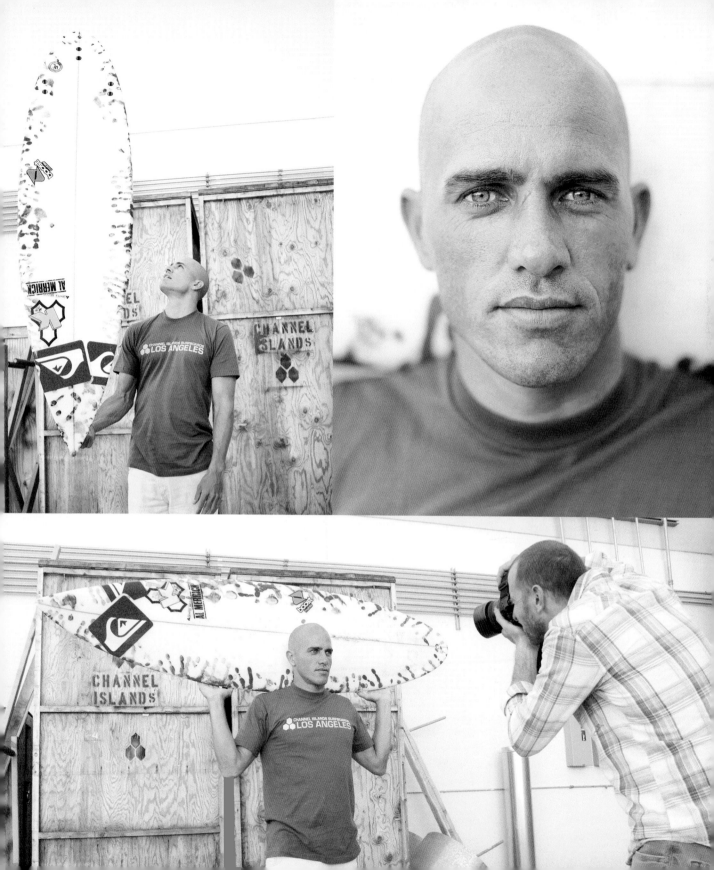

Without the zoom, when I use this lens, I tend to get in close, some would say too close. When photographing a person this may result in a little distortion to the face. I think a touch of distortion creates an amiable, honest, and intimate feel. Plus, because it is a focal length that is shorter than most, it helps me get out of my comfort zone. The lack of zoom requires that I move my feet and engage.

Telephoto Zoom

In general, the word zoom is used to describe a rocket ship that moves quickly and often soars up into the air. Telephoto zoom is an appropriate name for this type of lens. The word *telephoto* refers to magnification, and these lenses allow you to work quickly to get up close. It's thrilling to be a ways off and then look through a high-powered telephoto zoom lens. Instantly, you feel like you're there. Even more, these lenses give you the ability to compress the scene. In other words, they make objects in the frame seem connected and close.

To understand how these lenses work, think about standing next to a tall skyscraper. As you look up the building will appear towering and huge. If you look toward the top of the building it will make you feel uneasy, almost as if you might fall back. What you've just experienced is similar to a wide-angle lens. Then imagine you are one mile away and looking back at that same building with a pair of binoculars. The building will appear tall and skinny, like a small spike that is pointing up into the sky. That is how a telephoto zoom lens works.

Perhaps that example will help you imagine this lens on a smaller scale. Photographing people with zoom lenses has the potential to create a very flattering look. Rather than wide and distorted, telephoto lenses make people look their best. And telephoto lenses allow you to blur the background and simplify the scene. For zoom lenses the background

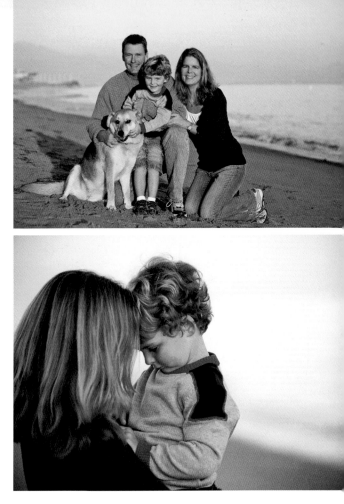

Using a 200mm zoom allows you to create a flattering look.

is key. (Remember that for wide-angle lenses you need a foreground.) Even blurred, the background becomes a backdrop of color, shape, and form.

Now that we've discussed lenses and their range, you still might wonder which one is best. That question is difficult to answer because it is so vague. A better question might be, how can I take what I've learned and put it to good use? Or how can I gain a bit of wisdom while I seek to create photographs that reflect who I am?

What Exposure?

Now it's time to take the plunge and make pictures with more control. My colleague Ralph Clevenger says, "Green means granny, and green has got to go!" On most cameras, whether point-and-shoot or DSLR, the green rectangle stands for automatic mode. Choosing green is like deferring to the expert and letting someone else decide. Sure, there are times when you're in a pinch and you have to go with green. If you want to soar to new heights, you're going to need to try something new.

Going Beyond Green

The four options that give you the most creative control are Manual, Aperture Value (or Aperture), Time Value (or Speed), and Program. While at first glance these options may seem confusing and abstract, they are actually quite simple. In order to chop things down for size, let's focus on the two that will initially help you the most: Aperture Value and Time Value. First, here are a few words about exposure.

In Automatic mode, the camera determines the exposure on its own. As a result, people can typically capture properly exposed images without much thought. When using Automatic mode, you give up much of your creative control. In contrast, the more creative modes, like Aperture Value and Time Value, provide you with the means to set exposure and create a more compelling image.

What exactly is exposure? Exposure is the combination of a few factors; aperture, shutter speed, and ISO. I remember when I first heard these terms, I thought, oh no, this will never make sense. Yet, to start making great pictures, there are three basic ideas that can help: Use Aperture Value for depth-of-field (how much focus in the frame); use Time Value when you want to slow the shutter and create some blur; use ISO when the light in the scene is too dark.

Introducing Aperture

In photography, the word *aperture* refers to an adjustable opening that lets light flow through the lens. The size of the opening is made bigger or smaller by choosing an f-stop number. In order to understand f-stops, let's consider a couple of simple anecdotes. The first has to do with f-stops and light; the second, with how we can begin to use f-stops for creative means.

I've always thought aperture and f-stop were beautiful words. But these words rarely show up in poems or songs. The exception is a great song by Jack Johnson called the "F-stop Blues." In this song, Jack sings about the beach: "Driftwood floats, after years of erosion. Incoming tide touches roots to expose them. Quicksand steals my shoe. Clouds bring the f-stop blues." Being a filmmaker, Jack knew about f-stops, but what's the connection between clouds and f-stops?

This song was written while Jack was filming one of his famous surf movies. When the sky was bright, filming wasn't a problem. Then dark storm clouds rolled in and the scene became darker and darker. He would have to choose a lower and lower f-stop number in order to let more light in. Because he was using a vintage lens when the clouds rolled in, the scene became too dark and he didn't have any lower f-stops to choose. There wasn't enough light to continue filming—hence the blues.

Whether you're making a movie or capturing a still frame, f-stops work the same way. Their primary function is to control how much light flows through the lens. Thus, f-stops play an important role, both with function and form.

Aperture and Creative Control

F-stops are functional but that is not all. The f-stop number gives you the ability to control visual aesthetics. Learning how to use them well will become one of your biggest assets. To make sense of the

Shooting this image at f/2 blurs everything except the eyes, creating an intriguing Halloween portrait.

Aperture and Shallow Depth of Field

When you are photographing people, it's intriguing and flattering to use a low f-stop like f/2. With careful focus and composition, the result is a photograph where the eyes are sharp and the ears, hair, shoulders, and background are completely blurred. In this way, you can take creative control and choose what you want the viewer to see. Humans are attracted to areas of sharpness to help us make sense of the frame. And this doesn't just work with people photographs but with every subject under the sun.

If you want to become an exceptional photographer, here's what I recommend. Set your camera to the mode that prioritizes the Aperture Value (or Aperture). Choose the lowest number that is available based on your lens. Keep in mind that the lower the f-stop number, the more expensive and better the lens.

Not only does this kind of lens allow you to take pictures with less available light, the resulting images have a distinct and beautiful look that is unparalleled. While your lens might not go that low, don't worry about it and begin with what you have. Later you will want to get something that at least goes to f/2.8 (for more on gear, see Chapter 11). For now, choose a low f-stop number, focus on specific points, and take pictures of everything you see. The results will speak for themselves.

At this juncture you may be thinking, why don't people shoot with a shallow depth of field more often? The answer is simple. Shooting with a shallow depth of field is risky. With so little in focus it becomes incredibly easy to miss the shot. I say the risk is worth the reward. You will have to experiment with this creative technique and then decide for yourself.

Aperture and Wide Depth of Field

In 1932 photography was emerging as an art form. The medium was young and growing in many different ways. On the West Coast, soft-focused Pictoralism

potential creative control, let's exaggerate things. As a people photographer, imagine that you have 25 people standing in a single-file line. You are positioned just a bit away and step to the side so that you have an angled view and can see the entire line. If you want to make a photograph with one person in focus, you choose f/1. If you want to make a photograph with all 25 in focus, you choose f/25. It's that simple.

This anecdote is a slight exaggeration. You don't choose your f-stop number based on the number of subjects in the frame. But conceptually this idea illustrates an immensely valuable point. The lower the f-stop number, the less in focus, or the shallower the depth of field is. The higher the number the more in focus, or the deeper the depth of field.

When you select the Aperture Value (of Aperture) mode, the camera prioritizes aperture and figures out the rest. In other words, this mode allows you to select an aperture and the camera determines which shutter speed will work best. With that in mind, let's consider using Aperture Value in two basic photographic scenarios—portraits and landscapes.

was starting to catch on. It was a very creative time and everything was up for grabs.

Thirty-year-old Ansel Adams and ten of his photography friends decided to take a stand. They wanted to bring more clarity to their craft, so they formed a group called f/64. Their intent was to create "pure" photography made up of sharp images and maximum depth of field. Even the group's name comes from the aperture, which provides the widest possible depth of field on the large format camera. And thanks to the way f/64 championed the cause, photography grew and flourished in wonderful ways.

When you look at many of Adams's landscapes, you cannot help but marvel at the composition, amazing details, texture, and sharpness throughout the entire frame. If you want to capture images with detail and sharp focus all the way through, set up your tripod and grab a wide-angle lens. Next, choose an f-stop number that is as high as f/16 or f/22. Then, position the lens and focus 1/3 of the way down the frame. This will ensure the best sharpness for the whole frame. Finally, recompose and fire away. Even if you don't photograph landscapes, this technique works whenever you want to increase sharpness and widen depth of field.

Shutter Speed

Remember when you were a kid and you would spin in circles out in the backyard? When you spun around, the world became a blur. The spinning was disorienting, but that was what made it so fun. In photography, creating motion can make even the most ordinary scene come alive. And learning how to work with shutter speed can make photography new and fun.

When you select Time Value (sometimes called Speed), the camera prioritizes shutter speed and takes cares of the rest. In other words, you can select a shutter speed without worrying about what aperture works best. Before we discuss how to creatively begin, let's talk about a common problem with shutter speed—camera shake.

Camera shake occurs when hand holding a camera with a low shutter speed and causing an undesirable blur in the frame. To avoid such blur, there is a general rule of thumb: Select a shutter speed that is shorter than 1/focal length. For example, if you have a 100mm lens, choose 1/100 second or faster. In this way, if you brace yourself and hold the camera steady, you will decrease the odds of a blurry frame.

Other times, while using the same lens, you will want to use blur in order to add effect. In these situations, you can choose a shutter speed slower than 1/100 and then move or zoom the camera. The actual shutter speed amount will vary depending upon the light. Experiment to determine what works best. There are a number of different types of blur you can achieve. Try the following techniques to get started: panning, spinning, and zooming.

Pan, Spin, and Zoom

Panning involves selecting a slow shutter speed and then panning the camera at the same speed as the subject. For example, if a taxi drove by you would focus and position the lens so that it always pointed directly at the car. As the camera was panning to follow the taxi's pass, you would press the shutter and voilà, you would have an interesting frame.

Spinning involves selecting a slow shutter speed, focusing the camera, and then physically rotating the camera to pivot like the hands on a clock. To successfully execute a spin, try to think of the lens as the center axis point around which you rotate. Keep in mind that the image will be most sharp in the center, while the radial blur will gradually increase toward the edge of the frame.

To create a zoom blur, use a variable lens that allows you to quickly change the zoom amount. First, select a slow shutter speed and then focus what you see. Next, simultaneously twist the zoom

Panning with a slow shutter speed makes this ordinary scene unusual. For more blur use an even slower shutter speed.

control and press the shutter release. If you time it right this will create a stunning look. If you don't happen to have a zoom lens you can accomplish the same trick. Choose a slow shutter speed and focus the scene. Next, quickly pull or move the camera backward (or forward), then back, and press the shutter release at the same time.

ISO

In certain ways, the technological advancement of digital capture has started to plateau. We now have big enough sensors to create files that are sufficient for most billboards. In more common terms, the megapixel wars are starting to wane. What was once a fistfight is now more sophisticated and subtle. Almost all cameras, even pocket cameras, have enough megapixel range. There are still other significant technological discoveries and changes. One area that has recently revolutionized how cameras are made is ISO.

ISO is a term that has been around for some time. For film and digital capture ISO refers to light sensitivity. And while film and digital capture are incredibly different, the particulars of ISO run on a parallel plane. In both cases, there is a trade-off between light sensitivity and detail. Let me explain.

A low ISO number equals a low sensitivity, while a high number equals a high sensitivity. Typically, it's best to select the lowest ISO number possible for the scene. You will capture the highest quality frame. With film, a higher ISO results in more grain. Film grain can be appealing and can be used to create a distinct look. On the other hand, when you increase the ISO for digital capture, you're bound to increase undesirable noise. Perhaps later, we'll look back and nostalgically appreciate noise. For now most agree it just doesn't have much appeal.

Higher end cameras can capture more quality at an incredibly high ISO range. And there are certain times when you're shooting when there won't be enough light. In those cases the only viable option will be to increase the ISO. Be sure to take some test shots and experiment with your camera to determine what constitutes an acceptable range.

Left Behind

In a way, I think of this book like a travel guidebook that inspires you to embark on an adventure. And while the book seeks to lead the way, the secret mission is that this gets left behind. The best adventures do not occur by following someone else's path. They happen when you make your own. True camera creativity is exactly the same. This chapter and the ones that follow are simply a springboard to get you started.

There will inevitably be times when you get stuck in a rut. Often this happens as a result of accidental neglect. We forget about inspiring ideas and when left alone they grow mold. The mold takes over and turns ideas into regulations and rules.

When you find yourself in this spot, remember that the finest photographers don't ever give up and they never ever arrive. Revisit the pages that captivate you most, like opening a window to let some fresh air in. Don't stay in your comfortable seat—true camera creativity requires that you go outside. With camera in hand, let the fresh outdoor air fill your lungs and revitalize what you see.

Guest Speaker

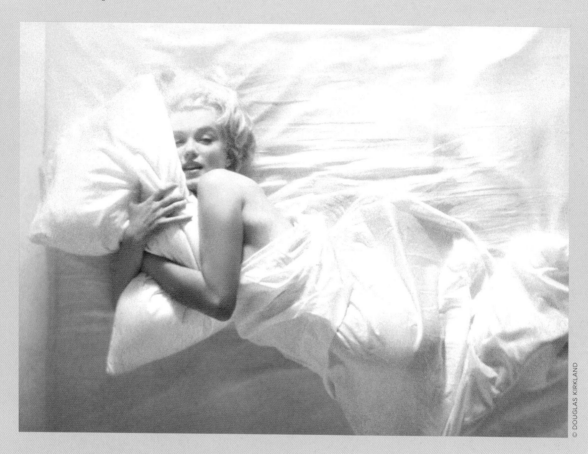

© DOUGLAS KIRKLAND

Douglas Kirkland

One afternoon while having lunch with Douglas at his home in the Hollywood Hills, I was struck by his humble tone. Douglas has always been someone who is immensely generous, creative, and alive. And he has consistently used his cameras in creative ways. Like this iconic portrait of Marilyn Monroe taken from ten feet above. To see more of his legendary work: visit www.douglaskirkland.com.

What inspires you?

My earliest inspirations were the copies of *Life* magazine that came to our house in Fort Erie, Canada, on Friday afternoons. They showed the world in the most exciting way through the eyes of Gjon Mili, Alfred Eisenstaedt, Gordon Parks, and Margaret Bourke-White, to name just a few. From my earliest days, photography has always been about interpreting people or places, capturing a moment, a mood, a light. I understand the world better by looking at it through a camera.

I look at the everyday world around me, I look at the work of other artists, I listen to great music. Being alive is being inspired.

What makes a photograph good?

This is such a subjective question. Freshness, information, exploration of cultures, aesthetic pleasure, composition, impact, stimulation, romance, emotion... I could go on forever.

What character qualities should the photographer nurture?

A healthy dose of ego that doesn't degenerate into arrogance. Sensitivity to continuous change. Resilience and adaptability.

What is your advice for the aspiring photographer?

I believe you have to be totally committed and realize you are entering an increasingly tight and competitive world. It is possible to get in, but once you succeed you can never coast or sleep or you will be quickly overtaken. It is a great world and it is worth the continual pushing.

LET THE
ADVENTURE BEGIN

PORTRAITS

5

IT IS PART OF OUR HUMAN NATURE to be interested in and attracted to others. Many of the most compelling photographs of all time have been of people. And as my close friend Evan Chong, also a photographer, once said, "Portraits are valuable because they extend beyond the limits of the ordinary experience."

Portraiture has been of profound interest for thousands of years and its course has been as diverse as its subject matter. While it is impossible to determine the root of our love and fascination with photographs of people, their value—and our interest—continues to grow.

As portrait photographers, we humbly push our boat out into the larger sea of this genre of art. The context reminds us that whoever we are or wherever we are, we have something to contribute. Because at their core, portraits are photographs of individuals created by individuals.

Because you are unique, you have the potential to create lasting and compelling photographs of people no matter how young, how old, how introverted, how extroverted, how inexperienced, or how experienced you are. And as an individual you are always growing and changing. You have untapped potential and therefore, many of the most meaningful such photographs of your life still lie ahead. We dedicate our efforts in this chapter to this profound, ever-changing topic of people photography.

Become

At the photography school where I teach, just before the students graduate, they have to pass a final review. At one of these reviews, the famous Jay Maisel had come to review portfolios. If you are not familiar with Jay or his photography, he is a creative force to be reckoned with. Not only is he a legendary photographer, he is the quintessential New Yorker. His reviews are both honest and tough. Exactly what students need before they head out into the real world.

One bold and talented student received a decent review. Yet, the student wanted more. He asked, "Jay, what do I need to do to take more interesting photos?" Without skipping a beat, Jay volleyed back, "Become a more interesting person." And it is true, isn't it? The kind of pictures we make reflects who we are. Or as photographer Chris Rainier said another way, "at some point photography becomes autobiographical. In order to create better photos, we need to go out and to develop who we are."

"Who are you?" Or even better, "Who are you going to become?"

So the question remains, "Who are you?" Or even better, "Who are you going to become?" Photographer Rodney Smith said something similar to what Jay Maisel said, except with a slightly different spin: "To create better photos, you need to become a better person." Undoubtedly, your personal development will lead directly to the type of photographs you make.

Ease

How then can we begin to develop, grow, and change? How do we become an artist who excels? In my own experience, the best way is to start simply, quietly, and exquisitely. Let me explain.

Over the last few years, I've had the incredible privilege of interviewing, photographing, or simply spending time with some of the artists I most admire. Whenever I have one of these encounters, my observations and awareness are heightened. And here is one of the things that I have noticed. Whether it is hanging out with the musician Jack Johnson at the local beach or sitting down for breakfast with Steve McCurry, all of these people are good at asking questions and they are amazing listeners. Even more, most do not think of themselves as "special" or as someone who has "arrived."

They are humble. They are at ease with themselves and this puts them at ease with the world. And all of this is not an act; rather it is an approach to life of authenticity and gratitude that deeply values others and values the creative process. So how, then, do you as a portrait photographer begin?

Joyce Tenneson, one of the world's leading portrait photographers, is incredibly prolific. In creating her best-selling book *Wise Women*, she photographed 450 people in one year. And that was on top of doing her commercial work, speaking engagements, and teaching workshops. The final result of her efforts is a series of profoundly moving portraits. "I don't make small talk," she says. "I start off by asking a question of significance. And that begins our dialogue." And this is a dialogue that often leads to discussion of the deeper things of life. It's no wonder her portraits have such depth.

If you want to create better photos, try following Joyce's lead. And the next time you are taking someone's portrait, slow down, look, listen, ask, engage, and talk about something that really matters.

Stillness

In my mind, to call Rodney Smith a celebrated photographer falls desperately short. Rodney is more than that. I've always been interested in the creative heritage of legends like Rodney. One aspect of his story has stuck with me. After college and some traveling, Rodney went on to study theology at Yale. It was there that he learned the value of asking questions. And now, decades later, his questions are still a significant part of his craft. In fact, in his words he "seeks to create photographs that ask questions rather than provide answers." It is the question or the mystery that keeps people coming back again and again to his photography.

A few years ago, I was having lunch with Rodney. At one point in the conversation, Rodney said something that stopped me in my tracks. He said, "Stillness of hand cannot make up for emptiness of heart." The rest of the lunch was a blur. Afterward, I went back and wrote down those words in my journal.

The truth in those words resonated with my soul. It was the idea that good photography is never the result of technique. Of course, technique (like holding a camera still) is critical, yet for the artist, technique never travels alone. Rather, it is inextricably paired with its soul mate, the heart. And the task of the portrait photographer is to keep the heart healthy and alive. As Richard Avedon once said, "To be an artist, to be a photographer, you have to nurture the things that other people discard. You have to keep them alive." Otherwise, you risk drying up, only to create potentially accurate yet lifeless photographs.

What then is the condition of your heart? Calloused, complacent, and closed or focused, free, and full of life? For I agree with Arnold Newman, who once said, "We do not take pictures with a camera, but with our hearts..."

The best way to begin is to photograph someone who is meaningful to you. I admire Nick Dekker. He is a teacher, talented photographer, and master printer.

Lady

The golden southern California sun slowly drifted toward the Pacific Ocean and I was caught up in this quintessentially perfect day. All of a sudden, the music stopped and I knew that was my cue; it was game time. One of my favorite musicians, Ben Harper, and his band had just finished rehearsing and would soon be heading my way. I was set to take some portraits of Ben and the band, yet it would be a tricky photo shoot. There was only a short window of time before the guests started showing up for this private outdoor performance. The moment had arrived; it was now or never, and I was excited.

Small talk was made and we were getting ready for the shoot. One of the concert promoters walked up with some VIPs and another photographer. They were here to take some "trophy" photos. I couldn't help but smile. The pale corporate-looking VIPs stood with giddy oversized grins next to Ben, the calm, cool rock star-artist. The juxtaposition was humorous and the moment awkward. Ben was of course gracious, yet authentic. Meanwhile, the photographer wasn't content. She needed Ben to smile and made her request. No response. She prodded, and soon her cajoles turned into pleads, "Ben, smile... Ben, smile... Smile... Say CHEESE." Finally, Ben responded, "Lady, I smile with my eyes." Enough said. The photographer pressed the shutter release and captured a mediocre image at best.

Moments later, it was my turn. My approach was simple, our conversation ordinary. I set up my wooden camera, looked through the viewfinder, focused, snapped a few pics, and we were done. And in my photos, Ben had smiled with his eyes—what a gift! I was so excited I could barely contain myself. Fortunately, I had enough sense to remain calm and simply say, "Cool, thanks, Ben." Ben replied, "Yeah, that's it?" I replied, "Yep." Ben, "Cool." We had an understanding, a mutual respect, and the shoot was finished as easily as it began. In fact, it was so simple it was almost as if it didn't happen, and that's exactly how I wanted it to be.

Obvious

The photographer's task is to see beyond the ordinary. Yet we limit our vision, thinking that smiling or expression is only done with the mouth and the lips. How shortsighted. You don't have to go to New York to watch a solo ballet performance to pick up on how expressive the body can be. Right now, or the next time you are around people, look with the intent of finding expression. You will quickly find more varieties of expression than the Inuit have words to describe snow.

The Inuit are said to have hundreds or even thousands of words to describe snow. While that may be an exaggeration, they do in fact have a wide range of expressions and words related to snow, because of their intimacy and familiarity with it. Wouldn't it be interesting to talk with an Inuit about snow? Can you imagine how much you would learn?

The words we have reflect what we know, what we observe, and what we see. And the problem with a portrait photograph isn't the subject. As Annie Leibovitz, one of the most accomplished photographers of all time, says, "If a photograph is a failure, it is no one else's fault but my own." The problem lies with us. Many times, what we look and ask for is too limited, too obvious. We need to dig deeper.

As a teacher, I often come across student work that is too obvious. The student, of course, thinks the work is original, poignant, and compelling.

I explain to the student, "Imagine that you're an English major interested in becoming a famous novelist. You've just submitted a short story in which you

Musician Ben Harper.

use a curse word in every other sentence. How is your teacher going to respond? It is easy to predict, isn't it? The teacher will ask you to rewrite the entire story without using the curse word. And it is not about morals; it's just that the curse word is easy, too easy. If you want to be a great writer, express that same emotion without using (or overusing) a trite word."

If you want to be a great portrait photographer, broaden what emotions and expressions you elicit and aim to capture. Pay attention to the details and you, too, will soon uncover previously hidden truths and ideas. You will soon discover what type of photographs you want to accomplish.

In my own work, rather than emotional photographs, I strive for emotion. The difference between emotional and emotion may seem subtle, yet it is a subtlety that matters. It reminds me to look for the slight nuance or gesture rather than the obvious and overplayed. It sharpens my vision, my perceptions, how I communicate with people, and finally, when I decide to press the shutter.

I'm not saying that you need to follow what I do. Rather, you need to go down this path and decide for yourself. You need to broaden and deepen your own emotional vocabulary in order to discover how to create more compelling and engaging photographs.

Significance

While smiles can be wonderful, many times in portrait photography smiles are not the goal. Annie Leibovitz does not ask people to smile for her pictures. You really have to stop and think about that for a moment.

Is the lack of smiles a problem? I don't think so. Perhaps this aspect of Leibovitz's work is a mystery to be explored. Leibovitz says, "It is a relief to tell someone they don't have to smile." And why does this message come as such a relief? Perhaps because asking someone to smile is asking for something inauthentic and insincere.

If a photograph feels fake, it loses impact. And ultimately, the most artistic and poignant photographs connect with the viewer. A photo has to be believable in order to get beyond the surface. As Aristotle said, "The aim of art is to represent not the outward appearance of things, but their inward significance." We want to know what is happening on the inside. And that's what love is, isn't it? Think about the Sting song, "Every breath you take, every smile you fake. I'll be watching you." A fake smile is unmistakable, and in a relationship we want more.

There will always be give and take. There will be times when you want to capture or even create joy-filled photographs. The point isn't to always be subdued, but rather that an authentic expression is always better than something that was forced.

Story

In literature, a good story cannot be force-fit together. It must first invite and draw in the reader. Once the reader is "in," the story must continue to fit together and deepen the narrative in a way that feels right. As John Updike wrote, "A narrative is like a room on whose walls a number of false doors have been painted; while within the narrative, we have many apparent choices of exit, when the author leads us to the one particular door, we know it is the right one because it opens."

And so it goes with photography, especially photography of people. As a portrait photographer you get to decide how to invite the viewer in, how much story to tell. For example, I have been working on a project photographing legendary surfers. In approaching this project, I knew I could photograph

Shaun Tomson is a legendary world-champion surfer and one of my personal heroes. He has honestly and gracefully weathered many storms, including the tragic loss of a family member. In his eyes you see more than an icon, more than a surfer.

Tom Curren is a quiet and humble man. He is down to earth and honest. Tom is a surfer like no other, undoubtedly one of the greatest and most influential of all time.

them as mythic legends. But the commercial surfing world has done that over and over again. I wanted to go beyond the myth and discover a place where an authentic voice has space to speak quietly yet profoundly. I've always preferred the simplicity and subtlety of this tone.

As I planned the shoot, I was reminded of Philippe Halsman's words, "A good portrait is incredibly hard to create. There is too much temptation to pander to the individual rather than portray them as they really were." I refused to take the easy way out. I wanted something authentic showing the victories and the defeats. The story line isn't always clear-cut, but when the photographer leads us to the one particular vantage point, we know it is the right one because it deepens what we already feel on the inside.

Happy

Well, what about those times when you do want a smiling photograph? Like many photographers, I'm more comfortable behind than in front of the lens. But if you want to improve your photography, you need to have your picture taken to understand what it's like on the other end of the lens.

I needed a "happy" portrait of myself for an upcoming project I was working on. I explained what type of portrait I needed to a photographer friend. He agreed to shoot some photos. Before the shoot, I said, "I always have a hard time smiling naturally in photos." What was my friend to do? Or rather, what are you to do in those situations?

Gerry Lopez is a surfing legend. His laugh is contagious and his stories are full of fun. On this shoot Gerry is *talking story*, as the Hawaiians say. The set of photos is conversational—simple pictures taken in between the lines—that show his authentic candor and brightness.

In the pursuit of authenticity, do you just passively sit back and let it go?

How did my friend respond? Without losing a beat he said, "Oh, that's no problem, I'll just have to make you laugh." What a brilliant response. During the shoot, he did make me laugh and the photos were amazing.

Follow

The New York Times once called Richard Avedon "the world's most famous photographer." And rightly so. Avedon had a talent for capturing people like no other. His photographs, like his life, are full of intensity, vitality, and depth. Avedon was passionate and committed to his craft. In fact, his passion propelled him to photograph until the end of his days. Late in the year 2004, Avedon was on assignment. He clicked the shutter of his camera and then died. The loss of Avedon was, and continues to be, immeasurable.

Avedon once said, "If a day goes by without my doing something related to photography, it's as though I've neglected something essential to my existence, as though I had forgotten to wake up."

As a portrait photographer, Avedon had the unique ability to create striking images of a wide range of subjects; whether photographing powerful presidents, French fashion models, or weathered, worn-out Wisconsin farmers. A quick survey of his images will make anyone wonder, how did he do it? How did he capture such detailed, precise, and riveting photographs of such a range; from Obama to the local beekeeper? Much of his success is often attributed to who he was as a person. And that person came out in interesting ways as he interacted with those he photographed.

At times, he was gregarious and energetic. He would dance, leap, and cheer with camera in hand while on a fashion shoot. And his energy and movements magnetically brought out fluidity and vitality to otherwise perfect and placid models. Yet, his magnetism didn't only illicit movement and excitement. How did he create such precise and direct portraits like those from the America West series? How did he draw out such intensity in his subjects?

In pursuit of an answer, I had the opportunity to talk with someone who was close to Avedon, his right-hand assistant and printer who played an active role in the American West project. What I discovered was fascinating. The subject would step in front of Avedon's old 8 by 10 camera. Avedon would go under the dark cloth to double-check the composition and focus. Next, he would gallantly throw off the dark cloth, which was caught by an assistant. Then, Avedon would stand next to the camera and gaze at the subject. Many times, at this moment few words were exchanged. Rather, Avedon would imperceptibly shift his weight, change his posture or body language. The subject, not knowing what else to do, would do the same.

And that is the brilliance of Avedon. He didn't hide behind the camera. The photo shoot became a collaborative dance. And it wasn't simple mirroring either. Avedon's presence and quiet communication was simultaneously a statement, question, and invitation—I'm with you, trust me, follow my lead. And the subjects almost always did.

Substance

People watching is easy. Approaching a stranger, directing a celebrity, or simply asking your boss to pose for a portrait is difficult. Despite being awkward, it's almost always worth it.

Growing up, I had a quote above my desk, "Risk is the substance accomplishments are made of."

And it is especially true for the portrait photographer. If you want to create images of substance, you have to take a few chances. On this topic, nothing is more inspiring and illustrates this idea better than Yousuf Karsh's historic photograph of Winston Churchill.

It was 1941 and Yousuf Karsh was set to photograph Winston Churchill after one of his presentations. Churchill wasn't in the best of moods. He lit a fresh cigar and told Karsh, "You may take one (photograph)." Karsh recounts in his own words:

> Churchill's cigar was ever present. I held out an ashtray, but he would not dispose of it. I went back to my camera and made sure that everything was all right technically. I waited; he continued to chomp vigorously at his cigar. I waited. Then I stepped toward him and, without premeditation, but ever so respectfully, I said, "Forgive me, sir," and plucked

Winston Churchill without his cigar.

© YOUSUF KARSH

the cigar out of his mouth. By the time I got back to my camera, he looked so belligerent he could have devoured me. It was at that instant that I took the photograph.

That photograph of Churchill became something of an icon. It was as if Karsh had created a photograph that perfectly reflected the defiance and determination of Churchill and Great Britain. It became a rallying point for a nation at war and one of the most reproduced photographs in the history of photography. But there were two photographs taken that night. The second photograph was in the same pose, but Churchill's mood had softened and he was smiling. That image, of course, was forgotten.

Now, let's turn our focus to your own story. What's holding you back from creating amazing photographs? What risks do you need to take? Risk in portrait photography is integral. And sometimes the risk may be as simple as nodding toward your camera to ask permission for taking a portrait of someone in a far-off land. The risk may be asking a celebrity to climb on top of the roof of her car. Or perhaps the risk may be closer to home, like asking your father, who hates having his picture taken, to pose for a portrait. Either way, I encourage you to begin to think about what risks you could take in order to develop further as a photographer.

Good Enough

After you dedicate an immense amount of energy, time, and money to attend and graduate from photography school, there is a distinct payoff. As a faculty member at such a school, I watch and learn from the growth of our students. And it is incredibly gratifying to see them go out into the world at the top of their game. They are so well trained—but perhaps sometimes too well trained.

> I use my camera to extend and slow life's time frame. Sometimes it works and other times it gets in the way.

One particular student became interested in portrait photography while at school. He understood the education process: You get out what you put in. He put in huge efforts, and a few years into his education it was paying off—he was becoming quite a success.

Just before finishing school, he decided to take a trip back home. One of his goals was to take some portraits of his family, in particular of his father, whose health was declining. After flying for 20 long hours, he arrived. There was something special about returning home at this stage in life. It was his chance to share with his family who he had become. He had a wonderful visit and then returned to school.

One of his classmates eagerly asked, "How was it? Did you get a photograph of your dad?" He said, "The trip was amazing. A ton of really good quality time... Yeah, it's funny; I didn't get any portraits of my dad. The light was never good enough." A few days later, the student received the news. His dad had passed away.

If there is one lesson that photography has taught me—life is short. I use my camera in order to extend and slow life's time frame. Sometimes it works and other times it gets in the way. Either way, whatever gear you have, whatever light is available... it is good enough. Don't let another day pass.

Practical Tips

At this juncture, if you're like me, you're probably fired up and ready to fly. How can we get off the ground? One way to keep the momentum going is simply to begin shooting. Then as you're working, try to integrate a few of these practical setup and shooting tips to further your progress. Remember these tips are meant as a springboard for developing a more complex and varied portrait photography skill set.

Lessons from the Studio for Natural Light

In learning how to photograph with natural light, there is so much that can be gleaned from lighting in studio photography. Let's begin by selecting a few studio light characteristics that work well for certain portraits.

For starters, in some studio photographs, you'll notice that the light is soft and the eyes sparkle. This results from the use of giant soft boxes to create softer, more diffused, more natural light. Reflectors bounce light back onto the subject in order to fill in or brighten the shadows. The sparkle in the eyes is the result of all of the above light sources.

And here's the good news: If you develop a trained eye, you can find all of these lighting conditions in the most ordinary locations. In fact, certain photographers have developed such a strong sense of light and location that they never use anything but natural or available light.

Use Window Light

I grew up in Northern California in a beautiful home that was designed and built by my father. One of the huge walls in our living room is entirely made up of windows. The view from that room is spectacular, and the light inside the room is unbelievable. It's perfect for portraits.

You don't need a wall of windows in order to find good portrait light. In fact, almost any window will do. All you need is indirect sunlight, which is soft and flattering. It minimizes blemishes and wrinkles and allows the subject to open his or her eyes. Even more, windows are comforting. They

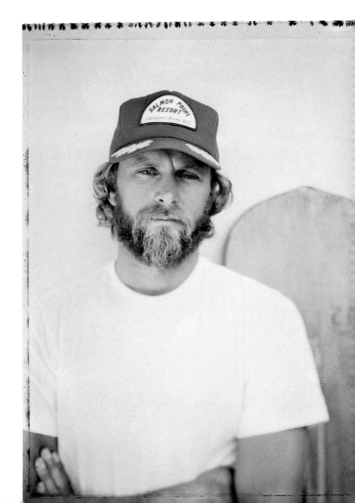

Taking risks sometimes means finding a new location or using a different camera or lens. This photograph of Keith Malloy was taken within minutes of the other one, and the end result is a completely different mood.

are openings to the outside world. Who doesn't like to sit next to a window and look outside? This comfortable context has the potential to relax and open up a subject.

Use Open Shade and Move Around

What if you're outside and the light is harsh? In those situations, why not follow the lead from legends like Richard Avedon, who kept things very simple and often shot in open shade? Open shade is basically anything outdoors that does not receive direct sunlight, like the shadow of a tree, your front porch, the shaded side of a barn or building, or even better, the inside your garage with the door open.

Regardless of the context, ask your subject to step out of the harsh light and into the shade. Then look for the light and have your subject move around. Notice what happens when your subject moves deeper into the shadows or closer to the direct light. While you're looking to find the sweet spot, look for the reflected light in your subject's eyes.

If you position your subject on the shaded side of a building, look to see what other buildings are around. If there is a bright white building close by, it will act as a reflector, bouncing light onto the subject. Position the subject to take advantage of any of these environmental reflectors. Or climb up a small stepladder and have the subject slightly look up so that the brightness of the sky is reflected in his eyes.

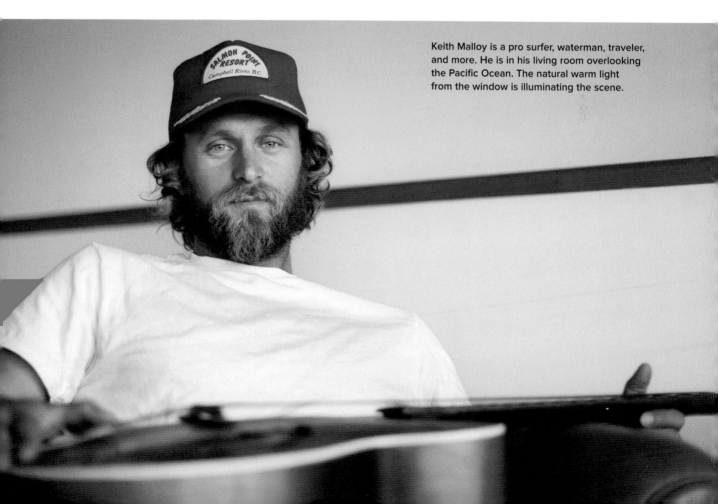

Keith Malloy is a pro surfer, waterman, traveler, and more. He is in his living room overlooking the Pacific Ocean. The natural warm light from the window is illuminating the scene.

Most photography manuals say to never take pictures at noon. With a little ingenuity you can always find a slice of open shade. Here is surfer Tom Curren at his home in Santa Barbara.

If you're still having trouble, ask your assistant to wear shiny reflective sunglasses. Examine the reflection you see in the lenses and use the larger surface area of the sunglasses to visualize how the light will later look reflecting off the subject's eyes.

Remember that finding and using available light is only part of the equation. It's the equivalent of the studio photographer learning how to use studio lights. And there's more to photography than being a technician.

Shine Bright and Lighten Up

I asked one of my teaching colleagues, Nino Rakichevich, what advice he gives students when photographing people. Nino is a seasoned and accomplished photographer, so I was curious to hear his response. He enthusiastically responded, "Have fun! And don't forget that you have to be a people person in order to be a people photographer!"

The next time you are about to meet up with someone for a shoot, take a deep breath. As you exhale, let go of as much nervousness as you can. Instead of thinking about missing the shot or what could go wrong, ask yourself, what can I do to lighten and brighten things up a bit?

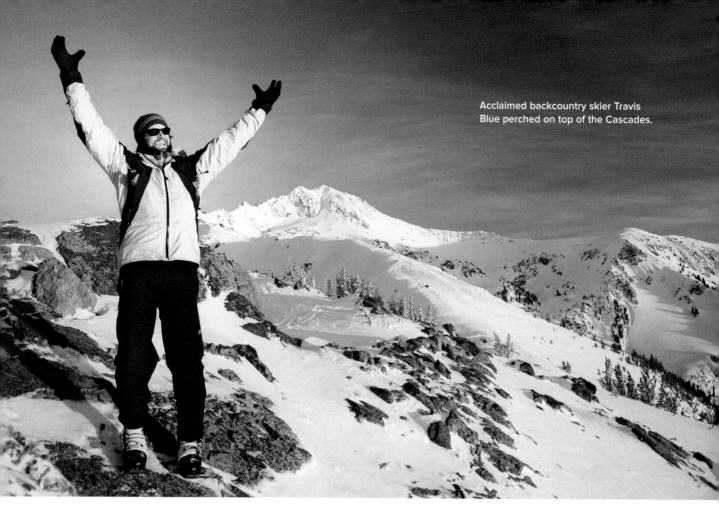

Acclaimed backcountry skier Travis Blue perched on top of the Cascades.

Look Around the Frame

We are drawn to other people's eyes. This becomes even more pronounced when we are looking through a camera. The camera gives us the courage, validation, and privilege to look without faltering directly into someone's eyes. With this privilege comes a unique responsibility to look into the subject's eyes and then to look around. Let me explain.

It happens to so many beginning photo students. They've finally built up the courage to photograph someone they admire or think is beautiful, handsome, or fill-in-the-blank. After the shoot the student brings in the photos and asks for your critique. At least in one respect, the teacher's response is the same for so many beginners. The lighting and the subject look nice. What about that distracting element in the background? What about the pole sticking out of the subject's head? What about the way you compositionally cut off his ear? What about...?

What went wrong with the shoot? The student was so focused or mesmerized by the beautiful or handsome subject that he or she forgot to look around. Eventually, the top students learn the remedy. They intently look at the subject, but then they literally look around the frame. After some time, they develop a strong sense of peripheral and spatial vision. The peripheral vision helps them become aware of surrounding elements, whether they are brightness, shadows, or distractions. The spatial awareness helps them recognize how their subject fits into the frame.

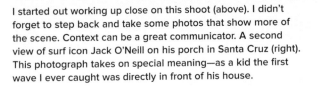

I started out working up close on this shoot (above). I didn't forget to step back and take some photos that show more of the scene. Context can be a great communicator. A second view of surf icon Jack O'Neill on his porch in Santa Cruz (right). This photograph takes on special meaning—as a kid the first wave I ever caught was directly in front of his house.

Take Three Steps Forward

If we were to randomly flip through ten beginning portrait photographer portfolios or ten family photo albums. What is the most common mistake we would find? The subject is too small.

To take better pictures of people, set up to take the photo. Press the shutter and get the shot out of your system. Then take three to five steps forward. Get close, I mean really close. Some of my best portraits were taken only an arm's length or two arms away. Of course you have to keep in mind that the closer you get, the more potential for distortion depending on the lens you use. Therefore, before an important shoot, you're going to need to experiment with your lenses in order to find the sweet spot for the look that you are after.

Walk Away and Look Back

I was recently at a dinner with a photo editor of one of the world's most prestigious publications. I asked her, what makes a good portrait? She replied, "I like a photograph that feels candid or real. And, it has to say something." One way to develop your skill at saying something is to include more in the frame.

In other words, after you've stepped forward, hang your camera on your shoulder and go for a hike. Walk away and look back. Find a new perspective that tells a completely different story. Not only will this provide you with the opportunity to capture something new, it acts as a nice intermission. Consider it a chance to breathe some fresh air. In turn, this will give both you and your subject a break from performing. Even better, the walk will lead you to new locations and new ideas for your shoot. After snapping a few pics, walk back and keep the momentum going.

Use Shallow Depth of Field

As you start to develop stronger photographic awareness, you'll start to develop a discerning eye for what makes certain portraits powerful. One technique that is frequently used is a shallow depth of field so that the subject is in focus and the background is completely out of focus. This particular look draws attention to the subject in a flattering way.

To have more control and flexibility, set your camera to aperture priority. Next, choose the lowest possible f-stop. The lower the number, the shallower the depth of field. In other words, if I use an 85mm at f/2.0, I can create an image with the eyes in focus and the ears completely out of focus. If I set the 85mm lens to f/16, the entire subject and potentially the background will be in focus.

Photographer Douglas Kirkland in his living room in the Hollywood Hills.

Not only is shallow depth of field incredibly flattering, it simplifies the image and slows the viewer down. The selective focus draws the viewer to an exact point and in some ways replicates how we see and experience important events.

Think back to a moment where you were drawn into someone's eyes and time slowed. At my wedding, I can remember our first dance. Locking eyes and focusing and everything else was a blur. The emotional intensity of the moment called for an intense selective focus. And here the old adage less is more rings true. By using a shallow depth of field, we photographers can potentially replicate the way human vision works in order to create more engaging images.

Make Sure the Eyes Are Sharp

At photography school, upon hearing the reasoning for shooting portraits at a shallow depth of field, the students leap out of their seats after class with high aspirations. The next week, they return to class for a critique, eagerly awaiting a shower of accolades and praise to flow from both mentors and peers. The critique begins and the photographs have improved. Yet, certain flaws keep popping up like gophers in a freshly planted lawn. As the mistakes show up on the big screen over and over again, the students sink lower and lower in their wooden chairs.

Many of the mistakes are common: composition, lighting, fake smiles, and awkward poses. The most common mistake had to do with focus and here's what happened. Their cameras were set to the lowest f-stop number. The focus set, the composition defined, the model moved, and finally the shutter released. As a result of the movement, the eyes were now out of focus. The eyes need to be tack sharp. We're drawn to eyes, and a picture gives us an opportunity to experience eye contact in a new kind of way. In most of these photos both eyes were out of focus. In others, a subtler problem occurred— the near eye was out of focus.

The near eye is the one closest to the viewer. It's the eye the viewer looks at first. If that eye is out of focus the viewer has to visually scramble or reach over to the next eye. While the photo may technically look fine, it won't feel right. Dissonance will set in. The good news; now you know the problem. And this problem is easy to fix and the results are well worth your efforts.

In people photographs we are first drawn to the face. Honest, authentic, and strong eye contact creates a connection and causes the viewer to look once and then to look again.

Shoot Low or High

Think about fun house mirrors. These mirrors change our shape as we walk to tall, short, round, square, or silly. And they're a ton of fun. On a photographic level, the exaggerated mirrors teach something valuable about the many ways to change perspective.

In our day-to-day context we encounter a more subtle mirror trick. In many clothing stores the mirrors are slanted and tipped backwards. When you look in the mirror, your image is tall and skinny and you're more inclined to make a purchase.

How does this relate to photographing people? While there is never one perfect perspective for photographing people, many of the best pros move. Try a high perspective and it can hide a double chin, strengthen the jaw line, and trim away a few pounds around the middle. For a full-length portrait, drop down on one knee and shoot from belly-button height and it can lengthen the legs, add some height and create a flattering look just like tilting or slanting a mirror backward. If you're shooting a standard head and shoulder portrait, bring the camera up to the height of the subject's nose.

Which perspective is best? Whichever works to accomplish the look you are going for. To get better at portraits, try out each one of these ideas. They are not rules but guidelines to get you going. Begin practicing and you'll quickly discover what works best in different situations.

A low perspective shot of Joe Curren to emphasize the tracks and the surfboard. With a wide-angle lens, having a subject in the foreground makes for a strong composition.

It's Just a Camera

Pull a rabbit out of your hat and everyone will clap. Pull a high-end professional camera out of your bag, and some will lean forward, some will lean away. In our current cultural context, cameras are so many things: fascinating, intimidating, intriguing, alluring, and social. Whenever I am out shooting, people come up to me and talk to me about my camera: "How many megapixels? How much did it cost? Hey, I have that same camera."

Cameras trigger emotional responses. Sometimes you can use the response to your advantage. If someone is curious, this can naturally lead you to taking their portrait. What if a camera gets in the way? Even Avedon said, "I hate cameras. They interfere; they're always in the way." Many times the camera makes people nervous. Here's what

I recommend. Take your camera out of the bag before you arrive. A camera around your shoulder is much less intimidating, and it will help others get used to it being around.

Next, treat your camera nonchalantly. What this actually looks like will depend on you and it will vary from situation to situation. Here are a few things that I try. I find an excuse to set my camera down in some type of common space, on a coffee table or on someone else's desk. I ask someone to hold my camera while I go grab something from my bag. Or I ask them to look through the viewfinder, take a self-portrait, or take a picture of the scene. I do whatever I can to get them involved. And I want them to know that they don't have to act different, it's just a camera.

Breaking the rules by photographing a person with a fish-eye lens. The warped perspective fits perfectly with the freeform and fluid style of one of my favorite architects, Jeff Shelton.

Shaun Tomson and the dawn of a new day.

Take a Breath and Move Around

Ask someone other than a model to pose for a picture, and their feet will turn into sand bags squarely planted beneath their shoulders. It's as if they are bracing themselves for the face-off between the scrutiny of the camera and their own insecurities. And it is not their fault; I do the same thing. What I need when someone takes my picture is a bit of direction. It helps to have someone tell me how to breathe, look, and move.

One of the best ways to help someone let go of hidden tension is to ask them to exhale, to take a deep breath. Even better, ask them to look at the ground, exhale, and then look at the camera. Getting someone to look away is incredibly helpful because it gets him moving and gives him something to simple to do.

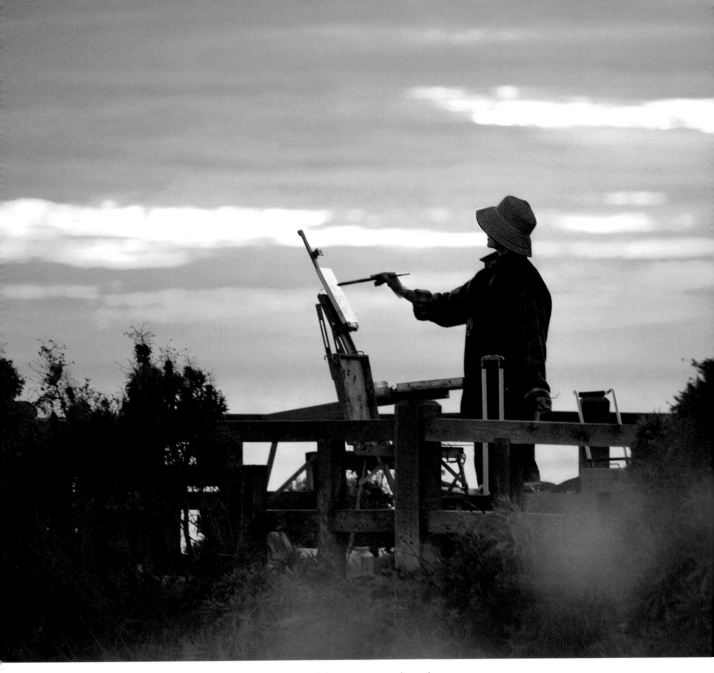

With the painter moving her brush, the photograph becomes more dynamic than if she were standing next to the easel. By lowering the position of the camera, you're peering into a private moment without interrupting her.

If you're just standing there, it's easy to feel stupid. Make him feel smart. Then ask him to move: to walk, turn, rotate his shoulders or shift his weight onto his back leg. Suggest he place his hands on his hips, then behind his back, then folded on his lap. Get him to stand up and then sit down. Get him to move naturally and it is a win-win-win. It will get your blood pumping and the creative juices flowing. The shoot will be much more enjoyable and the final results will be much more compelling.

Find a Complimentary Voice

We could follow the examples on prime-time TV or the movies where the photographer lathers up the model with glowing compliments: "That's beautiful baby, oh yeaaahhhh!" and so on. Personally, whenever I see those depictions of the photographer-model relationship I turn green. How could I ever do that? Do I really need to do that?

The answer is a big NO. What you do need to do is find a way to compliment that is authentic to both the situation at hand and to your own voice. In a way, it is a little bit like a sales pitch. Are you going to sell used cars or brand-new BMWs? The used car salesman uses flattery and emotional antics. The BMW salesman takes a more calm and sincere approach. For even more ideas, think back to the words that have meant the most to you. A compliment is simple, not overpowering but life giving. As Mark Twain said, "I can live for two months on a good compliment."

Typically, in our day-to-day lives, we don't take the time to compliment people, and that's where you need to start. Today try to give five compliments to people that you know or don't know. Start simple: "Wow, that color is really flattering on you." Or use the slang that is comfortable to you: "Bro, that is an unreal tattoo. Tell me about it." Today is the day to begin to develop the art of speaking kindly to others.

Be the Incurable Optimist

Photographers are a lot like rock climbers; the steeper and more challenging, the better. Solving the problems isn't dreaded, it's expected and even enjoyed. In other words, photographers are those who embrace the challenge. Rarely does a portrait photographer encounter a situation where she doesn't have to work hard and where something doesn't go wrong. In spite of this, the best people photographers are incurable optimists. In particular, they have to see beyond the circumstances.

If something goes wrong with the shoot, whether it is related to clothes, a posture, the camera malfunctioning, whatever—they don't express it negatively. For example, let's say a model is trying too hard and a pose doesn't look good. Rather than screwing up your face and hollering, "Ugh, that looks forced and awkward—loosen up!" the best people photographers have grace under pressure and instead try to reframe things in a more positive way, "All right, let's change it up, how about trying this…" Then when something does goes well, they call it out: "Wow, that was great. Nice."

After the Final Shot Counts

The flow of a photo shoot mimics the basic structure of a story—a beginning, middle, and end. The point of resolution, or the ending, often comes as a bit of a surprise. Yes, we knew where the story was leading, but if the ending was completely predictable, it probably wouldn't make for a great story. And the same goes for many good portrait shoots.

After a photo shoot has been going for some time, there is nothing more welcomed these three final words: That's a wrap! After those words are said, high fives are given and the success of the shoot is celebrated. Even more, those three words validate all the efforts and build a sense of accomplishment. And here's where the master storyteller steps in.

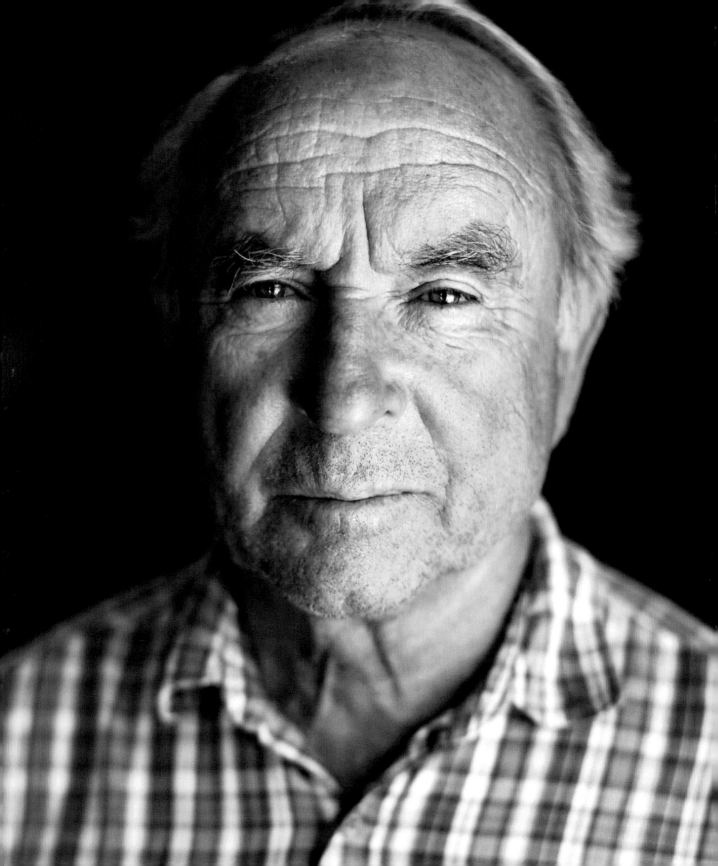

The master storyteller leads you to a point in the story so that you think it's over. But then there is the surprise ending. And that's exactly what you need to do in your portrait shoots.

You authentically thank and compliment your subject. Then you figure out how to take just a few more photos. Perhaps you say, "You know, I have exactly what I need for the client; they are going to be ecstatic. Is there any chance we could do a couple more photos just for the heck of it... I have this idea." And guess what? The subject is relaxed and the performance is over and these surprise ending photos are almost always the best of the set.

Before you go off and try this, here are a few things to keep in mind. First, find a way to integrate this approach into your own workflow that is authentic. Second, you have to go with the flow. Sometimes the subject will say, "Sorry, I really have to go." If that's the case, there's nothing lost. It is not something you need to do on every shoot.

Finally, if this technique doesn't work out, keep on trying it in different ways. You'll soon discover your own style and strategy. Don't give up, because when you find your own voice it will lead you to previously unattainable results.

Another one of my heroes is Yvon Chouinard—explorer, environmentalist, and the founder of Patagonia. Chouinard has always been ahead of his time, and you can tell by his eyes he is a force to be reckoned with. Here he is photographed with natural light in his blacksmith shop in Ventura, California.

Gear at a Glance

For photographing people it's best to keep your gear simple and accessible. I typically go for a two-tiered approach. In other words, I group my most important gear together so that I know exactly where it is and so I don't have to dig through less important gear to find it. Then the less important gear is grouped as well.

Here is what I did on a recent shoot of a celebrity athlete. I was going to start close so I hung a camera with the 85mm f/1.2 on my shoulder. Then I packed a shoulder bag (tier 1) and a backpack (tier 2). The backpack was loaded up with all of the extras: lenses, extra CompactFlash cards, backup batteries. In the more accessible shoulder bag, I packed all the essentials: a 16–35mm f/2.8 for environmental portraits, a 70–200mm IS f/2.8 for the flattering look with proportions, perspective, and blurred background, a zip CompactFlash card holder, and a Rocket Air Blower to clean off the lens. In my back pocket, I placed an extra camera battery.

The equipment that you use will vary from shoot to shoot. Keep in mind that when photographing people the key is to choose gear that doesn't get in the way. For example, let's say I am going to be photographing someone who is famous, yet who prefers the simple artist's life. Because I've always felt the 50mm f/1.2 was an honest lens, I'll bring that with the camera hung on my shoulder. Then I'll opt to leave everything in the car, except maybe for a journal notebook in my back pocket. When we talk, I'll listen well and maybe jot down a few notes. Then, hopefully the shoot will progress in a natural and an unencumbered way.

Some may be thinking, only one lens—how limiting! Exactly. Many times this limitation will get me thinking and it will require that I move my feet.

Workshop Assignments

In order to take your photography skills to a new level, try the following assignment elements: survey, shoot, share, and review and respond.

Survey

The survey suggestions below are in no way complete, yet the intent is to begin to broaden your perspective and expose you to different ways of thinking. For more extensive resources, recommended reading, links, and more, visit the companion site: visual-poet.com.

READ: Annie Leibovitz at Work

There is so much wisdom that we can glean from learning about photographers' approach to their work. And in this concise and insightful book, Leibovitz talks about how a wide range of her pictures were made. It is an easy and delightful read.

Yet, if you are unable to read this book, try the following. Approach a local photographer and explain to him that you are going through a photography workshop book. One of the book's assignments is to learn from photographers you respect. In particular, the assignment requires that you ask, "How have you, and how do you, create compelling photographs?"

WATCH: Annie Leibovitz, Life Through a Lens

This movie can be rented from Netflix.com. If you can't rent the movie at least watch the trailer on youtube.com. As you watch it, take notes on what you notice.

VISIT: www.richardavedon.com

When you view Avedon's images, be sure to have a notebook and pencil. Look at the photographs both emotionally and critically. Even if you are not talented at drawing, try drawing a few rough sketches of your favorite images. Next to the drawing, include descriptive adjectives and notes. Begin to deconstruct why certain photographs captivate you. If time permits, also visit: pdngallery.com/legends/.

SEARCH: Annie Leibovitz behind the scenes on Google

Be sure to try searches for other photographers as well. For example, "Jeff Lipsky photo shoot behind the scenes." There are a whole range of these movies that show photographers at work. Many are available online, and you'll be surprised how insightful they can be.

BUY: one of your favorite magazines

Rather than read the magazine, flip through it one page at a time from the cover to the end. As you go, cut out all of the people photographs that you like. Paste them up on a piece of cardboard or start a file folder where you save your favorites. Get in the habit of saving images you like.

Shoot

To expand your people photography skills, do the following assignments. They are intentionally open ended so that you can modify them to best fit who you are.

1 **Environmental**

 Create five unique "environmental" photographs of five coworkers or family members. By environmental I mean, compose the image so that the location and context are an integral aspect of the photograph.

2 **No Faces**

 Create five telling portraits of five different people, without including the face of the subject.

3 Subjects You Admire

Photograph five people you admire for similar reasons. For example, breast cancer survivors, successful artists, or skilled athletes. Before you begin, come up with a set of questions to ask each person, such as, "As you look back on your life, who has helped you the most to get you where you are today?" or "What has kept you motivated?"

4 Object to Start Conversation

Photograph five people in front of an object. For example, hang an old worn-out American flag. Ask your subject to stand in front of the flag and take a photo. Then ask her what she thinks about the war in Iraq. Take photos in between the conversation.

5 Prop with Subjects

Create five photographs of five different people with the same prop. Props help people relax, give them something to do, and draw out different personality traits. Here are a few prop ideas: vintage binoculars, cowboy hat, shovel, guitar, ladder.

6 Strangers in Same Context

Create 15 photographs of 15 strangers. Shoot all 15 photographs the exact same way. First, choose a subject. To get you going, here are some ideas from my past students: war veterans, corn farmers, security guards, people with tattoos. Then choose a context. For example, one student bought a red velvet chair, set it up on Hollywood Boulevard, and photographed people in the chair.

If you have a hard time approaching strangers, try this line: "I'm sorry to bother you, but I'm a student working on a photo project. My teacher (blame it on someone else) requires that I photograph 15 people I don't know. Would you mind helping me out?"

Share

Sharing your photographs sharpens your vision as it requires that you clarify what you're trying to communicate. In addition, publicly showing others an edited set of images is incredibly motivating. It motivates you to step it up a notch and show your best work. And the show acts like refining fire, burning off all of the unnecessary impurities. For this assignment try both of the following approaches:

1 Photo Show

Host a dinner in your home showcasing your images. Tell the guests that the "show" is a workshop assignment and that each guest will get a free photo. No strings attached, no pressure to buy or even to like the photos.

Next, create a way to display the photographs. Use twine and clothespins at a hardware store. Hang the photos off the twine just like you would hang clothes to dry. Or simply tape photos to mat boards (you can buy these at art or frame stores). Most important, come up with a clean and simple way to display the photos.

By taking a risk to share your art, it will challenge you to grow. And who knows, it might spur on someone else to take a similar risk. The next thing you know, it will catch on and you'll be part of a thriving group of aspiring artists.

2 Flickr

In order to share your photographs on a broader scale, share them on the Web. In particular, post your set of your photos to the Flickr group for this book (www.flickr.com/groups/visual-poet). Be sure to tag them with the appropriate assignment info: Chapter 5, assignment #2, No Faces. On Flickr we can view and comment on each other's photos. I'm excited to see what you come up with.

Review and Respond

After the survey, the shoot, and the show, it's time to review what has been done and think about what comes next. This is where you can begin to separate yourself from the swarm of mediocre photographers. As one of my photo mentors once said, "Anyone can say a photograph is good or bad. Yet you haven't arrived until you can say *why* a photograph is good or bad." And it is the why that we now give our attention.

Take some time to jot down a few notes. What worked? What didn't work? What could have been better? If you really want to grow, ask a close friend to help you objectively review each step of the assignment. Try to identify the qualities of the best and the worst photographs. Then, work to define your style. How would you describe it in a few words—maybe authentic, edgy, and contemporary?

After you have spent some time debriefing, close the chapter on what has been done and turn toward the future. At this stage I find it helpful to literally turn a page in my journal and start anew. Based on your review write out three to five goals:

1 To get paid to do what I enjoy best.

2 Get published in _____ magazine.

3 Create a best-selling book.

4 Have the opportunity to meet and photograph inspiring people from all walks of life.

Then write out some small steps in order to begin your goal-based journey. First, save up to be able to hire a designer to create a brand identity. Launch new brand and buy business cards. Get a subscription to a particular magazine. Assist for one of the magazine's lead photographers. Begin a portrait photo project called _____.

Guest Speakers

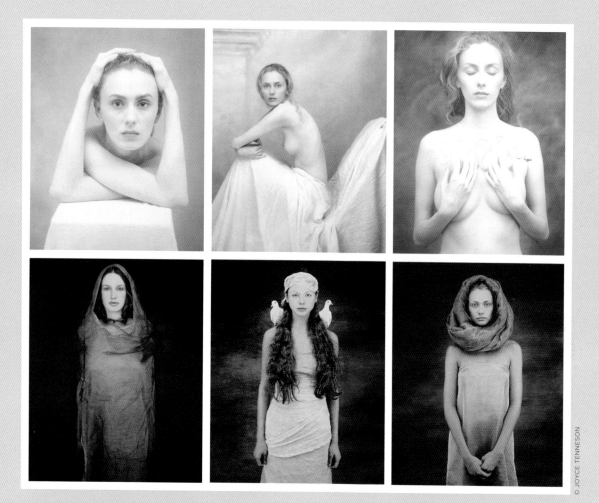

© JOYCE TENNESON

Joyce Tenneson

I sat down with Joyce Tenneson for an extensive talk about the art and craft of photography. I was inspired. Her authenticity, insight, and depth caught me off guard and even brought tears to my eyes. And so it is with her photography. At first glance, the simple and innocuous becomes intense, intriguing, and profound. No wonder she is often described as one of ten most influential female photographers in the history of photography. To view more of her work visit: www.joycetenneson.com

What inspires you?

Meeting new people and finding out what makes them tick. I try to see what they don't reveal to the world. What are their secrets? For me being a portrait photographer just came naturally, because I was interested in looking at people, observing them, but also talking with them.

What makes a photograph good?

I think a photograph is good when people want to look at it over and over again. There's something mysterious about it that makes you wonder, what is it? There's a power that an image has when it's really successful. It defies verbal description or analysis.

What character qualities should the photographer nurture?

Themselves! I think that every great portrait photographer does work that looks like them. There's a reason why, for example, Irving Penn's images look so different from Richard Avedon's images. Here are two guys from the same ethnic background, same age, and same opportunities in New York at major magazines. But the two men are vastly different. What makes them tick? Who they love, the way they treat other people, what they do with their free time. All of that is *in* their pictures. And that's what makes a great photographer.

What is your advice for the aspiring photographer?

I think it's really hard out there, but there is always room for greatness. I think about my assistants, the ones who do well, and there is an intrinsic passion for their work more than anything else. Maya Angelou said that if you're alive and you're on that journey, and you're passionate about what you want to do, and you're willing to put in the time and visualize yourself where you want to be—then you'll get there.

Rodney Smith

Rodney Smith approaches the world with curiosity and wonder. He doesn't impose ideas, but he asks intriguing questions. And his photographs have a poetic cadence that is magnetic, alluring, and timeless. Once you see one of his photographs, you know it is his and you can't look away—the simplicity, geometry, proportion, and elegance draw you in. For more inspiration visit: www.rodneysmith.com

What inspires you?

One of the traditional aphorisms that I think is appropriate to this question is that art gives form to feeling. This simple and complicated quest is probably

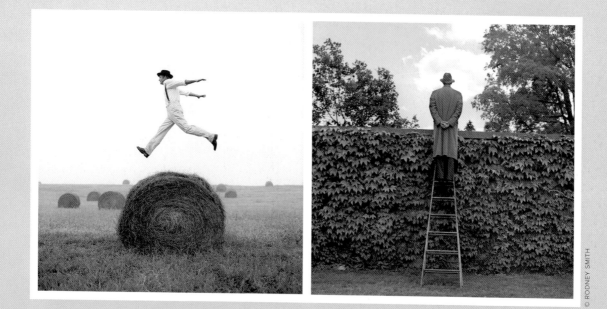

at the root of all matter. For me, the way to give form to my feelings is visually. For others, it may be through literary or musical means. But the desire is the same. When I have run out of feelings—I guess when I run out of breath—I will probably no longer have the desire to make photographs.

What makes a photograph good?

Another complicated question. One of the most difficult things to do is to speak very privately. If you are able to do this, for some reason, the photograph takes on a much larger, universal interest. It's ironic that those who speak the most privately are in fact speaking the most universally. Most people confuse speaking about the immediate world around them, talking about the popular culture, with speaking on a deeper level. Most contemporary photography is interesting as it is a reflection on the culture, but it misses a deeper insight into the human dynamic.

What character qualities should the photographer nurture?

Focus, focus, focus.

What is your advice for the aspiring photographer?

Choose photography for love rather than for fame, fortune, and glory.

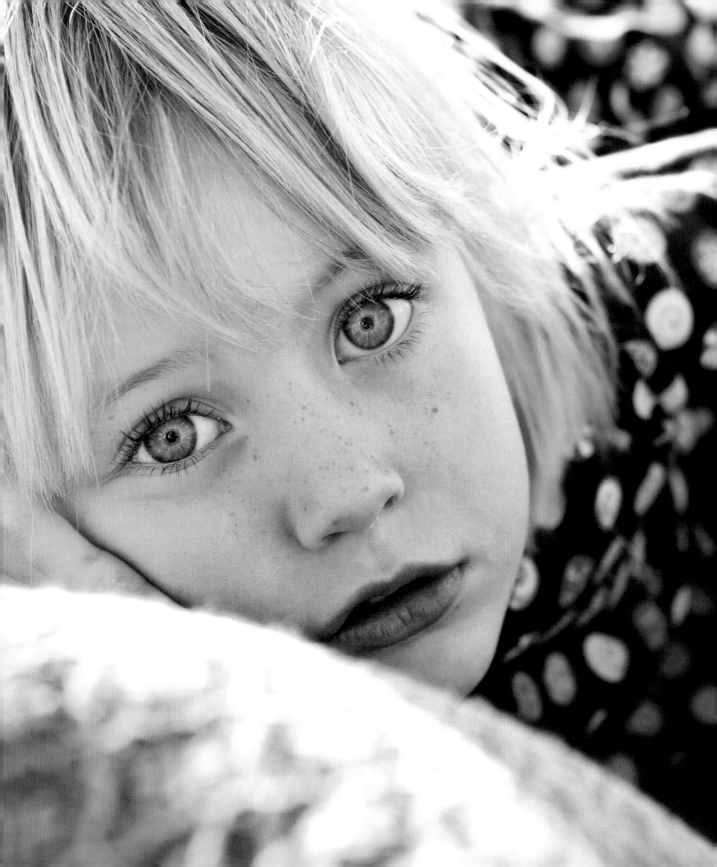

KIDS AND FAMILIES

6

STEP 1: GET MARRIED. Step 2: Have kids. Step 3: Buy a good camera. This is the path that thousands of eager couples follow. In fact, family is the number one reason why cameras are purchased. It is a great reason to pursue photography, whether as a professional or as a parent or grandparent. Photographs have something unique to offer. They emulate the way our mind extracts and freezes significant moments in time. Photographs make these moments accessible, elevating them to iconic stepping stones to walk on for the rest of our lives.

Photographs bring a unique joy. While family is complicated and far from perfect, the fabric of family will always be invaluable. I like how my Hawaiian friend says it: "*Ohana* means family and family means nobody gets left behind." If I ever had to escape a fire, my family photographs are what I could never leave behind. These photographs are valuable beyond price.

How can we get more out of life by taking better family photographs? That's what this chapter is all about.

The Time Is Now

Having kids is a revelation like no other. Before kids, we float in an inner tube down a river. On this journey, there are bits of direction, defining moments, and deadlines. Without rudder or oars, we float with the tide. Then we get married or commit to a partner.

Soon the baby grows and the stomach expands. Between breaths a few startling words are uttered: "She's coming—let's go!" The birth happens and your heart swells. Life is redefined, and it's not all about you. This new little addition is wonderful, and all you want is to be her hero. And you have to capture every fleeting moment—those tiny feet, first smiles, and first steps.

No longer passive, you jump out of the inner tube and gather your family in a new vessel. You become a force to be reckoned with. A force that will get the most out of this journey for all parties involved. This new perspective heightens your awareness and appreciation of time. And this is when it truly hits you—time is limited.

As a new dad, I reluctantly accepted the reality that time was limited and compressed. I could see my daughter learning to ride a bike and coming home from school as a teenager. And then I envisioned some scrawny boy knocking on the door to take my sweet pea to their senior prom. Then my heart sank and tears welled—she was waving as my wife and I drove away in our empty car after dropping her off at college.

Not only do we look forward, we look backward as well. Parents can look at a 20-year-old child and simultaneously see her as a messy-faced 2-year-old. With a camera in hand, you can capture it all.

Magnificent

New parents enter the brave world of parenthood armed with diaper bags and expensive cameras. Parents make great photographers because they notice all of the little details. But there is always a tinge of disappointment because the photographs don't look as spectacular as the ones in the camera's brochure. It's difficult to figure out all the buttons on the camera in between changing diapers and chasing a toddler around the backyard.

Scrambling for a solution, parents switch the camera to automatic mode and press the shutter with increasing speed. With storage devices that hold hundreds of photos, why not take a few more? With so many photos, finding the keepers becomes an insurmountable task. Parents are right to err on the side of more rather than less. It's rare to meet a parent with grown children who says, "I wish I had taken fewer photos."

Even with the best intentions, taking more photographs isn't always the best solution, as it often leads to sloppy results. What we need to learn is how to transition from the mediocre to the magnificent. Such a transition requires more than just technical know-how. It is a mix of who we are, how we think, and what we do.

One morning I stayed home to spend some one-on-one time with Annika. We were wrestling and telling stories on the bed. She listened intently and fortunately I had a camera close by.

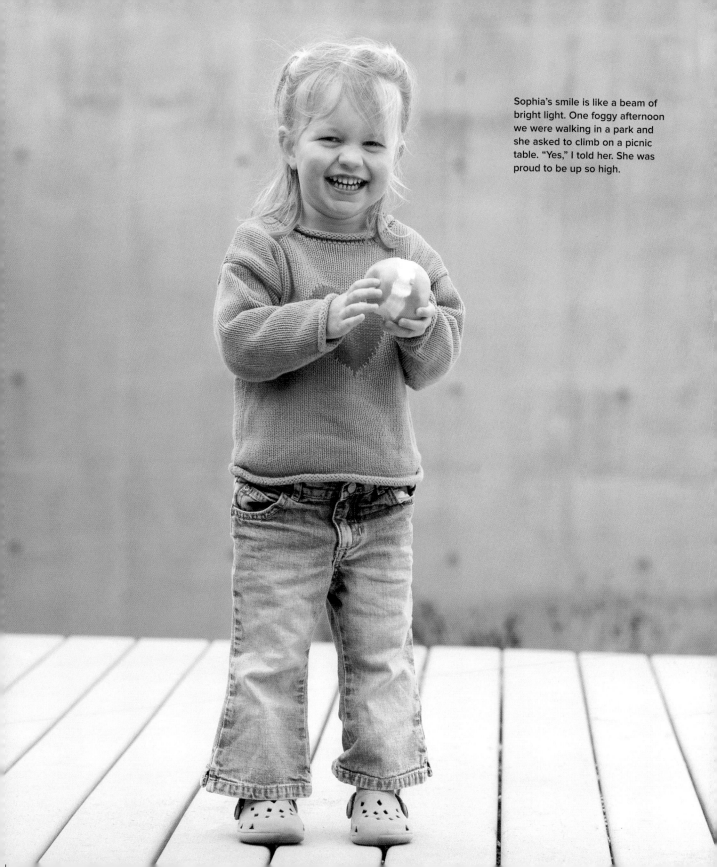

Sophia's smile is like a beam of bright light. One foggy afternoon we were walking in a park and she asked to climb on a picnic table. "Yes," I told her. She was proud to be up so high.

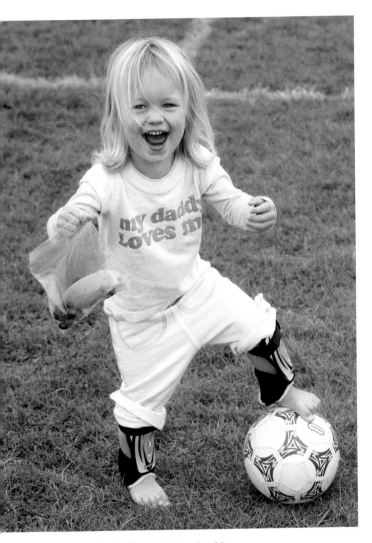

Sophia likes watching her big sister play soccer. I bought her some shin guards too. She joyously played the part.

Approach

Great photographs of kids and families capture something special. Capturing alludes to the idea that something is fleeting. And it's true, time is relentless in its progression, but photographers and parents have to be careful not to take the idea too far.

The best parents know that the sands of time can never be stopped. Thus, parenthood is not about stopping or capturing. Rather the family's aim is to build up strong individuals who are connected and independent. They know that when a family works well, it builds up strong people who are connected and independent. These people are eventually pushed out of the nest to go and fly on their own. Good family photography requires an approach that doesn't impose but invites and frees.

Photographing families and kids requires an expansion of how we already think. Otherwise it's easy to impose pressure on the situation that undermines the intent of the shot. Let me explain.

Have you ever seen a parent try to take a picture of a group of reluctant kids? It's like trying to herd cats. Eventually the parent gets frustrated and says something he will later regret, yelling at his child to sit still, act happy, or smile. And you've probably noticed that forcing someone to smile typically doesn't work well.

There is a common saying, "You can lead a horse to water, but you can't make it drink." Well, it's actually not true. The solution is to feed the horse a bit of salt, which makes it thirsty. And that is what the best professional photographers do; they engage and then elicit a response without using force or threat. These photographers create an experience that is both freeing and fun.

The best photographers realize and accept their unique role as a catalyst. They look for every opportunity to sweeten things up.

Catalyst

As a kid, there's nothing better than having a cool uncle and my Uncle Jim was the best. He made us laugh harder than anyone else and bent some of the ordinary rules. When we were with him, we wouldn't get in trouble—my parents let things slide.

And the same goes for good photographers. Believe it or not, having a camera in hand gives you a license to bend a few of the rules and act as a catalyst.

This means you can ask for different types of behavior. During one photo shoot I asked the kids to pick up some fall leaves and throw them in the air.

Next I asked them to jump off a rock and then climb a tree. Then I handed the kids some water balloons and the fun really began. The shoot was a success. If I were just an observer, I never could have asked for such behavior. The camera justified it.

The best photographers realize and accept their unique role as a catalyst. They look for every opportunity to sweeten things up. The results of such an approach are delightful—memory-filled photographs. And those memories not only live on in the images, but in their hearts as well.

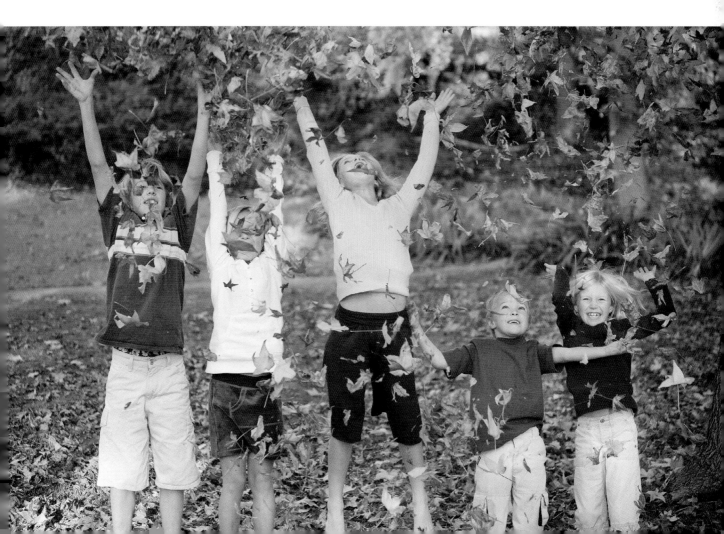

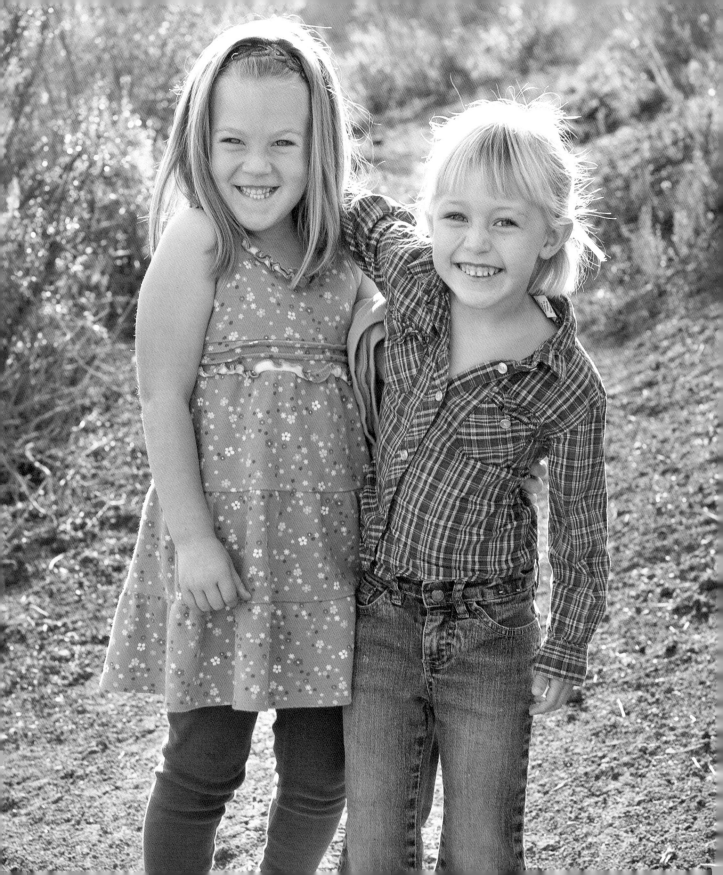

Affection

All humans need affection, and there's nothing more powerful than the human touch; it connects, softens, and enlivens. All families display affection differently. Sometimes as a photographer who is outside a family system, you have the ability to be an "affection bridge builder." In other words, because you don't know exactly how the family interacts, you can potentially create some special connections.

While I was photographing one family, I quickly understood that the father was preoccupied, tough, and gruff. During the shoot the dad stood still, tolerating the inconvenience of having his picture taken. It was obvious he was only interested in the portrait session in deference to his wife's desire.

At one point, the dad was standing next to his curly-haired son, who was perched on a big rock. I asked the dad, "You're strong enough to catch your son, aren't you?" Without missing a beat, the boy jumped off the rock and into his father's arms, giving him a huge bear hug and nuzzling his head against his neck.

The dad was startled but then melted. You could tell that they hadn't hugged for a long time. The mom tried not to show it, but the tears welled up in her eyes. The father and son started to wrestle and play. Soon the son was standing on his dad's shoulders, and Dad was throwing him up in the air. There was a new connection, a new closeness, all because of a camera.

Other times the bridge building may be subtle but equally as important. Sometimes it's as simple as asking a family to sit next to each other, walk together, hold hands or hug. Never underestimate the power of proximity and the importance of touch. It has the potential to bring a whole new dimension of humanity and togetherness to your photographs.

While hiking up a trail I asked Annika and Sydney to turn around. There's nothing better than a good friend.

Don't Smile

It's heartbreaking when a child learns how to fake smile—to produce and perform rather than show how she really feels. A fake smile can be identified from miles away. A child's smile should be unfiltered, unrehearsed, and unmistakable. That's why children's expressions are so precious.

You have to let go of the *need* for a smile. So often we think that only a happy photo will do. Who's happy all the time? What a good portrait needs is authenticity. If the expression is true the image will last.

Talented photographers approach kids at their level. And kids love to play. In fact, play is their main source of exercise, communication, and development. Play is everything. Its appeal is universal and has the potential to turn monotony into majesty. Play isn't limited to jungle gyms or toy rooms.

Once while waiting for a shoot to begin, I noticed some rocks and a paper cup. I gave each of the kids five rocks and then set up a cup. I said, "Let's see who can knock over the cup." The game evolved and progressed. Soon we had cups stacked up and other cups hanging off tree branches. We had a ton of fun with a simple game.

The transition to the photo shoot was easy. While we didn't throw any more rocks, we continued to have fun and the photo shoot became an extension of the game. The kids were all natural smiles and the results were great. The chances of smiling while playing are huge.

What if the child still isn't relaxed enough for a genuine smile? In those cases, I resort to a classic game of "get you." In a sarcastically serious tone I say, "Seriously, whatever you do, don't smile. Really, don't smile." Usually the child smiles. Telling her not to gives her the upper hand when she does. When she smiles, I say in a fun tone, "Oh no, don't smile." We are both laughing and smiling. The only downside to this approach is it's easy to forget to press the shutter release because you'll be having so much fun.

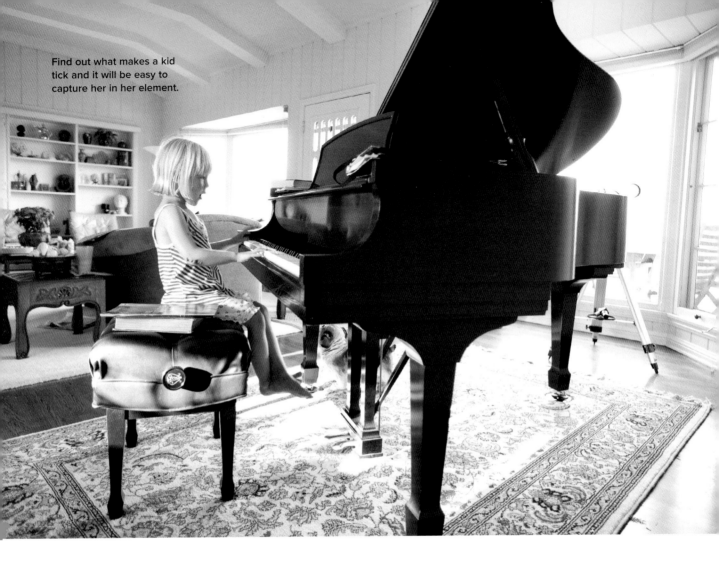

Find out what makes a kid tick and it will be easy to capture her in her element.

Call the Shots

Recently, one of my relatives was visiting and she was trying to coax my daughter Annika into being photographed. Annika was swinging on a trapeze bar and the relative asked her to stop for a picture. She wasn't in the mood and loudly said, "No pictures!" Later I asked her, "Why is it that you sometimes don't like having your picture taken?" Annika said, "Because I have to sit still and I want to play!" What a wonderful response.

Kids love to move. My relative's request was an interruption that brought up the age-old question, Why should I do this for you and what do I get out of this? We take pictures because we see something that is beautiful and we want to capture that beauty. It is easy to forget that the feeling isn't always mutual.

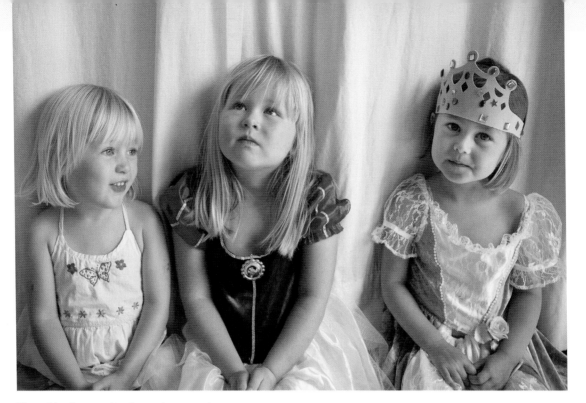

Three friends preparing for a princess party.

We're constantly giving kids directions. We want them to stand up, sit down, behave, be quiet, smile, this or that. Sometimes kids just want to be kids. And even more, sometimes kids want to call the shots.

The best photographers know this and try different approaches. Rather than ask someone to stop they say, "Wow! Your trapeze swinging is amazing! If I got my camera out, do you think you could swing even higher?" While this doesn't always work, the odds are in your favor, as most kids love having the chance to show off.

Another effective approach might be, "Wow! It would be so cool to have a picture of you on the trapeze. The only problem is I don't know where I should stand." This gives the kid a chance to take the higher ground. She might say, "You should stand right there." Then you stand in the wrong place and ask, "You mean here?" "No, right there," she says.

"Ohhh, thanks!" The child typically smiles one of those wonderful "I'm smarter than you" smiles. And when you click the shutter, it's hard not to smile exactly the same way.

Dress Up

My two young daughters love to play dress up. I cannot tell you how many times they play princess while I'm forced to play the role of the prince, the evil witch, or the mean stepmother. They absolutely love to make believe. And here's the trick for family photos—let them make believe, even if it means a different kind of dressing up for a formal family portrait.

With or without dress-up clothes, take the time to learn about what they like. Ask them about make

believe or their favorite things to engage them and set the tone. Let them be the fireman who jumps off the bench to save the day or the ballerina who twirls and leaps. Or if they are older, ask them about their sports or music heroes and which ones they would like to be. While these older kids may not jump or dance, their eyes will light up as they talk about their own dreams and aspirations.

My mom figured this out. She once let my brother and me dress up like cowboys for a photo session. We walked strong and tall and our voices were deep. It was the Wild West and we took cowboy photographs. After we got these out of our system, we relaxed and let the photographer take some "cute and normal" pictures. But these shots were taken last and they were taken on our terms. Or so we thought then.

Parenting 101

Kids like to make their own decisions. This can either be the source of great conflict or you can use it to your advantage. If it's bedtime, rather than saying, "Go to bed," you say, "Would you like to go to bed in two minutes or five minutes?" When they get to make the choice, there's less friction. This same approach can be used for photography.

When photographing kids or families, you need to watch and wait.

Consider this scenario. You're photographing a family and are walking along the beach with the kids. You comment, "Those rocks are interesting but they are probably too big for you to climb. Rather than climb the rocks, should we just take some pictures on the sand?" Their response is predictable, "No way, let's climb 'em!"

The trick is to come up with questions where either outcome is desirable. In this situation, the sand or the rocks would work well. In order to make the images compelling, I needed the kids' collaboration. This is true any time that you photograph people. Regardless of your technical photographic talent, good photographs of people are always a gift to be grateful for.

Watch and Wait

Recently, I went on a photo trip with acclaimed nature photographer Ralph Clevenger. On our way up the California coast we stopped to photograph the elephant seals. The size and number of the seals on the beach were astonishing. I excitedly went from location to location taking my pictures. Ralph set up in one location and waited. At the end of the day we compared photos. I was awestruck as he scrolled through his set of photos—they were unbelievable. Mine were mediocre. His patience and persistence paid off. Most wildlife experts have that same perspective. They set up and anticipate the activity.

When photographing kids or families, you need to watch and wait. The more familiar you become with kids, the more predictable their unpredictability. At first, a child's behavior seems erratic and unexplainable. The more you get to know him the more you know how he will react in different situations. The photographer needs to become like a behavioral scientist or field biologist, observing kids' behavior.

The result of such observation leads to great results. This approach helps you anticipate and slow down. This skill is especially valuable with children and families. If you try to hurry up a water buffalo, it will simply sit down in protest. The protest has nothing to do with the activity but with being forced to speed up. There is nothing worse than an entire family waiting for one stubborn relative to join the group for a portrait. When this does happen, let it go. Your patience and persistence will always pay off.

I watched and waited as these sisters clambered on some beach rocks. Eventually they sat down and glanced my way.

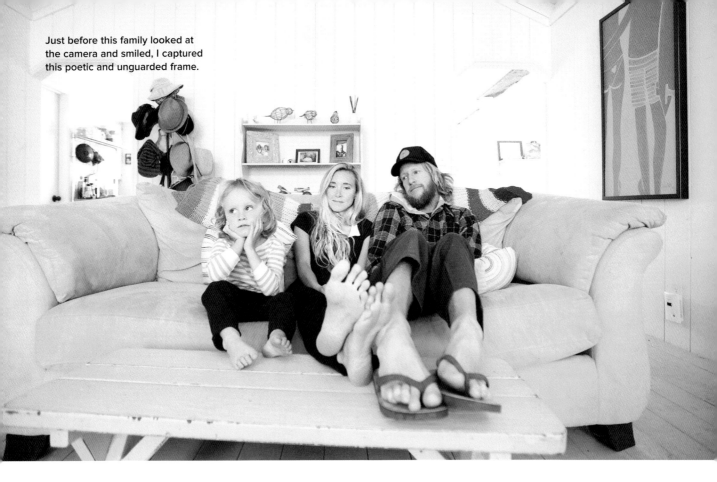

Just before this family looked at the camera and smiled, I captured this poetic and unguarded frame.

In-Between Moments

A number of years ago, one of my friends produced a photo essay, "Forgotten Moments." The premise of the essay was that while there are thousands of beautiful moments we observe, we only tend to remember the Kodak moments. The other ones get lost in the shuffle. These forgotten moments have a unique and intriguing beauty that often surpasses the obvious ones.

This project opened my eyes and led me to expand what I look for when taking pictures. Rather than just looking for the picture perfect, I've become interested in the moments in between the action. I look for the ones before or after the performance.

I've discovered that when photographing people, these moments can sometimes be more interesting because they are unguarded. They tend to reveal a deeper or more intriguing side of the subjects.

Creating photographs of the in-between moments requires more than acute observation. You have to intentionally create breathing room for these moments to occur. Here's one technique I use. After I finish setting up I say, "Hey, I still need a bit more time to set up. Do you mind relaxing for a few more minutes?"

Typically, the response is positive and it gives the subjects a chance to catch their breath. It puts them at ease and makes for a less dramatic and more natural photo shoot. Then, while tinkering with my camera gear, I'll start up a conversation and begin to snap a few pics. Many times these informal portraits become some of my favorites.

Practical Tips

Reunite at Sunset

Family life is wonderful yet complicated. It begins with the morning rush, a few quick kisses and hugs, and then everyone goes off in their own direction. After school, work, and workouts when the sun nears the horizon, the family reunites. There is nothing I enjoy more than coming home after a good full day. My daughters stop and look up. They squeal, "Daddy!" and run full speed with outstretched arms, practically knocking me over with their hugs. We embrace, spin, wrestle, jump, and play.

If there ever was an ideal time to photograph a family, it is then. Not only is the light absolutely perfect, it suits the subject matter. When the sun sets, people pause, stand close together, and watch it sink over the horizon. The light is warm, reflective, and thoughtful. It softens even the most jaded critic. Even more, the timing fits the rhythm of the family perfectly. After a day of hard play and work, kids and parents are ready to be together.

The photographer needs to show up and let the magic begin.

As the winter sun drifted toward the ocean, I decided not to take the obvious frame. When photographing people less focus can sometimes communicate more.

Find the Best Location

Finding the best location is paramount for iconic family photographs. The best locations require no shoes. They are natural, simple, full of texture, and alive. These are the ones you visit and think, "Why don't I come here more often?"

By taking photographs in such places you create meaningful geographic connections and build memories. I've known family members who will go back to places where their family has been photographed to remember and to bask in the presence of loved ones both lost and alive.

Taking off your shoes relaxes you and enlivens your senses. It is an act of being fully present. With bare feet you are limiting your range; you probably can't run miles away, and you slow down. But whether the shoes come off or not isn't the point. Find places that make you want to kick off your shoes, play Frisbee, and momentarily forget all of the worries of the world.

When composing the photographs, keep the context clutter free. This typically means you avoid structures, plastic playgrounds, and power lines. Keep it simple and look for backdrops made from the natural world—fall leaves, cherry blossoms, beach rocks, or wheat fields. At the same time, as beautiful as these natural locations sound, there is a valid time to change your approach.

If you find a location that has visual interest and has texture, by all means take photographs there. An old weathered red barn, broken-down tractor, or train can be great locations. There is something wonderful about family portraits in places with such history. The juxtaposition of the old and new and the submessage of the passage of time have the potential to be both nostalgic and beautiful.

Use Props with Kids

When I worked at the Walt Disney Studios, I loved walking through the prop house with my coworkers. The warehouse was filled with props from many of the major Disney and Miramax motion pictures. Handling the props ignited our imaginations and brought the actor out of us all—it was a blast!

The same thing happens with kids; they love props. Experienced photographers know this and use them to their advantage. Sometimes the prop may be something as simple as a kite, sunglasses, an umbrella, or a suit coat and tie. Of course, bubbles, helium balloons, and candy also work incredibly well. Surprise a child with a ten-inch lollipop and you can imagine how he'll grin. Then let him perform and make the prop part of the picture.

Don't Hide Behind the Camera

One of the joys of photography is that it frees us from thinking about ourselves. We hold up our cameras, aim, focus, and forget. If you want to be a good family photographer it pays to remember.

We need to remember what we look like to kids. The next time you're near a mirror, hold up your camera and talk to yourself. Depending on the size of your camera, you won't be able to see your eyes, your mouth, or much of your face. It isn't very engaging.

Some photographers hide behind their cameras. If you want to connect with kids you have to set the camera down, make eye contact, and interact. Then when you start taking photos you can always try one of the old "look at the birdie" tricks.

While strawberry picking in upstate New York, Sophia's basket was filled to the brim.

Look at the Birdie

On a recent family photo shoot, I was helping out a colleague. While he was taking pictures he said to the kids, "Wow, look at that, there's a bird. Look at that birdie!" He had attached a funny-looking toy bird to the top of his lens. Throughout the shoot, he stuck the bird on his head, on his shoe, on a branch. The kids were constantly laughing and couldn't wait to see where the bird showed up next.

Another popular attention-getting toy is a candy Pez dispenser. These contraptions can be easily modified to fit into the camera flash hot shoe. This definitely gets the kids' attention, especially if you toss them a few Pez candies in between taking pictures.

Regardless of how simple or elaborate your technique, be sure to engage. And experiment with interacting without a big black box in front of your face. After a few trial runs, you'll create results that will set you apart from the rest.

Involve Others in the Process

Cameras today come with quite a bit of clout and can easily become a distraction. Many people see professional cameras and say, "Wow, that must be expensive!" Then, when you start using the camera, because they think it is expensive they become a bit nervous or formal. And that's exactly what you don't want.

The best way to diffuse such thoughts is to get the family involved. I typically say, "Oh no, this is actually an older camera, but it works fine." Then I'll set it on the ground while I dig through my bag to find something else, or I'll hang it around the neck of one of the kids. That will surely make the kid feel important. Basically, I want to let them know it is just a simple tool and nothing to be afraid of.

While photographing the parents I'll get the kids involved. When I'm using a tripod and shutter release, I'll explain how it works to one of the

Baile held my camera and helped me take portraits of her family. When it was her turn a few minutes later you can tell that she was now on my side.

Get Your Subject to Move

With a video camera in hand, I asked a friend, "I'm making a surf movie; you mind walking through the frame?" He froze and responded, "Oh, no. I don't know how to walk naturally." I said, "Give it a try." He stiffly walked by the camera. Why is it that when a camera is pointed at us, we lose our natural poise?

I attribute this to "camera consciousness." We begin to process the idea that this act will be recorded, remembered, and reviewed. And this consciousness leads us to self-consciousness and tension. Few people are free, limber, and loose in front of a camera. We all disguise our tension in different ways, whether by overstretched smiles or awkward posture.

Ask your subject to stand up, sit down, walk, run, climb, jump, spin, or high-five.

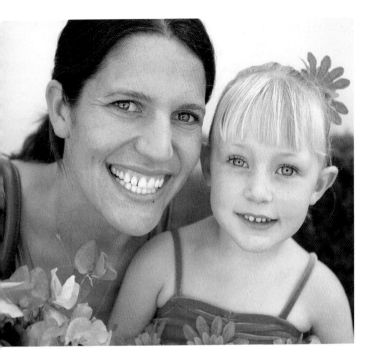

My wife Kelly and Annika after a magnificent ballet recital.

The best remedy is movement. People typically don't know what to do on a photo shoot. They need a director who leads the way. Ask your subject to stand up, sit down, walk, run, climb, jump, spin, or high-five. Get them moving and you will get the heart pumping and the lungs breathing. This brings color to the face and vitality to the skin. Any type of movement requires concentration and thus distraction from the camera and self-consciousness.

Have Fun

Photographing family and kids is not a one-time event. You are setting the stage for further photo shoots, so fun is important. Otherwise, the photos may not turn out well and you jeopardize future photographs. You have to think about the big picture.

kids. Then I'll walk away and say, "Ok, now it's your turn." The kids light up and the photographs they make are typically wonderful. The parents warmly look at their little photographer to be and respond to their child's every request to move closer or to smile. It's actually quite fun.

If involving kids makes you nervous about your gear, don't do it. It requires a certain level of relaxed attentiveness and trust. You can develop your own techniques for getting the family comfortable and involved. Perhaps this means passing the camera off to one of the parents. Or even better, try holding the camera while one of the smiling kids takes his turn pressing the shutter.

I once heard a friend say, "Getting my picture taken is about as fun as going to the dentist." And dentists get a bad rap, but that's because they haven't met Dr. Ruby. Dr. Ruby is our family dentist who thinks big and somehow magically makes having your teeth cleaned a blast.

After coming home from Dr. Ruby, my daughters are beaming. They tell me wonderful stories and show me their stickers, their no-cavity club T-shirts and balloons. As a result, my daughters' teeth are healthy and their opinion of brushing and dentistry is nothing but wonderful.

Family photographers could take a couple of cues from Dr. Ruby. Make the event fun and memorable and the results will speak for themselves. Sometimes this means creating photographs that are funny so that the fun lives on. Other times this means simply having a good time.

Bring Families Together

When family and friends are together, the dynamic is truly synergistic. And photographers have the ability to bring such togetherness to fruition. With camera in hand, you can get people together. This is especially wonderful with kids. For when kids are surrounded by their best friends they come alive.

Capturing this togetherness is enlivening and empowering. Think about it; why is it that we take and cherish photos of ourselves with our friends? These photos help us remember who we are—you with the guys crowded around the campfire, or the classic photos of you with your bridesmaids. Whatever the context, those photos help remind us we are not alone.

Kids need this more than we can imagine. To create and share such photos is an incredible gift. Such photographs are formational; they bring hope, give shape to the world, and bring comfort during a long lonely day.

Isolate Your Subject

One of the highlights of being a dad is one-on-one dates with each of my daughters. There is something special about this one-on-one time. As we sit on the beach and eat ice cream, I learn things about each daughter I never knew were there. I never could have discovered these aspects of my daughter's personality had we always been in a group. Even more, we have a new and different kind of fun. And the same goes for photography.

There is something incredibly poignant about a photograph of a child by herself. The lack of others and of context has the potential to elevate photographs from particular to conceptual. In other words, certain solo photographs become more about the concept of innocence, childhood, or dreams.

The challenge is to capture these photos amidst the shuffle. And fortunately, it isn't as difficult as it seems at first. Sometimes it is just a matter of saying, "OK, so I'd like to take pictures of each of you by yourself. Why doesn't each of you pick a rock or spot where you'd like to be?" A comment like this makes my job easy. Quickly the objective is turned into a bit of a challenge. Without fail, each child quickly finds and defines his own territory. All I have to do is move from spot to spot and press the shutter.

Document Family Accomplishments

Why is it when athletes win a world title or score a touchdown, they wave to the camera and say, "Hi Mom. I did it!" Or how about at the elementary school concert where half of the kids sing while the others stand on the stage and wave to Mom and Dad? It's as if there's something even more special about sharing and celebrating with family. I think it's because families are aware of all that leads up to the moment. Tight-knit families rally around each other's accomplishments, whether big or small.

I knew there was potential to make a good picture on these steps. Rather than direct Annika I said, "If I were to take a picture, where do you think it would be best to sit?" She picked the perfect spot.

There are times when taking pictures interrupts and other times when it ignites. Photographing family accomplishments is definitely the latter. Cameras are expected at ballet recitals, soccer games, horse shows, or the top of the mountain after a long hike. When you pull out a camera after a success, it makes people light up, hug tighter, smile bigger, and jump higher.

Long-time family photographers anticipate accomplishment and capture it like a prize-winning photojournalist. The key is to be ready and to go with the flow. If you need someone to move one way or another, be subtle. Otherwise, if you provide too much direction you risk ruining the raw emotion of the moment. Most important, let the child have his moment, congratulate him, and snap away.

Gear at a Glance

Families and kids are predictably unpredictable. Therefore, it's best to be prepared for a wide range of circumstances. Because there are so many variables, try to keep your approach simple. You don't want to create an overly complex shoot; otherwise the family and kids may never feel comfortable. Or you risk your camera gear getting stepped on, lost, or damaged.

I recommend keeping all of your gear in one large bag. I like to use a simple and strong Lowepro backpack that fits my lenses—16–35mm, 50mm, 24–70mm, 70–200mm—and a couple of camera bodies. While my pack is loaded up with some serious gear, I rarely use it all. I find it is helpful to start off using one of the shorter focal length lenses so that I can talk with the kids or family members.

One of my all-time favorite lenses is the 50mm. Typically; this lens is best for ¾ or full-length portraits of adults. Otherwise, if you move too close it causes a bit of distortion that can sometimes be undesirable. When photographing kids, because they're smaller, I find I can get much closer. Getting really close and creating a touch of distortion can draw in the viewer. In fact, when I use a 50mm lens many people assume I am friends with the subject because they sense the closeness. And I take this as a compliment.

Then at some point I will go back to my bag and switch lenses to change up the mood a bit. Typically I reach for the 70–200mm, which requires that I step away from the action. This gives the family and kids some breathing room. In addition, using a zoom lens can create an incredibly flattering look.

Most important, make sure not to fumble with your gear so you can focus on staying engaged with the subjects. Sometimes this means keeping the lens you've selected on the camera rather than changing it up. It's critical to remember that good photography isn't dependent upon what lens you choose but how you use the lens you have.

Workshop Assignments

Survey

Our culture is inundated with photographs of kids and families. And we're constantly exposed to this type of photography in marketing and personal galleries because everyone wants to share their kid's photograph. In spite of the volume of images, many of them look the same. The photography is too straightforward, too obvious and cluttered. To refine your skills, it's helpful to analyze and enjoy a wider range of photographs. Visit the links below to expand your vision and take note what inspires you and why.

VISIT: www.josevillakids.com

Jose Villa is a highly acclaimed photographer and a graduate of the photography school where I teach. I know firsthand that Jose is an amazing and authentic person. And there is so much that captivates and inspires me in regard to his photography.

VISIT: www.jonathancanlasphotography.com/wedding.html

Jonathan Canlas is another inspiring and engaging photographer. His works provide a fresh perspective while simultaneously being timeless. His approach is personal and the results are stunning. (Look at the Families tab on his site.)

VISIT: www.christarenee.com

Christa Renee's photographs are vibrant and her client list is extensive. If you're interested in learning more about the commercial side of kid photography, her site (which has a Kids section) will become a great source of inspiration.

VISIT: www.boden.co.uk

For a top-notch commercial inspiration, visit this site for the clothing company Boden. Once you have navigated to the site, choose the options Boys and Girls. Here you will discover a vibrant set of commercially viable images. If you're looking for this type of inspiration, be sure to request a catalog, as the printed photographs are even better.

Shoot

Photographing families and kids is incredibly rewarding and gratifying. Follow through on the shooting assignments below to take your skills to the next level:

1 **Kids With Props**

 Purchase a unique prop. Here are a few examples for inspiration: bamboo umbrella, vintage red wagon, weathered American flag, pirate flag, antique magnifying glass, telescope, oversize lollipop, old-fashioned camera, worn-out parachute. A great place to begin to look for props is at your local thrift store.

 Next, set up a photo shoot with a close friend's kids. Bring the props and explain to the kids that your homework assignment is to photograph kids with these objects. Ask them, "Do you have any ideas about how we could take the pictures?" Let them take the lead and follow along.

2 **Juxtapose the Young and Old**

 Contact a neighbor, friend, or family member and explain that you have to create a photo shoot where the goal is to capture the young and old together. The larger the age gap, the better. Whether that means a granddaughter and her grandmother or a father and son, seek to bring the two together.

 Aim for an intimate heart-warming portrait of the granddaughter on her grandmother's lap. Or ask the father and his child to go sail their boat out in the pond. Do whatever it takes to bring the two together in a way that captures something unique.

Your goal is to photograph three groups of people in order to create a set of three photographs based on this theme.

3 Record Jumps

There is nothing like being airborne, and kids know this better than anyone. They love to jump. In this assignment your goal is simple: Create a set of ten photographs of kids jumping. Here's a hint: The best jumping photographs are taken from down low so that the subject looks that much higher. If you can find something the kids can jump off of, compose the images in a way that catches the kids in midair without the object they jumped from. This perspective will add a bit of mystery and draw the viewer in.

4 Define Your Family

Family means many different things. Your task in this assignment is to create a personal visual definition of the word. In other words, create a set of photographs that defines your family.

This may mean that you need to photograph everyone in your immediate and nuclear family. Or perhaps your closest members are your sister, your cousin, and your cat. In that case photograph them in a way that shows what you feel.

The goal of this assignment is not only to capture family, but to do so with feeling.

5 Capture Number One

Everyone has someone they care for more than anyone else in the world. This will of course mean different things to different people. Yet the one thing I do know is it is easy to overlook those people we value the most.

In this assignment, your task is to photograph the person who has the highest seat in your heart. Here's the twist: Create one set of photographs that capture day-to-day life—smelling the morning coffee, walking the dog, and picking tomatoes in the garden in the afternoon. Then create another set of photographs where you go all out. This may mean you buy your wife a new red dress or go on a hike to the top of Half Dome in Yosemite. Either way, try to create a set of portraits that are authentic yet extravagant.

Share

Good and compelling photographs of our families are invaluable. Sharing such a gift with others is priceless. In addition, sharing reveals interesting things we could have never known. After I gave a print to one relative she said, "Wow, this is the only portrait I have of my dad. Thank you." I was astonished and completely unaware that she didn't have others. In other situations, you'll continually discover what photographs people enjoy and why.

1 Mounted Print

The downside of digital is the lack of artifact. Because most of our images are now displayed digitally there's nothing to hold. This assignment is set to counter that. Select the best images from one of your assignments. Upload the images to an online photo service like mpix.com. Then order at least five large size mounted prints. If you haven't done this before, try foam core mounting for starters. For more info visit www.mpix.com/Mounting. aspx. After the prints have arrived, wrap them up with nice paper, write a note, and hand-deliver them to the person or family that would appreciate them most.

2 Flickr

In order to share your photographs on a broader scale, share them on the Web. In particular, post your set of photos to the Flickr group for this book at www.flickr.com/groups/visual-poet. On Flickr we can view and comment on each other's photos. Make sure to include the chapter number and assignment name. I'm excited to see what you come up with and I will be sure to stop by and leave comments myself.

Review and Respond

Now it is time to get some honest feedback. First, take a few moments to select your favorite images. Rate each image based on a 0–10 scale where 10 is high. Provide a value for each of the following criteria: Authentic, Unique, Timeless, Emotion, Expressive.

Next, ask a close friend or colleague to review your photos and provide his own rating. After all of the images have been evaluated, take some time talking through the photos discussing what worked and what could have been better. While this can be a painful process, it will help you begin to refine your craft. And always keep in mind that art and photography are subjective. There is no "right" photograph; use this process as a way to refine and hone your skills.

After formally evaluating the photographs, informally ask one of your subjects which photos she liked best. Don't just ask the adults, as it's always surprising and interesting to hear what kids have to say.

Finally, take a few moments to journal and articulate what you learned through this process. Then begin to map out other family or kid photographs you would like to capture. For example, one of my personal goals is to create a good portrait of my dad. While I've taken a few portraits, nothing has come close to capturing my vision of him. And that's what is wonderful about photography; the more you take pictures, the more you will want to take pictures. There will always be more on the horizon.

Guest Speakers

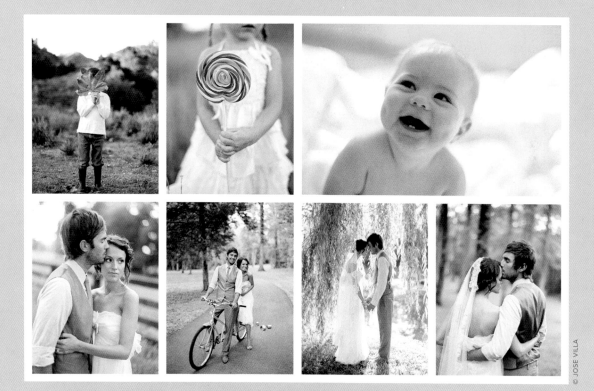

© JOSE VILLA

Jose Villa

Jose Villa is an honest soul. His roots run deep and his photography is an authentic reflection of who he is. Being successful has always been an afterthought rather than the goal. Jose is now one of the top family and wedding photographers in the world. Always at peace and ever persistent with his artistic vision, Jose creates photographs that compel. See his work at www.josevillakids.com.

What inspires you?

Travel that takes me outside of my comfort zone. I love to see the world. One of my favorite places to visit is Mexico—its stunning light, old buildings, amazing people and hospitality. Old vintage cameras like Rollei's also inspire me. I really love my Holga camera, too—it's a plastic camera that offers much. It provides a great way to shoot and see in a totally different way. You have to compose your images and really think about your shots.

What makes a photograph good?

Composition, light, and emotion. And if there is a connection between the photographer and the subjects, I consider it good.

What character qualities should the photographer nurture and develop?

Be gentle when you shoot. Don't be overbearing...show your genuine self and your subjects will do the same.

Advice for the aspiring photographer?

Don't let digital take over your life. Pick up a film camera and start there. Really master your camera and know your lighting and color so that you don't have to do anything on the computer, which takes you away from being the photographer. Once you have this down, shoot from the heart. Don't let anyone tell you how to shoot. The business will follow; create beauty first.

Greg Lawler

Greg Lawler is a creative, unorthodox, and dedicated artist. His photographs embrace life as it is, not as it should be. His work is down-to-earth, generous, accessible, and warm. Here's the best part—Greg isn't a legend. He doesn't own fancy equipment and never went to photography school. He is a dad and has many passions beyond his profession. Greg brings a camera everywhere he goes and makes pictures of his life, family, and friends. Each year we beg him take our family photos. And many of these photos are my all-time favorites. To view the last set visit www.visual-poet.com. For more information on Greg, visit www.greglawler.com.

What inspires you?

Those magical moments when whatever it is that you are looking at—a photograph or painting, skyscraper or sunset—is calling out: You can create! or You must create! When the light is hard and the angles are sharp or when it is as soft and tangible as silk, all these things inspire me to pick up my camera and participate. Photography inspires me to capture life being lived and remembered. Using a camera to preserve a moment or a gesture is inspirational.

What makes a photograph good?

A good photograph demands that you remember it. You have no choice. You are permanently changed and you will think of that photo, the emotions that it stirred or the message it communicated, as long as you live.

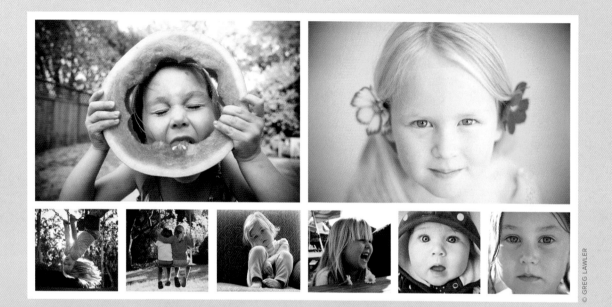

What character qualities should the photographer nurture?

Perseverance and self-awareness are important. Learn about yourself. Follow your heart and work hard to overcome the aesthetic gap between your creative vision and your technical ability.

Advice for the aspiring photographer?

Don't be afraid! Follow your intuition and see where it leads. Every human is innately creative. Remember that you are the artist and that there is no "wrong" in art. Always have your camera with you. Your favorite camera may change over time but always, always keep it close to you. Spend time with people who inspire you. Look at art and photography that makes you want to grab your camera and start shooting!

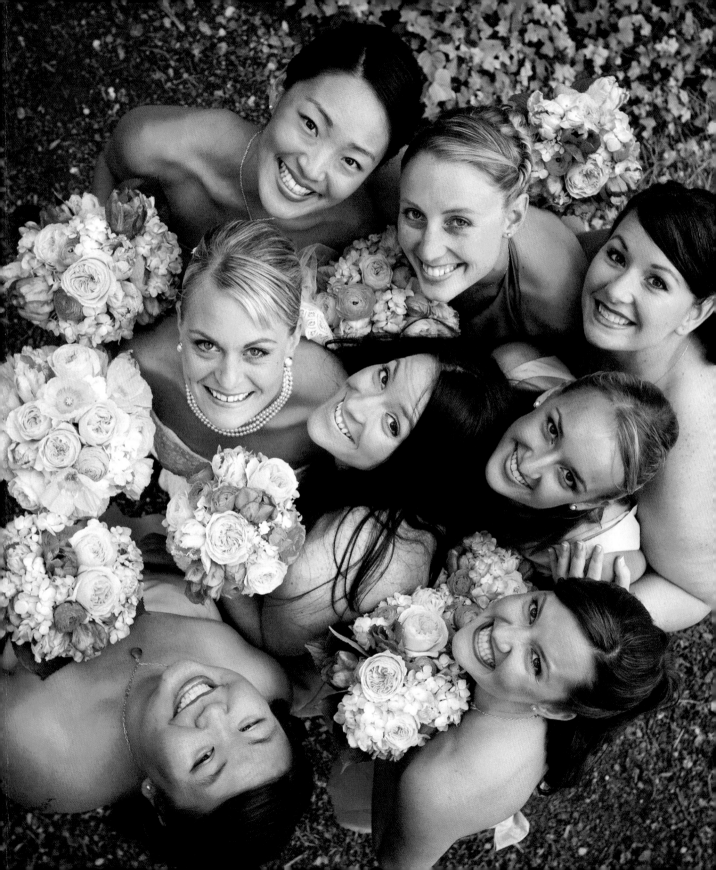

WEDDING BELLS

7

THERE IS NOTHING better than walking the cobbled streets of an ancient Italian town. The aroma of fresh-baked bread, oregano, and ripe tomatoes fills the summer air. The warm afternoon light creates a mood that says the world is a beautiful place. Suddenly, church bells clang and create a beautiful song. The shopkeepers in the village close up quickly and the celebration begins. It's a sight to behold: colorful clothes, big hugs, strong kisses, a cascade of flowers, heartfelt music, wild dancing, and delicious-smelling food. If only I had a camera in hand.

What is it about weddings that requires bells to ring? Bells summon parishioners for a service or ring slowly and somberly at a funeral, but when a wedding occurs, they're rung so vigorously that their peals become a delightful cacophony that is simultaneously nostalgic and hopeful. Even when we're tourists in another country, the sound of wedding bells resonates with us.

Wedding celebrations are deeply rooted in a larger cultural and historic context. They are part of the fabric of who we are. And while certain aspects of the celebration have fallen in and out of fashion, one thing remains—weddings are wonderful. They are a time of immense celebration. They're a perfect time for photography. Those who capture authentic wedding photographs give a gift that exceeds the flavor of the cake and the delight of the beautifully wrapped presents.

Here's the good news. We all go to weddings now and again, and these celebrations are great opportunities to hone your skills, whether you are the main photographer or simply a guest. Getting better at wedding photography is not contingent upon being an amateur or pro. Weddings are the perfect training ground for anyone interested in learning how to be a better photographer. This chapter is devoted to rethinking weddings and then to discovering how you can capture more compelling and timeless photographs.

Paradox

My 14-year-old heart skipped a beat when I looked across the biology classroom. She sat at the science table poised and ready to dissect a frog. I knew true beauty when I saw it, and I was in awe. Her long dark brown hair, huge smile, and sparkling eyes.

A decade later, our big day arrived and it exceeded every expectation. Our love blossomed and hasn't stopped. Who knew that so much could start with a glance, a hand held, and then a kiss? And who knew that something so limiting could be so absolutely freeing?

Marriage is quite a paradox. You find freedom by giving it away. In limiting your options and establishing a lifelong commitment, love freely soars to new heights. It's nothing short of a miracle of beauty, mystery, and harmony. And I know this firsthand. On my wedding day, love welled up in a way words still cannot capture. I am ever grateful to have a few pictures that inch a bit closer to capturing how I felt and still feel today.

It is one thing to watch and another to be involved. Involvement adds value, and in weddings this is key.

Value

Love is a journey. As you move forward into the unknown, the past takes on even more meaning. Take my wedding photographs. I treasured them as a testimony to the beauty and wonder of that day. The photos were important but not yet priceless.

Over a decade later, their value has grown exponentially in form and function. Those photos act as an anchor point. They inform, remind, and empower. A quick glance through the album is both sad and exciting. I see relatives who've passed away and kids before they have grown up. When I see a photo of my bride, I think I am the luckiest man alive.

So what are my wedding photographs worth now? It depends. They are not worth much to you, but to me they are priceless. As the minister said on our wedding day, "Today you stand here googley-eyed and in love. But remember this. Cars don't matter, houses don't matter, and jobs don't matter. Many things will come and go. But this commitment that you make today—it matters." Many years later everything surrounding that day matters more than ever.

Participate

It is one thing to watch and another to be involved. Involvement adds value, and in weddings this is key. The typical couple's intimate relationship takes a new turn. Rather than a romantic walk on a beach, it becomes a great and spontaneous gathering like the one in that Italian village.

What makes a wedding celebration unique is that the guests are not there to simply observe. All are invited to participate, listen, and remember their own vows as they eat the cake and dance under the stars. It is sharing the story that adds value. And the memory of a wedding lives on, getting better with time.

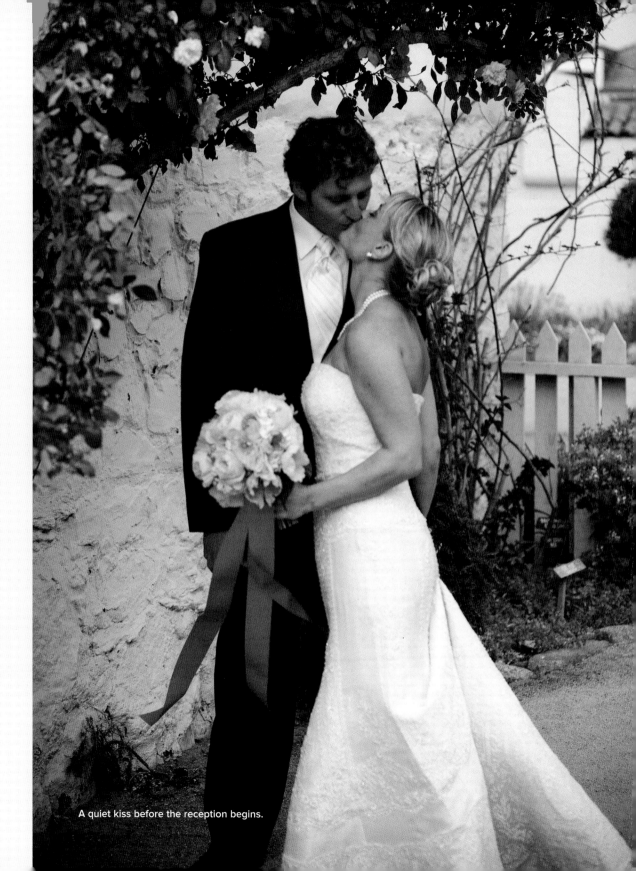

A quiet kiss before the reception begins.

The excitement and celebration of the bouquet toss.

Those who take part in a wedding reminisce, "Remember Travis and Holly's wedding when the cake fell over? Remember dancing and the ocean view?" We remember weddings because of our participation and because of their significance. Our attention is tuned and focused. Our senses are alert and alive. And it's the task of the photographer to capture it all. The best wedding photographers show more than the bride and groom. They tell the story of all who were involved.

Story

Wedding photographs are valuable, but their worth changes with time. For years, I considered our photographs to be something valued only by my wife and I. Now these photographs are beginning to belong to someone else.

Whenever we flip through the album pages, our two young daughters' eyes light up. From their perspective, the retro gold-lined pages are on par with Cinderella and the Little Mermaid. This is a real life

fairy tale, and their parents are center stage. My daughters realize they are part of this story, too. Being part of the story grounds us and gives us a sense of place in an otherwise overwhelming and ever-changing world.

My interest in our wedding photographs has shifted. Now I love and value these photos for someone else, too. Someday when I'm gone, my great-grandkids may flip the pages and my daughters will tell a few stories. The images will spark memories and they will tell about how their parents met in Biology class and loved each other so well.

Approach

A wedding photographer's job is to tell a timeless tale. This is no easy task. Wedding photographers not only master the technical specifics of shooting in a wide range of circumstances, but they do so with elegance and fluidity. And they do all of this while seeking to create images that will be valued for generations.

In spite of that, it used to be common to hear professional photographers say, "I would never photograph a wedding. I'm above that kind of work." And I can understand why, because for a long time this type of photography was stuck in a rut. The result was obvious, direct, and uncreative. Recently this has completely changed. The field of wedding photography has gone through a revolution and is now more creative, artistic, and relevant than ever.

Your approach makes all the difference in the world. As a pro or amateur, you have to decide what story to tell—formal, staged, stiff, or something different. The difficulty in taking creative risks lies in the need to deliver. Weddings are full of internal and external pressure. In fact, it's the one place where absolute strangers will tell you what pictures to take.

A simple moment of elegance and beauty (top). At weddings dancing takes on a whole new form (bottom).

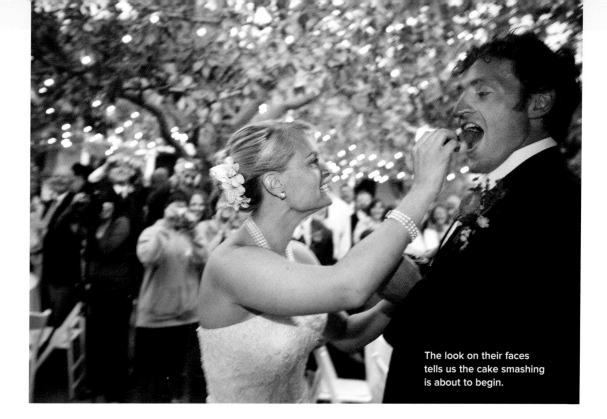

The look on their faces tells us the cake smashing is about to begin.

Sometimes the direction comes in the form of suggestion: "Oh, look how cute that is, you should take a picture." Other times it gets a bit more forceful. "What are you doing? Turn around, take that picture." Yet in spite of grumpy Aunt Susie's ideas, you can't give away the control. Take a few snaps to get someone off your back, but it's your game.

Before the game begins, ask yourself, what am I going to photograph—what's supposed to happen, or what actually happens? Here's the distinction that separates the mediocre from the magnificent. Photographing what's supposed to happen, you risk creating photographs that are stiff, forced, and lacking life. We all know what's supposed to happen—everything goes smoothly, everyone is happy, the cake is cut and not smashed on the bride or groom's face, and so on. These moments make up many of the traditional bride and groom's shot request lists.

You may want or need to take the photos on the shot list, but don't stop there. Become the journalist who captures the candid events as they unfold. With this approach your photos will become authentic, funny, engaging, and alive. Don't give in to the pressure to do otherwise. Remember, it's your game. You can choose to be the photographer who captures it all—the main events, the sidelines, the mistakes, the laughter, the crying, the hugs, the humor, and more.

Practical Tips

Take Engagement Photos

Relationships are a journey, and getting engaged is an exciting fork in the road. Most newly engaged couples are proud, hopeful, and affectionate in a unique way. For the couple this has been a huge leap—buy a ring, tell family, and set a date.

The best wedding photographers understand this journey and know that there is no better time

to connect with the couple. It is the chance to take pictures of a couple stepping into their new identity. You'll find that these couples are relaxed, affectionate, and ready to begin. Your job as the photographer is to direct and to draw out their closeness.

Even more, it's a chance to take pictures without all the pressure or presence of family and friends. And of course, it is your opportunity to get to know each other. Good people photography almost always flows from relationships, and taking part in the engagement and delivering good photographs builds trust and friendship.

Photograph the Preparations

It takes months to plan a wedding, and the actual day is a culmination of the efforts of dozens of people. Make sure to be there early to document all the preparations that lead to the big day. The bride and groom will thank you later, as they never would have known all that happened.

Capture the Details

Recently, I went to a wedding that was warm, inviting, and artistic. It was a perfect reflection of the bride, an athlete and yoga instructor, and the groom, a surfer and musician. The best weddings are like that. They reflect the personalities of the bride and groom. Your job as a photographer is to capture the essence of the day, both the overall experience and the smaller things. Focusing on details like guest books, bouquets, or the bride's bare feet is a great way to tell the story.

Experiment with Perspective

Everyone brings a camera to weddings. Many times the attendees' cameras are even better than the pros'. Some photographers find this stifling and ask, "What am I supposed to do?" I find the challenge invigorating. Seeing all the other cameras motivates

Details like fountains full of flower petals and guest books broaden the scope of the wedding day story.

me to create and capture something different. It's a constant reminder that I need to push harder.

One of the best ways to create unique photographs is to experiment and change your perspective. Sometimes you can change it by what you ask others to do. A few bridesmaids can lift the veil and then you mix up the results. But you may need more direct participation like jumping up on top of

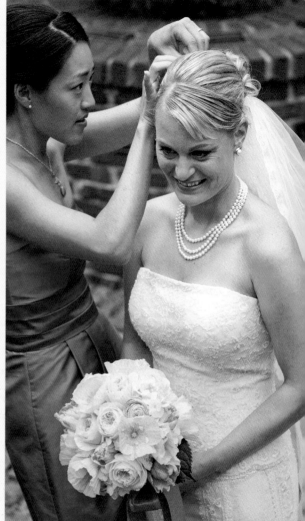

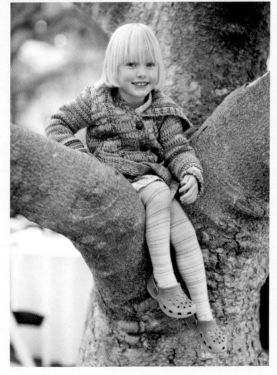

Weddings have everything—the bride, the groom, and kids waiting for cake.

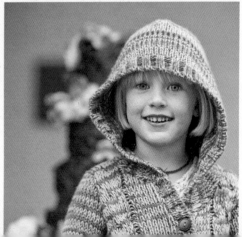

a wall to photograph down. They're surprised by your jump and you get an interesting new angle. For a bird's-eye view, try climbing a tree and photographing straight down as was done with the opening photograph in this chapter.

Go for a Walk

Many times, when you point a camera at someone they freeze, not knowing what to do. It is the wedding photographer's job to be the director, inviting different characters to play their part. Even as you position people they will still move stiffly and smile awkwardly.

The best remedy is to get them to move in a comfortable and fun way. I try something like this: "I saw this great spot for a few pictures. How about if we go for a walk?" Once you get them walking they will talk, laugh, and naturally stand side-by-side. As this happens, your directorial role decreases as their awareness of the camera subsides. With all of this movement, you're bound to create new opportunities for otherwise missed photographs.

Hang Out with the Groomsmen

Photographing guys in the wedding party can be tough. A group mentality sets in. They want to be cool, and cool means kicking back and relaxing. Follow their lead and you'll discover that the best photographs of the groomsmen will come from simply hanging out with them. Keep your technique informal and wait for the opportunity to have a bit of fun. And remember you are on their side. When you pitch a photo idea try something like this: "I have this cool idea; let's walk over to those trees, crank through a few photos, and be done with it. You guys in?" This keeps them relaxed and the mood informal.

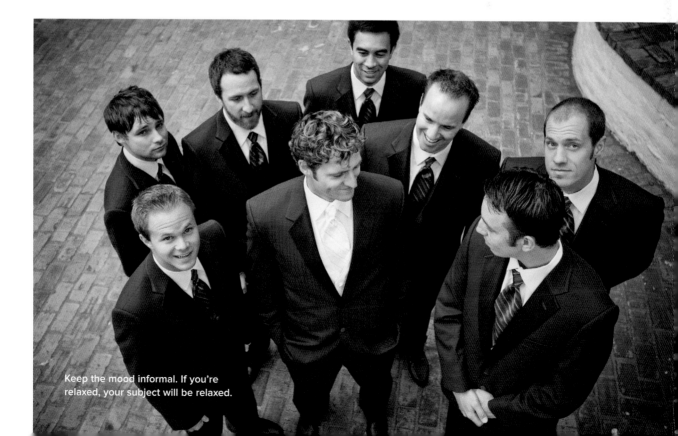

Keep the mood informal. If you're relaxed, your subject will be relaxed.

Photograph the Bridesmaids

After all the work of ordering dresses and matching shoes and then putting on makeup and styling hair to perfection, the bridesmaids are usually eager to have their picture taken. Seize the opportunity and bring the group together for informal shots. It will be easy to get them to stand together and smile, but don't forget to ask them if they have any picture ideas. Do what you can to involve them in the process. After the main photo session is over, be on the lookout for more candid photos as they touch up makeup, fix stray hairs, hold small children, or talk informally in twos and threes. Sometimes these intimate moments between the official action are the best of all.

Capture Families and Kids

Few events bring families together like a wedding. Compared with family reunions, holidays, and birthdays, weddings are unique. Families are well dressed, well fed, and have nowhere else to go. Kids feel giddy in new shoes or a special outfit and love the excitement. Weddings only last a handful of hours and family members tend to put up with each other. The potential for great photography is endless.

Use Available Light

The best wedding photographers search for quality light and take advantage of what's available. When the light is harsh, they take two approaches.

First, if the sun is bright, they use this to their advantage to create strong and stark images. Or they go even further and shoot straight into the sun so that the images are backlit and full of lens flare. At other times the best solution is to look for protection from the sun by way of an overhang, a wall, a tree's shadow, or open shade. And indoors, the best wedding photographers gravitate toward the soft natural light that pours in from windows and doors. Scout out your natural light sources and be the photographer who makes the most of whatever light is available.

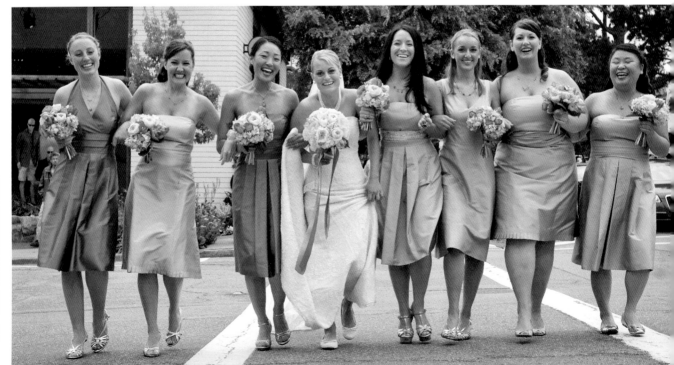

Leave the Crowds

For the bride and groom, their own wedding can easily become a blur. There are so many people and so much to consider. They are at the center of the whirl. It's the photographer's task to not let things spin out of control. Because you have a camera, you have the right and duty to ask the bride and groom to step away from the crowd. Try to get the obligatory family and wedding party shots completed before the ceremony. Then spirit only the bride and groom away when they are relaxed after the ceremony. This gives them the chance to take a deep breath, to look into each other's eyes, and to revel in the moment. It may be their only chance to be alone all day. And it is in these moments that many of your best pictures will be made.

Gear at a Glance

At weddings there are no second chances, so it is best to be well equipped. In most situations, wedding locations are easily accessible, so it won't be a problem to bring extra bags of gear. With so many guests bringing cameras to weddings, it is a good idea to try to differentiate your photographs by mixing things up a bit with your equipment. Bring a whole range of gear: two digital cameras, one digital point and shoot, one or two film cameras. And include a wide assortment of lenses: fish eye, 16–35mm, 50mm, 35–70mm, 70–200mm, a tripod, flash, extra batteries, and extra CompactFlash cards.

One of the decisions you'll need to make is how to store all the photographs. Some people prefer to clear off their CompactFlash cards onto portable drives like the Epson P-3000 Media Viewer throughout the wedding. Others invest in extra CompactFlash cards, as these are more compact and require less attention.

Either way, with all of this gear it is easy to become bogged down. I divide up my gear into two or three of my Lowepro bags. Typically, I walk around with a camera or two with the 16–35mm and 70–200mm lenses. On my shoulder I have a small or mid-size shoulder bag called the Stealth Reporter filled with a few essentials. I like these bags because they are simple, strong, and easy to work with. Because I'm walking around, I want to travel light and have what I need accessible. Finally, I bring a rolling carry-on suitcase camera case. Lowepro, Think Tank, and Pelican Products all have great models. I pack up the carry-on with the heavier and less essential gear.

Workshop Assignments

Survey

Most of us have not spent enough time looking at top-notch and timeless wedding photography. Our sensibility for this genre may have dulled and our visual memory is cluttered with low-end and uninspired photographs. To improve your own wedding photographic skills, you need to wash these images away and replace them with something better. Below are a few ideas that will get you going.

As you begin to explore these resources, you'll soon discover that the culture surrounding wedding photography is wonderful. Wedding photographers develop tight networks. They stick together, learn from each other, and are quick to compliment each other's work. Many of the best photographers have blogs, offer workshops, and share their trade secrets. Use these resources as a springboard to further your development as a photographer:

VISIT: www.elizabethmessina.com and www.kissthegroom.com

Elizabeth Messina is deep, kind, warm, and full of life. Her passion is contagious and her approach is simple. She is one of those rare individuals whose work directly reflects who she is. After you visit her portfolio and her blog, it will soon become one of your favorites.

VISIT: www.michaelcosta.com and www.michaelandannacosta.com/blog

I first met Michael Costa at Brooks Institute, where I teach. I instantly knew he would go far. Michael has a great laugh and smiles with his whole face. He and his wife, Anna, have teamed up and they are now considered among the best in the field. They absolutely love what they do and it shows in their pictures.

VISIT: http://www.josevillaphoto.com and http://josevilla.bigfolioblog.com

If you read Chapter 6, you may remember that Jose Villa is a highly acclaimed photographer and a graduate of Brooks. Throughout his career he has stuck to what inspires him and has created a thriving studio. That's one of the things that inspires me about Jose; he is 100 percent authentic and his work is stunning. Jose has returned to speak to my classes and his presentations are nothing short of pure inspiration.

VISIT: www.popphoto.com/Features/ Top-10-Wedding-Photographers-of-2009

When you visit this Web site, be sure to click on the top 10 and the top-nominated photographer links to view some of the best wedding photography in the world.

VISIT: www.weddingstylemagazine.com

Here you will find a high-end wedding publication filled with wonderful photography. You can even click through a digital version of the publication to get some more ideas.

READ: Wedding Photography Unveiled: Inspiration and Insight from 20 Top Photographers, by Jacqueline Tobin

READ: Existing Light Techniques for Wedding and Portrait Photography, by Bill Hurter

While there are hundreds of books written on the topic of wedding photography, some are a bit dated or not very unusual. These are two that I'm confident you'll enjoy.

Shoot

To expand your wedding photography skills, complete the following assignments on your own or at weddings where you are not the primary photographer but a guest. These assignments are intentionally open ended so that you can modify them to best fit who you are and the event you might cover.

1 **Follow the Leader**

Based on your research and viewing the resources listed, find five photographs that inspire you. Look for ones that are unique, distinct, and full of personality. For example, let's say you like Jose Villa's photographs with the bamboo parasols. Order a parasol online and set up a shoot with the intention of creating photographs based on what inspires you. Of course you will want to add your own style to the mix. This is a great way to begin to experiment and develop your own style.

2 Crop and Break the Rules

Typically wedding photography follows the traditional compositional rules, like the rule of thirds or only cropping subjects in flattering ways. In this assignment break the rules.

At your next wedding strive to create some photographs where the composition is more like jazz. Photograph the bride and groom and don't include the heads; just show their bodies. Or try photographing the bride only showing her hand on her hip, her bent elbow, and her shoulder. This approach is risky, but as you review your photos and find one or two that are good, they will be so good you will want to pop open a bottle of champagne.

3 Hands, Shoes, and Flowers

In this assignment your task is to select one, yes, just one, wedding detail. Then photograph that detail like it has never been done before. Choose something like hands, shoes, flowers, cameras, purses, lips, eyes, or the cake. Once you've picked your detail really go after it.

Let's say you pick the cake. Your first step is to find out the name of the cake baker. Next arrange to photograph the making and baking of the cake. Then photograph the confection as it's loaded into the delivery truck. Ride along in the truck and photograph it being taken out and set up at the reception.

At the wedding, photograph a child looking at the cake or try catching one of the kids snitching some frosting. Photograph the cutting of the cake. Then pick up a piece and hold it in front of you. Take pictures as you walk with the cake to deliver it to a friend. Pick up a fork and imagine your camera is attached to it. Get some shots as you scoop up a piece and as it enters a smiling mouth. Then take a picture of the cake from above the plate when it's almost gone and one more when it's completely gone. Create a story that has never been told.

4 Bird's-Eye View

The problem with most photography is that it is done at eye level. And eye-level photographs fall short because this is how we regularly see the world. At your next wedding, seek out ways to gain different bird's-eye views. Try climbing up on a fence, a wall, or up a tree. If the location is without anything to climb on, that's even better. All you need to do is bring along a stepladder or find a chair and shoot from above to create images that will rise above the rest.

5 Blur

Many wedding photographers worry they are going to miss the important shot if they experiment. And while this nervousness is justifiable, I say let it go. At your next wedding when you are not the main photographer, create photos that blur.

Work to create all different kinds of blur. Shoot some photos completely out of focus. For other photos, pan and zoom to create motion blur. Don't forget to set your camera on a tripod or just a table and create some extended exposures. By going through this exercise you will make some horrible mistakes, but you will also learn some valuable techniques, like vibrant colors and big shapes work well when shooting out of focus.

6 Magazine Cover

In order to get a magazine cover or to be published, you have to begin to shoot with the final destination in mind. In this assignment your goal is to create the perfect magazine cover or ad. You will need to shoot vertically in a portrait orientation. When you compose the

image leave plenty of negative space for the magazine's name, cover copy, or text. While you are shooting try to capture iconic, stand-alone photographs. Look for those moments that sum everything up.

After the shoot, use Photoshop to place a magazine name or copy on top of the image. Get a feel for how it all works together. By doing this and learning how to visualize what a cover shot looks like, you will be ten steps closer than your competition to making that dream a reality.

Share

Wedding photographs are some of the most commonly printed photos of any genre. With other images we're content to share them digitally, but wedding photographs are like artifacts that take on a new value over time. Photos are printed and presented in many ways: with borders, without borders, on canvas, mounted, in blurb books, or in high-end photo albums.

1 **Albums**

You can always try the usual techniques for your printed results, but why follow the crowd? Do something creative. One friend of mine printed his pictures and then bought an old vintage book. He taped the photos on the pages covering up the text. Another friend bought an old wooden box and tacked in some fabric. She filled the box with her prints and passed it off to the beaming bride.

2 **Flickr**

In order to share your photographs on a broader scale, put them on the Web. (Make sure to ask the bride and groom first.) Try posting your set of photos to the Flickr

group for this book. You can find the group at www.flickr.com/groups/visual-poet. When you add your photos to the group, be sure to tag them with the appropriate assignment info: Chapter 7 Weddings, assignment Blur. On Flickr we can view and comment on each other's photos. I'm excited to see what you come up with and I will be sure to stop by and leave comments.

Review and Respond

It is safe to say that we all have too many wedding photographs. The sheer volume makes editing a critical task. In order to improve how you edit your photos, print out a large set of about 100 photos. Next, lay them out on a big table or on the living room floor. Then begin to organize the photos into groups of 10. Base the organization on some similar theme, like smiles, flowers, dancing, details. Next, edit each stack so that your favorite sits on top. When you're finished you will have a grid of ten stacks of photos with only the top photos showing. These should be the best of the best.

Now invite a friend or colleague to come over and have a look. Ask her for input and ideas. Have her go through the stacks and see if she agrees with your picks. In this way you can begin to discuss and articulate how and why you edit the way you do. Or if you find this approach tedious, why not just do it on a computer? The results will bring a bit of method to the madness. Your skills will be refined and ultimately it will make you a better shooter.

Finally, if you're an amateur who is interested in learning more about wedding photography, there's nothing like assisting for a pro. Call up a local photographer in your area and ask if you can carry some bags and help out at his next wedding. While you may not get paid, the insight and experience you gain will be priceless.

Guest Speakers

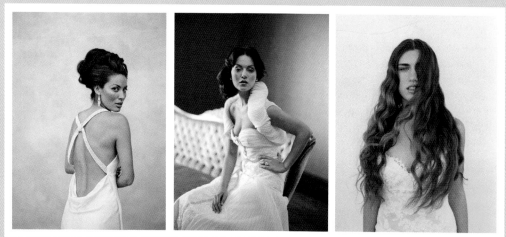

© ELIZABETH MESSINA

Elizabeth Messina

Elizabeth Messina fell in love with taking pictures at a young age. After years of patient development, her passion blossomed like a peach tree planted next to a fresh water stream. Now Elizabeth is one of the most sought-after and award-winning photographers of our time. Even more as a person she has a broad smile and full heart. Elizabeth is a romantic and her images epitomize the word. To view her portfolio visit: www.elizabethmessina.com.

What inspires you?

Little moments and gestures...genuine emotions...a sleeping child...a delicious meal...life.

What makes a photograph good?

A good photograph is evocative—it makes you feel.

What character qualities should the photographer nurture?

It's important to have passion and to be tenacious. Passion will help you create art and care about what you are doing. Being tenacious will help you navigate the business of being an artist.

What is your advice for the aspiring photographer?

Trust yourself and follow your heart.

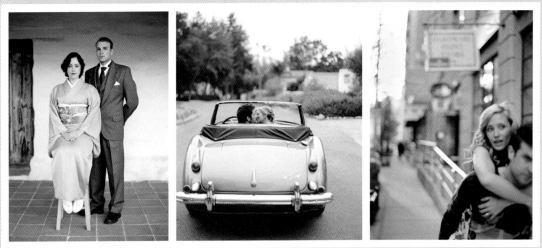

© MICHAEL COSTA

Michael Costa

I first met Michael Costa as a student. He was bright, eager, kind, and undaunted by whatever task was at hand. Michael's motivation was strong and his vision bursting at the seams. Teaching gives you a bird's-eye view, and from the start, I knew Michael would go far. Michael has stayed the course being authentic to who he is. Now, he is an artist of great repute—a learner, a leader, a risk taker, and generous with his craft. Michael is the kind of person you want to be around. For more information visit: www.michaelandannacosta.com.

What inspires you?

I've always been inspired by movies, fine art, fashion, and other photographs. I love to shoot for how a scene makes me feel, because my goal is to evoke an emotion. Locations are huge sources of inspiration as well, everything from modern to gritty. So often I see a wall or background and think, "How amazing would that be to..."

What makes a photograph good?

When all of the elements work in unison to successfully create a mood, a wonderful photograph is born. The photograph has a unique element that has rarely been explored. A good photograph must have something to say.

What character qualities should the photographer nurture?

The photography community is very small and word gets around quickly. Be kind and speak positively about other photographers, professionals—heck, everyone!

What is your advice for the aspiring photographer?

Delivering prints to other professionals, especially wedding coordinators, is one of the keys to success. It's funny because this most basic form of marketing is often overlooked and neglected. You could spend $30,000 on advertising in magazines and not get one phone call. Photographers must capitalize on their most powerful resource, one that every professional needs for their own Web site and promotional material.

A couple of jewels: Always keep your promise, go above and beyond, and give more than what is expected—good work equals more work. Make your mantra "How can I serve?" not "What can you give me?" Have a good attitude and always stay positive.

TRAVEL 8

TRAVEL IS AN AWAKENING EXPERIENCE and takes many forms: jaunt, tour, excursion, sojourn, visit, expedition, odyssey, outing, passage, pilgrimage, quest, safari, or adventure. When we travel we tap into more of who we are.

Travel begets travel, and it is more contagious than most experiences. Travel stories rekindle latent desires to explore, discover, and see. And people savor everything surrounding their travel, including stories, souvenirs, and pictures, as it reminds them of who they are, where they once stood, and who they want to become.

The traveling photographer has the privilege of taking part and immersing herself in this amazing aspect of life. For travel truly is one of the greatest privileges. It is a chance to let go and to be swept away. John Steinbeck said, "A journey is like marriage. The certain way to be wrong is to think you control it."

In this chapter, we will plunge into the topic of travel photography. Whether your travel is simple or elaborate, for business or pleasure, this chapter will inspire you to think about what it means to travel and how to create photographs that capture the experience.

Wind

When you travel to a new location, it is wonderful to be immersed in the scene—the cacophony of sights, sounds, and smells. All of these elements work together.

The best travelers are like sailors who know how to harness the wind. With keen and sparkling eyes they find the right tack and glean even more. And in my estimation, there's no better way than to travel with a camera in hand. The first step is that simple, carrying a camera. This is where it all begins.

The wind comes and goes and few are aware of its path. Sailors build up a sensitivity so that the invisible becomes plain as day. Having a camera does even more. While other travelers walk by unaware, the photographer pauses and sees what is invisible. The acuteness of your vision becomes unfettered and free. You can pan, zoom, speed up, or slow down like a well-shot feature film. Small details, color, textures, and patterns jump off the screen.

Look for the scenes that tell a larger tale. Like this timeless photograph taken in Essex, Massachusetts.

The decisive moment. A new stage of the adventure begins as Martyn jumps from the boat into the placid emerald waters off the Channel Islands.

Essence

I had just returned with a group of friends from a surfing trip to the Channel Islands located off the Santa Barbara coast. A fellow surfer asked us how it went. One friend responded first: "Bro, it was awesome." The surfer asked, "That's it?" "Yep, it was awesome!" "OK," the surfer said, "what about you guys?"

Another friend paused, grinned, and then leaned forward, speaking slowly: "The emptiness and desolation of the islands was peaceful, alluring, and refreshing. There was a thick white fog, no wind, and the water looked like emerald green glass. When you caught a wave it was so clear you could look through and see orange starfish and purple sea urchins on the reef below. And the waves, oh the waves, they were playful and perfect. We jumped off the boat at 9 a.m. and didn't return until 4 p.m. Hours and hours of surfing with some of your best friends in the world with no one around!"

Both surfers responded to the same question, "How was the trip?" We all had the same experience. But the second surfer added a bit of texture, color, emotion, and spin. These details made all the difference—they created a picture that was the essence of the adventure. And that's what the most inspiring travelers do. They develop a plot, perspective, and story that pulls you in.

Amidst the hustle and bustle of this London market a few pedestrians stop to stare.

Written Words

Cleverly articulated words entice the imagination and quicken a previously slow-beating heart. Words have the power to convince our imaginations to nimbly leap from one idea to the next. If you want to get better at travel photography, you need to delve into the world of words.

The best place to begin is with travel writers. These vagabonds bend every ounce of their literary expertise to further their cause. They consistently do every day without expense what others do only once a year for two weeks. They are paid to travel, touch, taste, listen, and explore. Start reading their books and you will begin to see and experience travel anew. These writers will not only confirm what you know, they will give you more and serve as a springboard for your photography. Reading will give you clues about what to look for and how to capture and convey what you feel.

Travel Talk

My parents love to travel and they love to get together with friends. It was the end of summer and they sent out invitations, inviting their friends to a party at our home. The invitation asked each guest to come ready to talk travel. Everyone was instructed to dress in a way that reflected a recent or favorite trip and to bring at least one artifact (souvenir, train stub, or the like). The gathering was festive and full of laughter, wild stories, and great food. Even the quiet ones opened up when it was their turn. From a young age, this showed me that everyone loves to talk about travel.

In fact, if you are ever caught in one of those awkward situations where the conversation runs dry, bring up the topic of travel and the floodgates will open. As a photographer, learning how to ask

One of the locals recommended that I catch the sunrise at this spot. I'm glad I listened to his advice.

Through travel we become something new, and I know this firsthand.

about travel and then listen to travel stories is a great asset. By listening, you will solicit more. The more you hear, the better equipped you'll be. Many times I've found some of my favorite travel locations simply by taking the time to ask others what they enjoyed about a country, a town, a festival, or a particular city block.

The time to talk about travel isn't just when you're back home. When you're out on the road, asking others about travel can be an instant point of connection and help you find hidden sights you might have missed. Most travelers love to tell about their trip and share what they've learned, seen, and experienced. I strike up a conversation like this by saying,

"Wow, the snow and this waterfall are amazing. Have you hiked further up the trail?" The response: "Yes! And just up the trail there are these unbelievable aqua blue natural hot springs—you definitely have to check them out. Hike up to the right; there's a secret little trail where you can take some amazing pictures with that camera of yours."

Experience

The philosopher Martin Buber said, "All journeys have a secret destination of which the traveler is unaware." Travel is more than sightseeing; it is change that runs deep into who you are, what you think, and how you want to live.

The experiences of travel deliver something intangible that often supersedes what you prepared for. Travel is a series of discoveries and rediscoveries, and in the end, it surprises us with what we've learned and who we've become. The cliché was right all along—the journey is the destination.

One great thing about travel experiences is that they get better with time. That's partly what makes travel so valuable and so fun. The experience of travel is much better than something you own. Traveling creates memories, a sense of connectedness, vitality, and a new life.

Through travel we become something new, and I know this firsthand. When I travel with my wife, Kelly, we become better friends, lovers, and soul mates. By getting out of our day-to-day routine, we see the world and each other anew. The travel photographer taps into this idea. She shows the world something that hasn't been seen before. He takes the viewer to a new land. And this takes on many forms. Sometimes the photos inspire and other times evoke change. There is an amazing range. Travel photographs have been known to inspire epic adventures, save a species, and even stop horrific wars.

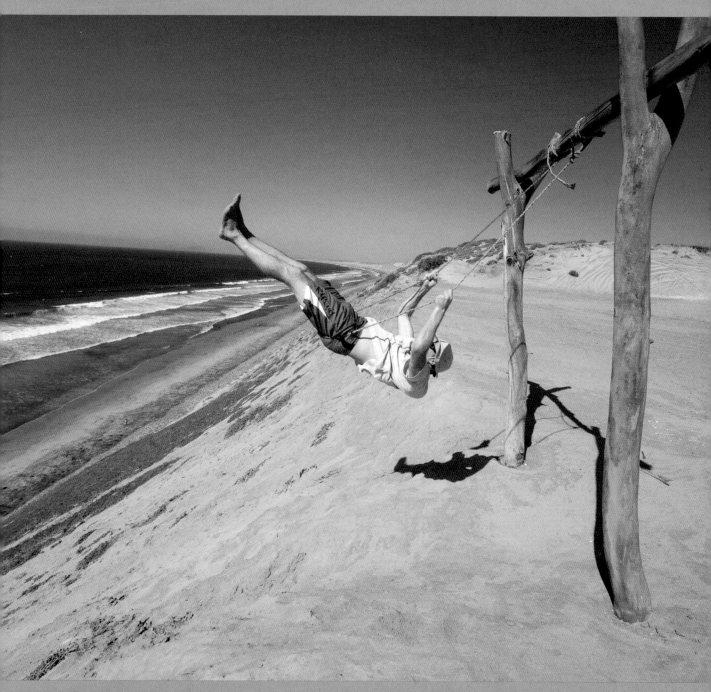

Stray away from the paved roads and populated towns and you can make discoveries like this. Adventurer and surfer Martyn Hoffmann swings high above the beach below.

New Eyes

It happens to us. We return from a trip and see things anew. How could so much have changed, or is it the other way around? I remember returning home after living in Madrid for a year. Everything that was once normal was completely brand-new. I was shocked, dismayed, and excited all at the same time. It was classic reverse culture shock, where I felt like a fish out of water. My vision was completely revived. I had new eyes.

And you don't always have to travel far to see anew. Stay at home and learn a new language and you'll gain another lens to look at the world. The new language will make you aware of your own.

I remember how learning certain Spanish words expanded my vision. Take the Spanish word *parabrisas*. *Para* means stop and *brisas* means wind. Later when I hopped in the car I thought about my native English word, *windshield*. I now thought of it as two words: *wind* and *shield*. This led me to look at the piece of glass like a knight's shield that stopped the wind. It was as if I had never seen the object before. Experiences like this happened thousands of times.

If you are lucky enough to combine travel and new language, you are destined for a visual epiphany. As a photographer you can tap into this new awareness, both abroad and when you return, and take photographs of the things that catch your eye.

Discovery

When I was in college, my family decided to spend Christmas in Europe visiting my older brother who was living in Germany. At that time, everyone except my younger sister had spent time in Europe. This was her first trip and other family members were quick to say, "Amanda, look at that! Taste this! Look over there!" All of these well-intentioned messages got old very fast.

It is one thing to share your excitement, but not at the expense of surprise. Discovering something on your own is always more fun. We travel in order to be surprised. Even on repeat visits, we want to

Some pictures are quiet. This one you can hear. And it's asking, "What destination is next?"

My favorite trips involve finding a way to get off paved roads.
This one is in Mexico along the Baja California coast.

see new things, meet new people, and taste new foods. All the surprises and details become more prominent as you focus and click the shutter of your camera. Your goal is to capture the wonders of travel in a way that will let the viewer discover something for the first time.

The best travel photographs don't give it all away. The viewer looks, then looks again and then smiles and says, "Ah-ha!" You want the viewer to say, "I've seen hundreds of pictures of the Eiffel Tower, but I've never seen it like that!"

Sharing

When I lived in Spain, I was studying at a university in Madrid, but my true education came from traveling. My adventures were many and diverse—running with the bulls in Spain, watching snake charmers in Morocco, sleeping in abandoned castles in Portugal, eating gelato three times a day in Rome, and surfing huge waves in Southern France. Every ounce of energy I had went into living life completely and fully.

After a year of adventures, I returned home. I couldn't wait to tell my tales. To my dismay, I discovered that I only had about three sentences before someone else would chime in. The conversations would unfold like this. "How was Spain?" I would respond, "Thanks for asking. It was amazing. I had the chance to travel to a number of places like Switzerland and Morocco..."

Just then someone else would butt in, "Oh yeah, I've been to Switzerland. I went to climb the Matterhorn with my dad. We almost died but it was really fun. And then we..." At this point, my opportunity was gone. Quickly, I learned that I needed to take a new tack.

You have to capture iconic images that sum up your experiences.

The same goes for travel photography. We return from life-changing trips with hundreds of photos. Subconsciously we think, "How could someone else not be interested in my experiences?" And we start to share the photos and their eyes glaze over, or they are distracted and start to tell their own story. If the photos are in a magazine, the viewer flips the page. How can we keep them on our page?

The trick is twofold. First, you have to capture iconic images that sum up your experiences. Second, you can't pause and show them the clutter. Rather, cut to the chase and show them the best of the best. Lure them in with the few photos that make them desperate to see more.

Two Roads

Once you have read Robert Frost, it is impossible to forget this line: "Two roads diverged in the wood, and I—I took the one less traveled by." The words dig deep, to question who we are and who we want to become. For the travel photographer this isn't just a nice cliché to tack up on the wall. Rather, it is something to put in your coat pocket and hold close to your heart.

Travel photographers are faced with nonstop choices. Should I go where the guidebook says or is there another way? My friend said I have to see this monument, but what about that one? Beginning travelers and travel photographers are immobilized by the decision. If I hop off the bus now to photograph that festival, I may not make it to the Taj Mahal. What should I do? The savvy traveler follows Yogi Berra's lead: "When you get to a fork in the road, take it."

Travel requires a certain level of inner commitment to find the right location. At the major locations like the Grand Canyon or San Francisco's Pier 39 there will always be signs that say stand here, Kodak picture spot. When I see these signs, I think of them as interesting forks in the road. They beg the question, What should you do? Should you not take that picture? Or should you embrace the irony and make the ordinary extraordinary? You could take pictures of every Kodak sign and location that you see. You could build up a set of these photos from around the world and make a book.

Whatever path you choose, the worn down or the lightly trodden, keep Frost's words close at hand. In every situation there are photographs to be made that have never been seen before. Take us down a new path and remind us what it means not to be a follower. Surprise us and show us how to be unique, how to be an individual—whether that means photographing off the beaten path or Kodak picture signs.

Rather than avoiding famous spots like the Brooklyn Bridge, try to change your perspective and capture a few distinct views.

Postcards

A colleague of mine had just landed his first *National Geographic* assignment. This was the culmination of many years of hard work, and he was ecstatic. He arrived at the location and jumped in feet first. The first day of shooting didn't turn out as expected.

Every time he pushed the shutter, in his mind he was trying to get a "National Geographic shot." The magic just wasn't happening. At the end of the day, he felt he didn't have a single keeper and he was devastated. After sitting down in a café to review his photos, his problem became self-evident. He was trying too hard. Some things just can't be forced.

The next day he woke up early and walked around without taking any pictures at all. He found a tourist postcard rack, and thumbed through a few dozen cards. This gave him an idea that he's used successfully ever since.

When you arrive at a new location, first get all of the obvious shots out of your system. In other words, take the postcard shots. After you have done this, you are ready to do the work of the photographer. I've come to apply this logic to almost every type of photography I do.

Sometimes this means thinking in terms of days, while other times it all happens within a matter of minutes. Either way, it provides space and time for me to really get to know a location or a subject. It allows me to think of some pictures as taking notes, sketching ideas, and writing rough drafts. All of these elements then work together toward the final photographs.

This approach redirects my focus in a healthy way. It reminds me that good photography is less about consumerism and more about relationships. And the

The London Bridge photographed two different ways.

best relationships are forged over time. They are built on trust, honest interaction, true listening, and give and take. If you want to create photographs that have meaning, you have to be involved.

To make someone else care, you cannot just take photographs but must be taken by them yourself. When the photographer's mind and heart are evident, the viewer's focus is redirected beyond them. Such photographs magnetically draw the viewer in and they, too, momentarily become part of the scene.

Monkey Paw

After returning from Italy, an amateur photographer friend said, "The light in Florence is alive, yet the quality of Tuscany light is incomparable." It is common for travelers to talk about the quality of light from their most recent destination. You have to wonder, is the light really better in one place versus another, or is it just that in some places you're paying more attention? Undoubtedly, different geographic locations have different colors and qualities. I'd bet that's not the only factor. The older I've become, the more I've come to realize that what you see is contingent on who you are.

As a traveler you are bound to leave your iPhone and laptop in the hotel and sit in a 2,000-year-old plaza and sip tea. Without distractions and self-imposed pressures, the world does indeed look a bit brighter. In fact, most travelers' profound memories occur when they are sitting and soaking it all up. I wonder what would happen if we took time to sit, drink it in, and really pay attention in our day-to-day life?

Travel awakens the inner artist. Our numb and jaded senses do a complete 180-degree turn. As Dagobert Runes says, "People travel to faraway places to watch in fascination the kind of people they ignore at home." Inconveniences become

An abstract view of the London Eye created by getting close and composing with a zoom lens.

adventures, traffic jams become opportunities to slow down, and getting lost seems to be the goal. As travelers we discover one of the great paradoxes of life: By letting go we gain more.

This is similar to the proverbial story about how to catch a monkey. Cut a hole in a coconut large enough for a monkey's hand. Place something shiny inside the coconut and then attach it to a tree. The monkey that finds the coconut will squeeze his hand in and close his fist around the shiny object. The monkey is caught—unwilling to open his fist, the monkey holds himself prisoner.

Travel teaches us to let it go. Each trip is like a training session in what matters in life. The job of the travel photographer is to create photographs that act as a visual life manual. Why else do you think people hang up so many travel pictures around the office? Those images stand as a contradiction to their context. They remind us of the true value of shiny things and the need to open tight fists.

Practical Tips

Photograph in All Types of Weather

Experienced travelers don't depend on good weather. They know that weather can be fickle, and they always have a contingency plan. The same is true with the best travel photographers. Rather than pack up their gear when it rains, they walk around with an umbrella. When their hands are cold from bitter weather, they wear small-fingered, warm mountaineering gloves.

These photographers are not disappointed by the weather but embrace and engage with what Mother Nature has sent their way. While certain elements may not make for the best sightseeing, they may deliver a one-of-a-kind combination of mood, color, and tone.

Revel in Each Sunrise and Sunset

Vocalists value harmony, novelists care about well-written words, and kids love ice cream. The travel photographer treasures the transition from light and dark. Make pictures that celebrate the beginning and end of the day. The visual quality and caliber of such times transcend, animate, and inspire. Drink it in and let the moving sun remind you of things gone and coming once again.

Become a Night Owl

Darkness is an opportunity for light to shine. With less light, the effect on the image is sometimes more profound. Making pictures at night requires keen eyes and owl-like stillness. Perched with a tripod as the scene unfolds, the night photographer captures city skylines, sparkling skies, time-lapsed movement, solitary lampposts and signs, silhouettes, and houses glowing from the inside. And

An inviting pub on a rainy night in a small British town.

Old signs are a perfect place to look for color, texture, and the passage of time.

while making pictures at night requires a bit more, don't let a trip go by without walking in darkness with camera and tripod in tow.

Find Colors Palettes

In Greece the blue-domed houses with whitewashed walls and red bougainvillea soothe your soul. In the Napa Valley the bright green vines, deep purple grapes, vibrant blue skies, and white puffy clouds are unforgettable. While the rest of us enjoy the view, the best travel photographers are smitten by such color combinations. They fastidiously take pictures like visual notes that compile a palette for each and every town. And the color palettes show up in the most prominent and the least likely places. Like Easter eggs, they are hidden among it all. Become the photographer who hunts with eager eyes for such treasures as these.

Feel Textures and Discover Time

Time and texture go hand in hand. Sometimes time passes quickly with a harsh and unforgiving touch. Other times, it is a slow, subtle caress that makes the rough and sharp both soft and smooth. Like seeing an old friend after 20 years, traveling to new places makes one aware of time's toll. And the etched texture and wrinkles tell a story.

Travel photographers gravitate toward markings of age—new and shiny or weathered and worn—as they expand the envelope of our imagination. And the photographed texture causes days to become decades and then centuries. The viewer's own self-reflection slows down and takes on a new scale. Once prominent, the viewer now contentedly seems small.

Capture Signs for Context

Signs safeguard, suggest, inform, indicate, depict, direct, welcome, and warn. Signs are ubiquitous and universal and the best ones communicate across cultures. Yet signs are individual and most are built one at a time. Like the wine enthusiast who stocks his cellar, the travel photographer builds a library of photographed signs. With each added image, the collection gains alluring intrigue and intrinsic value. For signs enlighten by creating context and connecting with the viewer. If you haven't already started photographing signs, begin now.

Eat the Food First

In our diverse world there are common threads that connect us all. Food is one of the central strands. It is a thread that is tightly woven with a culture. In fact, one of the great joys of traveling is to taste new food. This is our way to participate and ingest rather than just observe. As we sample the cuisine, we become enmeshed and connected to a place in a wonderful way. By photographing food we capture these connections and the deeper idiosyncrasies and interests of people and their land.

People Capture the Place

While many things reflect geography and culture, people are the true embodiment of a place. If you are traveling in another neighborhood, city, state, region, country, or continent, the people are different. In spite of our differences, we are the same. For the traveling photographer, people photography is one of the greatest celebrations of humanity. It is an opportunity to capture something specific that at the same time has the potential to transcend time and place.

Take the time to learn about, listen to, and really get to know the people of a specific place. Such an approach is not only personally enriching, it will

Local festivals bring the creative residents out into the streets.

help you create more thoughtful and thought-provoking photographs. As you photograph people, aim to capture it all and let your images become part of your discovery and dialogue. Create an array of photographs: individuals up close and far away, people working and playing, hands, feet, dress, silhouettes, crowds, and more.

Architecture such as this is the result of one ruler's fascination and fantasy.

Festivals as Cultural Touch Points

Festivals are times of feasting and celebration that are centered around a specific activity, religious belief, or something of cultural significance. Festivals bring people of all ages together in a unique way. Whether a small outrigger canoe festival in Samoa or an elaborate Carnaval celebration in Brazil, people momentarily let go of their differences and gather around a common cause. Having the opportunity to photograph such festivals, both big and small, is even the most seasoned travel photographer's delight. If you haven't photographed a festival, perhaps now is the time to schedule a trip. And finding out about festivals is easier than you would imagine. For example, simply Google "Spain festivals" and you will instantly find a calendar and description of over a dozen travel-worthy festivals and events.

Divide the Landscape into Thirds

The vast landscape tells a broader tale. Thousands of years of weather, growth, and sometimes-human interaction shapes the land. In return, the land shapes the people. When you travel with fresh eyes, you can see and hear the echoes of the passage of time in the landscape. Capturing such grandeur within the frame is a challenge few can truly do well. But the bigger the challenge, the better the reward.

For starters, when you seek to create compelling landscape photographs, try beginning with a few old tricks. First, photograph during the best light of the day. Next, show grandeur by including scale — include a person as the base of the 200-foot-tall waterfall. Then resist the temptation to compose splitting the scene in two—land and sky.

Instead, remember the thirds—one-third rocks, one-third water, and one-third sky. When using a wide-angle lens, shoot with a small aperture and then gain maximum sharpness by focusing one-third of the way down the scene and recompose. Finally, including a subject in the foreground will greatly improve the visual appeal. More important than these few techniques, be sure to experiment as you let yourself be taken away by the scene.

Architecture that Reveals

What we build reflects and shapes who we are, whether it's the cold concrete buildings of Eastern Russian or the inviting log cabins of the snow-capped Sierra. Architecture is an art form whose presence acts slowly. After years its effect is practically irreversible. A building's presence goes deep like a heavy anchor on the ocean floor. Frank Lloyd Wright suggests, "Without an architecture of our own, we have no soul of our own civilization." Whether you find that architecture means all of these things or not, what is made by humans is fascinating.

When traveling you have the chance to see both ancient and modern architecture that has been built

brick by brick. Photographing buildings is not taking pictures of wood, glass, and steel. These are pictures of the human touch and all that led up to their development. Rather than walk by an old building that catches your eye, stop and study it with your lens. Create images that captivate your imagination and convey this one particular aspect of time and place.

New Perspective on Monuments

Monuments reflect a culture's larger scale and have a distinct value. The trouble with photographing them is that they are often created to stand alone and to communicate without question. They are direct, easy to read, and impenetrable. Most moment photographs fall short as they perpetuate a repetitive tale. How can the travel photographer say something new? The photographic solution is simple—say less and you will tell more. In other words, create photographs that are more indirect. Try cropping and composing your shot to show less of a well-known monument. Change your perspective and shoot both high and low. Or try shooting at sunset as a silhouette. Whatever technique you employ, draw the viewer in and seek to make photographs that are interesting where the subject is identifiable only after a second glance.

Find What's Most Important

Travel is a mixture of people and place. Many of my favorite memories are bound together with the people I traveled with. In fact, in many situations the people were more important than the place. Don't become so focused on the volcanic red lava flow in Hawaii that you forget to take the portrait of your laughing daughter standing on a surfboard. Or even better, pass off your camera to someone else and step into the frame. Those who leave space to use the camera in these ways never regreat such shots. For while other photographs may have general appeal, these personal images are priceless.

© NIKKI BURKE

These vacation snapshots of my daughter Annika and me on a
surfboard may not sell but are priceless in their own way.

Gear at a Glance

One of my most valuable gear lessons came by way of living and traveling in Europe. I learned that no matter how big a backpack I had, I would fill it up. The solution to traveling light was to use a smaller bag. Traveling became easier and I was constantly surprised by how little I really needed. The same goes for travel photography. It all starts with the bag. Here's what I recommend.

Select a bag that allows you to have space for your camera gear plus a few more items. In my experience, you'll almost always want to bring some water, food, a hat, and an extra shirt. Make sure you have room for those other items. The backpack I use for shorter trips is the Lowepro AW Mini Trekker. This is a strong and compact all-weather backpack that doesn't bog me down. For longer trips, or if I need to bring my laptop, I reach for the Lowepro Vertex 200 AW. Whatever you choose, select a pack that has built-in all-weather protection. You never know when the weather might change.

In certain circumstances, I travel with a Pelican 1510 Carry On Case. This case is waterproof and incredibly strong. The only downside is weight. If you're roughing it, there's nothing like a rugged Pelican case to protect your gear.

On most trips I bring three lenses: a wide 16–35mm, regular 50mm, and a zoom 70–200mm. If I have extra space, I'll throw in the fish-eye just for fun. Of course, you'll want to pack supplies for cleaning your camera and lens. Next, be sure to bring plenty of CompactFlash cards. Some prefer to offload their cards to an external device. My preference is to simply buy more cards. This approach is more stable and takes up less space.

Include extra batteries and at least two identical battery chargers that work in both wall outlets as well as in the car. If you know that you will be out in the wild, be sure to pack a solar charger. One that's worked well for me is the Solio Universal Hybrid. If you will be traveling to a location where wetness and moisture may be an issue, pack a small dehumidifier in the base of your bag. For less than $10, you can buy the one I use, Hydrosorbent Silica Gel SG-40.

A tripod is an indispensable tool while traveling. It needs to be lightweight, compact, and strong. I travel with the Gitzo GT-530. There are some locations where tripods are not allowed. In those situations a monopod will come in handy. And because of the way a monopod works, most medium-quality monopods will do. Don't buy a nice one unless you know that you are going to use it all the time. Most important, look for one that collapses and becomes small.

Workshop Assignments

Survey

Getting better at travel photography requires noticing the details. As Moslih Saadi aptly stated, "A traveler without observation is a bird without wings." Explore these resources as a way to expand your vision. This is not an exhaustive list but rather a concise mix that will pique your interest in a range of different types of travel photography.

VISIT: www.stevemccurry.com
www.chrisrainier.com
www.ericmeola.com
www.artwolfe.com
www.vincentlaforet.com

These individual portfolio sites include some of the best travel photography in the world.

VISIT: www.lonelyplanetimages.com
and www.lonelyplanet.com
www.fodors.com/travel-photography
www.tpoty.com

These sites access a broad range of inspiring travel-related photography from multiple photographers, including travel photographers of the year.

VISIT: http://traveler.nationalgeographic.com
http://traveler.nationalgeographic.com/
photo-archive
www.nationalgeographicstock.com
http://photography.nationalgeographic.com/
photography

National Geographic produces some of the best travel-related content. Follow the links to tips, contests, photo galleries, and more.

SEARCH: www.auroraphotos.com
www.magnumphotos.com
www.gettyimages.com
www.corbis.com

Before going to a location, build up your visual familiarity with the place by searching for its name on one of these top-notch stock photography sites. Also discover what types of travel photographs are the most marketable.

WATCH: "Travels to the Edge
with Art Wolfe" on PBS

Get a feel for what it is like to travel with an internationally acclaimed photographer. This series is full of both practical information and awe-inspiring visuals. And visit his Web site at www.travelstotheedge.com and www.usa.canon.com/dlc/travels/index.jsp for more information on his work and to see photo galleries, trailers, tips, and a current PBS schedule.

READ: On the Road, by Jack Kerouac
Travels with Charley, by John Steinbeck
The Call of the Wild, by Jack London
A Moveable Feast, by Ernest Hemingway
The Great Railway Bazaar, by Paul Theroux
The Snow Leopard, by Peter Matthiessen

Find a great book about a place you would like to visit. These are a few travel literature favorites to get you started. Pay close attention to the visual images that the books create in your mind.

Shoot

To expand your travel photography skills, complete the following assignments. They are intentionally open ended so that you can modify them to best fit your journey and the types of photos you would like to shoot.

1 **Travel Without Traveling**

It is easy to think that good locations equal good photography. Such thinking leads us to believe that if only we could travel to *x* location then we would get good photographs. One of my colleagues teaches a travel class where he requires that his students "Think globally and photograph locally." Their assignment is to make the ordinary extraordinary by creating photographs where they live.

This is a challenging project because we have become overly familiar with our immediate surroundings. This assignment sharpens observation skills like no other. Without going more than 15 miles, set out to photograph your geographic context like it has never been photographed before. Imagine that you are a foreigner and have only a short time to capture what captivates you. Create a set of at least 20 strong photographs.

2 Fill the Frame

This assignment is designed to get in close with your subjects. The goal is to create 10 to 15 photographs where the subject fills the entire frame. Use a focal length that is closest to a "normal" 50mm lens. Next, use tape to prevent changing the zoom. Doing this will require that you physically move yourself forward and backward in order to compose.

3 Create Space

Some of the most alluring travel photographs are those that allow you to walk right into them. These images are simple, uncrowded, and pristine. Your task is to create five photographs that create an inviting space.

As you look through the viewfinder, compose to convey a sense of openness and relief. Typically the subject is small and the rest of the frame is left wide open. By having a large amount of negative space it relaxes the senses and invites the viewer in.

4 Pick Colors

Create a set of 15 photographs where the main subject is color. In other words, disregard what the actual subject is (an umbrella, church, street sign), and photograph it so that the color is of primary importance. In addition, try to compose the photograph so that there are only two or three colors. By reducing the number of colors, the photographs will feel more colorful.

5 Select a Theme

Select a theme like simplicity, serenity, happiness, excitement, or loneliness. Next, go for a walk and only take pictures that fit into your theme. Create a set of ten such photographs. While this sounds simple, it is more difficult than it seems. It will be hard not to photograph other things, but this focused approach will heighten your senses. It will also develop patience and the drive to look long and hard for that particular theme.

Share

Sharing your photographs sharpens your vision, is incredibly motivating, and helps you grow as a photographer. For this assignment try both of the following approaches:

1 Host a dinner party

Most people love to talk and learn more about travel. After your next trip, say to Spain, invite a group of friends over for a Spanish-themed dinner. Hang up your photos along twine with clothespins. Set out a few artifacts from your trip and prepare some delicious Spanish food like tapas, paella, and sangria. Throughout the dinner party ask your guests to share about their own travel adventures. In situations like these, there is no need to push an agenda. Let your photographs speak for themselves and set the tone. Finally, let the gathering simply be a time to celebrate the many wonders of travel.

2 Flickr

To share your photographs on a broader scale, post them on the Web. In particular, post your set of your photos to the Flickr group for this book. You can find the group at www.flickr.com/groups/visual-poet. When you add your photos to the group, be sure to tag them with the appropriate assignment info: Chapter 8, Travel, assignment Pick Colors. On Flickr we can view and comment on each other's photos. Post some images—I'm excited to see what you come up with.

Review and Respond

One of my favorite rainy-day pastimes is sipping tea by the fireplace while I flip through the pages of my travel journals—there is no better way to relive memories of the road. Then I pick up a stack of proof photographs as if I am there once again. There is something poignant about reflecting on travel. It is a time to think about where you've been, what you've seen, and who you've become. In the same way, it is worthwhile to review the photographs that you have created as a result of this chapter.

First, make some rough prints. Then find a space with a comfortable chair and no critics. Spread out the photographs so that you can see them all. Pick out a few of your favorites. Flip the photographs over and make a few comments: Why is this photograph good? What do you like about it? What led up to this moment? In this way you can begin to "journal" and take "class notes" that can later jog your memory. At first, these notes won't seem valuable. But months or even years later, these messages will have the potential to light a creative fire.

Next, pick out a few of your all-time favorites and consider submitting them to a contest or feature. There are a number of great contests, but one you definitely don't want to miss is the *National Geographic* Your Shot. This is a place where *National Geographic* readers submit their images and the top photos are regularly included in the magazine. To find out more, visit the site http://ngm.nationalgeographic.com/your-shot/your-shot. Click on "daily dozen" and "top shots." Here you will see some amazing photographs. Once you get a feel for what they are looking for, take some time to submit some of your own. Who knows, maybe you'll end up in the next *National Geographic* issue!

Guest Speakers

Steve McCurry

I had breakfast with Steve McCurry recently and we talked about the challenges and rewards of teaching photography. He shared a few words that stuck: "The main thing is getting students to find their own way." Here are a few tips from him that will quicken your step and revitalize your vision. Enjoy more of his work at www.stevemccurry.com.

What inspires you?

Henri Cartier-Bresson's work has been an inspiration to me, but people living their everyday lives inspire me, too. Fishermen cleaning nets, families sharing meals and celebrations, artisans crafting their wares, nomads continually on the move; even the most seemingly mundane activities can be inspirational when you look beneath the surface.

What makes a photograph good?

If you look at the photographers whose work we admire, they've found a particular place, theme, or subject, dug deep into it, and carved out something that's become special. And that takes a lot of time and a lot of work—that's not for everyone. A great photograph really needs to say something about a person or give some insight into his life or how his life is different than yours and mine.

What character qualities should the photographer nurture?

Curiosity. Being curious about the world around you, this planet that we live on, I think is very important. With any endeavor, whether it's music, literature, or architecture, I think hard work and perseverance are essential qualities that are absolutely necessary to a career, especially in photography. A sense of humor is also an important quality. So often when I'm in a foreign country, the best way to break the ice is by making a joke, possibly about yourself. I've found that humor is universal.

What is your advice for the aspiring photographer?

I'm surprised at how young photographers often don't have a sense of the history of photography and aren't familiar with the work of say, Henri Cartier-Bresson, André Kertész, Dorothea Lange, or Walker Evans, to name just a few. Again, be curious.

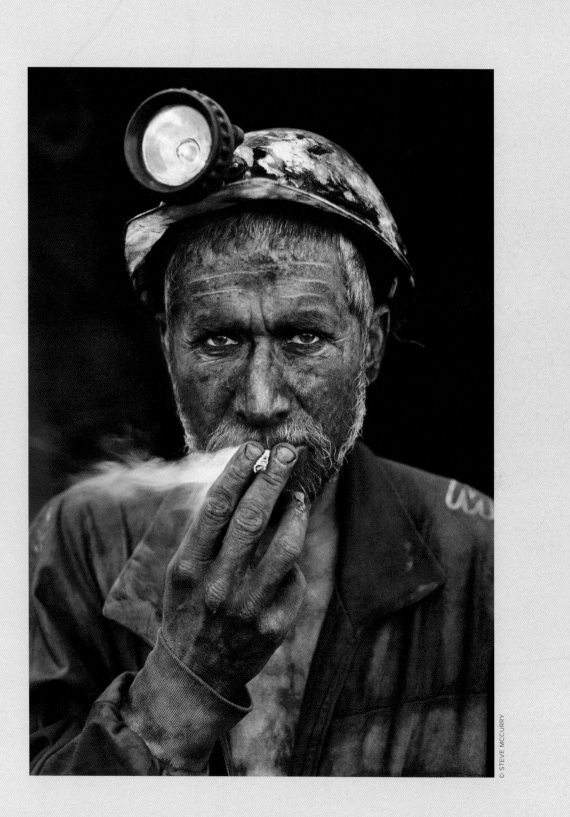

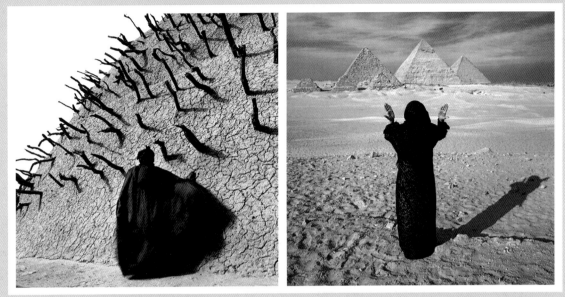

Chris Rainier

Chris Rainier is considered one of the leading documentary photographers working today. His work has been showcased in major publications and galleries. A *National Geographic* fellow, Chris has a broad and deep heart and his photography is a clear extension of who he is. Watch slide shows of his work at www.chrisrainier.com.

What inspires you?

The world is amazing and we live in an incredible time in history. My life's mission is to document indigenous people around the world. As a culture disappears, we are in a race against time not just for posterity but also to revitalize it.

What makes a photograph good?

When you feel something. When a photograph operates right in your solar plexus. I think of those photographs that served as a catalyst for change. Like the photographs taken of Vietnam that changed that conflict. It is when one iconic moment becomes larger than the event itself. I'm always seeking those moments, and while they don't always happen, I remember what Ansel Adams said to me: "If I take one good photo a year I am doing well." I aspire to that standard.

What character qualities should the photographer nurture?

Ansel Adams said something else to me near the time he passed away: "Put off short-term gain for long-term goals." His words have helped me push on. When I got those 100 rejections, I kept pressing on. I keep asking myself, "What can I do that is really going to make the difference?"

What is your advice for the aspiring photographer?

Ignore the naysayers and follow your passion. And while the field may be smaller and more difficult to break into, somewhere there is an open door. Do what you must to go and find it.

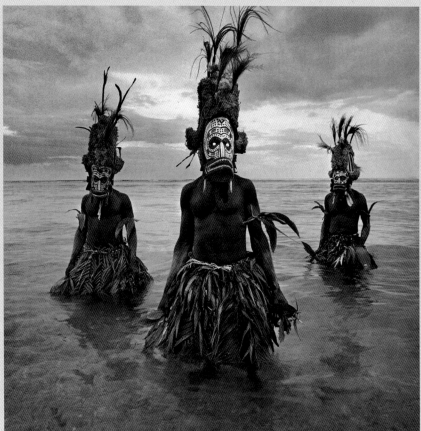

© CHRIS RAINIER

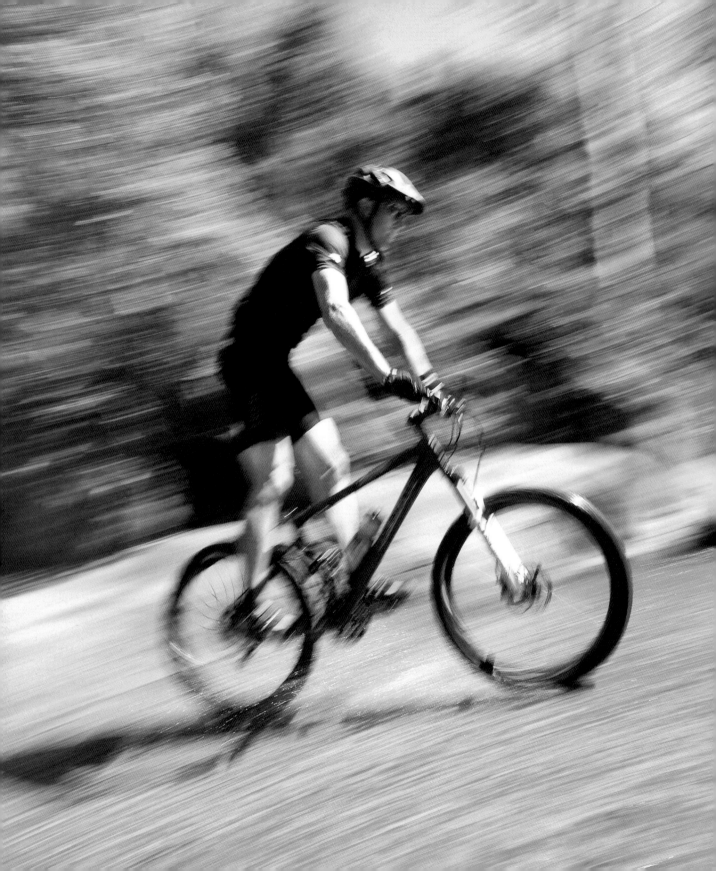

ACTION AND THE GREAT OUTDOORS

9

PHOTOGRAPHY IS ROOTED in vision and the art of seeing. Experienced photographers don't clock in and out. Their trained eyes see what escapes the rest of the world. The eyes are powerful. We are pulled in the direction of what we see and this causes us to see more. With time and experience, the pull becomes stronger and the rhythm gains momentum and repeats itself again and again.

For many photographers, this process develops an intrepid drive and passion for the world. It compels us to wake up at sunrise, hike to the top of mountains, kayak frigid waters, surf exotic waves, and notice the dewdrops on a flower. Photography furthers the many adventures and joys of life. Because of photography, I am not content to sit on the sidelines. I use my camera to capture these moments, and it makes me want to live them even more.

In this chapter, we are going to jump feet first into the world of the active photographer. This is for the photographer who cannot be contained by the normal limits of genre and topic. Rather, this photographer combines the lines of the natural world, the great outdoors, and the many facets of sport and exercise. These distinct areas become inseparable. They are connected by a contagious curiosity and an appreciation of the natural world.

Perspective

Climbing sandstone without ropes isn't typically the best idea. Over a dozen years ago a friend and I were 90 feet up on a vertical sandstone cliff. My friend stood in a small wind cave as I attempted to climb the next section of the wall. Suddenly, I began to slide and fall. In slow motion, I could see my climbing partner anchor himself by grabbing a rock with one hand. Then, as if it were a one-frame-a-second stunt, in one fluid motion he caught my wrist and swung me 180 degrees to safety.

Without a doubt, I would have fallen straight to the ground and life would have been over. To a greater or lesser degree, many of us have had an experience like this. Such a view redirects and shapes who we are. It made me determined to live fully, deeply, and completely. Having imagined death, I more desperately want life.

That's one of the main reasons I go on adventures and explore with a camera in hand. This perspective fuels my passion. At times, even this deep-rooted passion wanes. What then? How can we keep it alive?

Grateful

Mike, a student at the photography school where I teach, was a rare individual. His humble confidence, inner peace, and vision filled the room. He was a photographer extraordinaire. You hardly noticed that he had a slight limp.

One day I decided to ask him about his walk. Mike smiled and began to tell me an unforgettable tale. He explained that growing up in Kauai allowed him to surf nearly every day. One typical morning on the north side of the island, he was stalked and then taken down. It was a huge tiger shark that nearly killed him, biting off his leg just below the knee. Fortunately, he fought back, punching the shark in the nose, and with help from his friends his life was spared. It was stunning to hear this story directly from him.

As I continued to ask him questions, what struck me most was that he wasn't bitter, jaded, or upset. Rather, his gratefulness acted like a filter through which he interpreted the scene. He had catalogs of things he was grateful for, both big and small. And as I've traveled through life I've discovered this common theme: those who are active and live life to the hilt are often those who are most grateful.

Perhaps by taking focus off our little worlds, we step into the grand scale of the outdoors. This expands our horizons and redefines our place. This I do know: Taking time to be grateful is a surefire way to refuel your passion. Gratefulness thaws the soul and builds acute awareness. For the active photographer, such qualities feed your vision, keep your passion alive, and propel you to do even more.

Tip the Scale

My whole life I have always believed that the time is now; the adventure has already begun. The present is a gift—you just have to open it up. Mark Twain famously said, "Throw off the bowlines, sail away from the safe harbor. Catch the trade winds in your sails. Explore. Dream. Discover." We hear those words, but few answer the call. A friend returns from a journey and tells a wonderful travel tale. Yet, still some remain recalcitrant. How much more convincing will it take?

As humans, we move in the direction of our most dominant thoughts. When we see a good image, it uniquely commands our attention, ignites our imagination, and tips the scale. Our imagination is quick to respond and challenges us, Why are you not there? We look around and question the

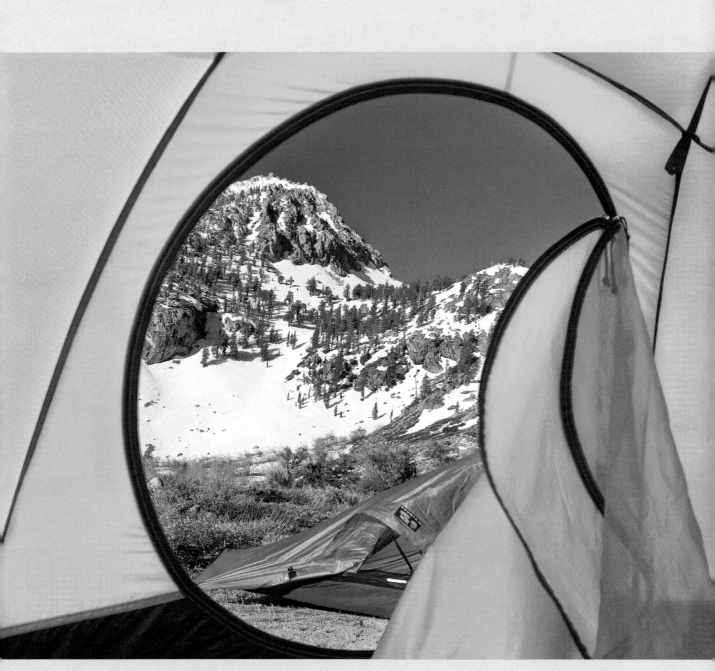

Having a camera nearby enables me to capture images like this when I wake up. Keep a camera at your side wherever you go.

Deep in the backcountry, the position of this subject in the frame adds a sense of scale and grandeur and invites the viewer to find some snowshoes and follow along.

voices in our head. The photographs prod us to use our imagination to join someone who has already stepped into the frame.

In more practical terms, if you want to become a great outdoor photographer, you need to enjoy the photographs of others. These images will get you moving. Then when it's time to capture your own, you'll discover that this realm of photography is not a linear path. Rather, capturing compelling outdoor photographs becomes circuitous and leads you back around again.

At first, a photograph savors what has gone past. Then, the memories reignite the flame. The photograph may be good, but the experience is always better. This pushes you forward, making you want to set out again. The best artists and photographers know this loop well and they seek to capture it all. Rather than just photographing the mountaintop, they take pictures as the journey unfolds. The pictures become a story that invites the viewer along. And such pictures suggest that we never fully arrive. We constantly press on.

Renewal

The conveniences of modern life insulate us from many discomforts. This comfortable existence can easily soften or sabotage our desire to thrive. Getting outside and feeling the warm sun or cold, crisp air reawakens the senses and corrects our course.

Photographing people with a habit of being active and outside helps us to embrace the elements. Being around such people brings out the best part of ourselves, and we become part of a larger tradition of the great outdoors.

In 1874, John Muir was hiking through the Sierra wilderness to a friend's cabin near Yosemite Valley. He was hiking without a fleece hat, Gore-Tex gloves, waterproof jacket, or GPS navigation tool. Muir noticed a storm brewing and he made a decision. He hiked to the tallest hill and climbed to the top of a 100-foot tree. From this vantage point he rode out the storm. He described the experience as "one of the most beautiful and exhilarating storms I ever enjoyed." While the rest of us would have chosen shelter and fire, Muir took another path. He embraced and even relished the storm.

Getting outside and taking pictures teaches us about life. Rather than flee, we face forward. Ansel Adams knew this well. He often suggested that he didn't photograph landscapes but weather. Adams looked for cloud cover and storms everywhere he went.

Why weather? Weather connects us with who we are. Sometimes the best photographs are taken just as dramatic and dark clouds break free and the sun shines through. Other times the weather is more simple and subtle. Perhaps the sky is filled with wispy and unhurried clouds that travel across the horizon. Their journey echoes our own.

The winter sun sets in the Eastern Cascades.

Value

Like most journeys, this one took time. Two people were packed in a truck on a mountain road. Next, while on skis, one was towed behind a snowmobile until the mountains became too steep. Finally, we hiked for many hours. Out of breath, cold, and depleted, we arrived. Falling down in the snow with my backpack still on, I was broken down and lay still to catch my breath. My muscles ached and my feet burned. Never before had a bed made of snow felt so good.

Soon my strength returned and I stood up to absorb the well-earned view. The Eastern Cascades stretched on as far as we could see. Complete quiet. I was in awe. We quickly set up camp and prepared to eat. Top Ramen noodles never tasted so good. My jacket never felt so warm. Everything was better up there. And it wasn't a result of the thin air.

By being active and getting outside, we gain experience and tenacity. Photographing our activities adds a layer of value as we create pictures. For example, you may consider the above sunset and mountain range photograph nice. When I stare at jagged peaks and the distant vista of Mount Rainer, I am revived. I remember every detail, every moment, and every pain. This photograph helps me face tough decisions. Rather than take the easy path, I consider the cost, commit, and press on.

In moments like these, I discover that photography isn't just another way to further my ego. This realization re-centers my approach—it reminds me that some of the best photographs have little to do with how well they are received. Rather, a photograph's value can and often should be based on that which enriches both who you are and who you want to be.

Path

Frank was a Canadian whose father didn't think he would amount to much. In spite of this he made his way to the University of Southern California, where he decided to study architecture. Midway through his second year he took an architecture class and failed.

Frank's performance was so poor that his teacher pulled him aside and told him to get out and to never take another architecture course again. It was a fork in the road, and in both directions the view looked dismal. Without wavering, Frank decided to forge his own way. He retook the class, bent on receiving an "A." Fortunately for us, Frank Owen Gehry didn't let someone else define his path. He received that "A" and pressed on to become one of the most creative and well-known architects of our time.

The greatest artists and athletes share a similar tale. In the face of challenge they say, "Bring it on!" Consider sports like surfing, river rafting, rock climbing, or golf. The bigger the wave, the more rough the rapid, the steeper the rock wall, the more difficult the obstacles, the tougher the competition—the better the game. It is one of the reasons we love sports, because it transcends the activity at hand.

Andy and Mike catch their first glimpse of questionable surf conditions after hiking for miles on one of the Channel Islands.

Transcend

In photography, genre-based classifications are used quite often; portraiture, architecture, sports, and celebrity. While such groupings help us place what we do, they don't accurately describe who we are. Perhaps there is another way.

One of my favorite photographers, Anton Corbijn, was asked, "What is it like to be a celebrity photographer?" He was put off by the question. "I don't photograph celebrities. I photograph artists who are my friends," he said. Internally, Anton redefined his trade, and the results show in his breathtaking and uber-famous photographs. Someone he photographs often is Bono of the rock band U2. Bono explains, "Anton is one of my best friends...and we [U2] like working with him because he doesn't photograph us as we are, but who he believes we will become."

The photographic world will always need genre, but the next time you are shooting why not bend the rules, at least in your mind? You'll soon discover this is what the most admired photographers do. Suppose, while on location to photograph a mountain biker, you notice dewdrops on a bright orange flower. Rather than pass over the poppies thinking, "It's out of my range...I'm a sports photographer," take the pictures of what catches your eye, unrestrained by genres.

In other situations, thinking outside of genre may involve a bigger mental shift. Fine art photographer and friend John Paul Caponigro was telling me one time about photographing the sand dunes in White Sands National Park in New Mexico. On his first few visits to the park he took pictures of the sand and nothing turned out. Months later it dawned on him. He had to photograph the sand as if it were water. He went back with this in mind and made some of his favorite photographs of all time.

Solitude

One of my favorite places is a hard-to-access surf spot north of where I live. Because it requires a boat, I don't make the trip often. Every time I go I think, "Why don't I do this more often?" When we're sitting in the anchored boat, the view from every direction is unfettered by buildings and people. The ocean is teaming with sea life and completely pristine.

When I travel to this location, I always go with friends. But I really go there to be alone. The simplicity and solitude of the empty horizon slows me down. As an active photographer I keep this in mind. Rather than hungrily devouring the sights, I take only a few frames. The majority of my time is dedicated to the experience of surfing in clear water while getting reacquainted with the place.

It is one of the rare places where I don't feel that I have to take pictures. Instead, I jump from the boat into the sea and the grime and dirt of self-focus washes away. After hours of catching choice waves, I'm back in the boat. Then I pick up my camera. I'm not there to take pictures limited to surfing. I want to document and capture what I feel. With this shift, the pictures become personal and are shaped by who I am.

If you want to create photographs that haven't been done, invest in yourself. People will tell you it is all about capturing the essence. I say capture the essence of what captivates you most.

If you want to create photographs that haven't been done, invest in yourself.

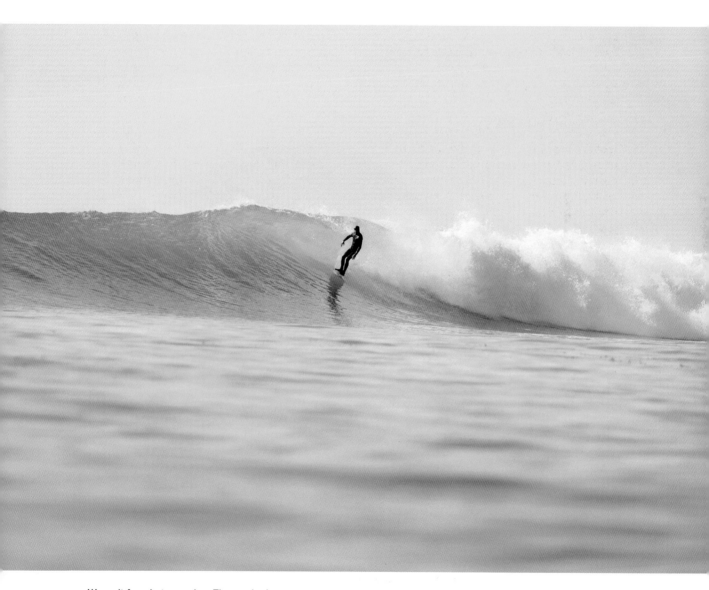

We wait for what we value. Those who have
discipline discover that patience pays off.

Hours of endurance training shape a world-champion ironman triathlete's legs.

What it can provide is the ability to see past the difficulty at hand. Resilience develops undefeatable doggedness, persistence, and perseverance to the end.

Resilience and tenacity are not formed overnight. They take time. The active photographer looks for an opportunity to create photographs that encourage us to endure. Such images remind us that strength and character take time, and they beckon us further down the path.

Endurance

Athletes and outdoor enthusiasts teach us about resilience, an often-overlooked and misunderstood trait. Resilience requires hard work. We confuse resilience with optimism, which mandates that we wear a happy face. Whatever our understanding, nothing gets done and our immobility is self-justified.

As the environmentalist Yvon Chouinard said, "There's no difference between a pessimist who says, 'It's hopeless, so don't bother doing anything,' and an optimist who says, 'Don't bother doing anything; it's going to turn out fine.' Either way, nothing happens." Resilience is the person who defies the odds. When he gets knocked down, he bounces right back, again and again.

Without resilience we wither and waste away. Resilience is something you *are* born with, but it needs to be fed to grow. And the best food for resilience is misfortune, challenge, and change.

Think about it for a moment. If we bounce back from something easy, are we really resilient? True resilience is the key. It is not about ignoring problems and it doesn't magically make them go away.

Style

What is it about style that is so compelling and cool? I remember first thinking about this while in high school. I was on the soccer team and watched lots of people play. Nobody had style and poise like Tyson. When he scored a goal it was like poetry. He wasn't statistically better than other players, but in my mind he was a better player because he had a signature style all of his own. What is it about style that lures us in?

Style is expression. It's close to creativity but contains more identity. Style is a result of who we've become. It is a small detail, a distinction that shows up when we take the typical and deal with it in our own way. As a result, style begets more style.

One of my favorite surfers is Tom Curren. He is one of the world's best, but his approach is simple, understated, and pure. He has more style than anyone else I know. A few weeks back I was surfing with Tom at a local break. I was riding my favorite surfboard, affectionately dubbed the Magic Carpet. At one point, I asked Tom if he wanted to trade boards for a few waves. He took off on the Magic Carpet and rode it in ways I couldn't even comprehend. I was inspired. After trading back, I caught a wave and my approach was new and alive. Seeing, or rather experiencing, his surfing style on my board gave me a new vision to extend my own.

Resolve, determination, and resilience have
made Chris Lieto one of the world's best.

We have all seen flowers with morning dew. By leaning over and getting close, we have a whole new view.

The best tour guides learn and then share. They get to know a location and use their knowledge to reveal otherwise hidden secrets. They make the invisible visible. And while the rest of the world walks by, the tour guide stops, studies, and soaks it in. This detailed approach deepens our experience.

The active photographer taps into this and makes images that connect with what we may already know about a place; then she tells us more. The details cause us to lean in and look again. They remind us of the value of small things. While this path may not be direct, it is beautiful. As Anatole France wrote, "If the path be beautiful, let us not ask where it leads."

Early Bird

Mornings are my favorite time of day. There is something wonderful about getting up before the rest of the world—the darkness, the cold, and the anticipation of light. I am one of those people who wake up alert, alive, and ready to go. And while we are all wired differently, I believe being a morning person hinges on a a choice.

As a young guy, I was asleep and under the covers. Unaware of the time, I was startled when my brother shook me awake and said it was time to get ready for school. I dragged myself out of bed and slowly got ready. I was in a bad mood. The next day, my brother shook me again. I replied, "I don't want to go to school." He responded, "What? Bro, today we're going skiing at Squaw!" I jumped out of bed, full of energy, and ready to hit the slopes.

I realized then that my "mood" was something that I could change. I had a say in the matter and being a morning person is a choice that I have fully embraced. It doesn't mean that getting up is always easy, but few of the best things in life come without a fight. Regardless, if you prefer to sleep in, as an active photographer set aside at least a few days

Details

Imagine that you took a trip to the Costa Rican jungle. You could wander aimlessly through the jungle by yourself hoping to see something, or you could hire my friend Neil. He is an adventurer and eco guide, and with him the jungle would come alive. "Listen. Can you hear that? Look up that tree. There's a howler monkey." He would use his local knowledge to guide you to a river. "Look at the colors of the tiny dart frogs sitting right next to that 12-foot crocodile. Those frogs are poisonous..." Neil would tell you stories and name all the plant and animal species. It would be an unforgettable trip.

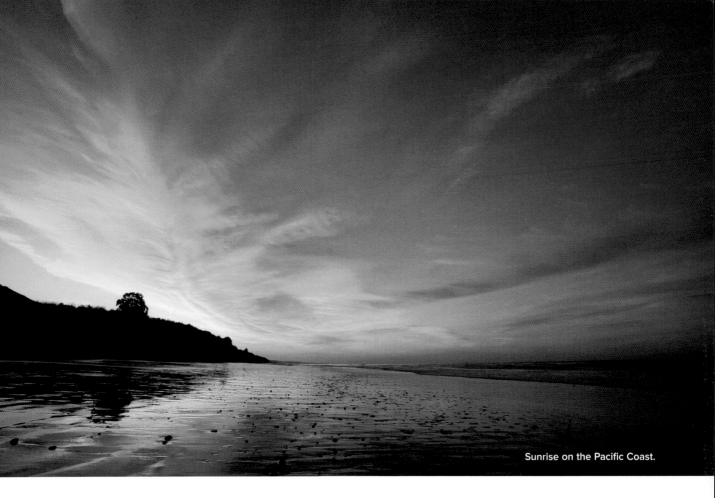

Sunrise on the Pacific Coast.

to get up early. The sunrise is never the same and seeing it rejuvenates the soul. Some will say, "Why not just take pictures at dusk?" Sunset is a wonderful time, but certain scenes look best before all of the people have arrived.

Suspended

Time flies and cameras help us capture motion in a wonderful way. Almost every outdoor film has at least one slow-motion scene; whether it is the surfer catching a giant wave or the hummingbird caught midflight. I like to think of such slow-motion visuals as the ones that mirror the metronome of breath and heartbeats.

Think back to the last time you had an experience when everything slowed. Typically, these are the adrenaline-filled events that cause your heart to beat out of control. As your heartbeat quickens, it is as if the whole world slows.

I remember paddling into one big wave. I held my breath and paddled as hard as I could. My heart was pounding but it was as if time stretched so I could experience one beat at a time. I saw every drop of water, the entire 15-foot-high wave, the wipeout, and the impact of the wave that broke my rib. I was held under water and then my memory sped up as I gasped for air.

Even as I write this memory, I'm unconsciously holding my breath, only exhaling as I type "gasped for air." Why is this pause in time our experience?

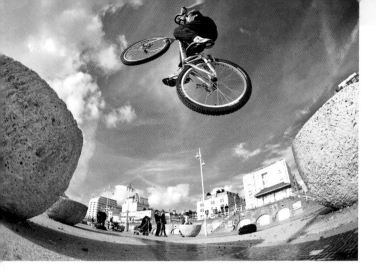

With the camera resting on the ground and pointed up, this perspective adds a bit of drama to the cyclist frozen in midflight.

Need for Speed

Spin your head from side to side and your vision will blur. Hold out your index finger at arm's length, focus on your finger and spin around. The finger stays in focus while the background blurs. This is exactly how our eyes see motion and speed when we are active in the great outdoors.

This disorientation is exciting and invites the viewer into the action. And motion can be used in many ways. In some situations, motion is pure acceleration and exhilaration. Other times, the fuzziness of time slows and the speed takes on a new conceptual form.

I was on assignment photographing Trek mountain biker Travis Brown. Travis thrives on long-distance all-night races. He is lean and mean. In just a few minutes I took a whole series of shots that were strong. I got everything I needed—good composition, clearly visible sponsor logos, and a cool look. I asked Travis to do a few more passes, as I wanted to have more variety and add some blur.

Is it conditioning due to watching movies, or is it the way our heart works? I don't know. But what I do know is that we love moments of action that are slowed and then frozen in time. With time suspended, we hold our breath, watch, and then wonder how and why.

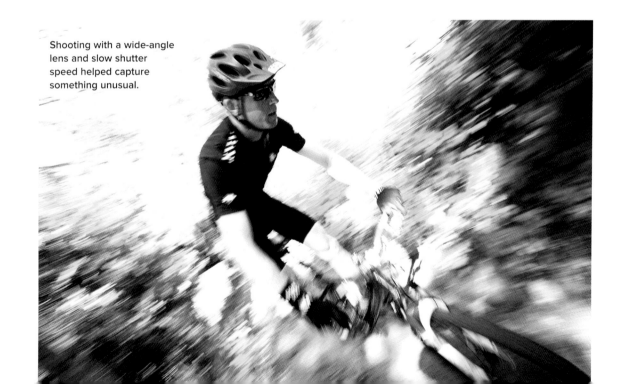

Shooting with a wide-angle lens and slow shutter speed helped capture something unusual.

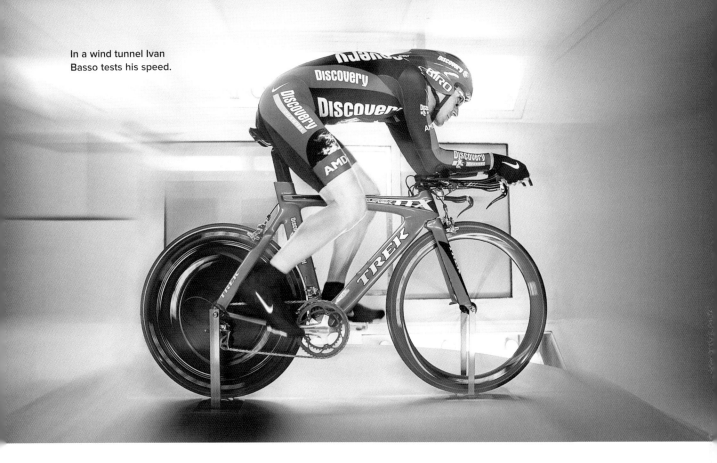

In a wind tunnel Ivan Basso tests his speed.

Inside Out

Wind tunnels are interesting. They are used to test aerodynamics and speed. The first time I visited one I saw state-of-the-art road bikes and ballistic bombs stacked side by side. It was quite a sight. Before I arrived, the crew at the wind tunnel had finished testing the bombs. I was there to photograph and document the aerodynamic testing for a few top athletes.

First it was Ivan Basso's turn. At the time he was considered the fastest competitive cyclist in the world. He set up and a team of 12 specialists gathered around, each contributing something from his or her field. A Stanford Ph.D. in biomechanics began with some ideas. A roar of conversation and study ensued. Positioning and gear were modified again and again. Prototype bike parts flown in from around the world were swapped in and out. Even the helmets were hand delivered by the world's leading helmet designer. This swirl of activity went on for a while. Finally, a warning light was issued and everyone cleared out. Alone inside the tunnel, Ivan started to pedal as the 20-foot-high turbine began to spin. Like at an aquarium, we watched through the glass walls. Once Ivan was at full speed, the effort and analysis began. I was in awe.

I slightly slowed my shutter speed, pressed the camera to the glass, and captured a frame. While I have other good photographs from that day, this one stands out from the rest. The collaboration of color, blur, and motion somehow worked together to become an outward expression of what I felt on the inside.

Practical Tips

Get Healthy and Stay Active

Top outdoor photographers regularly get outside. They eat healthy foods and stay fit. These photographers are in shape not because they have to carry their gear but because it makes them feel more engaged.

The more life they have, the more life will be found in their photographs. For the sake of your vision and photographic vitality, do whatever it takes to amp your fitness level up a notch. If you've been sitting inside on the couch reading this book perhaps it's time for a break. It's always much better outside.

Start with Shooting the Preparations

Adventures begin long before you hit the trail. There are maps, planning routes, and shopping at stores. Then the packing, and of course hurrying out the door. As an active photographer, take pictures of it all. Not only will this get you in the mood, it will help make your camera part of the tale. Others will get used to having you and your camera around. Photographing the story throughout sets you apart as one of the few who can tell the whole tale.

Understand Time to Anticipate Action

Deconstructing time and how it passes can help you capture those who are engaged in sports or outdoor adventures in a meaningful way. You need to ask, why does time fly, and what does that mean? I think it has something to do with memory. When we forget all the details of life that have occurred in the midst of an experience, we can't believe how much time has passed. Thus time flies out of our reach.

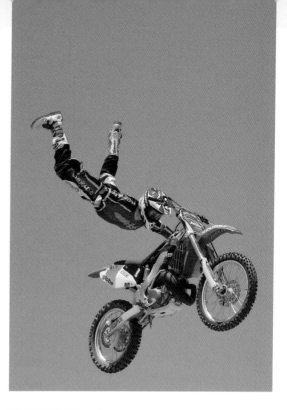

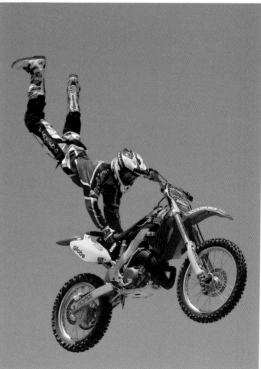

As you think about time, you will start to see it anew by noticing rushing water or a human propelled through time and space. And by developing your awareness and isolating with the frame, you can start to capture new moving events as they unfold. In more specific terms, you can use your camera to anticipate action and make the world come alive with a sense of motion. These photographs can then act as "memory points" that make time's flight slow down.

Shoot in All Kinds of Light

Connoisseurs build up expert experience with fine arts, food, or wine. They have a great sense of taste and a high standard of quality. But as their sensibility flies high, they can sometimes overlook the sweetness of the simple. This happens all the time with photographers and light.

Photographers become so familiar with the quality of light that they pontificate and brag, "I never shoot except for sunrise and sunset." Such photographers miss out on so much. They will never capture the geometric shapes, harsh shadows, and direct lines that occur only at noon. I say, rather than just dawn or dusk, delve into all 24 hours of light. Each is wonderful in different ways.

In other situations, quality causes overfocus so that we miss the whole scene. We carefully set up and take pictures of the sunrise and sunset. Yet we forget to turn around and see what else is going on behind us.

The sunrise or sunset is easy and obvious; there has to be more. And there is, for it's not just the sun but what it lights with its mysterious rays. In fact, I know one famous nature photographer whose best photographs are created by intentionally turning his back to the setting sun.

In any type of light, I encourage you to develop the habit of looking over your shoulder and being open to surprise. Don't let your sense of quality limit or stifle your creative potential.

> Rather than just dawn or dusk, delve into all 24 hours of light. Each is wonderful in different ways.

After the Sun Goes Down

When I was a child and the Northern California nights were warm, my mom, dad, brother, sister, and I would camp in the backyard. We would pull out our sleeping bags and set up on the large redwood deck. I have fond memories of lying there, listening to the night and watching the stars just a few feet from our house.

For the active photographer, memories like mine are built all the time. Getting out at night with tripod and camera is a treat. The night is like a blank canvas full of possibility. Long exposures reveal motion, star trails, and more. Plus, the lengthy exposure time gives you a chance to slow down, listen, and really absorb what's happening around you.

Capture the People and Their Gear

Sport-specific and general outdoor magazines are chock-full of gear guides and professionals' reviews. We're drawn to gear and to those who use it. Outdoor enthusiasts relate to their gear in interesting ways. This relationship reflects who they are.

Take time to photograph athletes and their tools of the trade. There are so many ways to make this happen—on location, in a garage, workshop, or just passing by as athletes prepare to start a race. If you're feeling even more creative, stage something and arrange the gear so that it envelops an athlete on all sides. Whatever your approach, don't miss out on capturing people and their gear.

Photograph Athletes in Repose

Athletes and outdoor enthusiasts have incredible energy. The more active you are, the more energy you maintain. It is easy to spot an athlete from a hundred yards away; the way he carries himself, the way he moves, his composure and confidence. Athletes look different. Step a bit closer and it becomes more pronounced in his eyes and face.

Athletes are typically photographed amidst the action. Don't miss out on their moments of repose. Relaxed and rested, the athlete's kinetic force remains full. Candid is best, as in this photograph. After a day of skiing, Travis and Holly were standing close by the door. I swung my camera around, they briefly looked up, and I took the shot.

Holly and Travis revitalized after a day of skiing.

Frame Athletes Out of Their Element

Do you remember as a child seeing a favorite teacher out at a store? It was a shock—how could she be here? In your mind, her whole world was the classroom, and that's where she belonged. Seeing her out of context was curious, confusing, and kind of cool.

The same goes for athletes and outdoor adventurers. We know where they belong. When we see them out of context it quickens our view. Once, I remember going over to the house of a celebrity athlete I had seen only in posters and on award podiums. The athlete was in the backyard wearing old clothes. He was wrestling with a lawn mower trying to cut down waist-high weeds—if only I had my camera ready that time!

Simple, subtle, and perfect style.

Context communicates and we can use this in interesting ways. As a creative photographer, look for locations and situations where you can capture outdoor enthusiasts and athletes out of their element. At times the juxtaposition of athlete and place gives us something different to see, like this photograph of triathlete and ironman champion Chris Lieto.

Capture Individual Style

Those who are drawn to the outdoors are a colorful bunch with bright-colored clothes or bandanas, big beards, or tattoos. Active people generally don't give in to the pressure to be "normal." Action teaches you that life is too short. As an active photographer, work to capture the many varieties of personality and style. Sometimes this means photographing what you see. Other times it means using gear to create a spin of your own.

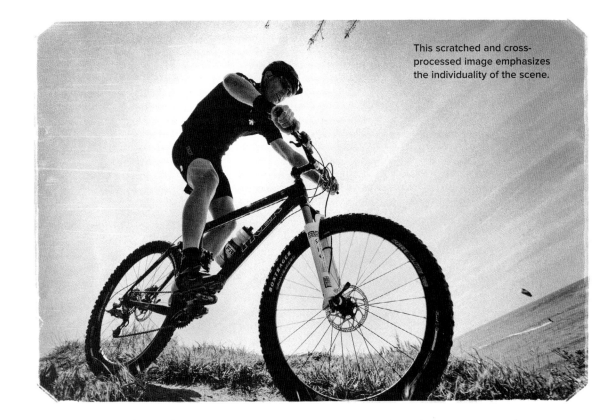

This scratched and cross-processed image emphasizes the individuality of the scene.

Gear at a Glance

Gear isn't something to be polished and kept in a glass case. Rather, as an avid outdoor photographer your gear is meant to be used. To make great pictures your gear will get dirty, damaged, and wet. Make sure to have insurance and bring what's appropriate for the task at hand. Approach your adventures knowing that eventually something will go wrong.

With these thoughts as the backdrop, buy a couple all-weather backpacks that allow you to move. Get one medium and one large. That way if an adventure requires less gear you can move more nimbly with a smaller pack. The two I most frequently drag up mountainsides are the mini and regular Lowepro all-weather models. Whatever you end up choosing, find something that fits well, stays on tight, and isn't cluttered with unneeded bells and whistles.

When traveling light, I bring minimal gear. For lenses I'll choose a 16–35mm wide and a 70–200mm zoom. These will more than cover the bases, and limiting my choice of lenses helps me "get in the zone." Without unnecessary options, you are forced to work with what you have. I find that this refines and strengthen what I see.

Be Prepared with Your Gear

As a photographer in the outdoors, being well prepared is paramount. Beyond your camera, here are a few tips to help get you ready. If your camera bag isn't waterproof, bring a sturdy plastic trash bag. Fold the trash bag and then use heavy-duty rubber bands to compress it small. Both the bag and bands will come in handy. Next, include one of those plastic shower caps you get in hotels. Stretch the cap over your camera when there is intermittent rain. This is especially helpful when you are using a tripod and don't want to have to reset everything just because of a little rain.

Invest in extra batteries and battery chargers. In addition, buy a battery charger or outlet that can be plugged into a car cigarette lighter outlet.

Operating a camera in cold temperatures can be difficult without proper gloves. Buy a pair that fits tightly so you can still use all the controls. I never leave for a cold climate without a pair of Mountain Hardwear Power Stretch gloves.

Plan for the worst and include any repair supplies or tools you might need. In my camera bag I bring a medium-size Leatherman multi-tool, an Allen wrench set, and a small flashlight.

Finally, nothing is worse than "hitting the wall." This happens when you haven't hydrated or eaten properly and you become extremely fatigued. I rarely regret bringing along some water, Power Bars, and Power Gel. Sometimes I use the supplies, and other times I pass them on to athletes that are in need.

While some of these tips seem obvious, you'd be surprised how many people forget photography requires preparation and a great level of endurance. Work hard to never be caught off your guard.

Workshop Assignments

Survey

There are many ways to have adventures outdoors. The range of activity is as diverse as the people who play in this realm. There is always more to learn, discover, and explore. Below are a few select links to the sites of past students, friends, and colleagues who will help you begin to build up your photographic skill in this area.

VISIT: www.coreyrich.com

Corey Rich is so good it is ridiculous. He's a globe-trotter with a golden eye and gregarious grin. Once you visit his site it will be hard to stay inside.

VISIT: www.patitucciphoto.com

Patitucci Photo is the collaboration of a husband-and-wife team—Dan and Janine. The Patituccis are adventurers, and their photography has a signature style. I admire the pictures these two make.

VISIT: www.ralphclevenger.com

Ralph Clevenger grew up in North Africa, studied zoology, and became one of the best photographic teachers at Brooks. His outdoor photography is full of vibrant color that triggers emotional response.

VISIT: www.dcollierphoto.com

Dave Collier is an award-winning landscape and travel photographer who is known to create stunning and vivid photographs.

VISIT: www.georgelepp.com

George Lepp is one of North America's best-known contemporary nature photographers. His passion for natural beauty and environmental responsibility is revealed in his beautiful and compelling images.

VISIT: www.auroraphotos.com

Aurora Photos is a large-scale stock agency specializing in outdoor adventure, lifestyle, sports, travel, cultures, and journalism. Go here to get specific ideas; use the advanced search tool.

VISIT: www.turnerforte.com

Turner Forte is the combined talent of husband-and-wife team James and Courtney. They are wonderful people and have a great feeling for the outdoors. At their site you will find an engaging portfolio along with a stock photography site.

VISIT: www.walteriooss.com

Walter Iooss is one of the legends of sports photography. He has worked with *Sports Illustrated* for over 45 years and has photographed over 300 types of sports. I guarantee you've seen his photographs; you just didn't know they were his. While not all of his photographs are outside, those interested in more traditional sports will find his work a great source of inspiration.

VISIT: www.davehomcy.com
www.lowtiderising.com
www.soensphoto.com
www.jeffdivinesurf.com

As a surfer I couldn't resist including a group of surf-related photography sites. While you may not photograph surfing, I hope this set inspires you to begin to collect links to sites that showcase a particular type of photography. As you will discover with these sites, many of the photographers take pictures of the same thing, but they all do so with a style of their own.

Shoot

Spend some time with your camera and get outdoors. Use these assignments as a way to challenge yourself and develop new skills.

1 **Turn Around at Sunrise**

 Pack your camera, tripod, and a snack. Get up early and travel to a location where you have never been. Then take pictures at sunrise. Here's the catch—you can't shoot anything that includes the direction of the sun. Turn around and take pictures with your back to the light. Begin shooting the moment the sun clears the horizon. Press the shutter ten times—no more, no less. You goal is to create ten beautiful images where the subject is light.

2 **Scale that Overwhelms**

 The goal of this assignment is to show grandeur and scale. The task is to photograph a person so that he or she is the central subject matter. Do this in a way where he is dwarfed by his surroundings. In other words, create photographs that would not be complete without a person in the frame, yet let the frame fill out and tell the story. You goal is to create five images.

3 **Blur to Show Motion**

 Motion blur makes a photograph come alive. The thrust of this assignment is to do a study of speed to learn what can be done. Find an ordinary location and ask an athlete to come along. Lower your shutter speed and pan your camera with the subject as she runs, bikes, jumps, or kicks. Your goal is to use motion to make the ordinary extraordinary. Take at least 75 photos while changing your camera settings and the athlete's activity. Edit the set of photos down to the ten best.

4 Shoe Perspective

This assignment will help deepen your appreciation of perspective. The task is to shoot 30 photographs of three different athletes from "shoe perspective." In other words, take photographs only from a low position or lying down on the ground. Include the athlete's shoes and feet in the frame. Before you begin visit www.patituccistock.com and do a search for "shoe." Use these photographs to set your sights on what can be done.

5 Color Quilt

The colors of the outdoors abound: red leaves, orange pumpkins, yellow sandstone, green moss, blue water, purple plants. Your assignment is to photograph nature in a way where color is the primary theme. Set aside one hour and go out on a quest for color.

Take pictures where you fill the frame with color. As you shoot keep in mind that the ultimate goal is to create a ten-by-ten grid. After shooting, print the photos and position the images side-by-side. The result should resemble a colorful quilt made by all your different frames.

Share

1 Cards

Good outdoor photographs can go a long way. You just have to find the right context. And one of the best is cards. Why not make your own? Visit www.moo.com and upload your images to order sets of postcards or greeting cards. The price is affordable and the quality is nice. Be sure to include your information somewhere on each card and then begin to give them away. Send some my way and I'll include some snapshots on our companion

Web site: www.visual-poet.com. And when you pass off a stack of cards, people will be glad for the gift. In that moment, ask them which cards they like best—it will be a great source of feedback and praise.

2 Flickr

In order to share your photographs on a broader scale, share them on the Web. Post your set of photos to the Flickr group for this book. You can find the group at www.flickr.com/groups/visual-poet. When you add your photos to the group, be sure to tag them with the appropriate assignment info: Chapter 9, assignment #3, Blur to Show Motion. On Flickr we can view and comment on each other's photos. I'm excited to see what you come up with and I will try to stop by and leave comments myself.

Review and Respond

After you've finished the assignments, take some time to sit down and write out the most important thing learned from each one. In other words, distill your experience into a phrase. Next, write down what went wrong, what went right, and why. Finally, strategize about what comes next. Perhaps you need to organize another adventure or just take a simple walk outside. Whatever it is, do what you must to seize the day. Life is too short for living any other way.

Have I convinced you to get outside yet? I hope that the call continues as you create compelling photographs, which inspire others to do the same.

Guest Speakers

Ralph Clevenger

Ralph Clevenger's approach is simple and alive. He's more than the sum of his parts; adventurer, pragmatist, scientist, environmentalist, athlete, artist, and world traveler. Ralph is a friend, colleague, and mentor; someone who I strive to emulate. For more information visit: www.ralphclevenger.com.

What inspires you?

There's a lot of *who* in the *what* of this question. I'm inspired by people. I'm inspired by places. I'm inspired by photographs and paintings and videos and movies and books, and by a few other things, too.

When I was a little kid I wanted to grow up and become a marine biologist so I could explore the ocean like Jacques-Yves Cousteau. What he and his crew did inspired me to choose a life involving the outdoors and adventure. My dad inspired me by taking me skin diving, camping, and fishing. Teaching me how to tie knots and whittle a stick, how to build a fire and pitch a tent. How to cast a fly into an eddy and clean a shotgun. Dad would document our adventures with an old 8mm movie camera and edit short films to share with friends and family. It became obvious later that his filming was inspiring me, too.

Photographers like Pete Turner, Ernst Haas, David Muench, Jim Brandenburg, Craig Aurness, Douglas Faulkner, George Lepp, and Ernest H. Brooks II have all inspired me with their images and their words.

Sitting quietly in wild places inspires me. Sometimes I'm far from home—on a rock hill in Tanzania, or the bow of a ship in Antarctica, or beside a lake in Alaska. But many times I'm a few steps out my front door in my wife's garden after a spring rain.

Light inspires me, especially the light after a storm, when the sky is still confused and can't decide whether to clear up or keep storming. The sun breaks through, turns the air pink, and I get really inspired.

What makes a photograph good?

A good photograph needs only a few things. It needs a subject—anything can be a subject—but good photographs aren't a puzzle where you have to wonder what the photographer saw or wants you to see. A good photograph needs to use lines or shapes that work with the universal laws of design and balance—you know, all that golden mean stuff. And that's all it needs, nothing more. Keep it simple. It's pretty intuitive: You look at a photo or painting and you feel something; tension, calm, awe, excitement. That's a good photograph.

What character qualities should the photographer nurture?

Be stubborn, persevere, and keep working at it until it's right. Do it over. Be human. Realize that you're not just a recorder of things but a participant. Be sensitive to your subject, whatever it is. Be creative. Don't be afraid to fail or you'll never get better. Have fun; it's not brain surgery.

What is your advice for the aspiring photographer?

Learn the craft, read the manuals that come with your gear, and test and practice with your equipment. You have to know your equipment so well that you don't even think about it. Only then can you concentrate on making great images.

Read the books, blogs, and Web sites of other photographers, artists, filmmakers, and businesspeople. People are very willing to share what they know. You need to interact and learn from like-minded people to move forward. Take workshops and go to seminars; become part of the community.

Do what you love. If you love fashion photography, get involved with fashion; learn makeup, work at a modeling agency, sell clothes, study fabrics. If you love sports photography do sports, participate as a player, shoot peewee football, high school tennis, work at a sports store. If nature photography is what makes you happy, go hiking, volunteer at a state park, repair trails, work at the zoo, get involved with animals and conservation. You have to live it to photograph it better than everyone else. Don't give up.

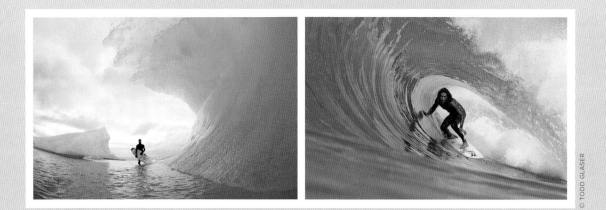

© TODD GLASER

Todd Glaser

Todd Glaser's handshake is strong and his smile is broad. With a sparkle in his eyes and a down-to-earth tone, he is talented beyond his years. For more information visit: www.tglaser.com.

What inspires you?

For me inspiration is completely dependent on the mood I am in. Whether it's from the music I am listening to, books I have read, or the places I have been, I feed off the energy of the people around me.

What makes a photograph good?

To me a good photograph evokes emotion and tells a story.

What character qualities should the photographer nurture?

Be confident yet humble, work hard, but have fun. Build good relationships. Be willing to go with the flow and still get the shots you want.

What is your advice for the aspiring photographer?

Be passionate about what you are photographing and never stop learning. Don't be afraid to push yourself. Everybody makes mistakes, but it's what you learn from them that helps you in the long run. Put yourself in uncomfortable situations and see what happens when the images come out.

Never stop shooting!

FOUND OBJECTS AND SUBJECTS 10

FOR SOME OF US, our drive to discover has been lost like a set of old keys. We get used to life as it is and follow the same old rut each day. Sometimes, the monotony of life seems a bit insane.

Albert Einstein said, "Insanity is doing the same thing over and over again, expecting different results." Discovery won't happen if you drift along. If you seek, look, listen, and delve into the mysteries of life, discovery will fuel a new vision. What was once lost is found and you'll be able to use that old set of keys to open new doors.

Found photography is an approach of pursuing colors, patterns, details, or subjects in new locations or accidental arrangements. You may find great inspiration in the midst of disarray, or notice something new that you've never seen before. The point is to explore with your eyes and your heart and look for opportunities beyond your routine and outside your comfort zone to make compelling photographs.

Swept Away

Are you ready to discover and gain more? Start with a walk, and you may be lucky enough to get lost. Walking seems innocuous and safe, but J.R.R. Tolkien wrote, "It is a dangerous business…going out your door. You step onto the road and if you don't keep your feet, there's no knowing where you might be swept off to."

Walking with a camera in hand is part of the photographic tradition. Whether on city street corners or sandy sidewalks, photographers have always loved to walk. It is both simple and profound. Walking has led to many of the world's greatest photographs.

Because I like walks, I hang my camera by the side door. It dangles from a hook next to well-used backpacks, jackets, hats, and the old dog leash. When I see the camera, it looks at me like a puppy dog, whimpering and pleading, "Please, can we go outside?"

When you have a dog, she persuades you to go for a walk. I've wondered, is it the human walking the dog or the dog walking the human? Perhaps it is a bit of both. While you can restrain and direct with the leash, dogs like mine have a powerful tug of their own. Excited by a scent or a cat, sometimes she gets away. Chasing her down I get disoriented and lost. We usually find our way back.

When walking with camera in hand, I lead the way. But my camera drags me this way and that just like my dog. I lose track of time and place. Absorbed by the colors, sights, and sounds, I quicken my steps, and I am swept away by it all.

Image Maker, Image Taker

Finding photographs requires loosening your grip on what feels like home. Being open to surprise will help lead you. At Brooks, where I teach, I find that the students who can make or set up the best photographs also have the hardest time finding them.

Many of us enjoy the comforts of control, whether creating conceptual ideas in our mind or making pictures in a clean and controlled studio. Using our technical skills and in our comfort zone, we can make amazing photographs happen. But sometimes when we attempt to go out and find an image, the disorganization and lack of control overwhelms us.

Learning from photographers like Elliott Erwitt helps. He said, "You can find pictures anywhere. It's simply a matter of noticing things and organizing them." This begins to make a dent. Rather than organize what's in front of the camera, to our surprise, it can be done the other way around.

As we learn to notice and to use camera techniques to organize the scene, we improve our skills. In other words, by finding photographs we become both better image makers and better image takers.

Improve your vision as a photographer by letting the subject matter find you.

Keen

Right now, my two daughters adore everything related to princesses: toys, books, movies, dress up, and more. What they love shapes what they see. I'm constantly surprised by their keen eyes. The other day I was running fast along a beach path, pushing them in the jogging stroller.

All of sudden they both yelled, "Look, Cinderella!" I looked but didn't see a thing. They pointed again and I still didn't see. Finally, two blocks ahead of us in the midst of a crowd I spotted a girl wearing a Cinderella T-shirt.

To find photographs and to really see, you have to appreciate and care about something. Once you start to care about moments, colors, shapes, lines, or forms, you will see them everywhere. In turn, as you see more, you care more until ordinary things become beautiful. As Jean Anouilh said, "Things are beautiful if you love them."

Green Grass

It is easy to discover visual interest and beauty on some far and distant shore. We fall prey to "if only" thinking: if only I lived there, if only I had that camera, if only I packed that lens. "If only" thinking is a downward spiral that leads us to inactivity—we fade and dry out.

As the cliché goes, the grass is always greener on the other side of the fence. I've often wondered how did it get so green? The answer is simple: lots of bright sunshine, blue water, and consistent care. If you want your context to be verdant and alive, it's up to you.

Like sunshine and rain, photographers make a place come to life. That's why being a photographer is a delightful task. And while there is a place for what is staged and set up, I'd rather photograph something that occurs on its own. This sharpens my eyes and reminds me that good photography, as Elliott Erwitt said, "has little to do with the things you see and everything to do with the way you see them."

I was intrigued by this row of statues and watched as one woman leaned in nose to nose. I quietly said, "Eureka!" and quickly pressed the shutter.

Eureka!

Occasionally, after I tell someone that I'm a photographer they say, "Wow, that must be hard. It seems like all of the pictures have already been taken." I always think to myself, sure, but they haven't been taken by me.

In fourth grade, my class visited the gold country in Northern California. Dressed up like miners, a guide took us to a river to pan for gold. After a few minutes, my friend Doug suddenly shrieked, "Eureka!" He wasn't sure what he'd found, but everyone crowded around to stare at the shiny rock. The guide sauntered over and said it was most likely fool's gold. Then he picked it up and with widened eyes the guide said this is true and pure gold. The class was in a frenzy.

The gold nugget was tiny and not worth much. We had seen similar rocks for sale in the tourist store. But Doug's gold was one of a kind, priceless beyond compare because he found it. It was his treasure.

The same is true when you find a photograph. The best ones are like gold hidden in the ground. They don't surface on their own. You have to search with patience and persistence. Whenever I see one of those treasures within the camera frame, I push the shutter and remember Doug. When I say "Eureka!" out loud, I get some strange stares. When you've just discovered gold, who cares?

True

Photographing a well-known place is a challenging and rewarding game. Approaching the scene is exciting, and then we become aware of the obvious shots that are embedded in our memory. Like a bad song we desperately want to forget, the typical views and angles lure us in. The challenge is invigorating. How can we create something new?

I had a new camera and needed to break it in. I could have chosen something easy, but I decided to visit the Santa Barbara Mission. The location is beautiful, but it is as obvious as it gets. This was my challenge. Tourists visit by the busload. Taking my time, I worked to create some unique frames.

Back in my office, I was opening the photos as a student walked in. He stopped, looked, and looked again. He said, "Those are the best photos of the mission I have ever seen." While I appreciated the exaggerated praise, I didn't want this teachable moment to slide by. "Why?" I asked him.

Anyone can have an opinion. One of the signs that a student has arrived is when he can say why a photograph is good or bad. This student responded, "Well, that one surprised me. It's original. It's the only nonduplicate image of the mission that I've ever seen."

Some things are so obvious they become trite. Like leaving for work and saying to your partner, "I love you." Yes, the "I love you" is true, but it isn't expressed with much thought. One morning I said, "Kelly, you are like sunshine that fills our home. You are my soul mate, companion, and friend. I love your strong character, elegance, and grace. You are athletic and musical. I want to grow old by your side." As a photographer, that is your task; to say what is true, but to say it anew.

Action

Clint Eastwood's rough and authentic approach has made him an actor and director of immense fame. As a director he takes an interesting approach. Typically on most movie sets, someone slaps the clapboard shut and shouts, "Action!" Clint found the slap and shout a bit abrupt as an actor. With his movies the film rolls when he quietly says, "You can begin when you are ready." Rather than jump-start the scene, he lets the acting naturally unfold.

The best photographers don't start or stop a scene; they let it unfold. Like a chameleon they naturally blend into the background. As a director they trust the actors and without making a big deal, they let them play their part. The photographer is there to capture, participate, and observe.

After the crowds cleared, the street performer set out this sign.

Outside In

During a visit to New York City for the Fourth of July, the spirit of celebration filled the hot summer air. There was music, dancing, street vendors, performers, and ethnic foods. On that particular day, the city was an enormous stage.

The scene was so cluttered and busy it was difficult to know what to frame. I stepped back, put my camera away, and tried to take it all in. What would make a good subject? I remembered what Henri Cartier-Bresson said: "In photography, the smallest thing can be a great subject. The little, human detail can become a leitmotiv."

I stepped back into the swell of activity, but my vision was secure. Instantly, I started to notice the most fascinating small details—from the way people walked to the multicolored trash. Gesture, light, color, and theme were everywhere.

Finding photographs requires that you step back. This intermission from all the activity helps clear your senses and gives birth to new ideas. You ponder how someone else will see the frame without experiencing the event. Others will view your photographs from the outside in. You can compose and frame to tell a slice of the story, and that's all the story they will know. Do this well and that slice can connect and transcend both time and place.

One of a Kind

Every day we walk a distinct path. What we see, how we respond, and who we interact with is completely our own experience. Each of us is one of a kind. And finding photographs depends on realizing how distinct we actually are. If you can tap into what makes you different, what sets you apart, you can begin to find photographs that will be completely your own.

For example, I was speaking at a conference in Brighton, England. Before the conference began, I needed to do a sound test, so I walked on stage and the view was surreal. I seized the moment. Using the self-timer I ran and sat down so the picture would have scale. While many people took photographs at that event, no one else had anything taken from the stage.

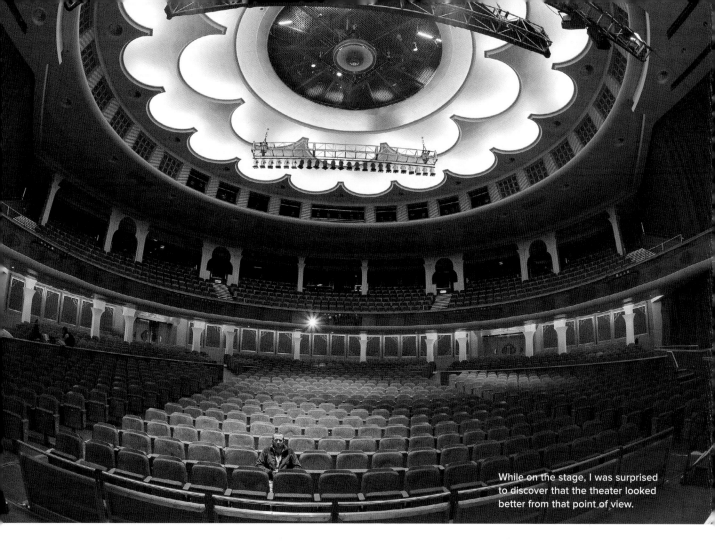

While on the stage, I was surprised to discover that the theater looked better from that point of view.

Sideways

The searching photographer realizes that in addition to one's own distinct course, there's more. Rather than walk the beaten and well-traveled path, they take risks and travel sideways, looking for another way to see.

I was excited to visit Austin, Texas. I had heard it was a music-filled, culturally eclectic, and vibrant town. When I arrived, everyone kept recommending that I walk down the main street with all the restaurants and bars. After the fifth recommendation to do this, I knew exactly where I needed to go. Main Street was my goal, but there was no way I'd take the recommended route.

Turning sideways, I found an alley on each side of the street. Every 20 feet I took another picture. The photographs of the alley were less particular and thus a bit more profound. Like a good poem they told an abstract tale. Later, I enjoyed walking down the main street and through the rest of the town seeing the typical sights. As I look back on that visit, my favorite photographs were taken in the alleys, where the tourists dared not tread.

The perfect photograph may only be a few feet away.

Plot

Sometimes gaining a new perspective is as simple as changing your own. Whether by switching up a lens or your point of view, quickly finding new story-filled photographs is an important skill.

It's funny how we drive right by beauty and visual interest just because it is close to home. On a trip if you notice something beautiful you stop right away. I had driven by a rustic church near my house dozens of times. Each time I absorbed the sight of the arches and the old wooden doors. Finally, I realized my oversight and pulled over to make a few photographs.

I walked into the courtyard with my camera and wide-angle lens. The first thing I noticed was a small fountain and a statue of a man frozen in an interesting pose. I captured the first frame but was too far away, so I walked closer.

I was attracted to the birds on his sleeves and how he looked to the heavens. Without knowing much about this saint, I captured another frame from behind that felt like a glance into a private moment of communication. This made me wonder what it would look like from above. Standing on the edge of the fountain I pointed my camera down from the heavens. I could identify with the expression; a perfect mixture of peace and an honest plea. I pressed the shutter and captured the last frame almost feeling like I could hear his thoughts.

The three good photographs were made only a few feet away, yet they couldn't be more different. Each one is true, yet unique. Involving yourself in a plot like this is a great way to learn. It refines both vision and technical skill.

Night

Night falls and photographers put their camera in a bag. But hidden by darkness, you can work unnoticed and the most illuminating and intriguing scenes will unfold.

On one trip, I was on a one-day layover in London. I was ecstatic to hit the pavement and make photographs to my heart's content. After a full day, I was exhausted. My feet ached and my eyes were a blur.

Rather than throw in the towel, I sat down and sipped some soul-soothing tea. Rejuvenated, I began to wander and got lost. With no sense of direction and no place to go, I settled into a healthy pace. The city was bustling and each time I turned a corner I discovered a whole new world.

Around one corner was a Christmas market. I set up my tripod and waited. I made a few frames, but the photos needed the human element. A group gathered by the merry-go-round. Then one Christmas shopper walked fast across the street. Turning to notice the merry-go-round he abruptly stopped and stared. I pressed the shutter release and gloated to myself. I got the shot!

But he didn't walk away. He looked forlorn and watched the kids spin around and then watched as more got on and then off. He continued to stand

and watch. Like me he stared at the scene. We were together but miles apart. It was obvious that he was sad. Eventually, it was my time to go. I looked over my shoulder and saw him standing there alone.

Photographing at night softens my soul. Being outside and looking at the illuminating glow of restaurants, buildings, and homes makes me long for my home and being on the inside. A good dose of night photography takes off the edge. It reminds me that photography changes who I am.

Practical Tips

Try Simple Color Combinations

The first step in learning about color is accepting that there is no such thing as correct color. Like a person's personality, there isn't some uniform ideal. The way colors relate to each other activates the mind. For example, warm colors (red, orange, yellow) tend to be vivid, bold, and energetic. Cool colors (blue and green) tend to be soothing and calm.

If you can find photographs that have both warm and cool tones, it will be a home run. The contrast will activate specific cells in the eye—the warm color will be noticed first while the cool tones recede to the background. The color combination is like a pair of amicably volatile and close friends, where each person brings out the best in the other. The color relationship is complementary and on the color wheel, the colors sit opposite each other.

A more subtle color relationship to look for is called analogous color. This is the relationship that is described as "two peas in a pod." If you photograph an open pea pod, the variety of green colors are analogous. The more common example for analogous color is fall leaves. One tree will be covered with muted reds, oranges, and yellows. While the colors are distinct they are all from the same palette; they belong together. On the color wheel, the colors sit next to each other.

Color creates mood, emotion, and effect. In addition, the mind uses color to organize the scene. If the color is too cluttered or complex, the mind moves on, unable to make sense of the scene. If the color is too simple, the mind will not be engaged and will lose interest. When searching for photographs, aim to capture color combinations where all the parts are arranged in a interesting way. This will capture and captivate the mind.

Create Juxtapositions with Unrelated Objects

Las Vegas is a curious city. It is the second most visited place in the world. It is a city of extreme contrasts: poverty and wealth, kitsch and high class, green golf courses and the dry desert. It is the perfect place to find photographs that are juxtaposed.

Juxtaposition involves positioning people, props, colors, shapes, and objects side by side in an unexpected way. The contrast creates visual intrigue. Photographers hunt for anything juxtaposed because they know these photographs will be unforgettable. On a recent trip to Las Vegas I decided to walk away from the main strip. Within a few blocks I was in a dry and desolate plot. I saw trash and abandoned car parts and the contrast was shocking, so I composed a few frames, which perfectly captured the feeling of that moment.

So what is the most traveled-to place in the world? The answer is Mecca. This difference between the East and the West, Mecca and Las Vegas, is startling to me.

Cropping in on one letter from this old neon sign enhances the vivid color relationship.

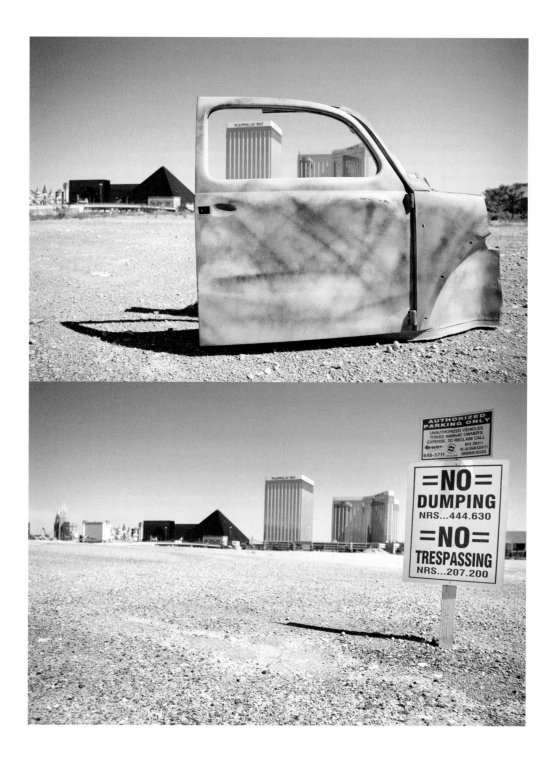

Shoot Signs by Moving Closer or Using a Big Lens

Finding old and interesting signs makes even the most seasoned photographer's heart beat fast. On that same trip to Las Vegas, I was trying to get my bearings and take in the great contrast. As I walked back toward my hotel, it looked ominously huge and as if it were covered with gold. I chose to walk directly across the street and found a stretch of dilapidated motels. Through the clutter, I saw the most amazing sign. Pulling a zoom lens out of my bag, I wanted the sign to stand out. I waited and watched. Suddenly, two birds touched down, my heart fluttered, and I pressed the shutter.

The trick to taking good sign photographs is to get close by physically moving or by using your biggest zoom lens. Then compose the frame to clear away the clutter. The photograph takes on new conceptual value. This doesn't mean you have to frame so tightly that you lose a sense of place. Make the sign the main subject of the frame.

Photograph Letters and Numbers to Explore Form

Letters and numbers are the basic building blocks of communication. Typography is the art and technique of arranging and styling letters. All letter forms, whether hand-written or not, have personality and voice. For example, the choice of color, size, and font style can be used to make the same word convey different meanings.

Finding photographs with letters, numbers, or combinations of both is a visual treat. When you notice the detail of the form instead of just reading, lettering and type take on a new tone. It seems to work best to compose one or two letters at a time. Then after you have built up a library of letters, try assembling them as a set or place them together in order to spell an interesting word.

Step Off the Beaten Path for Hidden Gems

To find unique photographs, you need to travel across town. For example, most cities have a place where the working artists live. Wandering around these neighborhoods can be a great source of inspiration. At first glance the creativity will be hidden. By walking around and talking with people you can soon discover some amazing gems.

In a beach town near where I live, everything looks the same. The town is pristine and attracts tourists far and wide. While there are some amazing opportunities to find photographs on the coast, occasionally I'll travel to the other side of the tracks. In a side alley that only a few people have seen, I came across a license plate wall. It resembled a patched-together outdoor quilt, and I snapped a few

The repetitive pattern is intriguing to the eye. Look close and you'll notice these license plates are on top of a door.

frames. I learned that a number of artists inhabited that part of town. Soon I discovered other visual quirks and curiosities that were embedded in the neighborhood.

In your own photographic journey when you visit a place, first become absorbed. Take in the typical sights and then look for more. Sometimes this means looking around the corner or maybe even traveling across town.

Create Photographic Collections

My sister collected toothbrushes and she had quite a collection. She had every size, color, and type that you could imagine: toothbrushes for babies, kids, and adults, even one for a horse. It was a quirky collection. As kids it was exciting because the more she collected, the more priceless the treasure.

At lunch one day, after I'd become an adult, a wise and successful mentor gave me some business advice: "Chris, if you put something in a collection, it will become more valued and more valuable." In other words, objects in a collection become a curiosity. As we become more curious the collection increases in value. As a photographer, this is a wonderful idea.

Creating collected sets of photographs is actually quite easy and fun. It begins by finding something you're interested in. Maybe it's banjos, bottle caps, armadillos, American flags, mailboxes, microphones, pay phones, or party hats. Once you've determined the subject, the game begins. Searching, seeking, and then finding unique and distinct subjects leads to more. As you share your idea or show photos people will start to contribute to the cause, and the momentum will gather. They'll tell you stories about where to go and what to look for. It's a quirky, fun, and fascinating way to explore the world.

The best photographers ask themselves, how can I make the clutter become visual, graphic, and clear?

Get Close and Fill the Frame

Have you ever walked on a beach and looked down to find a beautiful sand dollar? At the moment of discovery, as you lean over to pick it up, the object is all you can see. While you can technically see more, you focus in and mentally crop everything else out. That's how vision works when we are interested. As a photographer we can do the same thing by getting close and filling the frame.

The proximity of detail shots brings the viewer in. They make people lean forward to examine the small intricacies. In addition, filling the frame provides a comforting sense of clarity, inclusion, and completeness. For example, while backstage at a Ben Harper show there was a lot to see. The first shot was pulled back and thus cluttered and confusing. For the next few photographs I moved close and filled the frame.

Ben Harper's guitars.

The office next door.

Mine Where You Work

We spend the majority of our waking hours at work. Whether your job is exciting or not, it is a jewel mine for photographs. Learning how to take pictures at work is a great challenge. Typically, we become numb to our work setting and think of it as normal. What an opportunity to make the ordinary extraordinary. It is also an unobtrusive way to make life a bit more fun at work.

I pay attention to change. For example, an inspiring new colleague moved into the office next door. I knew that after a few weeks, I would get used to what I saw in that space. So I set out to make a few pictures before I became too accustomed to the scene. One of the first mornings I stopped by, the door was open and my new neighbor was out. The scene was poetically arranged. I grabbed my camera and made this frame.

Show Where You Are

There is no better time than the present to expand your vision. It depends more on you and less on the environment. It doesn't mean that you don't have to work to create something new. For me it might mean traveling on a plane and looking out the window, but photographers have already captured that view.

On one flight, after a passive glance at the clouds I wanted something a bit more arranged. Knowing the particulars of the airport, I sat poised as the plane touched down and was moving fast along the runway. I held my breath waiting for all the elements to align—the horizon, the wingtip, and the yellow line. My moment arrived and I pressed the shutter. It was one of the lucky experiences where preparedness meets opportunity in graceful form.

Discover Line, Shape, and Form

Line, shape, and form are the three core elements of art. Finding photographs where this becomes the theme is exhilarating. It means that you have to look past the subject. In other words, you need to look beyond what you see to what structural elements make up the frame. If done well, the subject and the structural elements create a cohesive scene. One of my favorite times of day to look for these three elements is at noon. There's nothing like the harsh light from directly above to help define line and shape. In this photograph made at high noon, the lines lead and the shapes inform. Like a visual hopscotch, the eye jumps through the frame.

Create Directional Photographs

Direction creates drama as it leads the eye. Following a line is gratifying because we know which way to go and it makes a static image feel alive. Creating a direction can be done in a number of ways.

Where the yellow line and wing tip align.

The light at high noon
reinforces the line, shape,
and form in this frame.

The bats and the beach wall both take advantage of the use of lines to direct the eye.

I was in Austin, Texas, waiting for the evening spectacle of bats leaving their perches and flying into the night. I waited patiently and saw the sky light up. Composing carefully, I cropped out the skyline, bridge, and other normal details. Then I positioned the view so that the sun burst from the lower right corner. In this way, the eye gravitates to the bottom right corner but then slingshots back up into the sky.

In the second image, I saw an ordinary beach wall and was attracted to the pattern and light. Composing the frame in order to crop out the particulars, I wanted an image that drew you in. The eye cannot help but travel along the lines to the back wall and then forward again.

While these photographs have different degrees of impact, they both use directional lines to create visual intrigue.

Break the Rules

Purists will say you can only photograph what you find. I say have a bit of fun: Try creating found photographs where you break the rules. Most rules are guidelines and meant to be broken now and then. The other day, I was over at a good friend's house for brunch. Eggs and waffles were served in the kitchen. The Scrabble board game was out on the table. Why not combine these two objects? The result was a few fun photographs that captured breakfast in an unusual way.

My friend Kim makes the best waffles and this one is easily worth 15 points.

Gear at a Glance

Most photographers stand out in the crowd. Many of the best found photographs happen as result of "going underground." In other words, pro photographers use minimal gear and travel incognito. The goal is to be inconspicuous. Here are a few tips about gear that I've learned from some of the top professionals.

First, instead of a camera bag buy a small sandwich cooler bag at your local drugstore. These are inexpensive and typically well insulated, padded, and waterproof. Next, use gaffer's tape to cover the make and model of your camera. Then, bring only one or two lenses, which will require your mind to work. Typically, I wander the streets with just a 50mm lens. When I bring another one in the lunch bag, it's a wide-angle 16–35mm. Finally, attach a logo-free strap to your camera. You can modify your own or find used ones at old camera shops.

Or if you're feeling a bit more creative, do a Google search for "seat belt camera straps" or "guitar camera straps." You'll find a range of offbeat options. This approach hides your serious intentions, halts potential conversations about camera models, and allows you to slip inside the scene unnoticed to capture your images.

Workshop Assignments

Survey

The field of "found photography" isn't something that can be easily defined. Rather, it is an arc that many people follow. The links below are intended to broaden your horizons and develop your sensibilities. There will be photographers and photographs that you like more than others. When you visit these sites, let go of your affinity and see what you can learn. Keep in mind that these resources are just the beginning.

VISIT: www.elliotterwitt.com

If there is only one site you visit out of the set, let it be this one. If Erwitt's photographs ignite your imagination, be sure to visit your local bookstore and see them in print. There's something even better about the surprise of flipping a page and seeing his work in a collected set.

VISIT: www.magnumphotos.com

Magnum Photos is a photographic cooperative of great diversity and distinction. Henri Cartier-Bresson said it well: "Magnum is a community of thought, a shared human quality, a curiosity about what is going on in the world, a respect for what is going on and a desire to transcribe it visually." Visit the site and click on the link for photographers. Start off by viewing the work of Henri Cartier-Bresson, Robert Capa, Walker Evans, and Alec Soth.

VISIT: www.masters-of-photography.com

Visit this site to gain a deeper exposure to some of the greatest photographers of all time. While the site is awkward to navigate, pay attention to the list of names and do searches based on what you've found. Begin by viewing the work of Joel Meyerowitz and Sebastiao Salgado.

VISIT: www.chasejarvis.com

Chase Jarvis is a contemporary commercial photographer. His vivid imagery combined with his personal and down-to-earth approach has inspired many. Chase believes that "the best camera is the one you have." Visit the site and click on the iPhone gallery to view images that back up this claim.

VISIT: www.paulliebhardt.com

Paul Liebhardt's travels have taken him all over the globe. His photographs are full of humanity. Visit this site and click through the many different galleries. Here you will gain inspiration from the photographs and the unusual category organization along many themes.

VISIT: www.joecurrenphotography.com

Joe Curren has traveled to most corners of the world, toting his camera. His compositions are thoughtful and natural—almost as if the camera wasn't even there. Enjoy the subtly and story of Joe's images.

VISIT: www.mattmallams.com

Matt Mallams was a former student of mine, and even in school his vision came from somewhere else. A prolific and humble artist, Matt captures moments that are completely his own. Visit his site to see through this relatively young artist's eyes.

READ: Humble Masterpieces–Everyday Marvels of Design, by Paola Antonelli

This is not a photography book. Rather it is a book on the marvels of design and everyday life. It is compact and easy to read. Flipping through the pages will help you see everyday objects in a new, extraordinary way.

READ: Faces, by Francois Robert

Faces is one of those books that is great to flip through when you're feeling dry. It is a small yet fun book that will remind you that in order to find, we must see. On its pages you will find a witty collection of expressions found in everyday objects that have uncanny resemblances to human and animal faces.

Shoot

1 Create a Collection

If you put something into a series or collection, it will have more value. The goal of this assignment is to create 25 photographs of the same theme, all photographed in the same way. In order to accomplish this assignment, choose something that is easily accessible: sofas, soup bowls, cell phones, or skateboards. You don't need to choose one of my suggestions; have some fun and come up with your own. Pick a topic that interests you. Then compose the photographs so that the subjects fit consistently in the frame.

2 Color Combination

Create six photographs of six different subjects where color combination is the theme. Create a few photographs that are found and a few that are arranged. Go out looking for unique color combinations and snap the frame.

Look for complementary and analogous colors. Next, buy one basket of blueberries and one basket of raspberries. Get creative and arrange the fruit into a picture, or position the different colors side-by-side. For even more impact, place one raspberry in the middle of the blueberries and vice versa. Play with color and color combinations.

3 Photograph Signs

The goal of this assignment is to create a 3-by-3 grid of nine photographs of signs. In your immediate surroundings, search for signs. Here are a few ideas—road, restaurant, gas station, state, bus stop, and warning signs. Try to photograph at least 30 signs and then assemble the best in a grid.

4 Outside the Comfort Zone

The aim of this assignment is to get you out of your comfort zone. The goal is to create ten newly found photographs. Visit a location where you have never been. This may mean the "other side of the tracks" (keep your eyes open!). In some situations it might mean simply doing something different. Go to this location bent on discovering something new.

5 Photograph Your Work

While at work, during one of your breaks create a set of photographs that are one of a kind. The goal is to create ten photos that reveal how your workplace would look to a child. Imagine you're 10 years old and you walk into your office. What do you see from that level and with those inexperienced eyes? Create photographs that make your job come alive.

Share

1 Select your favorite and most cohesive photographs from the assignment "Create a Collection." Print and then bind the photographs together in a unique way. Here are a few ideas: Use a hole punch on each image and then use twine to tie them together. Create a mini-booklet and use a sewing machine to bind the photos together. Bring the photos to Kinko's and have them add a blind seam or spiral hinge. After you have built your mini-book give it to a close friend. If you make an extra copy send it my way. I'll take a snapshot and may include it on the book's Web site (www.visual-poet.com). Or, send me a picture of the book.

2 **Flickr**

To share your photographs on a broader scale, put them on the Web. In particular, post your set of your photos to the Flickr group for this book. You can find the group at www.flickr.com/groups/visual-poet. When you add your photos to the group be sure to tag them with the appropriate assignment info: for instance, "Chapter 10, Found Objects, assignment #5, Photograph your work." On Flickr we can view and comment on each other's photos. I'm excited to see what you come up with.

Review and Respond

Finding photographs is about taking a journey that involves letting go. Letting go of comfort, control, perspective, preconceptions, time, technical mastery, efficiency, ego, and more. Yet, as on most journeys, what we discover is not what we set out to find. We learn about our world and who we are. Take a few minutes to jot down what you gained and learned from this chapter.

Finally, create a road map for what comes next. Is there an area of "found photography" you'd like to explore further? Or perhaps you've discovered a hidden talent you'd like to start to promote. Maybe it's time to create a calendar or coffee table book? Whatever you decide, map out a few steps that you can take to further your growth.

Guest Speakers

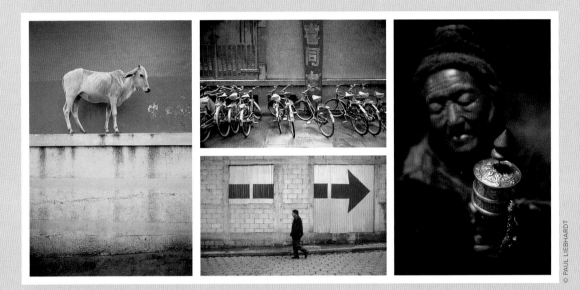

Paul Liebhardt

Paul engages life with a camera. He is brilliant, passionate, and off-the-wall. As a teacher, his vision, empathy, and unorthodox approach leave an indelible mark on his students. He has taught thousands of aspiring photographers to see more and never give up. To see his incredible work visit: www.paulliebhardt.com.

What inspires you?

Bob Dylan's poetry, Peyton Manning's passes, and Alison Kraus's voice. Frank Geary's buildings and Woody Allen's wit. Alex Webb's eye, Misty May and Kerry Walsh's digs, and Steve Jobs' mind. Irving Penn's career, Obama's eloquence, and Kobe Bryant's moves. Neil Armstrong's humility, Craig Ferguson's monologues, and Tiger Woods' desire. Bono's humanity, Aretha Franklin's soul, and Steve Spielberg's story telling. Nelson Mandela's courage.

These men and women have the essential qualities of a creative soul. They do their work with passion, intelligence, skill, grace, wit, and force of character. They all stand for something. They all matter. They do what they love with their whole spirit and heart. That's as good as it gets. And it's inspiring.

What makes a photograph good?

Duke Ellington was asked what makes a piece of music good. He said, "If it sounds good, it is good." The same thing is true about a photograph. If it looks good, it is good.

Good photographs enliven the mind and great ones serve humanity. They cause people to think about things they may have seen or experienced or felt before. The best ones, the ones we remember, are surprises—we do not expect them. If there is no surprise for the photographer chances are a viewer will not be surprised either. So I think it is true that it may be even better for a photographer to be surprising in his work than to be consistent.

One last thing—a good photograph usually contains a relationship. It may be as simple as colors or tones within the image that relate. Or it may be how certain elements of the subject relate to each other. What a photographer sees and the sometimes subtle and sometimes obvious connections he makes can make or break an image. The more unique those connections, the more surprises for the viewer.

What character qualities should a photographer nurture?

Curiosity. The best photographers are not necessarily the ones who know the most about photography. They are often the ones who know the most and stay curious about everything else. James Nachtwey has a degree in political science, not photography. Damon Winter, this year's Pulitzer Prize winner in feature photography, has a degree in environmental science, not photography.

Passion. If a photographer does not get totally immersed and passionately involved in some aspect of image making, he or she will most likely be replaced by someone who does.

A sense of adventure. Art can only flourish and artists can only grow and prosper when the sense of adventure is paramount in their lives. Surely the best pictures are made by those photographers who have some excitement about life and use their cameras to share that excitement with others.

Perseverance. The tenacity of a photographer's resolve is crucial. There are more photographers doing great work, going further, and digging deeper than ever. So in spite of enormous competition, a photographer has to hang in there—to not give up.

Courage. To take risks—to not play it safe with their work. Risk just might be the essence of it—that photographers may only be as good as they are willing to be bad.

Optimism. One of the beauties of this business is there is always tomorrow. You have to believe that tomorrow your pictures will be better.

What advice would you give the aspiring photographer?

Remember you're not just in the photo business; you're in the communication business. You're doing exactly what a songwriter does—saying something about something to someone else. The key question is deciding what you want to say.

Young photographers often structure their images only for their teachers, their clients or friends—but rarely for themselves. Sometimes your best work is done when you're doing it for yourself. If you're not doing personal work you are missing so much of what photography is all about.

Over 30 years ago Jay Maisel used to tell students to always carry a camera—to integrate a camera into their lives. If you do, he would say, you never have to go out and shoot because you're always out shooting. It's three decades later and I can't think of any better advice.

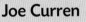

© JOE CURREN

Joe Curren

Joe Curren travels the globe and creates images with a contemplative silence from the clutter and complexity of daily life. Joe's style is cohesive and intriguing. His photographs draw you in and slow you down. For more information visit his Web site: www.joecurrenphotography.com.

What inspires you?

Scenes in nature, including trees, birds, the ocean, clouds, mountains, and unique light. Also looking at good photographs by good photographers. I'm mostly inspired by seeing a place for the first time, especially places that are cold, isolated, and unspoiled.

What makes a photograph good?

Mood, light, and composition are more important than perfectly front-lit images where everything is sharp or has detail. With travel photography I like images that aren't clichéd or postcard-like but provide a unique perspective and sense of place. When I'm happy with one of my own photos it's usually one that rings true to a prior mental image I'd made before visiting a place.

What character qualities should the photographer nurture?

Patience and pre-visualization are good character qualities to nurture. I like to sit back and wait for a scene that might unfold, even if it takes a while. If you don't have the patience to do this, you won't see as much and you will miss opportunities. Pre-visualization is important because it helps you to be in the right place at the right time, which is 90 percent of photography. A good way to nurture this is to study about a place or subject that you want to photograph to the extent that you begin to have dreams about it. Then your mental images will guide you and bring the subject to life.

What is your advice for the aspiring photographer?

Travel, invest in good lenses, learn to recognize quality light, and read as much as you can. Reading is one of the most important things you can do to make good images. It's best to focus more on reading about places than looking at pictures of them or subjects you want to photograph. This way you won't be influenced by other people's visual perspective and will come away with something truly unique and personal.

WHAT'S NEXT

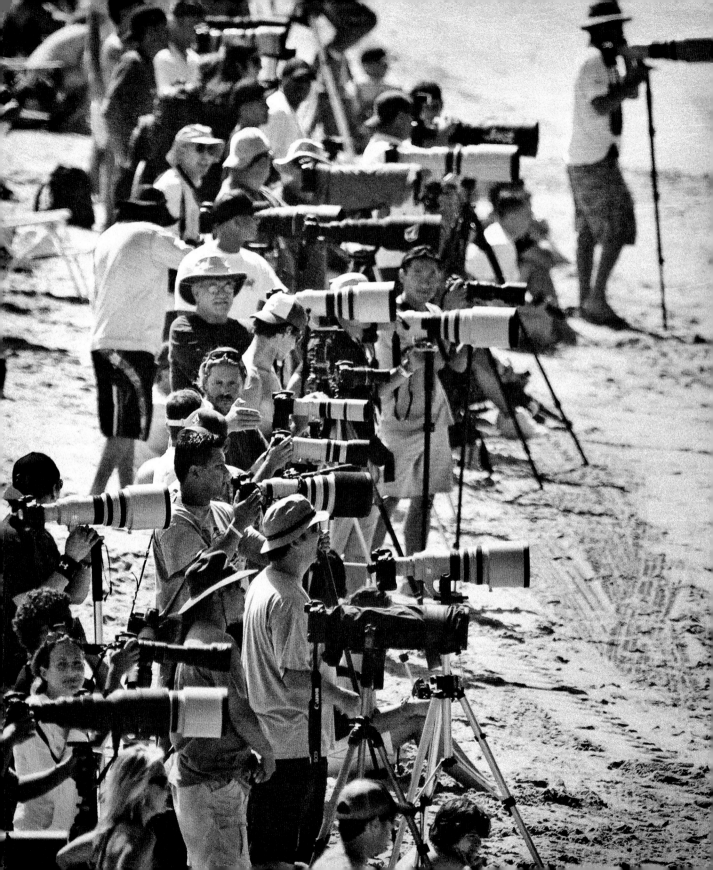

CAMERA GEAR 11

PHOTOGRAPHERS ARE A curious bunch. If you see another photographer point a lens, you can't look away. The curiosity of someone's vision draws you in. And there's a fascination with the gear. It makes you wonder, why is she using that lens? How will that help her see? Does she know something that I don't?

Cameras are just plain interesting to look at. In my office I have three different cameras sitting around. At home in our living room, I use old cameras as bookends. I have a few tucked into corners here and there in other places, too. Most people do not notice their presence, but when another photographer comes over he is immediately drawn to them.

My favorite camera doesn't work anymore. It was my grandfather's, and I display it on a shelf in our home. Sadly, I never met my grandfather, who died long ago, but I know many things about his life. I love to stare at that camera and wonder where he liked to point the lens.

Camera gear is undoubtedly interesting, and even non-photographers get in on the fun. I was recently shopping for my wife at a boutique. It was a regular shop, but they sold a few extras—purses, jewelry, and sunglasses. Piled in a basket near the counter was a jumble of old cameras with a sign pinned to the basket that said "accessories." Now that is something I had never seen before—if only I had my camera.

What matters is your creative vision, not the equipment that you use.

Seeing cameras made me wish I had my own. That's how camera gear works. It's as if they have a voice of their own—one camera requests another. Soon there's a whole slew of people gathered taking pictures of who knows what.

Justice

An accomplished photographer I know was at lunch with a friend in Beverly Hills. Midway through the meal, the chef came around to greet his guests. He was excited to meet the photographer and said, "I absolutely admire your work—it is wonderful!" He then noticed that there was a camera bag sitting next to the table and he asked, "Is this your camera; can I see it?" The photographer obliged and pulled the camera out of the bag. The chef's eyes grew big and then he sighed, saying, "Ohhh, that's why you take such amazing photographs."

The photographer was a bit irritated. After lunch he walked back into the kitchen. The chef said, "What a nice surprise." The photographer replied,

"I wanted to stop by and to tell you the lunch was exquisite. The food was divine. What type of pots and pans do you use?" Taken aback, the chef said the brand name. "Ohhhhhh," the photographer responded with a more exaggerated sigh, "that's why the food tasted so good." With that he turned on his heels and left with a satisfied grin.

Old Guitar

When my dad and his brothers were young, they purchased a guitar, an entry-level model made by Sears. When I was just a kid, that mediocre guitar was passed on to me. By the time I received it, it was weathered, worn out, and not worth much. After a few years I was ready to pass it on. It wasn't worth selling so I was going to give it away.

One day a new friend came over to my house. When he arrived the dusty and disheveled guitar caught his eye. He immediately picked it up. After a few minutes the old steel strings were all tuned up. He began to play a few quiet tunes and then

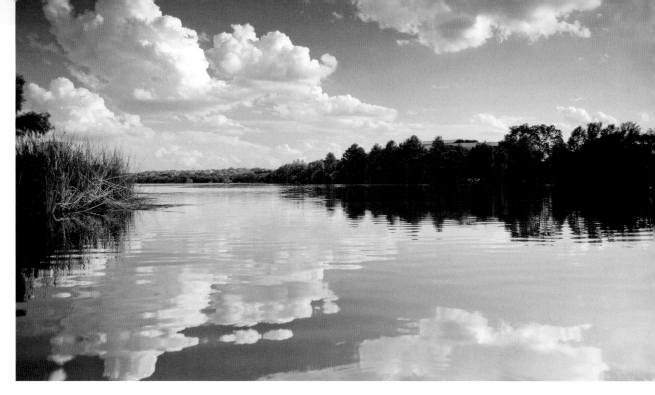

he really let go. Strumming hard and singing loud, he played some classic folk and rock songs. The guitar came to life and I couldn't believe the music that he made. How could I have ever have thought of throwing this guitar out?

For me that memory became priceless and the experience shaped who I am. True music comes from within. As for my friend, he has gained great musical acclaim. Regardless of his awards and fame, the music I like most will always be from the day he resuscitated that old Sears guitar.

Megapixel Mania

Photography gear is exciting and it can produce quite a buzz. Especially with some of the photography students I know. Whenever I get new gear, whether it's the latest and greatest or something used, my students take note. They will often come up and say, "Wow, that looks amazing." Then they will ask, "How much did it cost?" or "How many megapixels does it have?"

© BRUCE HEAVIN

Quality doesn't come from the equipment we use. Quality comes from within.

Occasionally, when I get questions like these from students I know well, I like to have some fun. Sometimes I hang my head and look at my toes and make up a diminutive lie: "Oh, this is actually an older model they don't make anymore. It only has 4 megapixels and it only costs $150." Surprised by the low quality of the gear, they will feel sorry for me and won't really know what to do. Looking embarrassed, they will muster up their most patronizing tone and say, "Oh, that's nice." Other times I will respond to their questions with a gallant reply: "50 megapixels. Crazy, isn't it? This is a demo unit one of my sponsors sent me today. It's not even out on the market yet!" This response makes the students light up. In their eyes you see respect, reverence, and awe.

In either case, I quickly let each student in on the joke. I tell the truth about the cost or the actual megapixel size. We laugh it off. I hope that the humor helps a deeper thought reach them—that the connection between our identity and the gear can be loose. We can have fun and make music with whatever we have.

To flip-flop this logic, externals do matter somewhat, but we don't want them to matter too much. Remember when we were younger and thought coolness was something we could buy? If only I had this car or that pair of shoes, then I would be cool. We are all tricked into thinking that value comes from the outside in. True coolness comes from the inside and goes out.

Good Enough

As images makers we depend on gear. Without the gear our art form couldn't exist. We need to learn about gear and what tool works best. But as we learn and buy better gear, we're tempted to think that better gear means being better off.

Some people wear too many hats. In this case I'm definitely wearing too many cameras.

These thoughts can be toxic as they place too much emphasis on the tool. Fortunately, life has a way of correcting our course. It's like when we discover an old photograph or hear an old jazz tune: The history of the art brings us back down to earth. We're reminded that beauty has been made for decades before. As the famous jazz musician Wynton Marsalis once said, "I don't think we should feel that because our tools have become more advanced, we are more advanced."

Advancement in photography doesn't come from building up an arsenal of gear. Rather it comes from growth, which happens inch by inch and year by year. At the same time, growth and gear are intertwined and there is a symbiotic relationship of give and take. Your gear does matter, but sometimes it will get in the way, especially if you have too much of it.

Peace

I was eager to buy my first high-end camera, so I set up a time to meet with one of my mentors. I showed up at the meeting armed with questions about every piece of gear. I pulled out my wish list and started to explain what I wanted to get. I thought to myself and then said out loud, "If only I had more money."

Before my teacher let the conversation go too far, he told me something important. He said, "You could go out and buy every piece of gear in a camera store and it still wouldn't be enough, because tomorrow something new would come out. And then the next day, three brand-new lenses would catch your eye!"

We continued to discuss gear and he sent me on my way. To this day, that discussion shapes how I relate to what I own. My teacher's wisdom extends beyond photography and gear. Our conversation seemed more about something existential like peace.

The next day my teacher handed me a piece of paper with a handwritten quote from Benjamin Franklin: "Money never made a man happy yet, nor will it. There is nothing in its nature to produce happiness. The more a man has, the more he wants. Instead of it filling a vacuum it makes one." I didn't need more money; I needed to spend wisely what I had.

Two Halves Make a Whole

A few years ago, an award-winning *Los Angeles Times* photojournalist visited the school where I teach. She had just won a prestigious photographer of the year award. Her internationally renowned photographs were both haunting and unique. In

Rather than obsess with what you wish you had, get over it and make pictures with what's in your hand.

her lecture, she talked about covering the crises in the Middle East. While showing some pictures, she told a few side stories that kept the audience on the edge of their seats.

One story involved gunfire while she was running from one place to the next. She dropped her only telephoto lens and to her horror it broke in two. Without missing a beat she picked up the two halves and duct-taped them back together. She tested the lens and determined that the auto-focus was broken but otherwise everything was fine. With the broken lens attached to her camera, she continued to cover the crisis as it unfolded before her eyes.

After her presentation, I couldn't stop thinking about her heartbreaking and beautiful pictures taken with a broken lens. Her story resonated and struck a major chord. Her message was a parable that said something I've felt was true. Rather than obsess with what you wish you had, get over it and make pictures with what's in your hand. Otherwise, you risk missing too many important shots and too much of the good life that is located right underneath your nose.

How Much Gear?

Before determining what camera gear will fit your needs, its best to step back and consider a few other issues. First, there is no magic answer to how much gear is best. Some photographers have a ton of gear and that works well. Others follow

Henri Cartier-Bresson, who advocated, "It is by the economy of means that one arrives at the simplicity of expression."

Bresson and others have inspired many photographers to go with less rather than more, including the fine art black-and-white photographer Keith Carter. Keith makes photographs that are stunning and complex. Years ago he decided to limit his approach. He uses only one format camera and one lens. For Keith these limitations have allowed for his work to flourish and grow.

I often compare camera equipment to backpacking gear. There are the ultra light trekkers who spend weeks in the mountains with all of their gear stuffed into a bag the size of a school kid's backpack. The other extreme are those who climb Mount Everest and have 30 sherpas carry their gear. Each technique has pros and cons. The way you go is a decision that's based on the goal and on what you like best.

As you forge your own path, remember that just because certain pros own every camera and lens doesn't mean that's the only way to go. That same pro probably has three assistants for each shoot. And until you have that kind of support, perhaps traveling light will work best.

These are two of my favorite camera backpacks. The one that I use depends upon the assignment and how I want to travel.

Time

Whenever you buy something, think about the item in the larger context of time. Buying a camera body is like buying a computer. When you buy a computer you know you should only count on it lasting for three to five years. The same goes for camera bodies. In the big scheme of things this isn't very long. Therefore, you have to ask yourself, what type of camera body do I need for this short amount of time?

When buying a camera body you can't really go wrong. As with computers these days, even the entry-level models work well. Basically, you can group or divide SLR cameras into levels like this: intro, medium, medium-high, high. Each level costs a different thousand-dollar amount: $1,000, $2,000, $4,000, $7,000. Deciding which level is best for you starts with tallying up all your expenses and determining which type fits your needs.

Before you go out and make a purchase, let's reconsider the topic of time. Certain photographic items have more permanence than others. Good camera bags will last dozens of years, and a hard-shell Pelican case is like a desert turtle that will never die. Bags don't cost much, so it makes sense to spend the extra 20 bucks to get what you will be using for some time.

Next, consider camera lenses. If you purchase a good one and take care of it well, the lens could outlive you and get passed on to your kids. When buying a lens, make sure you get it right. Good lenses make all the difference with regard to the quality of your final print. If the choice comes down to what lasts and what doesn't, invest less in a camera body and more in a good lens.

Camera Handling

Learning how to hold and handle your camera will ensure that you pull it out of the bag easily and use it often. First, get rid of the strap that comes with the camera. You need a strap that is simple, strong, and reversible. Plus, having one that can support some weight and won't cut into your shoulder or neck is helpful. I use a Tamrac N-45. It has everything I need. I modify the strap by removing the compact flash card holders and carefully cutting off the logo tag. I want my gear to be as simple as possible.

Hang and Hold

Know how to hang your camera correctly on your shoulder. Here's what most people mistakenly do: They hang the camera so that the lens points away from their body. With the lens sticking out and fully exposed, this is an accident waiting to happen. Flip the camera around so that it hangs on your shoulder and the lens points into the small of your back. This way it won't bang into objects or people when you're walking around.

When you are taking pictures, square off and get your feet under your camera. Don't lean forward and stick out your neck. Rather, move your feet, then brace your camera by positioning your left elbow in your chest and use that hand to hold the camera weight. Place your right hand on the shutter release, but be sure to keep your elbow tucked in. Basically, you want to be compact in order to support rather than extend the camera. This way you capture the sharpest frames.

Nature photographer Ralph Clevenger stabilizes his camera by sitting low and propping both elbows on his knees.

Better Stability

If you want to shoot with longer exposures you will need to improve your stability. First, whenever you are shooting brace yourself and your camera by leaning against something like a tree. Or, better, place your camera on top of a rock or fencepost. Another trick is to use a small portable duct-taped bag of rice. Buy the rice at the grocery store and completely cover it with duct tape to keep it from getting torn. I always carry one of these in my car—I think of it as my "bean bag tripod." Then I can place it somewhere and set my camera on top.

For longer exposures you will definitely want to pick up a good tripod and tripod head. The tripod head is more important than the legs, because it allows you to compose. While there are many different types, the best ones rotate around a circular ball head. Pick up a good ball head and you won't be disappointed. For tripod legs, here's what you want—something strong and compact that extends to tall. I prefer one made from a composite material like carbon fiber. Next consider how many sections

At sunrise Ralph hides behind some shrubs while using a tripod to create tack-sharp shots.

it has, or how it collapses. Four sections let the tripod collapse to a smaller size, but three sections are more stable. I value stability over size, so my preference is three.

Transportation

Photography equipment is heavy. Having an easy way to transport your gear is essential. A good camera bag needs to be simple, effective, and strong. New bags with all the fancy features are tempting. But when you're in the field, the bells and whistles just get in the way.

I think about camera bags in three sizes—small, medium, and large. The small bags are really useful when you don't need much, just one camera and a lens. A medium-size bag will fit one camera and three lenses. A large bag should hold most everything you need.

The basic choices for bags are shoulder, backpack, and rolling. The advantage of using a shoulder bag is that you can easily take the bag off and access your gear. Shoulder bags are flexible and allow you to take the weight off your back. Backpacks are great to distribute weight and provide you with incredible mobility. Rolling bags are a wonderful luxury, allowing you to carry an intense amount of weight without expending much effort.

Determining which bag is best depends on your port of call. I've found that I need at least one of each type. And while this may sound like a lot, investing in good bags doesn't have to break the bank. The ability to transport my gear has enabled me to get some amazing shots. I recommend you start simple by buying a small or medium backpack and then slowly build up to what you need.

Here's another tip: Purchase a rock climbing carabiner with each new bag and hook it to the top. I do this with all of my bags. Often, I clip my bags together so that one doesn't get lost. While I'm traveling and eating lunch, I'll use the carabiner to attach my bag to a chair to prevent someone from snatching it and running away.

Camera Lenses

When you ask a pro what lens to buy she will always say invest in good glass. Good glass doesn't come cheap. The better the lens the more it costs and the heavier it is. The quality and creativity it affords can be worth the extra expense. Buying lenses is not something that you do all at once. It's like building up a music collection—you start off with one song or album and then year after year you buy more. So it is with camera lenses.

Regardless of your camera brand, here's how I recommend that you begin. Start with the end in mind. Ask yourself what kinds of pictures you really want to make. I like to be able to cover the range. So for my interests I would start with three in mind: wide, normal, and telephoto zoom.

A good wide-angle lens like a 16–35mm will be perfect for capturing the entirety of a scene. A normal focal length like a 50mm will help you creatively capture the world in a way similar to how the eye sees. Finally, a telephoto zoom like a 70–200mm lens will help you create flattering images of people and landscapes alike. Think of these lenses as the building blocks for the rest. After you have these, you can add the more specialized lenses like a macro, fish-eye, or high-end telephoto zoom.

Typically, when you're purchasing lenses you can find the best glass by going with the fastest lens. In other words, the lenses with a lowest f-stop number like f/2.8 will be best. In contrast, a lens that is an f/4.5–5.6 will be inferior because of the optics and because the f-stop changes depending on the zoom.

The only time you don't want to get the one with the lowest f-stop number is when weight is an issue. For example, Art Wolfe, a nature photographer, can get whatever lenses he wants. When he travels, rather than bring a telephoto f/2.8, he opts for the lighter f/4.

The other thing to consider when investing in a lens is to always buy the VR or IS when you have the option. For Nikon lenses VR stands for vibration reduction. For Canon lenses IS stands for image stabilization. The name of this feature varies among brands, but it works the same way. Basically, the lens creates sharper images at lower shutter speeds. You can often hand-hold these lenses in lower light situations. This feature is key and can be turned on or off. You'll want to turn it off when using a tripod or the image will look worse.

Rather than rush out and buy fancy new gear, try renting a lens from your local camera shop. If you don't have access to a rental, shoot the lens around the store. Really get a sense for how it works and how images look and feel. Then when you are ready, don't buy everything at once. Buy just one lens and give it some time. You'll need to live with that lens to truly understand how it works.

What looks like a sidewalk sale is actually my gear packed and ready to go before a shoot—Gitzo tripods, Pelican case, and Lowepro bags.

Camera Body

Camera bodies come in all shapes and sizes. The variety is a mixture of form and function. Many people make the mistake of thinking they only need one. I've found that having different types of cameras can expand how I see. I'm not advocating that you spend big bucks to have more. You might be able to get something secondhand, or simply hang on to an old camera when you get a new one. Let's talk about a few different options.

Digital SLR

The digital 35mm SLR is the most common type of camera. It is compact, flexible, and easy to use. You can't really go wrong when purchasing this type of camera. The high-end SLRs are amazing, but even the entry-level models will do the trick. In fact, I know a few pros who used entry-level cameras on high-profile projects and the image quality looked great.

The advantage of using a lower level camera is weight. With SLRs, the lower the cost, the smaller the camera. Like many other photographers, I like to shoot with a midrange camera because it isn't too difficult to lug around.

Another issue to consider is the camera's build. The more expensive the camera, the more solid it will feel and the better it will be sealed. The best cameras are sealed against dust, moisture, and water. For photographers who do not shoot in rugged conditions or stormy weather, the extra protection is unnecessary. The cheaper the camera, the lower quality the seal; for most, even the entry-level camera's seal will be fine.

Cameras boast an array of features including megapixel size, frames per second, ISO quality, self-cleaning sensors, video capabilities, and more. The only way to discern which ones you'll need is to read reviews and see which camera offers what. You can find gear review links in the "Additional Resources" section later in this chapter.

Medium and Large

The 35mm format is based on a small digital sensor or piece of film. The advantage is that it is possible for the camera body to be compact and small. There are times when you want to capture more content. Many of the major campaigns that you see in magazines and billboards are captured with medium and large format. If you are interested in trying something new, consider experimenting with them. These cameras have huge sensors and capture images like nothing else. The only downside with the large format is that the digital cameras require a digital back, and to buy both of these you're going to need to sell both you and your spouse's car.

You can pick up an old film camera for next to nothing. And if you haven't ever experimented with film or if it's been a few years, giving this a try will open up a whole new world. In fact, film is making a bit of a comeback. This will happen even more as film becomes more difficult to get.

In digital capture, I can easily press the shutter 12 times in two minutes with no skin off my back. When I take pictures with my film Hasseblad, I only have 12 shots on each roll of film. And the film, processing, and scanning isn't cheap! I slow down and really start to think. This camera requires that I am engaged and involved.

Occasionally, I pull out an old wood and brass large-format camera. This camera takes time to set up, but I enjoy the process. The time helps me get familiar with a new place. I go under the black cloth to compose and view the image on the ground glass that's upside down and backward. This makes me see in a completely new way. I load the film one sheet at a time. The process is slow but the results can be divine.

Setting up at low tide during a beautiful
sunrise to make a portrait.

Odd and Old

I have a soft spot for things that are vintage and
worn, including an old and eccentric typewriter.
Although the keys barely work the results are
beautiful. Whenever I type a note, I'm reminded of
the power of tangible things. I often glance at my
bookcase and say to myself, books are beautiful.
Especially old books that were written with type-
writers one word at a time.

In art, the means or mechanism we use to make
something has an effect. And the effect can be great
or small. Try working with some different, maybe
even eclectic gear.

There are plenty of places to begin. Try a plastic
camera like a Lomo, Holga, or Super Black Fly. Each
of these three "toy" cameras will bring out something
new and will contradict the digital capture compul-
sion for control. With these simpler cameras, you'll

just have to let go. Or if you don't like plastic, how
about wood? Do a little searching and you'll be sur-
prised at the price as you discover how many old
and still functional cameras are around.

Two of my favorite things—a Hasselblad
and an old wooden boat.

Ready to hit the surf.

Water

Water is elemental and it is everywhere. I love water. I love to drink water, watch water, and get in water—to swim, surf, sail, kayak, snorkel, or scuba dive.

If you like water I recommend getting an underwater camera. Canon and Olympus make pocket cameras that can go 20 feet deep. Another great compact water/sports camera is the GoPro. This camera can be mounted on a helmet, kayak, surfboard, or your wrist. It shoots stills and video and is an absolute blast. I have three of these cameras and enjoy them a quite a bit. For more serious play, I put my pro digital SLR into a custom built housing by Del Mar Housing Projects. They make strong and lightweight water housings that are perfect for surf photography.

At least once in your life take a picture while you are soaked or submerged.

You don't have to follow my path, but do me this favor—at least once in your life take a picture while you are soaked or submerged. I'm confident you'll discover that mixing water and photography can be an immense amount of fun.

Deep Pockets

Small cameras are wonderful because you can take them anywhere. The industry refers to small cameras as point-and-shoots, but I think this name is misleading. It suggests that these cameras do not have any controls. But small cameras are now more powerful than ever.

I like to use another name—pocket cameras. That name is perfect because that is exactly where they belong. They are easy to carry and pull out. And while their size is still misleadingly small, don't let this dissuade you from using them to create something big.

Hang Up the Phone

Practically everyone has a camera on their cell phone. Many complain that the image quality is not very good. I always say, "Not good for what?" The point of a camera phone is not to capture the quality of a high-end SLR but to capture a fleeting moment with quickness and ease. These small cameras can teach you to see.

One day, I was walking to a location to meet a pro surfer for a photo shoot. My phone rang and I thought it was my friend so I picked it up the line. I began to talk and turned the corner at the place where I envisioned a good shot. Then I quickly explained that I needed to hang up. Before I put my phone away, I took a couple of snapshots. These photos revealed exactly what I needed to see. I needed to position the camera just a bit high to capture something with intrigue. While the photos weren't "good," they taught me to see.

Insurance

One of my photographic mentors taught me that our camera gear is meant to be used. This means that it will get dented, scratched, and maybe even waterlogged. If you want to take great pictures you obviously need to care for your gear, but you can't keep an eagle inside of a cage. Your gear is meant to fly and get outside.

Splash

One of my friends took those words to heart. He was down at the beach, walking in the water taking photos in the beautiful dusk light. Then his digital SLR camera slipped and dropped into the ocean with a splash. As he retrieved the submerged camera, his heart sank like an anchor.

Unfortunately, my friend didn't have insurance. Being a creative soul he came up with an idea. First, he bought a broken lens for $5 at a local camera shop. Then he attached the useless camera to the top of his car and drove around town. Now I know this sounds crazy, but imagine if you saw someone driving around your town with a camera on the roof of his car. Had he placed it there and then forgotten and drove away? In a panic you would honk and wave, signaling him to stop as he drove on. It was his version of an offbeat joke, which made many people laugh. A good thing my friend had a healthy sense of humor, but the camera was still a huge loss.

Assurance

If you're going to use your camera in rough situations, make sure you're well insured. Begin by checking to see if your renter or homeowner's insurance policy extends to cover your gear. If it doesn't and if you are going to start taking photography seriously, I recommend getting insurance ASAP. I've known too many photographers who have run the risk of not having insurance and lost everything they own. (For an insurance recommendation, see the Additional Resources links below.)

While insurance is practical, having the protection encourages more creativity. Because my gear is well insured, I'm willing to take more risks to get the right shot. I'm careful and take good care of what I have, but I'm also willing to step out a bit. Insurance helps you walk with confidence. And if you want to go far in photography you can't walk alone.

After this camera was ruined, its curious owner took it apart and stripped it to the bare bones.

Additional Resources

Gear Reviews

www.dpreview.com: This is the number one place to find detailed information about almost any camera. The approach is straightforward, detailed, and easy to read. This site is updated often with camera gear reviews and is cutting edge.

www.luminous-landscape.com: This site is managed by landscape photographer Michael Reichman. You'll find valuable discussion threads, tips, and valuable reviews of different types of gear.

www. moosepeterson.com/gear and www.moose-newsblog.com/moose-video-guide: Moose Peterson is a great photographer and teacher. His workshops and Web site contain a wealth of information. Visit the first link to learn about the gear Moose uses and why. Next, visit the second link to watch the videos under Camera Care and Camera Gear. Learn how to clean your camera sensor. You won't find information this good anywhere else.

www.photo.net/equipment: This is a general photographic community site that contains everything from photo galleries to expert tips. Visit this site for inspiration and information.

www.outdoorphotographer.com/gear.html: Many publications like *Outdoor Photographer* offer online articles and resources that will deepen your knowledge about gear. A quick word of caution: Most sites like these have a strong commercial bent. In other words, some of the advice will sound a bit more like an ad. Read between the lines and you'll find a wealth of information.

www.video.google.com: Start by doing a general search for "photographic camera equipment" and you'll come up with some good results—everything from photographers showing their camera bag to tips about how to use a specific tool. For more specific results try searching for "Chase Jarvis packing photography gear" and watch a movie on how Chase packs and handles his gear.

www.packagechoice.com: Package Choice by Hill and Usher is one of the few agencies that specializes in insurance for photographers. They are affordable, trustworthy, and prompt. If you have never considered insuring your gear, the added expense may be a turnoff. Yet the peace of mind and more important the help in time of need is worth every penny. I confidently insure all my gear with this company.

Vendor Information

www.bhphoto.com: At B&H Photo you can purchase anything and everything related to photography. In fact, a large percentage of pro photographers rely on B&H for their gear.

www.canoneos.com or www.nikonusa.com: While there is a range of camera manufacturers to consider, there are two brands that are most commonly used by the lead photographers of the world.

www.lowepro.com: Lowepro makes bags that are a perfect combination of form and function—simple and strong. Since I started making pictures I have used their gear and I've never been let down. In my opinion they are the world's best.

www.gitzo.com: My tripods of choice are the Gitzo carbon fiber tripods. They are incredibly well designed, strong, and lightweight.

www.reallyrightstuff.com: Really Right Stuff makes tripod heads that are the best of the best. The engineering is precise, strong, and reliable. The results speak for themselves.

Guest Speakers

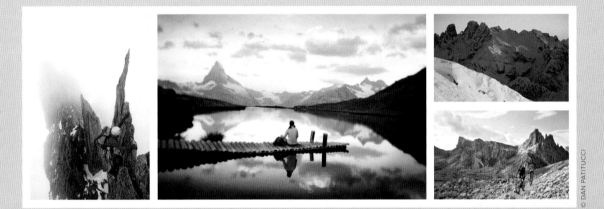

Dan and Janine Patitucci

Dan and Janine Patitucci are a dynamic husband and wife team. They create some of the very best images with fearlessness and finesse in an overly competitive field. Living between Switzerland and California and shooting around the world, they put their gear to the test. For more information and to see their work visit: www.patitucciphoto.com

What inspires you?

Passion. But visually, this comes in many forms.

We are both mountain sport photographers and mountain sport athletes. There is an energy we feel when we're being athletes; we want to capture the same feelings when we shoot. The edge in the determined eye, the smile from delight, the awe from being in an amazing place.

What makes a photograph good?

An image, no matter how simple or complex, must stir our emotions. We must be thrilled, desire to be there, made curious, disgusted, or happy. All this while seeing an image with thought behind the composition.

What character qualities should the photographer nurture?

A photographer must have their own passion for what they shoot. It's true when you're a pro that photography becomes a job and it's easy to lose the energy you once had. Passion for the subject matter keeps that energy alive.

If you photograph people you must connect with them at all levels. The images you make are sometimes an expression of how you feel about the subject.

A photographer must know themselves well.

What is your advice for the aspiring photographer?

Shoot what you love is a cliche for a reason; beyond this just shoot a lot. Study what you enjoy about images and apply it to your work. Experiment. For the career minded, be organized, understand that being a photographer is a profession and not a hobby.

Jeff Lipsky

Jeff Lipsky is one of the world's leading celebrity, fashion, and portrait photographers, but that's just what he does. Who Jeff is is down-to-earth and authentic. And who he is shows up as a reflection in the images he makes. For one of the world's best, Jeff uses camera gear in an interesting way—he shoots film and most often uses natural and available light. For more information visit: www.jefflipsky.com.

What inspires you?

The littlest thing can inspire me. I love looking at other people's art. I go to every gallery show that I can—classic or contemporary. Personally, I like the old school. I have an art book problem. I can never get enough of them. My son and wife inspire me. Sometimes my wife is just sitting in a chair and I wish I had my camera—so many moments of light and time to capture.

What makes a photograph good?

If an image inspires someone else, that's good. There's composition, light, and all the forms that make a good image, but it is really the feeling. The image perfectly captures a moment in time.

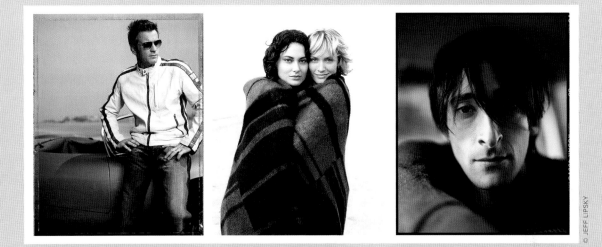

What character qualities should the photographer nurture?

Patience and tenacity. Sensitivity to your subject and awareness of everything—
the environment and treating people the way that you want to be treated. How
you treat your subjects is everything. Whether with a model, CEO, Olympic
athlete, or actor, I graciously thank them for giving me their time. I think being
grateful is an important trait.

What is your advice for the aspiring photographer?

You need to live in photography. Always do something for your career; call-
ing someone, working on your portfolio, or cleaning your lens. Carrying your
camera with you puts you into photography every day. Photography should be
a passion and not a career. Also, you have to have someone who believes in
you. My parents, wife, and family are my support base. My parents were pivotal.
They believed that I could do it.

John Paul Caponigro

John Paul Caponigro is a fine art photographer who creates images that ask deep questions. And this makes sense because John Paul has philosophical and intellectual roots. His photography is highly acclaimed. He is considered a pioneer of the digital age—writing, teaching, and speaking about everything from digital capture to color management. To learn more visit: www.johnpaul caponigro.com.

What inspires you?

Creation. Nature as an endlessly unfolding process. People light up with passion and commitment. What man makes in participation, collaboration, and communion with nature—respectfully. Acts of compassion and conscientiousness, whether random or not so random. Wonder shared. Inspiration is inspiring however it's demonstrated.

What makes a photograph good?

The same things that make any work of art good. Passion. Insight. Craft. Awareness of audience. Appropriate context.

All kinds of things make photographs interesting technically. Extraordinary detail, recordings made in packets of time that we find challenging to perceive (milliseconds or hours), simultaneously reconciling information at varying distances... or not, artifacts that are specific to the medium (like motion blur or lens flare), or things that are lost or found in translation.

All this can make interesting work, but none of it makes great work. Great work is made when people challenge themselves to sense more and respond more deeply than they ordinarily would and to bring back their newfound discoveries in meaningful ways. Whether great or small, somehow, I think the acquisition and transmission of wisdom is involved.

What character qualities should the photographer nurture?

An artist needs to develop the same qualities as any human being. Sensitivity. Curiosity. Compassion. Conscientiousness. Respect. Wonder. Artists' works are a reflection of themselves. Personal development leads to greater depth in our work. Our skills and viewpoints may vary, but our basic humanity doesn't.

What is your advice for the aspiring photographer?

"Follow *your* bliss." Remember, the world doesn't need another Ansel Adams. We had one. No one can replace him. But the world has never had you; a unique individual in a significant environment at an extraordinary moment in time. Be the best you can be. Make your contribution to the world. Find and refine your authentic voice. You may not know what that is right now or what that will become soon, but if you engage the process with all your being you will amaze yourself and everyone around you. Surprise us.

© JOHN PAUL CAPONIGRO

Make sure that everything you do in some way advances your public brand and or personal growth. There's a lot to be learned from the philosophy, craft, and business practices (they're all important) of those who have gone before you. But, you don't have to do it exactly as they did it. Make your life the life you want it to be. Be creative, resourceful, and persistent to make that dream come true. Dare to be an explorer. And bring us back your story. Make it a good one!

THE PATH TO BECOMING A PROFESSIONAL

12

FOR MANY, THE IDEA OF GETTING PAID to make pictures is irresistible. When it happens, the moment is laughable, delightful, and exciting all at once. I remember the first time I opened an envelope that contained a significant payment for my photographs. It felt like highway robbery (and in fact it still does sometimes). Then, I became quiet and stared at that check. This was significant. It was a turning point, and every ounce of my being was ready. It was both dream and destiny.

Becoming a pro is a difficult and nearly impossible task. The photography market is ever changing and oversaturated. It can seem impenetrable. The path to becoming a pro is littered with broken dreams and ill-used expensive gear. There's no use even trying, people may say to you; you might as well give up and resign yourself to living a dull life. While you're at it, you should probably stop going outdoors, and please don't celebrate your birthday with cake.

In certain areas of life, negative advice abounds like an unending apocalyptic tale. When you follow such bleak warnings the plot becomes parody. How can we make sense of these well-intentioned yet demotivating words? And is it true? Is it an impossible task?

That's entirely up to you.

Your Story or Mine?

I was eager, excited, and full of iron-strong love. My wedding was only one week away and I was walking on the clouds. An acquaintance stopped by for a visit. He looked me in the eye and said, "Chris, I've been married for 25 years—listen up. You better live it up now, because it's all downhill from here." And with that bit of advice, he was off.

Years later I was beaming with pride. I was on the brink of something new. My film was back from the lab and these were my best pictures yet. I arranged them on a light table just as another acquaintance walked by. "Look at these amazing pictures!" I told him. He scanned the photographs with a critical eye. He said, "It was a nice try, but photography is a field that doesn't cut any slack. You'll never make it far."

The advice stung both times. It was an insult to who I am, how I love, how I live, and what I create. I was at first infuriated: Who do you think you are? Then it dawned on me. I repeated the word "who" and it all made sense. I softened and was even a bit sad for these sorry souls. I finally understood their advice was autobiographical. They were telling me their story; their marriage wasn't any good, their photographic career never left the ground.

As for me, I will never live someone else's drab and dreary life. My time on Earth is my own. And I will dream impossible dreams, I will love until it hurts, I will never give up, and come hell or high water, I will find a way.

The Janitor's Closet

The stars in Steve's eyes twinkled like Hollywood lights. Like many teenagers, he was a dreamer and he wouldn't let go of his desire to make movies. After high school he applied to a top film school in Los Angeles but was rejected. Unwilling to give up, he would find a way. He applied again, and the second denial hurt worse.

Defeated, he was resigned to studying an unrelated topic at a second-rate state school. Unsuccessful, after a few years of college, he dropped out. Steve still wanted to make movies—old dreams die hard.

Whether by speed or strength, endurance athletes remind us to push on. Here world-class mountain biker Travis Brown cranks up a steep section of trail.

A typical janitor's closet or perhaps something more.

Without an education, marketable skills, or a job he didn't have much to do. One day he decided to take a tour of Universal Studios. The open-air tour bus drove Steve and the other tourists around the back lot. Steve hopped off the back of the bus half way through the tour, slipped past security, and began to walk around. He wanted to be here. Later that day he left and walked out the main gate with a newly hatched plan.

Not even old enough to buy a beer, Steve bought his first suit and a tie. The next day, he was ready to play the part. Dressed like the rest, he walked up to the entrance of Universal Studios, waved to the security guard, and walked right in. And he did this day after day. Soon he found an old janitor's closet he thought would work well. With a few pieces of discarded furniture, the closet was transformed into an office. And that is where it all began.

Within a handful of years, it was too good to be true. Steve was bursting onto the scene with his second feature-length film. The movie was a historic success and he has since become known as the father of all blockbusters. Steve, who we know as Steven Spielberg, found his own way. He never gave up, and neither should you.

Believe and Play Your Part

If you want to become a pro, it is possible. So where to begin—ambition? We all need to be driven and motivated, but I think you need something more. Sam Abel, the renowned *National Geographic* photographer, put it this way: "Ambition won't get you that far. You'll shift gears. You'll see something that's shinier. But if you believe..."

What would it take for you to believe that it is possible? Can you imagine what life would look like? Initially, your vision might appear like an intangible myth. Some will tell you, "Get your head out of the clouds—after all, we need to be practical." Does true greatness ever result from common sense? I chose to follow dreamers like George Orwell who conjured up their own myths and then lived them out. Orwell said, "Myths which are believed in tend to become true."

We've all heard of the self-fulfilling prophecy. What we imagine, we become. As humans we move in the direction of our most dominant thoughts. What's filling your mind? Even more, like Steve, are you willing to play the part? Life begins now.

Your Future Starts Now

I once made the mistake of asking my daughter if she wanted to be a princess when she grew up. She looked at me crossly and said in a corrective tone, "I already am a princess!" The adult perspective is to think that one day we will become. The truth is we never fully arrive and therefore we might as well start now.

Set your sights high because your dreams will determine who you will become.

At one point, before common sense kicked in, you dreamed big dreams. You imagined a life full of adventure, courage, love, and treasure. If you want to go pro, you need to revisit these dreams and take an unconventional approach. Typically, students think in terms of genre: automotive, food, fashion, celebrity, nature, portraiture, sports, or travel. By beginning with these genres student's dreams fall short.

Genre is external. It's something created by the industry for organizational purposes. It's like the Dewey Decimal system, which libraries use to organize and categorize their books. Rather than start with the system, begin with what kind of book you want to write. Don't examine what type of photography sells. Rather, ask yourself what makes you come alive.

My mentor and friend Bruce Heavin once told me, "Focusing on my passions was the best investment of my life." If you want a big return, don't go looking at business and net worth. Ask yourself, what is it that really makes me passionate? What excites me like nothing else? And who do I want to be? A dream creates the future.

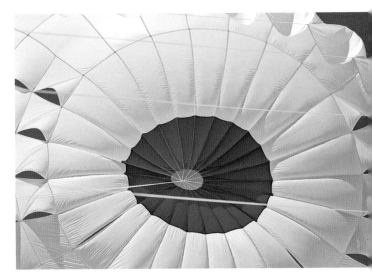

It's not the color of your parachute, but are you willing to jump out of the plane?

Chase Your Dreams

If you don't chase your dreams, your dreams will chase you. And when they chase you, they won't give up. As a teacher, I've seen this happen to hordes of people both young and old. The stories unfold by asking a simple question: How did you end up going to photography school?

One student, Stephanie, explained that she was a successful professional in a prestigious accounting firm in San Francisco. Fancy house, fancy car, the works. Her life was good, but she knew that it was not on track. She wanted more. As her salary increased, it became more difficult to leave. She looked me in the eye and said, "I knew that if I got one more raise, I would never leave. I just couldn't let that happen." She decided to leave and told her coworkers the plan, and they looked at her like she was a mirror. With awe and envy in their eyes they asked, "How is it possible? How are you doing this?" She responded, "I just am." Then they stared at her and wanted to say, "Can I come, too?"

Brian was a bright young student, but I could tell there was more. "What's your story, Brian, how'd you end up here?" I asked. "Well, since you asked... In high school I had headaches and thought they were the result of stress. I had a brain tumor. After surgery and treatment I'm now cancer free. It made me realize life is too short to neglect your dreams. I decided to do something I truly love, and here I am."

Jake had a strong handshake and a creative soul. I knew he was from Hawaii and was curious what had made him come across the sea. He explained that for the last 15 years he had run a successful business building homes. He said, "After 15 years, I got tired of building other people's dreams. It was finally time for me to build my own."

Photography is a field full of dreamers.

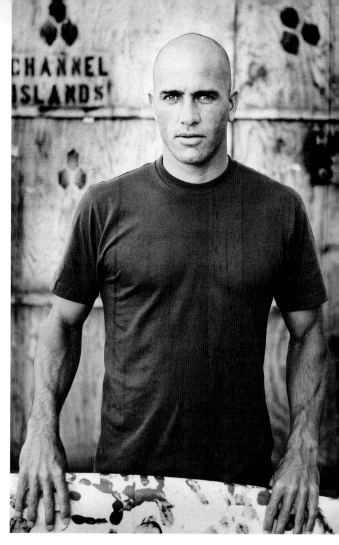

Kelly Slater transcends his sport. He is a dream chaser and dream maker, as one fulfilled dream ignites another.

Unique Story

Photography is a field full of dreamers. Whether self-taught or schooled, every photographer has a unique story. Start asking the photographers that you meet and you'll soon discover that their paths are curious, inspiring, and circuitous. It's rare that a photographer follows a set linear path. Rather

than A + B = C, all of life's distractions and experiences lead the way.

Photographers, like most artists, would rather not be caged in by industry categories. They are free to define themselves. In an interview, the lead singer of the rock band U2 was once asked what it was like to be a celebrity. He responded that he wasn't a celebrity but a "...scribbling, cigar-smoking, wine-drinking, Bible-reading band man. A showoff...who loves to paint pictures of what I can't see."

If you want to go pro, developing your own self-definition is key. Take a look at your story—what makes it unique? The secret lies within. It's who you are that shapes how far you go.

Know What and Why

Learning how to articulate who we are can act as a compass to what we do. Writing or speaking about our style, motivation, and drive is as difficult as it is clarifying. Because of the challenge of doing this, many photographers don't take the time. Immobilized by the burden, they're resigned to the many bland categories at hand. If you can set yourself apart, you will go far.

Photographers don't necessarily go into someone's office for a job interview. Rather, job interviews happen in day-to-day life. Consider riding on a subway or train in New York and someone notices your camera bag. They strike up a conversation and ask, "Are you a photographer—what do you shoot?" Most of my students would respond with something straightforward like, "Oh, I'm a music photographer." Will a response like this get the job? No way!

After a bit of coaching, here is one student's improved response, "Oh, thanks for noticing. I'm a music photographer. You know, I've been playing the cello since I was five. I just love music. There's something amazing about photographing musicians and trying to capture the essence of their sound."

This response will connect, pique interest, and get the conversation going. It will make the "interviewer" want to ask who you photograph or what kind of music you like. Ultimately, this conversation has the potential to stir up leads and secure new work.

Finally, when you articulate what you do, don't go overboard or tell them about your accomplishments. Rather, tell them about your interests by way of a brief narrative. Tell them the what and the why. Then, ask the "interviewer" a few questions of your own—what are her interests? What kind of music does she listen to?

Undercurrent Map

How you define yourself matters. It matters in day-to-day "job interview" conversations like the one above. Yet it matters even more with your big picture. One of the greatest photographers of all time, Sebastio Salgado, photographs many of the largest tragedies of our day. Salgado sees poverty, famine, and war through the filter of dignity. This filter shapes everything he does. Take some time to view his photographs and you'll quickly identify the trend. Whether it's a photograph of a starving child or a war-torn land, the undercurrent of dignity is present.

What will the undercurrent of your work be? If you want to be great, you need to begin to articulate who you are and how you see. Doing this has the potential to reflect the past and direct the future. There are a number of different ways to begin, whether writing out an artist statement, biography, or positioning statement or phrase. There are plenty of resources out there that can guide you through this process. To challenge yourself in a different way, try writing a collection of words that acts as a compass that will direct your path.

For starters, open a journal or find some paper and write your name in the middle of the page. Next, without judgments begin to write down words that

you would like to be descriptive of you and your work. Make this exercise less critique and more positive stream of consciousness. Here are some words lifted from my journal's page: wonder, wisdom, delight, drive, depth, alive, casual, curious, clam, conversational, catapult, natural, nutritious, nostalgic, simple, salt water, sea, musical, barefoot, integrity, iambic meter, gleam, fun, familial, friendship, listen, personal, vibrant, aloha, analogous, accessible, acoustic, authentic, tactile, timeless, unpretentious, and grace. See what you come up with.

I Want to Be

After brainstorming with words, take a few moments to write out a poem or some verse. Take a look at your word list and try picking something that could describe you and your work. For example, I'll pick the word *musical*. Next, qualify what that means. Here goes: Rather than an electric guitar, I want to be authentic and acoustic. Rather than in a studio, I want to be alive and outdoors.

These lines aren't brilliant, yet they begin to give shape to some ideas. Remember there's no such thing as bad art. If you write some awkward lines, that's OK—even Picasso painted rough drafts. Most important, write what you feel. And break up your sentences into shorter verse. Think of the lines like hooks where you can hang your hat. Here's another first draft, based on the word *sea*, which is about me and my work:

I want to be like sea who takes

sharp
broken
glass

and sees it through to the other side
deep and constant with many shades of blue
who's patience and persistence pays off in
subtle ways

luring others to be renewed
to gaze, breathe and slow down
to walk to the edge of solid ground
day dreaming once again
free and alive
while blue jeans get wet
from the white foamy waves

now changed

like the sea glass
in the faded wooden bowl
that sat next to my grandmothers
green shag couch

rough edges now smooth

even as a child, when
I twirled my fingers through that bowl
I felt like I understood something honest and true
once broken, but now new

holding up a piece to the window
as if illuminated from the inside out
was a muted yet magnificent glow
that was quiet and strong
it made me want to whisper

I want to be like the sea

Humble

Becoming a pro means you are no longer a hobbyist or amateur. It means that you get paid for doing something that you would gladly do for free. And the excitement of becoming a pro has nothing to do with status. It means that you can deepen what you do. In some ways, it's like going to graduate school.

When I was at graduate school, a close friend asked me what it was like. First, I explained, college was about freedom, discovery, and adventure. In graduate school it was a bit more. It reminded me of playing music with another talented musician; the more talented the other, the better my sound.

Amateur

Somehow the people who I was around brought out the best in me.

So it is with professional photography. It is a transition to a better place. Being a pro means the fun has only just begun. It's not the destination but a whole new space. And in this place, you are not above, separate, or apart. Rather, the better you get the more humble the ground. For it is a growth that connects you with the past and propels you toward the future.

Photography is a medium of experimentation, and you will always make mistakes. In the face of mistakes you cannot lose hope. Even when your vision sags and your confidence is cloudy—hang on to hope. It has buoyancy that will pull you through. Hope will remind you that being a pro is not about perfection but passion.

John Sexton is one of my favorite photographers. His work is both simple and profound. In a recent conversation he said, "While I am paid to make pictures, I will always be an amateur in the true sense of the word."

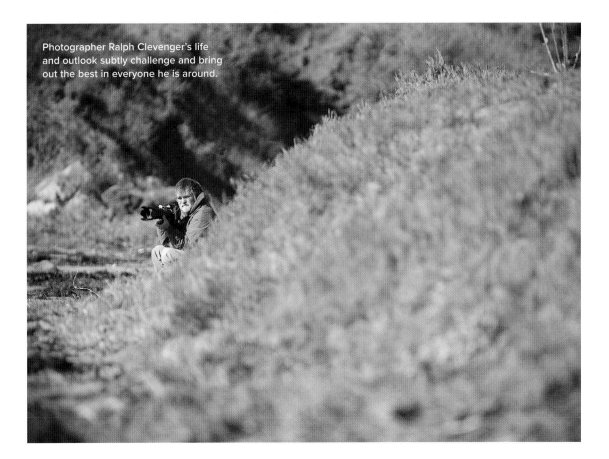

Photographer Ralph Clevenger's life and outlook subtly challenge and bring out the best in everyone he is around.

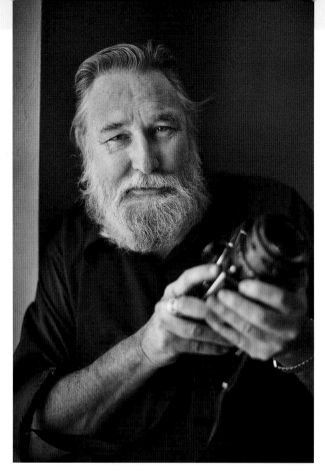

Nick is a talented printer, photographer, and teacher who constantly reminds me to make the most of what I have.

In some circles, the amateur is brushed aside. This mentality creates some cultural divide. What is behind that ill-used word? It comes from the Latin *amator*, which means, "lover, devoted friend, devotee, enthusiastic pursuer." And then the French picked up the word and layered on even more meanings of love. In contrast a professional is one who is paid.

Therefore, the more professional you become, the more amateur you need to be. The goal isn't to be one or the other, but both.

Begin Where You Are

During a time of world war, Richard was heading off to join the Marines. As a going-away gift his dad gave him a camera. Once settled into his rank with the Merchant Marines, Richard was given the bleak and boring task of taking identification pictures of the crewman. He used a simple camera and plain white backdrop. Richard made the most of it and caught a vision for more. Years later, Richard Avedon would use that same camera and set up to create what some call a few of the greatest photographs of all time.

If you want to be a pro, begin where you are; whatever your life experience, and whatever the odds. If the outlook is bad, try the up look and be sure to look past the trees.

Trash

As a high school English teacher, Steve did all right. His true passion was to write. When his novel was 75 percent complete, he thought it was a mess and felt defeated. He threw the whole manuscript in the trash. Later that day his wife was cleaning up the house. She was just about to empty the trash and realized what was inside. Secretly she salvaged the hand-typed document and read it straight through. When her husband came home, she told him what had happened and convinced him to press on. Once finished and published it was a bestseller, which allowed Stephen King to quit his day job to pursue his passion full time.

If you want to be a pro, you need "trash digging friends" like Steve's wife. Ask any successful pro and they will tell you the same. These are the people who believe in you more than you believe in yourself. And when you surround yourself with people like this, something magical begins.

No matter who you are, there will always be people who are strong critics and who cut down your work as if it were an old tree. It is easy to let the negative splinters of their thoughts get caught in your mind and become your demise. As Spike Lee once said, "You allow failure to enter your mind and it is already done." It you want to be free, removing the splinters cannot be done just by one.

One of my closest friends is Evan, and he thinks I'm really cool. Seriously, it's as if all my ideas are good, my skills are profound, and I can do no wrong. I feel exactly the same about him. He is a brother to me. When we get together the sparks fly. When I hike, camp, or surf with Evan, I become more skilled. It's not that I have different skills, it's that he believes in what I don't know is there. Good friends, brothers, sisters, spouses, and parents do this for us. And if you want to be pro, you can't pull it off alone.

My sister Amanda pursues the artistic and abundant life with elegance and resolve.

Surround Sound

You need to surround yourself with people who love what they do. Like all professions, photography has its curmudgeons who feed off crushing dreams. People like this spread their ideas like secondhand smoke. Don't breathe it in. Even better, run the other way.

Find people who are passionate and who embrace the challenges of life with grit. Let them be your source of ideas and inspiration. Like surround sound speakers, let the message of their life stream in from all sides.

If you can't physically surround yourself, find another way. I hung a picture of Mark Wellman above my desk when I was growing up. He is a man without limits; a paraplegic athlete who has used his arms to climb big rock walls like Half Dome in Yosemite. I remember shaking his strong and burly hand once. He said, "Success depends upon the ability to face whatever challenges come our way."

Sellification or Soul

Photography conferences are a curious mix of art and commerce. At a recent conference, I had a break in my schedule and thought I'd sit in on a few seminars. I didn't have a schedule so I just decided to walk down one of the halls, and I found exactly what I was looking for. The sign said there were two sessions to choose from. The class on the left was titled "Sellification" and the class on the right was called "Soul."

I first thought it was a parody to try to replicate the pro photographer's path. How do I make money? How do I have soul? I looked at the signs and realized they were both legitimate. Which one should I choose? I stood there for a moment, and then decided to attend both. It would be a fascinating exercise in contrast and comparison. I went to Sellification first to get it over with. Plus, I figured after that message I could use a bit of soul-filled focus.

Andy Davis is an artist extraordinaire. He has soul and his inspiration runs deep. In his studio he intentionally surrounds himself with art created by his friends.

Sellification was being preached to a sold-out crowd of eager disciples. I stood in the back and listened to the high-key, energetic message. It was chock full of acrostic-based tips, snappy messages, and evangelical promises of health and wealth. It was worse than I expected.

I opened the door to Soul and was greeted with warm smiles. Even though I didn't know anyone, the crowd felt like family. The message was dignified, honest, engaging, poetic, and practical. I thought to myself, "This is why I'm a photographer."

In reflection, I found it funny that Sellification was more "spiritual" than Soul. In spite of my opinion, both speakers did incredibly well. They both had something to sell—whether ideas, products, or promoting the companies who sponsored their event. And both speakers did a really good job. Speaking with other attendees, each side was convinced and ready to go. They were so different. It has to make you wonder, which way is right or true—is it art or commerce?

Renny Yater has been refining his craft of surfboard shaping for years. His approach is quiet, simple, and thoughtful.

Savvy

The guest speaker I had invited to speak to my class was clear: "It is either sink or swim. Become business savvy if you want to survive." And the students appreciated his words. They know firsthand that without a strong business backbone it will be difficult to thrive. The guest speaker continued, "It's not that difficult of a choice. There's no need to get sentimental. The competition is cutthroat. If you want to make it, you have to be realistic and business skills will pave the way."

The class rallied and cheered. In many ways, I agreed. I couldn't help but think about the uncanny similarity of his words to a quote I had recently read. It was Brigid Brophy who said, "Whenever people say, 'We mustn't be sentimental,' you can take it they are about to do something cruel. And if they add, 'We must be realistic,' they mean they are going to make money out of it."

In order to be a pro you must chart the course of art and commerce. How then can it be done? Or even better, how can it be done well? I think it is a matter of asking yourself what you want.

Unpractical

I want to breathe cold, crisp mountain air. I want to get up early and watch the sunrise as I sit on my surfboard and wait for waves. I want to contribute to the greater cause. I want to know and be known. I want every ounce of my being to be authentic and true. I want a deep and full life. As William Wallace said, "Every man dies—not every man really lives."

This perspective shapes everything I do. I think people get it wrong when they flip-flop their approach. Take my students who start with business and all that it means. They become great at business but

neglect having something to sell. Even more, they lose track of life and eventually become undone. What was once passion is replaced with apathy. The result is a bleak horizon and the shell of burned-out dreams.

What does all this mean? It means that I am unpractical in my approach and I will chart my own path. For example, I have been asked to do some amazing work that would allow me to travel, grow, and expand. Yet it would require being on the road for most of the year. Because of the travel, I didn't consider it an option—my wife is too beautiful and my kids are too wonderful. I'm not saying that I don't make sacrifices and work hard. But there is no way that I want to create pictures and look back on my life and mourn all that I missed. I take pictures to have more life and not less.

Each business decision you make will be unique and your own. If you want to excel, take jobs that are rooted in what you want, who you are, and who you want to become.

Statistics

Statistically speaking, becoming a pro photographer is nearly impossible. It is time intensive, cost prohibitive, risky, and just plain hard. The value of photography continues to drastically drop. The field is flooded with photographers of all types. The competition is strong.

Still I say, "Bring it on!" The deeper the risk, the stronger the reward. It is a challenge that I invite you to take. Like William Shackleton's advertisement for his Antarctic voyage: "Men wanted for hazardous journey. Low wages, bitter cold, long hours of complete darkness. Safe return doubtful. Honour and recognition in event of success."

Occasionally, I hear people talk about the competitiveness of photography as if were bad. I completely disagree. For starters, competition means value. We compete for the things we love best. And being a photographer is a wonderful trade. Second, imagine if photography weren't competitive—it would be a mess. Competition has the potential to bring out the best. Third, competition means that photography is hard, and that's exactly how I want it to be. If it were easy, we'd all lose interest and be on our way. Capturing the fleeting moments of life or the essence of a scene will forever have a magnetic force.

My grandfather was an unpractical man. He was vibrant and full of creative life. Unfettered by rules, he painted equally well with both hands. Before there were fonts he made up his own. His life lifted my sights.

Invest 315,569 Hours

Becoming a pro is unquestionably hard and therefore takes time. It takes time to hone your skills so that you can fluidly and consistently create compelling photographs. It takes time to gain technical prowess, develop vision, and learn the ins and outs of the trade. It's not uncommon to hear this thought: "It takes at least 10,000 hours to become great."

When I hear the 10,000-hour statistic in the wrong context, it makes me cringe. Often it is used as a way to tell people they are not any good and that they can't be any good for another ten years. Maybe it's because I'm a teacher or maybe because I believe quality can happen quickly. I've seen it done before. I've witnessed with my own eyes people who have broken records as a result of not believing in statistical odds.

I understand and agree with the intent of the idea—designed to encourage people to keep at it and to work hard. I think this one is more helpful after the fact—20-20 hindsight. It makes sense to someone who has lived and learned. But to the aspiring and hopeful photographer, it is too formulaic, particular, and precise. Such particulars stifle rather than inspire.

If we want to get particular, the other day I was on a photo shoot with a celebrity. I created a profound picture. Yet because who I am shapes what I see, I couldn't have created that picture until this year. Therefore, preparing for that picture took my whole life. Based on my age, if you would like to take a picture like that I recommend you invest 315,569 hours.

And here, the statistics obviously fall apart. Regardless, I do know with full certainty, the path to becoming a pro is difficult and it takes time. It is so difficult it requires more than hard work. It requires a dream.

I've known Chris Lieto since I was 16 years old. Even then he would dream beyond his means. It's no wonder he's become one of the world's best triathletes.

Unrealistic Dreams

Daydreamers know that realism isn't effective. Goals and dreams have to have an edge of unrealistic aspiration to get us out the gate. The more unrealistic the dream, the faster we move. Such dreamers take risks. The best dreams are so risky that they are ridiculed by everyone. When they are accomplished the redemption is sweet. If you want to go far, you need to begin to dream. As T.S. Elliot said, "Only those who will risk going too far can possibly find out how far they can go."

After working with hundreds of students and professionals, I've come to believe that most people's dreams are too small. In my classes, at least once I like to devote a few minutes to getting the students to shoot the moon. After a quick and peppy talk, I ask them to write down specific dreams. And I ask the same of you.

Create a few specific dreams as a way to create momentum and focus. When the night air is bitter cold, your dreams will focus your sight. They will guide like a far-off light. They will beckon you to sit down and warm your soul.

In the classroom, the exercise to write out one's dreams is brief. Yet the results are profound. One of the greatest satisfactions in teaching is when I receive word of a dream fulfilled. Like the call I got last week from a former student: "Remember that dream thing you had us do? Mine was to get a cover of my favorite magazine. And today, exactly one year and one day from my graduation, my cover has just released!" And with that, we celebrated with loud, crazy, and joy-filled hoots and hollers. Then, just as we were about to say goodbye, my former student said, "Man, we are so lucky we get to do what we do—the rest of the world is missing out!" I couldn't agree more.

Additional Resources

Making the transition from amateur to pro is exciting, but you will need some support. Check out these resources to help you get your dreams off the ground. Keep in mind that the list is in no way exhaustive or hierarchical, but intentionally short and hopefully meaningful.

As you discover more resources, be careful not to become bogged down. I've known many student photographers whose careers were derailed simply because they spent too much time focusing on resources. I hope these do more than simply keep you afloat but help you advance and thrive. For even more links and information, visit www.visual-poet.com.

Photography Books

Here are some old and new instructional classics to consider:

Photography, by Barbara London, Jim Stone, and John Upton: This general catchall photography book is often used in Photo 101 courses at schools.

Photography and the Art of Seeing: A Visual Perception Workshop for Film and Digital Photography, by Freeman Patterson: Freeman Patterson is one of my favorite authors. His love of photography is pure and his approach simple. I own every one of his books.

Tao of Photography: Seeing Beyond Seeing, by Philippe L. Gross and S.I. Shapiro: This is a book that I turn to again and again. I've read it more than any other book I own. It is deep and profound. It will shape who you are and how you see.

The Joy of Photography, by Eastman Kodak Co.: I enjoy this book because it is old. It was written at a time when photography was more relaxed. The content is dated, but it will always have a place on my shelf.

The Photographer's Eye: Composition and Design for Better Digital Photos, by Michael Freeman: If you are interested in studying composition and design, this is a wonderful place to start. The photographs, instructions, and illustrations are top-notch.

Understanding Exposure: How to Shoot Great Photographs with a Film or Digital Camera, by Bryan Peterson: This book is a bit dated, but it remains one of the best-selling photography books of all time. The content is simple, accessible, and enjoyable to read.

Within the Frame: The Journey of Photographic Vision, by David DuChemin: The author of this book is humble and honest and the photographs are stunning. This book will sharpen your vision and refocus who you are.

Photography Publications

PDN: Photo District News is considered the industry standard. This monthly publication covers the hot topics of today.

Communication Arts Photography Annual: Communication Arts is the largest international trade journal for visual communications. The journal covers every topic from interactive design to photography. Watch for the annual photography issue.

Aperture: Aperture is considered a serious and valuable quarterly photographic publication. Think of this as an alternative to mainstream photo magazines with less emphasis on commerce and more on the difficult and profound. This publication is not for everyone, but for those with of a more fine art taste.

LensWork: This publication focuses on black and white photo-graphy and the creative process in a way that is non-technical and non-academic. LensWork features articles, interviews, and photographic portfolios.

Photography, Business, and More

These titles focus on some of the business aspects of photography:

Annie Leibovitz at Work, by Annie Leibovitz: Learn from one of the most celebrated photographers of our time. Annie's voice is authentic and full of wisdom.

How to Succeed in Commercial Photography: Insights from a Leading Consultant, by Selina Maitreya, and **Portfolios That Sell: Professional Techniques for Presenting and Marketing Your Photographs, by Selina Oppenheim:** Selina has spent a number of years helping photographers make their businesses grow. In these two books (one by her former name), she shares some valuable tips she's learned from the trenches.

It's Not How Good You Are, It's How Good You Want to Be: The World's Best Selling Book, by Paul Arden: This is a small, unassuming book, written with tongue in cheek. At first glance what appears to be trite is actually quite profound. It is full of small morsels of wisdom.

The Photographer's Guide to Marketing and Self-Promotion, by Maria Piscopo: If you're interested in making a living as a photographer, this book will provide you with some straightforward and practical advice.

Photographic Inspiration

If you want to become a top-notch photographer, it's critical that you begin to surround yourself with top-notch work. Start building your collection of coffee table books on photography and art. If you're looking for a few recommendations, you can't go wrong with any of the photographers mentioned in this book: Annie Leibovitz, Ansel Adams, Anton Corbijn, Duane Michals, Richard Avedon, Elliott Erwitt, Marc Riboud, Rodney Smith, John Sexton, Henri Cartier-Bresson, and Steve McCurry. Before you purchase, visit www.amazon.com and read the reviews to find one that suits your style.

Blogs

Here are some blogs to visit and read on a regular basis:

http://alltop.com: This one-stop site gathers and displays popular topics from photography-related blogs on the Web.

www.aphotoeditor.com: Rob Haggart is a photo editor who provides insight into the trends of professional photography. Make sure to scroll down and click on links for photography books, promo card examples, and advice for assistants.

http://blog.vincentlaforet.com: Vincent Laforet is a commercial and editorial photographer of great repute.

www.chasejarvis.com/blog: Chase Jarvis is an immensely creative commercial photographer who consistently shares what he discovers and knows.

www.chrisorwig.com/flipside: This is my personal blog, where I post images, creative ideas, and noteworthy news.

www.joemcnally.com/blog: Joe McNally is a widely popular commercial photographer and workshop teacher.

www.johnpaulcaponigro.com/wordpress: John Paul Caponigro is a reknowned fine art photographer and workshop teacher.

www.pdnpulse.com: The Photo District News blog is a great source of information on the business of photography.

Portfolio and Brand Development

Without solid marketing, even the most talented photographer won't go very far. Take advantage of these resources to sharpen how you present yourself:

www.agencyaccess.com: promotion and marketing

www.brand-envy.com: brand development

www.lost-luggage.com: portfolios

www.myemma.com: online marketing

www.suzannesease.com: photographic consultant

Photography Agencies

Eventually, you may want to consider hiring a photographic representative or agency to help promote your work. Below are two of the best in the world:

www.artandcommerce.com
www.margecasey.com

Further Education

If you want to start making progress by leaps and bounds, consider taking advantage of the many ways to piece together and further your education with books, videos, and workshops.

DIGITAL POST-PRODUCTION

www.lynda.com: Lynda.com provides online training for a small subscription fee. When you visit the site, look for my Photoshop and Lightroom training titles under "Chris Orwig."

www.peachpit.com: Peachpit is a leading publisher of digital photography and related technology books and videos. If you are new to digital post-production, start with a book by Scott Kelby. He has created a range of books that are entertaining, easy to read, and full of valuable information.

PHOTOGRAPHIC WORKSHOPS

Workshops are a wonderful way to learn. Here are some workshop providers that might meet your needs. Whether you are a beginner or seasoned pro, you will find that a good workshop has the potential to quickly sharpen your skills and reignite your passion.

www.josevillaworkshops.com
www.leppphoto.com
www.moosepeterson.com/workshops.html
www.photographyatthesummit.com
www.rmsp.com
www.theworkshops.com
www.santafeworkshops.com
www.vspworkshops.com
http://workshops.brooks.edu

Guest Speakers

© CHASE JARVIS

Chase Jarvis

When I asked Chase to be a guest speaker, I told him this book project was a dream come true for me. Chase said, "I love hearing about dreams coming true. That describes my whole career." Chase's approach has been dynamic and humble. And he shares with others how to follow this path on his blog. For more information visit: www.chasejarvis.com.

What inspires you?

Art inspires me both professionally and personally. When I watch a good movie or see art on a wall, that stays with me for days and adjusts my thinking. People inspire me to try new things. And adversity inspires me, because it often brings the best out: to target, refine, and overcome something.

We live in an incredibly interesting time for photography from a technical and image-making standpoint. More pictures are being made and used in more ways with all the social media. It's an incredible intersection with innovative ways to shoot and share pictures. I find this inspiring.

What makes a photograph good?

The raw impact—the stopping power of a photograph, either simple or complex, whether the image is 10 by 20 feet or thumbnail size. This applies to war, sports, or wedding images. The photo stops you in your tracks. After you stop, the image has the ability to make you look at it, the volume of things in a picture, if there is a lot to take in.

What character qualities should the photographer nurture?

Hard work comes to mind first. I've mentored a lot of photographers and everyone wants to find success as soon as possible. But hard work is really important. Even if you are the best of the best, this is only a little sliver to stand on and it doesn't build a career on longevity. Most young photographers dramatically underestimate this.

Also, humility is a characteristic that is underrated. Take the little nos and setbacks and use those as drivers to push forward. You also need to be passionate, confident, tenacious, and curious. All of those characteristics plus humility will create a balance. Even if you hit a home run on the first project—the life of that is short.

Humor is important as well. If you can be light, a sense of humor goes miles. If you have a great time on set, it puts other people at ease and you can laugh about the happy and tragic.

What is your advice for the aspiring photographer?

Henry Ford said this: "Whether you think you can, or that you can't, you are usually right." That has always been something I turn to. There are roller-coaster rides everywhere in a photography career. The ability to hold in your mind what you want is really important. Play to your strengths, of course, but find out where you are weak and build those skills, too. And take everything I'm saying with a grain of salt. Seek a bunch of opinions. Read and learn about as many things as you can, and when you find something that speaks to you apply it.

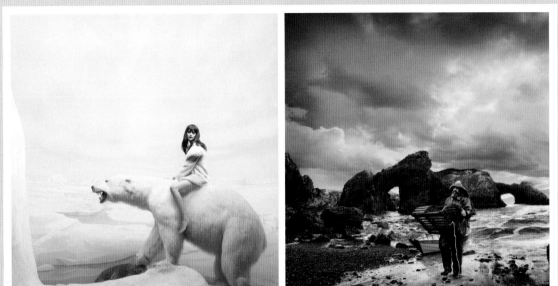

Erik Almas

Erik Almas speaks with a thoughtful and generous tone. His images are intriguing and impossible to ignore. The aesthetics and story draw you in for a deeper gaze. And that's a little bit like Erik's life. He grew up in Norway. His feet are firmly planted on the ground while his vision soars toward the sky. Read his bio and see his work at www.erikalmas.com.

What inspires you?

Life, art, and being curious. I seek out art more than I did in the beginning. Also books, movies, paintings, anything full of imagination, especially poetry that conjures up images in your mind. Sometimes I just walk to be filled with imagery and impressions. Other times I leave photography alone and do other things and stay away for a bit. Then it bubbles up and you have to take pictures again. Get a little distant from it first. It's good.

What makes a photograph good?

Pictures are so individual; there is no formula. For me, there need to be some question marks. I'm intrigued if there is something more to it than what you see. If you're responsive to the photograph somehow, and if it asks questions or reminds you of something in the past, then your response to the image is emotional. There is some kind of mystery that's going on outside the frame.

What character qualities should the photographer nurture?

Tenacity. Never give up. Even if you have a beautiful eye, you will not make it if you don't have drive to get pictures out for people to see and buy. Any guy in any wishful profession will tell you the same. More hard work and time.

You've got to train your eye. I think that comes with taking pictures. Always take pictures. Especially students who go and assist an established photographer and don't take pictures for three years—that's visual suicide.

Mentors are very critical. I had a few throughout school and then I assisted the photographer Jim Erickson. Mentorship is critical, imperative really. It is so crazy how everybody thinks that you can't learn a trade now in the same way that you might go to work with the shoemaker in the past. Being an apprentice is not valued, not cool. That is until Donald Trump came along with his TV show. It is important if you want to make it. Nobody really makes it on their own. I didn't anyway. I got help.

What is your advice for the aspiring photographer?

Don't give up. Find yourself a mentor and never give up. It is so rewarding to be a photographer, I get to travel and take pictures—it is fabulous. I have to pinch myself sometimes.

Success is nothing really. It helps you buy a house and a car and get great assignments. But my work was a bit purer when I started out, when I was honing my skills and establishing my style. Now clients say we love your work, go do what you do. I get more respect. They don't interfere as much, and there is more trust there. I don't have to work as hard to be myself. I'm more confident in what I do.

When you're younger, you take on everything that comes your way. Then after a few years, you may say, hey, wait a minute, how do I want to shape my life? Get some different recognition. That's important, too. I'd love to make pictures good enough for people who walk into a gallery to want to have them in their home. I'd do more fine art.

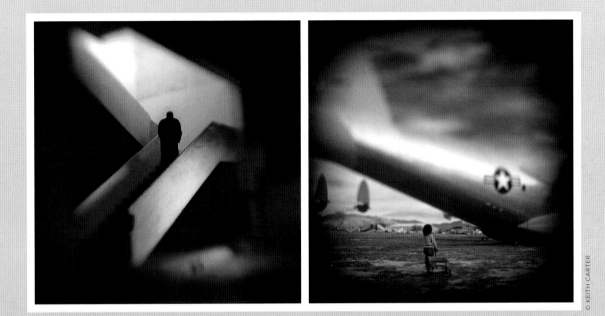

Keith Carter

Keith Carter is an unconventional fine art photographer. His images are rooted in the objective world, but they suggest something more. Keith approaches photography and life with vigor and passion. Read his biography and see his work at: www.keithcarterphotographs.com.

What inspires you?

Conversations with friends and colleagues, exhibits, books, travel, popular culture, folklore, and the work itself all contribute to inspiration. In the beginning, my inspiration was from poetry and books such as *Let Us Now Praise Famous Men*, by James Agee and Walker Evans. Today I never tire of revisiting the work of Eugene Atget, William Butler Yeats, Joseph Cornell, or Irving Penn.

What makes a photograph good?

For me it is always content. If you're the one making the photographs, the full weight and mystery of your art rests upon the relationship you have with your subject matter. Then there's the matter of your own personal aesthetics. Pick five photographs from the history of photography you wish you had made and ask yourself why?

What character qualities should a photographer nurture?

A good work ethic is the first thing that comes to mind. You have to find joy in doing the work itself—everything else follows. A love of reading provides a foundation of both comfort and ideas. There's an implicit kinship between writers and photographers. After all, the word *photography* comes from the Greek and loosely translates as "writing with light." I think about light the way writers think about words.

What is your advice for the aspiring photographer?

My own particular interests reside in the art world. I don't think there is any great mystery about making art. We all start out the same way: Learn your craft, work hard at trying to be coherent with your pictures, and pay your nickel and take your chance. The bedrock in a body of work is your subject matter and how you relate to it. If you have empathy and care about your subject matter, then the discoveries, deeper meanings, and understanding have a greater chance of evolving from that work.

Index

A

Abell, Sam 44, 258
action photography 179–205. *See also* outdoor
 photography
 anticipating action 194–195
 freezing time 192
 gear 196, 199–200
 lighting 195
 motion 191, 192–193
 photographing athletes 196–198
 practical tips 194–198
 preparing for 194, 200
 sharing photos 202
 shooting assignments 201–202
 slow-motion scenes 191
 workshop assignments 200–202
Adams, Ansel 4, 19, 47–49, 65, 183
Almas, Erik 275–276
Anouilh, Jean 209
aperture 63–65, 87
aperture priority 87
Aperture publication 271
Aperture Value mode 63–64
Arbus, Diane 47
architecture 60, 168–169
Arden, Paul 18, 25
artists, inspiration from 19
athletes 196–198
Aurora Photos 201
Automatic mode 63
Avedon, Richard 56, 73, 79–80, 83, 98, 264

B

backpacks 170, 240, 242
Basso, Ivan 193
batteries 170, 200
battery chargers 170, 200
Berra, Yogi 24, 160
Bilgere, George 57
blogs 271–272
Blue, Travis 85

blur, motion 201
blurred images 65–66, 145, 192, 193
Boden company 126
Bono 186
brand development 272
breathing 17
Brophy, Brigid 267
Brown, Travis 192, 257
Buber, Martin 156
Bullock, Wynn 48
Burroughs, John 44

C

camera bags 240, 242
camera body 244–246
"camera consciousness" 122
camera gear. *See* gear
camera phones 246
camera shake 65
camera straps 225–226, 241
cameras. *See also* digital cameras
 Automatic mode 63
 carrying everywhere 37–38
 considerations 235–237, 240
 cost 240
 emotional responses triggered by 92
 features 244
 film 244
 handling 241–242
 hiding behind 118
 insurance 247
 medium vs. large format 244
 pocket 246
 quality of 237–238, 240
 as sketchbook 37
 stability 241–242
 treating nonchalantly 92
 vintage 245
 walking with 208
 waterproof 246
Canlas, Jonathan 126
Caponigro, John Paul 186, 252–253, 272
cards, photo 202
Carter, Keith 240, 277–278
Cartier-Bresson, Henri 17, 37, 58, 212, 240
Castiglione, Baldassare 9

children 105–131. *See also* family photographs
 affection 111
 capturing special moments 106–110
 creativity of 18–19, 27, 28
 genuine smiles 111
 importance of "now" 106
 photographing 105–128
 playing dress up 113–114
 practical tips 117–125
 using props with 118, 126
 view of the world 39–41
 working with 108–116
Chouinard, Yvon 96–97, 188
Churchill, Winston 80–81
Clevenger, Ralph
 on automatic mode 63
 on editing 10
 interview 203–204
 patience/persistence 114
 photos of 241, 263
 Web site 200
close ups 172
Collier, Dave 200
color
 emotion and 44, 217
 favorite 28
 found photography 217, 227
 importance of 44
 outdoor photography 202
 qualities associated with 44
 shadows 44
 travel photography 172
 warm vs. cool 217
color palettes 166
Communication Arts 271
composition 42–43
conferences 47
contests 173
context 167
Corbijn, Anton 186
Costa, Michael 144, 148–149
Cousteau, Jacques-Yves 203
creativity 15–31
 "bad art" and 27
 becoming creative 18–29
 bold mistakes 24–25
 of children 18–19, 27, 28
 considerations 15, 18
 Dead Sea principle 29

 effort required for 17
 encouraging 17–19
 exercises 28
 factory tours 19–20
 getting stuck 66
 importance of relaxing 55
 limitations and 57
 literature as inspiration 25
 living in the moment 180
 other artists as inspiration 19
 pain/loss and 10
 perseverance and 53–54
 photography and 15–31
 positive thinking and 21
 searching for 21–24
 seeking unique experiences 24–25
 technique and 51–68
 Tesla on 52
 vs. style 189
cropping photos 145
cultural divide 264
Curren, Joe 90, 226, 231–232
Curren, Tom 77, 84

D

darkness 164
Davis, Andy 266
de Cervantes, Miguel 41–42
Dead Sea principle 29
dehumidifier 170
Dekker, Nick 73, 264
depth of field 63–65, 87–88, 89
details 58, 139, 145, 190, 212, 221
determination 188, 189
digital cameras. *See also* cameras
 35mm SLR 244
 megapixels 66, 237–238
 pros/cons of 17
directional photographs 222–225
discovery 6
distortion 62

E

Eastwood, Clint 211
editing 46–47
education 272
Einstein, Albert 38

Elliot, T.S. 269
Emerson, Ralph Waldo 53
emotion
 color and 44, 217
 triggered by cameras 92
 triggered by photos 76
endurance 188, 189
engagement photos 138–139
enthusiasm 42
environmental photographs 98
equipment. *See* gear
Erwitt, Elliott 208, 209, 226
"Eureka!" moments 210
exposure 63–66, 195
expression 74–76

F

factory tours 19–20
family photographs 105–131. *See also* children
 action shots 127
 "camera consciousness" 122
 capturing togetherness 123
 documenting accomplishments 123–125
 family involvement in 120–122
 gear 122, 125
 isolating subjects 123
 juxtaposing young/old 126–127
 location 118
 movement in 122
 practical tips 117–125
 sharing 127–128
 unguarded moments 116
 at weddings 142
 workshop assignments 125–128
festivals 168
film cameras 244
film grain 66
filter, internal 38
fish-eye lenses 59
fixed lenses 58
flash photography 57
Flickr, sharing photos via. *See also* sharing photographs
 family photos 128
 found photography 228
 outdoor photos 202
 portrait photos 99
 travel photos 172
 wedding photos 146

focus, changing 54
food, photographing 167
form 222
found photography 207–232
 close ups 221
 color combinations 217, 227
 directional photos 222–225
 "Eureka!" moments 210
 gear 225–226
 hidden gems 219–220
 "if only" thinking 209
 juxtapositions 217
 line/shape/form 222
 night photography 215–216
 perspective 212–215
 photographing letters/numbers 219
 practical tips 217–225
 reviewing photos 228
 sharing photos 228
 signs 218–219, 227
 workplace photos 222
 workshop assignments 226–228
France, Anatole 190
Franklin, Benjamin 239
freezing time 192
Frost, Robert 160
f-stops 63–64, 65, 87–89

G

gear, 235–253
 additional resources 248
 amount of 239–240
 being prepared with 200
 camera bags 240, 242
 considerations 235–237
 family photographs 125
 found photography 225–226
 insurance 247
 outdoor photography 196, 199–200
 portrait photography 97
 quality of 237–238, 240
 repair supplies/tools 200
 reviews 248
 snacks 200
 transporting 242
 travel photography 170
 traveling light 199
 tripod 170, 195, 200, 201, 241–242

gear (*continued*)
 using 199
 vendor information 248
 wedding photography 143
Gehry, Frank Owen 185
genres 186, 259, 261
Glaser, Todd 205
gloves 200
golden mean 42
grain 66
gratefulness 180

H

Haggart, Rob 272
Halsman, Philippe 79
Harper, Ben 74, 75, 221
Heavin, Bruce 259
Hemingway, Ernest 6
Hoffmann, Martyn 157
houses, drawing 28

I

iconic images 160, 161, 162
imagination, rekindling 9
inspiration 19, 25, 68, 156, 271
insurance 247
internal filter 38
Iooss, Walter 201
ISO number 63, 66

J

Jarvis, Chase 226, 272, 273–274
Jeffers, Robinson 19
Johnson, Jack 43, 63, 72
juxtaposition 217

K

Karsh, Yousuf 80–81
King, Stephen 264
Kirkland, Douglas 67–68
Kost, Julieanne 24

L

Laforet, Vincent 272
Lamott, Anne 17
landscapes 65, 168
Lawler, Greg 130–131
Lee, Spike 265
Leibovitz, Annie 58, 74, 76, 98, 271
lenses 57–58
 considerations 240
 distortion and 62
 fish-eye 59
 fixed 58
 macro 58–59
 normal 60–61, 243
 purchasing considerations 242–243
 recommendations 242–243
 speed 243
 stabilization feature 243
 telephoto 62, 243
 travel photography 170
 wide-angle 60, 192, 243
 zoom 58, 62, 243
LensWork 271
Lepp, George 200
letters 219
Liebhardt, Paul 55–56, 226, 229–231
Lieto, Chris 189, 269
lighting
 available light 82, 142
 in different geographic locations 163
 identifying qualities of 43–44
 lack of 164–166
 natural light 82
 open shade 83–84
 outdoor photography 195
 portraits 82–84
 reflectors 83
 sunlight 82
 sunrise 164, 191, 195, 201
 sunset 117, 164, 191, 195
 window light 82–83
limitations 56–57
Lincoln, Abraham 38
line 222
Lipsky, Jeff 250–251
listening 35–36
literature, as inspiration 25

locations
 challenges 44
 family photographs 118
 "over-photographed" spots 44, 46
 uninspiring 44, 46
 viewing with fresh eye 44, 46
long exposures 195
Lopez, Gerry 78–79
loss 10
Lynda.com 272
lyrics 6

M

macro lenses 58–59
Magnum Photos 226
Maisel, Jay 72
Mallams, Matt 226
Malloy, Keith 82, 83
Manual mode 63
McCurry, Steve 72, 174–175
McNally, Joe 272
megapixels 66, 237–238
"memory points" 195
Meola, Eric 57–58
Merwin, W.S. 10
Messina, Elizabeth 144, 147
mindful attentiveness 36
mindfulness 36
monkey paw 163
Monroe, Marilyn 67–68
monuments 169
moo.com site 202
motion 191, 192–193
motion blur 201
mounted prints 127
Muir, John 183
music 6, 24–25, 68
mystery 4, 5

N

naiveté 41–42
"National Geographic shot" 161
National Geographic Your Shot 173
Newman, Arnold 57, 73
night photography 164–166, 195, 215–216
nuance 37
numbers 219

O

observation, power of 34, 37
O'Neill, Jack 86
openness 35
order, sense of 42–43
Orwell, George 258
outdoor photography 179–205. *See also* action
 photography
 color 202
 endurance 188
 gear 196, 199–200
 lighting 195
 living in the moment 180
 photographing athletes 196–198
 practical tips 194–198
 preparing for 194, 200
 renewal 183
 resilience 188
 resources 200–201
 "roughing it" 183
 shooting assignments 201–202
 staying healthy 194
 time of day 190–191
 value 183, 187
 weather 183
 workshop assignments 200–202

P

pain 10
panning 65
patience 186
Patitucci, Dan and Janine 249–250
Patitucci Photo 200, 202
Peachpit 272
penguins 25
people, photographing. *See* portrait photography
perseverance 53–54, 185
perspective
 found photography 212–215
 high vs. low 90–92
 portrait photography 90–92
 "shoe perspective" 202
 travel photography 167, 169
 wedding photographs 139–141
Peterson, Eugene 4
phone cameras 246
Photo District News 271, 272

photographers
 amateur 263–264
 being inconspicuous 225–226
 hiding behind the camera 118
 improving skills 72
 internal filter 38
 networking with 47
 professional. *See* professional photography
 "Sprezzatura" and 9
 uncertainty and 41–42
 unique experiences of 212
photographic collections 220
photographic inspiration 271
photographic workshops 272
photographs
 blurred 65, 145
 details 58, 139, 145, 190, 212, 221
 directional 222–225
 emotion and 76
 environmental 98
 rekindling imagination 9
 sense of order 42–43
 sharing. *See* sharing photographs
 "trophy" 74
 value 183, 187
photography
 action. *See* action photography
 business of 271
 conferences 47
 creativity. *See* creativity
 discarding the unnecessary 10
 discovery 6
 effort required 17
 engaging the viewer 9
 failed attempts 53–54
 flash 57
 found. *See* found photography
 genres 186, 259, 261
 improving skills 208–209
 learning to see 33–49
 limitations 56–57
 messages in 6
 mystery of 4, 5
 night 164–166, 195, 215–216
 outdoor. *See* outdoor photography
 perseverance 4, 185
 poetry and 3–13
 portrait. *See* portrait photography
 power of observation 34, 37

professional. *See* professional photography
 saying more with less 6
 self-awareness and 72
 time of day 190–191
 travel. *See* travel photography
 truth in 4, 5
 "writing with light" 6
photography agencies 272
photography books 270–271
photography conferences 265–267
photography publications 271
Picasso 15, 19, 52
Pictoralism 64–65
play, importance of 56
Poe, Edgar Allen 4
poetry
 change created by 4
 considerations 3
 discarding the unnecessary 10
 discovery 6
 distillation 3
 diversity of 3
 Edgar Allen Poe on 4
 engaging the reader 9
 filling in the gaps 9
 messages in 5–6
 mystery of 4
 photography and 3–13
 power of observation 34
 rekindling imagination 9
 saying more with less 6
 truth in 4, 5
 as a way of life 10
poet's life 10
portfolio 272
portrait photography
 approaching strangers 99
 authenticity 87, 89
 close ups 87
 common mistakes 87
 complimentary voice 95
 conversing with subjects 99
 depth of field 87–88, 89
 eyes 89
 gear 97
 having fun with 84
 high vs. low perspective 90–92
 improving skills 98–99
 lighting 82–84

movement and 93–95
peripheral/spatial vision 85–86
photo shoots 95–97
practical tips 82–97
props 99, 118, 126
relating to subject 95–97
reviewing photos 100
sharing photographs 99
storytelling and 95–97
taking risks 82
during travels 167
workshop assignments 98–100
portraits 71–103
 Aperture Value and 64
 of athletes 196–198
 authenticity 76
 capturing individual style 198
 capturing substance 80–81
 depth of field 64
 "happy" 79
 individual style 198
 "out of element" photos 197
 posed 93–95
 smiles 74, 76, 79, 111
postcard shots 161–163, 202
professional photography 255–278
 believing in yourself 258, 259
 business savvy 267
 competition 268
 education 272
 following your dreams 258–260, 269–270
 humility 262–263
 hurdles 268–269
 negative advice 256, 262
 practicality and 267–268
 resources 270–272
 self-definition 261–262
 Sellification vs. soul 267
 starting out 264
 success stories 256–257, 265–267
 support network 264–265
 undercurrent map 261–262
 work required 269
Program mode 63
props 99, 118, 126
Proust, Marcel 33

R
Rakichevich, Nino 84
rainbows 39–41
Rainier, Chris 72, 176–177
reflectors 83
Renee, Christa 126
renewal 183
repair supplies/tools 200
resilience 188, 189
Riboud, Marc 12–13
Rich, Corey 200
rule of thirds 42, 168
Runes, Dagobert 163

S
Saadi, Moslih 170
scale 201
Sellification 265–267
senses, awakening 10
Sexton, John 35, 48–49, 263
Shackleton, William 268
shadows 44
shape 222
sharing photographs. *See also* Flickr
 family photos 127–128
 found photography 228
 outdoor photographs 202
 portrait photography 99
 travel photography 172
 wedding photos 146
Shelton, Jeff 92
"shoe perspective" 202
shutter speed 63, 65–66, 192, 193
signs 218–219, 227
silence 36
silhouettes 169
Slater, Kelly 60, 61, 260
slow-motion scenes 191
smiles 74, 76, 79, 111
Smith, Rodney 57–58, 72, 73, 102–103
snacks 200
solitude 36, 186
songs 6, 25
Sontag, Susan 43
Speed mode 63, 65
Spielberg, Steven 256–258
spinning 65
"Sprezzatura" 9

Steichen, Edward 52–53
Steinbeck, John 19, 53
stillness 73
stories
 searching for 24
 success 256–257, 265–267
storytelling
 portrait photos and 95–97
 travel photos 155–156
 wedding photos 136–137
Stravinsky, Igor 10, 56
style 188, 189, 198
sunlight 82
sunrise 164, 191, 195, 201
sunset 117, 164, 191, 195
surfers 76–79, 89
surfing-related Web sites 201
Szarkowski, John 4

T

tea stains 52
technique, creativity and 51–68
telephoto lens 62
telephoto zoom lenses 243
temperature 200
tenacity 188
Tenneson, Joyce 72, 101–102
textures 166
themes 172
time 166
Time Value mode 63, 65
Tolkien, J.R.R. 208
Tomson, Shaun 50, 77, 93
tools 200
travel 151–177
 becoming immersed in 152
 color palettes 166
 different view points 153
 festivals 168
 focusing on what's important 169
 food 167
 iconic images 160, 161, 162
 inner artist and 163
 memories 156, 163
 off the beaten path 159, 160
 packing for 170
 people 167
 postcard shots 161–163, 202
 practical tips 164–169

quality of light 163
reflecting on 173
sense of discovery 24, 158–159
shared experiences 159–160
signs 167
textures 166
themes 172
time 166
weather 164
Web sites 170–171
writing about 155–156
travel bags 170
travel books 171
travel experiences 156
travel photography 151–177
 architecture 168–169
 close ups 172
 colors 172
 creating space 172
 gear 170
 inspirational photos 156
 landscape 168
 monuments 169
 perspective 167, 169
 rule of thirds 168
 sharing photos 172
travel stories 155–156
travel writers 155
tripods 170, 195, 200, 201, 241–242
"trophy" photos 74
truth 4, 57
Turner, Pete 30–31
Turner Forte 201
Twain, Mark 180
typography 219

U

U2 6
"Until the End of the World" 6
Updike, John 76

V

value 183, 187
van der Rohe, Ludwig Mies 58
Villa, Jose 126, 129–130, 144
vision 33–49
visual-poet.com web site xiii, 202

W

walking 208
Wallace, William 267
water 246
water damage 247
weather 164, 183, 200
Web sites
 gear information 248
 surf-related 201
 travel 170–171
 wedding photography 144
wedding albums 146
wedding photographs 133–149
 approach to 137–138
 available light 142
 bird's eye view 145
 bridesmaids 142
 details 139, 145
 engagement photos 138–139
 families/children 142
 gear 143
 groomsmen 141
 importance of 133–134
 involvement of participants 134–136
 perspective 139–141
 practical tips 138–145
 sharing 146
 sifting through 146
 storytelling in 136–137
 wedding preparations 139
 workshop assignments 143–146
Wellman, Mark 265
Weston, Edward 48, 52–53
whimsy 55–56
wide-angle lenses 60, 192, 243
wind tunnels 193
wisdom 57
Wolfe, Art 243
workplace, photographing 222
workshops 272
Wright, Frank Lloyd 168–169

Y

Yeats, William xi

Z

zoom blur 65–66
zoom lenses 58, 62, 243
zooming in/out 65–66